The Screenwriter's Guidebook

INSPIRING LESSONS FOR FILM AND TELEVISION WRITERS

Christine List and Christine Houston

Third World Press Foundation
Chicago

Third World Press Foundation
Publishers since 1967
Chicago

First Edition
Printed in the United States of America
20 19 18 17 6 5 4 3 2 1

Library of Congress Cataloging-in-Publication Data

Names: List, Christine author. | Houston, Christine author.
Title: The screenwriter's guidebook : inspiring lessons for film and television writers / Christine List and Christine Houston.
Description: First edition. | Chicago : Third World Press Foundation Books,
2016.
Identifiers: LCCN 2016034137 (print) | LCCN 2016053342 (ebook) | ISBN 9780883783351 (pbk. : alk. paper) | ISBN 9780883787168 (e-book)
Subjects: LCSH: Motion picture authorship--Vocational guidance. | Television
authorship--Vocational guidance.
Classification: LCC PN1996 .L57 2016 (print) | LCC PN1996 (ebook) | DDC
808.2/3--dc23
LC record available at https://lccn.loc.gov/2016034137

ISBN: 978-0-88378-335-1 (paperback)
ISBN: 978-0-88378-716-8 (ebook)

Contents

Acknowledgements

This book would not have been possible without the encouragement of Haki R. Mahubuti, who approached us to write for Third World Press. After many years of studying and teaching the works of successful African American film and television writers, we were excited by the opportunity to create a guidebook to teach screenwriting with examples from the African American screenplays and television scripts we truly love and admire.

We'd like to thank Bennett Johnson and our editor Gwendolyn Mitchell, as well as Relana Johnson, Rose Perkins, Denise Billups and the staff of Third World Press who, along with Haki R. Madhubuti, have given a lifetime of resources, knowledge, and sacrifice to build Third World Press. We are humbled and honored to have the chance to publish our book with this historic Black institution. Additionally, we would like to thank all the teachers who taught us to love the craft of writing, and, of course, we also wish to thank the students at Chicago State University whose creativity and brilliance have nurtured and inspired us over the years.

We would especially like to express our gratitude to Shahari Moore for her invaluable contributions to this book. She is a gifted writer and passionate filmmaker who gave us wonderful suggestions and advice for the project.

Our loved ones and mentors deserve more than just thanks: Jerome Houren, Grace Houren, Payton List, Nora Catolico, Kate Kane, Virginia Keller, Deborah Tudor, Ramona Curry, Toni Perine, Chuck Kleinhans, Manju Pendakur, Anthony Adams, the late Stuart Kaminsky, and Alaina Reed-Hall.

Above all, we would like to thank the film and television writers who were so generous with their time and graciously permitted us to interview them for the book: Bill Duke, Robert Eisele, Kathleen McGhee-Anderson, Sara Finney-Johnson, Zeinabu irene Davis, Charles Burnett, and especially Dwayne Johnson-Cochran, who has

given us countless hours of guidance over the years.

Sadly, we must acknowledge the passing of Judi Ann Mason who fueled this project with sage advice and heaps of encouragement. As one of the first African American woman to be admitted into the Writers Guild of America and a trailblazer in the industry, Judi was an inspiration to so many. Those who had the privilege of knowing her remember Judi was a tireless supporter and mentor to all young African American writers who had the good fortune to know her.

Finally, we'd like to say that we've had a great time researching and writing this book together. We hope that we'll inspire you to put your stories down on paper and feel that exhilarating sense of accomplishment as you complete your first screenplay. We wish you much success!

Introduction

If you are wondering how to get started on the process of writing your first screenplay, you will need to start with the basics. Why not begin this process right now? Create a list of your top ten favorite movies and top ten television shows. Next, ask yourself, what is it about the writing in these film and TV projects that you love? Is it the story? Is it the dialogue? Is it the fascinating characters? Is it the fact that your favorite films or television shows place you into another reality, an imaginary world that you don't want to leave? Is it the independent or alternative aspects of these television shows or films that draw you in and illuminate your viewing experience, or is it just the way these programs make you laugh?

If you want to know which movies Hollywood thinks are in the top ten, or in the list of the top one hundred movies of all time, you can check out the websites of two organizations that have had a major influence on the creation of the canon of Hollywood cinema. Over the decades, members of The Writers Guild of America (WGA) and the American Film Institute (AFI) have put together rosters of their most revered and beloved films.[1] The movies on these lists do indeed deliver with truly enduring plots, compelling characters, and brilliant dialogue. Because of this, these classics have been used as the central examples in screenwriting books over the years. We're talking about great scripts such as *The Godfather, Chinatown,* and *Casablanca.* Once you check out these top one hundred lists for yourself, compare their choices with your list. You will most likely discover that the canon may not include the titles that you've put on your own list of favorites.

At this moment in film and television history, Hollywood is not exactly rethinking its canon, but it is slowly beginning to come to terms with the fact that the industry has been neglecting segments of its audience. Take, for instance, the historic moment in 2010 when Geoffrey Fletcher won the Academy Award for Best Adapted

Screenplay for *Precious: Based on the Novel "Push" by Sapphire.* He became the first African American screenwriter to receive that award. Though coming late in the long history of our industry, it is certainly an encouraging step on the part of Hollywood toward acknowledging the creative achievements of writers of color. Over the decades, the activism of women and minority groups who have threatened boycotts and launched repeated protests against offensive content in the media, have helped writers from all walks of life gain access to creative and management jobs in the film and television industry.[2]

Nielsen media research data shows that in 2012, African Americans spent more time than any other ethnic group in the U.S. using TV related media.[3] In 2009, African American households watched two hours more television per day than Caucasian households in the U.S.[4] Nielsen also reported that in 2010 African Americans saw 12 percent more films per year in the theatres.[5] According to the latest U.S. census reports, African Americans, counted together with Hispanics, now make up approximately 30 percent of the U.S. population, and by the year 2050, will grow to be the majority of our country's film and television viewers. Of course, 52 percent of the U.S. population continues to be made up of women. As a majority segment of the population, women are also showing strong gains in spending power and comprise a substantial source of advertising revenue and ticket sales for the media industry.[6]

Such audience trends, combined with public pressure, have led to some openings on the creative side of the industry, but still writing positions are not staffed to satisfactory levels. A 2011 report by the WGA[7] notes that, over a two-year period from 2007 to 2009, the percentage of minority writers working in film decreased from 6 percent to 5 percent. There were slight increases in the number of minority writers working in television from 9 percent to 10 percent. Clearly, diversity and African American voices are still very much under-represented in the industry.

Nevertheless, it seems that Hollywood is slowly but surely changing. The fact that one of the consistently top rated shows in prime time, *Grey's Anatomy*, was created, written, and is executive produced by an African American woman, Shonda Rhimes, is an encouraging fact for all screenwriters.

Unlike other screenwriting books, this book will look at the art of screenwriting for film and television by studying successful screenplays and television scripts written by female and male writers of African heritage.[8] In many cases, you will discover that these writers are using the very same story-telling techniques that Hollywood has utilized over the history of moviemaking. In other examples in this book, you will notice that these gifted writers are bringing influences to their writing from sources that Hollywood had not used previously, including certain global cinema traditions as well as other African American art forms such as spoken word, hip hop, and African storytelling techniques.

Unfortunately, there are not enough pages in any book to look at all the great work produced over the decades of African American film and television production. The writers mentioned in this book are just a few of the best screenwriters out there. We wish we had the space to mention all of them.

Writers write what they know, but they can also write beyond their first culture. African American writers have a steady track record of writing works that speak across cultures, creating stories that are culturally specific in detail while global in their impact and themes. As all Americans become more skillful at moving within the multi-cultural environment that is our nation, writers of every color and gender need to learn from each other. We invite all readers of this book, no matter what your heritage, to develop your craft through the study of the screenplays and television scripts mentioned in this book. We also encourage readers of our book to look to other screenwriting books as companion pieces to this text. A great script is a great script. We believe the more outstanding scripts you can read and study, the better your writing will become.

Part One of this book focuses on writing for film. You should read the chapters in this section in sequence and follow the exercises at the end. The exercises are designed to walk you through the steps towards completing a feature-length screenplay. Part Two of this book focuses on writing for narrative (also called "scripted") television. It provides a method of creating scripts for comedy as well as for dramatic formats. This section closes with a chapter that concentrates on the business aspects of writing for film and television. Part Three of this book includes interviews with producers and writers from the

Hollywood film and television industry as well as with screenwriters working in alternative venues. These interviews will provide you with advice on a variety of topics—from how to write stories with universal appeal to how to make it as a writer in this ever-changing media business. These professionals we have interviewed are all seasoned veterans who, along with their expertise, bring a historical perspective to the writer's table. We hope that these interviews will provide you with guidance and inspiration as you begin your quest to tell stories for the screen and become—as writer-producer Kathleen McGhee-Anderson so aptly describes herself—the next "vision-holder."

PART ONE

WRITING
FOR FILM

Starting Points

If you want to develop skills as a screenwriter, it goes without saying you should be watching anything and everything you can get your hands on: mainstream films, independent films, short films, alternative films, films by international screenwriters. You should watch as many films as you can stuff into your busy schedule. Dwayne Johnson-Cochran, the writer and director of *Love and Action in Chicago*, estimates he saw 2,500 movies between the ages of twenty-one and twenty-four. He sometimes watched three films a day—and this was before you could watch movies in your own home! He exposed his artistic sensibilities to all kinds of directing and writing "from Kurosawa to Ozu to Goddard to Truffaut, to Bergman to Tarkovsky to Ray, Nicholas and Satyajit, to Wenders, to Ford."[1]

Subscribing to a DVD rental, instant viewing, or On Demand plan is a great way to gain access to a wide variety of movies. If you live near a big city or a university campus, you should be sure to check out the schedules of the alternative movie houses and film societies around town. These venues are a great way to see movies that you can't find anywhere else.[2] In Chicago, for instance, there is a Silent Film Society where you can see classic old movies that demonstrate how to tell a story strictly through visuals. Remember, screenwriters must be masters of the visual as well as of the spoken word. Chicago also hosts more than a dozen film festivals such as the Bronzeville Film Festival, the Black Harvest Film Festival, the Chicago Latino International Film Festival, the Gay and Lesbian Film Festival, the Chicago International Film Festival and many others. Film festivals mount forums where the filmmakers, actors, and screenwriters are present to answer your questions about the movies. You should consider volunteering with one of these film festival organizations. It is a great way to meet others who share your obsession with movies.

You should also consider keeping a notebook where you can write down things you like or dislike about the movies you watch. Don't forget that consciously observing what not to do is also a great way to learn. If you don't have cable, consider it as an investment in your future. Turner Classic Movies, the Sundance Channel, TV One, Aspire, the Independent Film Channel, and Movies On Demand are all great sources of viewing older movies as well as new works that you can't see at the theatres.

Know Your Craft

Knowing your craft means considering the idea of directing your scripts yourself. The cost of owning your own equipment is within reach for most filmmakers and screenwriters. Many screenwriters are writers/directors/producers and find directing their own movies in a low-budget format is a logical way to break into the industry. Therefore, we recommend that you take as many film classes as possible. This includes cinema history, screenwriting, and film production courses, as well as acting courses. These classes will help you to deepen your understanding of how a film is put together from pre-production (the stage of filmmaking that involves everything before the shoot), through production (the shooting phase), through post-production (editing, music), and distribution (getting your film to your audience). Learning these aspects of filmmaking will broaden your perspective as a screenwriter. Many colleges have inexpensive extension courses in cinema. You can also find courses at film centers, museums, and even at your local library.

Finally, as you begin your quest to master the art of screenwriting, remember to read as many scripts as you can get your hands on. There are several websites that provide free downloads of original screenplays. Be careful to look for scripts that are drafts of the original. If a screenplay's not an original, it could be a transcription of the film and not the script used for the film. A good place to get copies of actual scripts is a company called Script City (scriptcity.com) that has hundreds of scripts available for purchase in their original format. Remember, when ordering scripts online, be sure to check with the webmaster to verify that the site has permission to download the script to you and is not infringing on someone's copyright.

You might also want to purchase the book *Screenplays of the African American Experience* by Phyllis Klotman. The book contains original screenplays for a number of independent films. You can find original scripts in the library collections of the Writers Guild of America and at the Margaret Herrick Library of the Academy of Motion Picture Arts & Sciences.

Reading scripts is key to understanding the language of visual description that writers use to set up scenes. Reading scripts will also help you internalize the screenplay format so that professional formatting becomes second nature to you as you write.

THE AFRICAN AMERICAN FILMMAKING TRADITION

Whether or not you are African American, it will greatly benefit you as a screenwriter to know more about the history of African Americans in the U.S. movie industry. From the advent of the movie camera, African Americans have been part of the American movie landscape. As early as 1916, Noble Johnson, a popular African American actor working for Universal Studios, joined together with fellow African American actor Clarence Brooks, and wealthy African American druggist, Dr. J. Thomas Smith, to raise $75,000 in capital to form the Lincoln Motion Picture Company— Hollywood's first Black-owned movie studio. Noble Johnson wrote the screenplay for their first hit *The Realization of a Negro's Ambition*. This silent movie classic, along with several other silent features produced by the Lincoln Motion Picture Company, proved to be greatly popular with African American audiences; so much so that Universal Studios eventually demanded that Johnson choose between working for Universal or for Lincoln.

In 1922, three films were directed and produced by African American women. The first was entitled *A Woman's Error* by Tressie Saunders. *The Flames of Wrath*, a five-reel mystery produced and directed by Maria Williams, then followed this film. Williams was the owner of her own production company—the Western Picture Producing Company. Also that year, the Osborne Players, a theatre group formed by the women of the St. Paul Presbyterian Church in Kansas City, Missouri, produced a film called *Seeing Kansas City in Action*. Written by Mrs. P. Earline, the movie was based on a play

entitled "The Minister's Wife." You can find out more interesting details about the early days of African American filmmaking by checking out the documentary *Sisters in Cinema* by Yvonne Welbon or the film *That's Black Entertainment* by William Greaves. There are several must-read books on the topic of early African American Cinema history as well, including *Migrating to the Movies: Cinema and Black Modernity* by Jacqueline Najuma Stewart, and Donald Bogle's Bright Boulevards, *Bold Dreams: The Story of Black Hollywood.*

One film we recommend as an excellent starting point in your pursuit of visual knowledge of Black images is a documentary called *Ethnic Notions* written and directed by Marlon Riggs. The movie looks at negative stereotypes of African Americans throughout the history of the U.S. and explains the social origins of these damaging images. Another film we suggest you see is *That's Black Entertainment*, which contains clips from early movies written and directed by African American filmmakers, and excerpts from the pioneering works of early African American sound cinema written and directed by Spencer Williams and the great producer-director Oscar Micheaux are featured. Micheaux started his own production company, making films that were distributed to black audience movie theatres throughout the South. The Producers Guild of America celebrates him as "the most prolific Black—if not the most prolific independent movie producer—in the history of American cinema."[3] He wrote, produced and directed forty-four feature length films between 1919 and 1948. Many of his films, as well as those of Spencer Williams, have been restored and are available for rental or purchase.

Fortunately, it is now much easier than it has ever been to get access to a wide array of Black independent films. Many films are being re-released on DVD and can be purchased through the bigger rental companies or are self-distributed by the filmmakers. Sometimes you can find them airing on cable on TV One. Above all, we encourage you to watch Black films.

There are several additional excellent resource guides on African American film history that we would like to refer you to. *Toms, Coons, Mulattoes, Mammies, and Bucks: An Interpretive History of Blacks in American Films* by Donald Bogle is considered the classic

reference guide to African American participation in the Hollywood film industry. Also *Frame to Frame I: A Black Filmography* by Phyllis Klotman and *Frame to Frame II: A Filmography of the African American Image 1978-1994* by Klotman and Gloria Gibson provide a comprehensive filmography of thousands of independent, as well as Hollywood, features that were written, produced, directed, or acted in by people of African descent. These reference guides include the names and addresses of the locations where the films are archived.

Beyond looking at the history, to expand your understanding of the aesthetic and social importance of Black films, you should consider reading books on African American film theory. Mark Reid's *Redefining Black Film*, Ed Guerero's *Framing Blackness: The African American Image in Film*, Manthia Diawara's *Black American Cinema*, and Valerie Smith's *Representing Blackness: Issues in Film and Video* are just a few of the works that develop critical approaches to Black filmmaking. We suggest you delve into a book like *Black Film as a Signifying Practice* by Gladstone Yearwood or *Black Women as Cultural Readers* by Jacqueline Bobo, and push your mind to embrace the complexity of African American cinema.

Books by and about individual filmmakers are always inspiring. Spike Lee's books give you an intimate look at the creative process he undergoes when writing and directing a film. We highly recommend all of his books. His biography, *Spike Lee: That's My Story and I'm Sticking to It*, written by Kaleem Aftab, is excellent reading. You should pick up a copy of *African American Screenwriters Now: Conversations with the Black Pack* by the late Erich Leon Harris. It is a great collection of interviews Harris did with major Hollywood writers during the 1990s.

If you're interested in experimental film, try *Daughters of the Dust: The Making of an African American Woman's Film* by Julie Dash. It contains the full text of the screenplay along with an in-depth interview with writer/director Julie Dash. A fantastic book you should definitely not miss is *Why We Make Movies: Black Filmmakers Talk About the Magic of Cinema* by George Alexander. This 550-page volume is packed with brilliant conversations with the leading African American directors of our time.

GENRE FILMS

Besides star appeal, promoting films based on their genres is one of the most powerful ways Hollywood markets its products to film audiences. *Genre* is a term that refers to the type of story you are telling. Some of the genres you've probably heard of are the horror film, the detective story, the gangster film, the western, and the romantic comedy. Within genres, there are subgenres; for instance, the zombie horror genre or the vampire horror genre.

It is important that you understand the story conventions of the genre that your own screenplay will be based upon. That means, if you are writing a "coming of age" genre film, you should watch as many movies as you can that tell coming of age stories; not so that you can write the exact same story, but so that you can understand the *cinematic conventions* of the genre. Many members of your audience will have seen as many or more films in the genre than you have. This is because viewers tend to have preferences for films based on the genres they enjoy most. Film audiences internalize the conventions of genre films and, thus, expect certain things to happen in the story. For example, in the coming of age film, *Boyz in the Hood*, the audience expects the protagonist to face a decision that will confirm that he is ready to live a responsible adult life. The audience for a coming of age film will expect the main character to also take some serious wrong turns along the way so that the final decision by the protagonist to take the path towards maturity is more difficult and meaningful. In a western, the conventions of the genre dictate that a main character be a loner who typically finds himself forced to fight the outlaws in town, despite the fact that he just wants to live out his own life in peace—to be left to his own devices to roam through the vanishing wilderness.[4]

It is every writer's job to understand the conventions of the genre she or he is working in; then work within the conventions (i.e. expectations of the audience regarding those conventions) while also creating something original. How can you do something new and original when these film genres have been around for decades and many of the genres themselves have their roots in thousands of years of oral storytelling? It is common knowledge among writers that there are only a limited number of basic plots out there for us to use: the protagonist struggles to find perfect love, a warrior

battles for territory, a hero must vanquish the evil creature from the community, a troubled protagonist struggles to overcome her personal demons, an antihero is toppled by his own tragic pride. What makes a story enjoyable is not so much dependent upon which of these timeless plotlines the writer is using, but rather the way the writer tells her own version of the particular genre storyline. It's in the details. Spike Lee, in an interview with Kaleem Aftab,[5] explains that he viewed a number of "bank heist" genre films before touching up the script to *Inside Man*, a film that Lee also directed. Lee and his collaborators carefully watched *Dog Day Afternoon, Serpico, The Usual Suspects*, and other heist films as part of the preparation for shooting their own rendition of the heist genre movie.

Once you start reading the trades, you'll notice that *Variety* and *The Hollywood Reporter* break out film earnings reports according to genres. If we look at the popularity of genres according to box office gross from 1995 to 2009, we see that 1,478 comedies were released, earning over 36 billion dollars and grabbing a 24 percent share of the theatrical market.[6] Adventure films came in second with a 19 percent market share. From 1995 to 2009, the adventure genre grossed 29 billion. However, in that fourteen-year period, only 417 adventure films were released compared to 1,478 comedies during the same time period. If we look closer at the data, we see that the average adventure film (think *Independence Day, Hancock, Three Kings*) grossed over $70 million dollars per title, whereas the comedies (such as *Major Payne, This Christmas*) averaged only $24 million dollars on each film.[7] Keep in mind these are averages. Many comedies, especially family comedies and animations, are consistently high grossing. *The Nutty Professor* brought in one hundred and twenty eight million dollars at the box office. *Media Goes to Jail* earned ninety million. *Jumping the Broom*, the first African American-themed film to open in theatres during the summer season, grossed 25.8 million through its first ten days.[8] Perusing this data in the trades will help to remind you that, when you are writing a Hollywood-style screenplay, you are writing for an industry that organizes itself around genres.

As more African American screenwriters gain access to Hollywood, old genres are being reworked in very powerful ways (for example, the Hughes Brothers' revision of the gangster genre

with *Menace II Society*). At the same time, new genre categories continue to appear. Many screenwriters prefer to write outside of the constraints of genre. Spike Lee is a case in point. Having made twenty films in twenty years, *Inside Man* is considered his first genre film. His other works seem to be constructed for the purpose of intentionally defying genre categories. A great example of this is Lee's *Do the Right Thing*. Voted into the top 100 screenplays and top 100 films of all time by both the WGA and AFI, *Do the Right Thing* is not a social problem film about Mookie, but rather a film that follows the story of an entire community faced with a decision to act or react, depending on how you interpret the ending. The famous open ending of the script, frustrating for Hollywood studio executives to accept, turned out to be the type of plot twist that Lee's generation of viewers readily embraced. Lee, a filmmaker's filmmaker, fits within a larger tradition of international cinema whose screenplays appeal to audiences not through the conventions of genre but through the intellectual brilliance of the work.

As an unknown writer, you will find that screenplays that fall outside of genre categories are often difficult to sell. If your writing tends to be more experimental or personal in nature, it may be that the only way you can get your script produced is to make it yourself.

THE PROBLEM OF REALISM

Something that's always interesting to discuss with first-time screenwriters is the problem of realism. Many beginning writers assume that the great writers are the ones who can literally replicate reality. If this is your view, challenge yourself to rethink that assumption by considering this. Great Hollywood movies don't copy reality, because real life does not fit within a hundred-minute neatly constructed narrative format. A good way to understand the difference between narrativized treatments of reality and reality itself, is to consider the following example from an experimental film called *Jeanne Dielman, 23 Quai du Commerce, 1080 Bruxelles* (1975) which was written and directed by a Belgian experimental filmmaker named Chantal Akerman.

The film contains an intensely long take of the female protagonist peeling potatoes. The shot goes on for several minutes and is tedious

to watch precisely because it is completely real. As an experimental film, the work is brilliant, focusing us on the unglamorized reality of a woman's life and also drawing our attention to the expectations we have when we watch films. Having seen so many movies throughout our lives, when we watch Akerman's film, we are expecting the shot to cut to a close- up, the mood to change, and for something "dramatic" to happen. The fact that *Jeanne Dielmann* forces us to question assumptions about our perceptions of film and how cinema depicts women is what makes this film a favorite of film critics who have called it a masterpiece. Yet, just as its unusual form accounts for its status as a great *experimental* feminist film, its hyperrealism (showing several uncut minutes of a woman peeling a potato) is also what makes it antithetical to Hollywood feature filmmaking conventions.[9]

Unlike experimental or documentary films, mainstream *narrative* films take reality and *fictionalize* it in intensely dramatic ways. Screenwriters of feature films take incidents that occur over time, boil them down to their most dramatic or funny or tragic elements and make a story out of that. Anything that is uninteresting and unimportant to the story is left out. Hollywood narrative movies use story structure that allows you to cut from one location to another, one moment to the next, without confusing the audience. To master the craft of screenwriting is to essentially master a powerful storytelling *shorthand*. It's your cinematic language as a screenwriter that allows you to get to moments of tragic intensity or humor without having to linger on reality as it really is in everyday life.

Have you heard the phrase *"suspension of disbelief"*? It's a convoluted way of saying that great movies lure us into the reality of the world on the screen, transporting us into the fictionalized reality created by the film. How does the screenwriter help the viewer into a state of suspended disbelief? The answer: by making the story and the characters believable within the environment she or he has created for the hundred minutes we are watching the movie. Poorly written scripts often have incongruous plots or unbelievable characters or dialogue that make us step back from the film reality and question what's going on in the movie.[10]

The fictionalized reality of a movie is, of course, something the screenwriter makes up to represent the concepts she or he is trying to get across to the viewer. A well-written fiction film will have a

certain element of truth value. In other words, it will capture the essence of our lived experience in a way that will ring true to the audience. Actually, often times, a fiction film can capture a truth as well or better than even a documentary can by getting at the essence of a situation or bringing out a deeper understanding of something. Take, for example, the life and work of the famous American, Malcolm X. If you watch the documentary episode of *Eyes on the Prize* that shows actual historical footage of Malcolm X, you come away with what feels like a truthful portrayal and understanding of the man.[11] On the other hand, if you watch the Spike Lee feature film, *Malcolm X*, in which Spike Lee fictionalizes the life of Malcolm X, you come away with an even more profound view of his life. Did Malcolm X really say the words he says to his wife and colleagues in Lee's film? Did each incident unfold exactly as it does on screen? Spike Lee can't know for sure, but the essence of Malcolm X, the man, his struggles and his triumphs, are more apparent to us in the fiction film than in the documentary film version of Malcolm X's life. That's not to say that documentaries aren't as powerful as vehicles for conveying truth as narratives are; it's just to say that a great fiction film can show a reality in a truthful, compelling manner.

REALISM AND YOUR LIFE STORY

The main reason for engaging in this discussion of realism early in the book is to discourage you from trying to replicate the exact reality of your own life as the main subject for your first film. We urge you to ask yourself, "Does your life story merit the big screen?" If you've taken other fiction writing classes, such as novel writing, you've probably been instructed to keep a journal or diary. In fact, you've probably been encouraged to write the story of your life as your first book. But it's important to remember that film is a totally different medium from the novel, and what works in a book has to be completely reworked for a film. In fact, adapting a novel for the big screen is a skill that most novelists don't possess. Novelists are masters at crafting detailed descriptions and interior monologues that can go on for hundreds of pages. Screenwriters are not novelists. We don't have twenty-four hours to engage our readers in myriad details about a character. That luxury is afforded to television writers over

many seasons, but unfortunately not to the feature film writer. We only have an average of a hundred minutes to tell our stories, and we, as screenwriters, must focus on telling the story through dialogue and plot. That's why some stories are more appropriate for the big screen and others are better realized as a novel.

So why not write your life story as the basis for your first screenplay? Antwone Fisher did it! Screenwriter Antoine Fisher had a keen understanding of story structure and scene construction. He also had an incredible story to tell with a very powerful message at the end. Most people have trauma and sadness at some point in their lives. Many people are betrayed by a family member, or they lose loved ones to illness, accidents, or violence. Most people have struggled to exist in the world. So if that's what's happened to you, and you want to write it for the big screen, you must ask yourself, "What's going to be so special and different about the way my story is told?"

Antwone Fisher's story is told in a masterful cinematic way. It starts with the young naval officer reacting violently to his situation. He is sent to see a Navy psychologist. These visits with the psychologist become a cinematic device for revealing the horrible experiences of Fisher's past. The movie then develops along two parallel plot lines: Fisher's struggle to connect with people in the present and Fisher's struggle to come to terms with his past. For the superb and satisfying ending of the film, the screenwriter gives us perfect closure of both stories when the main character is welcomed into his father's family by cousins and elders alike and invited to feast at their bountiful table. Fisher has found a connection to his past that allows him to become a loving and self-respecting man in the present. The movie has great story structure and a beautiful ending, not to mention interesting, complex characters and themes.

Now, if you can boil down your own life story into something as complex and meaningful as a film like *Antoine Fisher*, or as emotionally gripping as a film like *Precious*, then go for it. But if your life hasn't provided you with some deeper revelations yet, wait to tell your own personal saga until you've lived a little longer. The wisdom that makes for good storytelling comes with living life. For our young writers, remember that your autobiography will get better with age, and sometime in the future, you might find a way to make a great script out of it. In the meantime, try keeping a personal diary instead of

writing your life story as a film, or try writing your story for television instead of for film. Television is a medium that more closely patterns itself after long-form storytelling media (i.e., the novel) and allows for more variations in plot and character development. In part two of this book, you will learn about writing for television.

Another major problem that occurs when screenwriters write directly about themselves as opposed to writing about someone they know is that it is fundamental human nature that most of us can't step back and admit we do anything wrong. A great main character should have a flaw or weakness along with his or her strengths. Most bad scripts about one's own life story are bad because they contain boring main characters who are perfect people.

Most of us have a hard time accepting criticism about ourselves. The novice writer can ignore the advice of critics by saying to herself, "Well, that's the way it really happened." Remember, however, reality is boring. Our job as writers is to mold reality into great stories. Free yourself from the burden of that classic first feature screenwriting trap. Instead, take your initial steps into screenwriting with a fresh new compelling idea, informed by what you know, perhaps populated by characters who resemble and are informed by people who you know. You can create characters that may be like you but who are not necessarily exactly like you.

YOUR ART FORM, YOUR BUSINESS

Film is both an art form and an industry. In order to be marketable, new writers often feel a certain pressure to write in the genre of the moment. Don't fall into that trap. There is no way to catch the wave of the latest genre in time to ride it. Audience tastes fluctuate. The only way to get your foot in the door of Hollywood is to write a great script. To do that you should write for yourself, write what you like, and not worry about what you think the audience wants at a particular moment in time. If you try to second-guess your audience, you will lose your own voice as an artist, and that will hurt your work.

Spike Lee confirmed this philosophy in an interview with Kaleem Aftab when he said that the worst film he ever made was a movie he wrote to please his grandmother, who he loved very dearly, and who was the principal investor in a lot of his early film projects. The

movie was something he thought she would enjoy, but, in trying to figure out what would entertain his grandmother, he lost his own voice as a filmmaker and screenwriter. The resulting screenplay was mediocre in his eyes. So follow our advice, and the advice of most filmmakers out there, and be true to yourself.[12]

If you ever want to sell your script or see your film made by a producer and distributed, the first member of your movie audience will be the professional—an agent, a producer or producer's assistant, a development executive, or a low paid script reader—who reads your movie as it's written on the page. While there is no exact formula for a saleable screenplay, professionals who sell your scripts to producers and investors agree that they want to see a script that has a strong plot, multidimensional characters, and believable dialogue. Many agents and producers will also be looking for a script with a strong concept—an idea that can be pitched in one sentence that is original and so self-evident that everyone who hears it thinks, "I should have thought of that." Conceptually strong films are easy for agents to pitch to studios.

The importance of a great title can also not be underestimated. The title of your film is your calling card. It should draw attention to your script, not make someone want to put it at the bottom of the pile. The title of your screenplay should normally be no longer than five words. It should give the audience an idea of the theme of your movie. The best titles are clever, ironic, or hint at something deeper under the surface. *Eve's Bayou, Devil in a Blue Dress, Scary Movie,* and *Love and Basketball* are all examples of excellent movie titles. Try to stay away from titles that are vague and have no connection to your story. Be aware that your title cannot be copyrighted but can possibly be trademarked.

One of the keys to pleasing the person who reads your screenplay is to write something that is so good that your reader can't put it down. Even if the concept of your screenplay is not commercial, an agent can use great writing as a sample to get you an assignment—meaning a short-term freelance job. Many times a freelance job means you're writing someone else's idea. We'll talk more specifically about how these professionals will be interfacing with you and your screenplay later in the book. For now, just keep in mind that you'll need to have a well-written, industry-formatted script with no typos before you can expect anyone in the industry to take you seriously as a writer. So let's start writing.

Chapter One Exercises

1. Choose five of your favorite films, and watch them with a notebook in hand. As you're watching, make yourself pause the movie when there's something on screen that you really like. Now try to describe what it is about the film at that particular moment that you find so interesting or entertaining, and write it down in your notebook. Is it some brilliant line of dialogue? Is it the outrageous actions of a character? Is it a predictable or unpredictable plot twist, or just a series of events in an action sequence that keeps you coming back to this movie?

2. After you do this for each film, go back and compare notes. Did you find out that several, if not all, of the films you picked are within the same genre? What genres do you crave, and what are the story elements of the genre that you apparently like the most? Ask yourself, why do these movies do what they do so well?

The purpose of this exercise is the help you identify your own film preferences and also to train you to start watching movies with a critical eye. By pausing the film and interrupting the viewing experience, you can teach yourself to learn from what other screenwriters have done before you. From this exercise, you can also begin to consider if you want to write a genre film or try something noncommercial.

CHAPTER TWO
Screenplay Structure

We've all had the experience of leaving a movie theatre feeling disappointed because the story was unfocused or had an ending that didn't make sense. To keep your story from deteriorating into the kind of movie you'd want to walk out on, you'll need to create an outline of the plot before you start writing the script. If you don't outline the story first, inevitably you will end up writing yourself into a corner you can't get out of. Your unrestricted imagination will take you in the right direction for the first act, but, eventually, your story will become so disorganized that, around page 50, you will find it impossible to keep writing. The second half of the script will drag on forever, and you will be unable to come up with a good ending.

Screenplays are lengthy, major pieces of writing. A great screenplay can take months, and sometimes years, to write. Remember, the most critical phase of the screenwriting process is the time you spend working on your film's structure.

WHAT IS FILM STRUCTURE?

In a nutshell, film structure is *plot*. The plot is, essentially, *what happens* in the story. It is the series of actions, the chain of events that initiate the story line and eventually lead to the ending. The plot provides the logic behind the entire screenplay, and it is the road map that a writer uses to get from the beginning to the end of the film.

In classical Hollywood films, there is a *three-act structure* to the plot. This three-act structure was inherited by Hollywood from theatre and has been the dominant framing device used for stage plays in Western culture since before the time of Aristotle.[1] You can think of the three acts in a film simply as *the beginning, the middle*

and *the end.* In a typical 100 to 120-page script (one hundred minute to two-hour movie), the first act usually spans twenty to thirty pages—corresponding to twenty to thirty minutes of screen time. The second act is the longest, usually taking up fifty to sixty pages and lasting for fifty to sixty minutes on screen. The third act will be another short act, twenty pages or so long, lasting for fifteen to twenty minutes of screen time.

Of course, in film, unlike in theatre, the viewers are not given a broad gesture like a curtain coming down or house lights coming up to indicate that one act is over and the other act will begin. In the movies, the transition between the acts appears seamless to the audience. However, for the screenwriter, the transitions between the acts are perhaps the most important moments in the movie. This is because, at the end of acts one and two, films have *plot twists* or *turning points* that propel the story in a new, more complicated direction. In all but a few of the best scripts, something happens towards the end of act one, around page twenty-five, and at the end of act two, close to page eighty-five, that takes the story to a different level. Towards the end of act three, there should be a *climax* to the plot, a scene where the storyline comes to a point of maximum tension. After that will come *the resolution,* an ending that is logical and usually answers all of the story questions posed in the opening of the movie.

Within each act, there is a typical story structure that you should learn. The knowledge of this structure can be your guide to configuring the storyline for your own screenplay. In Act One, the plot question is planted in the mind of the audience. In other words, a situation is set up so that the viewer wants to find out the answer to something motivating him or her to keep watching (i.e. Will she find true love? Will he find redemption? Will she solve the case? Will he get his degree and inherit the family business?). In Act One, the main characters are introduced. The ambience, or place where the film will unfold, is established. The story builds in a forward trajectory until there is a major incident that serves as a turning point to start the next act.

In the beginning of Act Two, normally, the pace of the film slows down. The main character must readjust to a new situation. Often, early in Act Two, new characters are introduced or subplots come into play. The situation is slowly complicated for the main character.

Things happen to greatly increase the dramatic tension in the story, and all of this builds to a second turning point where another new piece of plot information thrusts the main character into Act Three.

The third act has the fastest pacing and moves quickly to the climax. If you were to create a graph of the plot, it would look like a series of steps moving up towards the climax. Think of the climax as the highest point in the dramatic action—the scene in which the answer to the plot question must be forced out of the situation. Once the climax occurs, there are usually a few more minutes in the film left for the resolution, where all of the main plot and subplot questions are answered, and a sense of equilibrium is reached.

You should think of your plot as a chain of events or actions that lead directly to the climax and conclusion. Each action or event that happens in your story, no matter how large or how small, should lead logically to the last scene in your movie. Let's look closely at the structure of several films as examples.

The Plot Structure:
Eve's Bayou, Boyz in the Hood, and Devil in a Blue Dress

In the film, *Eve's Bayou*, screenwriter, Kasi Lemmons, lays out her plot with a well-crafted three act structure. In Act One, we meet Eve and are introduced to the rest of her family. The ambience (or sense of location) of the French-speaking, African American middle-class culture of this small Louisiana Delta bayou community is established. We find out that Eve knows her father is cheating on her mother and that Eve's beloved Aunt Moselle has been cursed with losing all of the men she has loved. We suspect that Eve has the power to see the future.

The turning point comes at the end of Act One when Eve's aunt has a vision of someone being hit by a bus and advises Eve's mother to keep all of the children in the house until the aunt is sure it is safe to go out. This incident provides the turning point in the story that propels the action in a new direction. Now, in Act Two, Eve's mother and the children are trapped in the house for the summer. This creates a situation where the tension in the family home escalates. We see the level of stress within the family steadily rising because the children are confined inside the house with their mother for weeks on end.

In this second act, the mother also has a series of confrontations with Eve's father over his acts of infidelity. Eve's sister, Cisely, begins to menstruate. Soon, Cisely develops a belligerent adolescent attitude towards the mother. Adding to this, in Act Two, the plot is further complicated as Cisely starts to compete with her mother for her father's attention. Then, one evening, a bedtime kiss between Cisely and her drunken father goes too far. Cisely confides in Eve that she believes that their father is trying to seduce Cisely. Cisely feels traumatized and refuses to interact with her parents who soon decide to send Cisely far away to live with her grandmother. Eve feels threatened by these events. Eve feels that Cisely is being banished to hide the sins of their father. Eve decides she must kill the father to avenge her sister. Eve's decision becomes the next plot point in the movie.

Now the third act begins. In this final act, the story tends to pick up pace, and the dramatic plot conflicts come to a head. The apex of the storyline, the scene of most dramatic tension, the point where the main character pushes the hardest for what she wants in a screenplay, is the climax. In *Eve's Bayou*, Lemmons' powerful third act focuses on how Eve, a young girl, will manage to carry out her vow to kill her father. We see Eve going to the local Voodoo priestess for a charm that will cause her father's death. Once she has the charm, Eve runs into Lenny Mereaux, the husband of Eve's father's mistress, Matty Mereaux. Eve hints to Lenny that his wife has been cheating on him, thereby planting the seeds of suspicion in his mind and creating the circumstances for Lenny to become the agent of Eve's revenge. The climax comes during a confrontation between Lenny and Eve's father, Louis, which ends in Eve's father's death.

Eve's Bayou has a complex resolution. Eve's sister returns home. Eve finds a letter from their father that causes Eve to channel a vision of the supposed act of incest. The vision contradicts Eve's sister's version of what happened. Lemmons now replays the kiss between father and daughter from the father's point of view, showing Cisely's actions as inappropriate and the behavior of the father to have occurred in a reasonable adult context. Now Eve must wrestle with two interpretations of the same event. Nevertheless, even though we don't know the truth of what happened because we see the father/daughter kiss from two opposing vantage points, there

is still closure at the end of the film. The story of *Eve's Bayou* is the tale of how the interpersonal relationships in the family impact each child differently. Eve's vision at the end underscores this point by making the audience realize that the perception of an impassioned child can distort the truth. The subplot chronicling Eve's aunt's struggle to overcome a curse and find the courage to remarry is also resolved when Moselle marries for a fourth time. To sum it up, the structure of Eve's Bayou is as follows: Act One tells us who Eve is—a precocious middle child who believes she has killed her father; Act Two narrates the events that lead up to Eve's decision to kill her father; and Act Three explains why Eve thinks she was responsible for killing her father. The first turning point is when Eve's aunt has a vision of something terrible happening to the family that causes the mother to keep the family sequestered. The second turning point occurs when Eve decides to kill her father, and the climax of the movie happens when Eve's father dies. The resolution is when Eve's sister returns, and together, the two girls try to make sense of what really happened.

Now let's look at the dramatic structure of *Boyz in the Hood*, written and directed by John Singleton. In Act One, we are introduced to Tre, an elementary school-aged boy who is sent by his mother to live with his father. Tre befriends three kids in his father's neighborhood; Doughboy, Chris and Ricky who, unlike Tre, have no strong male role models in their lives. The turning point at the end of Act One occurs when Doughboy and Chris commit a crime and are sent off to reform school.

Act Two begins twenty-nine minutes into the story with Doughboy and Chris being welcomed back to the block after their release. All the boys are now teenagers, and the choices they must make in order to reach manhood are much more difficult for them. There is a gang in the neighborhood bent on provoking Tre and his friends into a mortal confrontation. Tre also has a girlfriend and struggles with the pressures of both losing his virginity and of his fear of becoming a teen parent. Tre and Ricky have their own goals to stay out of trouble and get into college. Tre plans to get into college through good grades, and Ricky will attend university via a football scholarship. The second act comes to a climax when Tre witnesses the gang members shoot and kill Ricky on the very day

Ricky's mother finds out that he's been accepted into college.

Singleton's third act is launched with extreme intensity. Tre runs home and grabs a gun. His father takes away the gun and pleads with Tre to make the right decision—to not ruin his own future by involving himself in a revenge killing. Tre, however, sneaks out and joins Doughboy and Chris to find Ricky's killers. The climax unfolds when Tre changes his mind about taking part in the revenge killing and asks his friends to let him out of the car. In doing so, Tre chooses the right path to manhood. Unlike Tre, Doughboy and Chris choose a tragic path—gunning down their rivals in cold blood. The subplot involving Doughboy reaches its climax in this way. In the sobering denouement that follows, we learn that only a few days later, Doughboy is executed by the rival gang. As for the main plot, we learn Tre and his girlfriend will both go to college. Thus, Tre completes his right of passage from boyhood to manhood.

You can also find a well-crafted three act structure in *Devil in a Blue Dress*, adapted for the screen from Walter Mosely's detective novel by screenwriter/director Carl Franklin. In Act One, we are introduced to the protagonist, Easy, a WWII veteran who has just been fired from his job as a mechanic in an auto shop. Now, desperately in need of a mortgage payment, Easy accepts a job from a suspicious-looking white man named Albright who pays Easy to find a white woman named Daphne Monet who Albright says frequents the clubs in the black community. Easy asks around and discovers that his friend, Coretta, knows something about Daphne. Coretta tells Easy that Daphne is her friend and has been dating an African American gangster named Frank Green. The turning point at the end of Act One occurs the next day when Easy is suddenly arrested after Coretta is found murdered.

In Act Two, now Easy must not only find Daphne for his unsavory client, Albright, he must also prove he did not murder his friend, Coretta. The plot development becomes extensive and complex in this act. Easy meets the alluring Daphne and is drawn into her predicament. She wants him to take her to see Todd Carter, a rich white businessman and mayoral candidate. However, Daphne first leads Easy to the house of a man who she says has a letter that belongs to her. Easy and Daphne arrive at the man's house to discover he's been murdered. Daphne steals Easy's car, leaving him

stranded at the murder scene. Upset and confused, Easy goes to Todd Carter looking for some answers. Instead of giving him answers, Carter explains he did not hire Albright and offers Easy a large sum of money to find Daphne. Carter, we find out, is a potential mayoral candidate. He confesses to Easy that Daphne Monet is his former lover.

Upon arriving home from his meeting with Carter, Easy is ambushed by Frank Green, a mobster and supposed lover of Daphne. Easy is saved just in the nick of time by the sudden appearance of his old friend Mouse—a trigger-happy hustler who we learn has had some mysterious dealings with Easy in the past. The police then show up and give Easy only a few hours—until the next day—to find Coretta's real killer. Act Two ends when Easy discovers the letter Daphne has been looking for is tucked into a bible in Coretta's house. The letter includes photos of the leading mayoral candidate, Terrell, playing with naked boys. That afternoon, Daphne shows up at Easy's house and offers seven thousand dollars for the pictures. She confesses that Frank Green is her brother, not her lover, and that she is actually African American and has been passing for white. Daphne explains that Coretta had been holding the photos for her but then threatened to sell the pictures to Terrell. When Daphne sent Joppy, the bartender, to get the photos back from Coretta, he ended up killing her. This second turning point is perfectly placed and comes seventy-two minutes into the movie, shifting the story in a new, even more dramatically charged direction.

With the new plot information, Easy is once again allied with Daphne as the story progresses into Act Three. Albright returns and kidnaps her. Easy grabs Mouse, and they both follow Albright to a secluded cabin where Albright and his goons are preparing to torture Daphne to get her to give them the pictures. In a wild shoot out, Easy and Mouse kill Albright and rescue Daphne. Mouse gets a bundle of cash and leaves town. Easy takes Daphne to see Todd Carter who says he is unwilling to risk the family reputation by entering into an interracial marriage with Daphne. Terrell's illegal activities are exposed, and his career is ruined. Easy is cleared on all murder charges and decides to open a detective agency. The perfect three-act story structure of this film makes it an excellent movie for screenwriters to study again and again.

The Main Character

In most successful feature films, the movie is structured around one main character or *protagonist*. There can be other strong characters in the story, but there is usually only one character that is the focus of the movie and carries the story. In a novel or television show, the writer can utilize many characters of nearly equal weight and importance in the story. Your typical novel is several hundred pages long, allowing a novelist to say so much more than a screenwriter can in one script. Think of how a novel takes many hours and days to read. A much greater amount of content and detail can be packed into a book than into a screenplay. With film, remember you have an average of only one hundred minutes to tell your story. As a screenwriter, your goal is to create an interesting central character. To do this, you are going to have to use up most of the screen time giving scenes to that main character. If you count the number of scenes in which the main character appears in a movie, you will find that most of the best movies have the main character on screen or included in some way in nearly every scene in the movie. Take *Eve's Bayou*, even in the scenes that are not featuring Eve, she is included in some way. For instance, when we see Eve's father making house calls to patients whom he is having affairs with, writer, Kasi Lemmons, cuts to Eve sitting outside the doors of their rooms. In this way, the viewer is always aware of Eve's point of view. When the story follows Eve's aunt as she helps her clients see into the future, Lemmons puts Eve in the hallway listening in on what's going on. The scenes are doing double-duty, developing the secondary characters but also fortifying Eve's character at the same time.

This also happens in *Devil in a Blue Dress*. Easy is in every scene in the entire movie. In *Boyz in the Hood*, the character of Tre is in most of the scenes, and when he is not on screen, the scenes revolve around some part of his story (i.e. when his parents meet in a restaurant and his mother tells the father that she wants Tre back with her). There are a couple of scenes that focus solely on Doughboy's and/ or Ricky's character, such as the scene when their mother is meeting with the college recruiter or when Doughboy shoots Ricky's killers. However, immediately after each scene involving one of the subplots, the story always returns to Tre.

As an emerging writer, if you are having trouble deciding who the main character of your story will be, you should ask yourself, from whose *point of view* will the story be the strongest? In *Devil in a Blue Dress*, the movie is about solving the mystery of the woman in the blue dress. Yet the story is not told from her point of view. It is told from the point of view of the character of Easy. It is about his life as a detective, his reactions to the events that occur as he unravels the mystery. Easy is who we really care about and identify with.

In the movie *The Wood*, the story follows the friendship of three young men who grow up in Inglewood, California. The screenwriter, Rick Famuyiwa, chose to focus the storytelling from the point of view of one of the friends, the character of Mike. Mike's consciousness acts as our filter on the narrative. By concentrating the story on just one of the three friends, the screenwriter does a better job with story development. If the points of view of all three friends were given equal weight in the script for *The Wood*, the story would have been much less developed. This is because Mike would get a lot less time in the movie to give us his own personal take on things. By making it a story of his experiences growing up with his friends, rather than their experiences from each of their own separate points of view, the movie is much more satisfying to watch. Practically speaking, if *The Wood* was not focused on one central character, all three characters would be competing with each other for screen time, and no one character's storyline would have enough minutes allocated on screen to be fully developed.

Think of the concept of point of view as who you tend to identify with in the scene. To understand how a writer uses point of view watch *Love and Action in Chicago* carefully. You'll find that you are led by the screenwriter, Dwayne Johnson-Cochran, to identify with the protagonist, Eddie—a celibate African American Catholic male assassin. A great screenplay lures the audience into identifying with what the protagonist *wants* in the movie by making that protagonist's point of view clear in every scene. In *Love and Action in Chicago*, Johnson-Cochran puts us inside Eddie's head. We understand that Eddie wants to get out of the business of government sanctioned killing. He also wants to be a good Catholic by maintaining his celibacy until he meets the right woman and leaves the business

forever. Though the situation is deliciously ironic and patently absurd, we love Eddie's point of view, and we enjoy identifying with his character.

One final note, there are exceptions to this tendency in feature films for a single main character and limited supporting characters. Great movies have also been made that follow multiple characters with no single standout protagonist. *Do the Right Thing* uses the character of Mookie as a filter through which we meet and identify with the main character—that is the neighborhood of African American people who reside on Mookie's block in Bedford Stuyvesant, New York. The movie is an allegory about racism in America, and, as such, it works well to script the neighborhood as the main character in the story, with each personality functioning as a facet of Lee's protagonist, the Black Community.

Similarly, in *To Sleep with Anger*, written by Charles Burnett, the family unit is the main character. What drives the plot is the collective need to maintain the family bonds despite the threats hoisted upon them by internal and external demons personified in the antagonist, Harry. Screenwriter Charles Burnett offers us a taste of each family member's point of view as he or she struggles towards the common goal of family unity.

ACTS AND SCENES

A screenwriter has a specific set of tools to work with to get the visual story across to the reader. These tools are often referred to as the *language of cinema*. Your main writing tool for conceptualizing the structure of your movie will be the concept of the *scene*. In film, a scene can be defined as a series of images or actions that take place in one location or over one time period. Each of your three acts is made up of many scenes. In a feature film, since Act One is approximately thirty minutes long, and Act Two is approximately fifty to sixty minutes long, and Act Three is around twenty minutes, you will have many more scenes in Act Two than in Act One and Act Three. We'll talk about the number of scenes you can expect to find in each act (according to conventions of genre) later on in the book.

Writers typically use the unit of the scene to break down a script and to construct an outline. You should start watching movies

very carefully to see when the scenes change. As you do, you will begin to realize that movie storytelling (i.e. using your cinematic grammar) allows you to switch locations and time frames via a cinematic shorthand. The use of cutting between scenes allows the screenwriter to say things in an abbreviated manner. To understand this concept, let's look at a few scenes from the opening of *A Soldier's Story.*

The film opens with the first scene set during World War II in the Golden Slipper Saloon. We see Big Mary belting out her Delta Blues to a room full of Black soldiers. Master Sergeant Waters, drunk and muttering to himself, stumbles out of the bar and walks down the street. We cut to the next scene, and we are on a foggy road. Sergeant Waters is on the ground. He's bloody. Film grammar has allowed us to create an ellipsis in time and space. The screenwriter can shift out of real time and cut right to the dramatic moment. In other words, we don't need to see that Waters turned the corner, went down the road, met his attackers and was beaten. We infer that those actions have occurred as we watch. We've learned the meaning of this cinematic shorthand from the thousands of hours of television and film we've watched over the course of our lives.

A great screenwriter can structure the scenes in his or her film using this visual shorthand, cutting out extraneous information and concentrating the storytelling on only the most important moments in the scene. By cutting to the heart of the scene, the writer can maximize the impact of the story on the viewer.

Plot Problem/Plot Question

A good story is a story about something. Sounds obvious, right? From a writer's point of view, doing the obvious, keeping the story focused on what the story is about, can be a substantial challenge. As we said earlier, most screenwriters select a main character, identify what that main character wants and structure every event in the movie around the protagonist's pursuit of what he or she wants. In *The Great Debaters*, the main character is the Wiley College debate team. The team members want to beat Harvard's debate team. The movie is about their quest to attain that goal. In *Love and Basketball,* a young woman wants to find true love with the boy next door. In

Sister Act 2: Back in the Habit, a Vegas performer wants to keep an inner-city Catholic school open. As you begin to think of your own storyline, you should ask yourself: *Who is my main character,* and *what does he or she want?*

The next step you can take to keep your eye on the storyline is to think of your plot as a problem to be solved and to phrase the need that the protagonist is trying to fulfill or the goal the protagonist is trying to reach as a *plot question.* Reframing the protagonist's quest towards achieving a goal in the form of a question to be resolved will help you to stay focused on taking your story to its natural resolution as you're structuring your plot at the level of the scenes. Let's look at a few examples.

Antwone Fisher is a movie about a young man who finds redemption by connecting with his long lost relatives. The plot of the movie follows this young man's journey through the pain of confronting his past: Antwone wants inner peace in order to become a man. Remember, the plot question for the writer of the story is just a way of restating what the protagonist's quest is about in query form: *Will the young naval ensign, Antwone Fisher, make peace with his past and become a man?* If you carefully view the movie and list all of the scenes on a chart, you'll discover that everything that happens scene by scene in *Antwone Fisher,* in other words, the entire plot line, is set up to answer that plot question.

Here are some other examples of positing the plot in terms of a question:

In *To Sleep with Anger,* a story about a family whose unity is threatened; the family wants to stay together and be whole again. You can think of the plot question as: Will the family kick Harry out, stay together and be whole again?

In *Eve's Bayou,* the story is about a young girl who decides to kill her father as a way to come to terms with what she thinks is her father's crime of incest. The plot question put simply: Will Eve kill her father and come to terms with what she thinks is her father's incestuous behavior?

In *Love and Action in Chicago*, we could say the question that drives the plot is: Will the main character, Eddie, manage to leave his employment as an assassin so he can retire and find happiness?

In *A Soldier's Story* the plot question that organizes the film is: Will the military investigator find out who killed Sergeant Waters?

In *The Great Debaters* the main plot question is: Will the Wiley College debate team go on to beat Harvard?

In *Love and Basketball*, the plot question is: Will the girl end up with the boy next door?

In *Sister Act 2: Back in the Habit* the plot question is: Will the former Vegas performer save the Catholic school?

Main Plots and Subplots

Most feature films have multiple plot lines. Often there are two main plots that relate to the protagonist and a number of secondary plot lines that relate to the secondary characters. For example, in *Eve's Bayou*, there are two equally strong main plot questions or problems. While the movie is following the plot question: Will Eve kill her father?—the story is also wrangling with a second plot problem: Did the father really commit an act of incest? These two plot lines are neatly woven together so that one storyline supports the other. This allows us to see the main character from two different points of discussion. Each of the two main plots echoes off the other. Additionally, the subplot with Aunt Moselle, a woman with visions who is cursed by the deaths of her husbands, is skillfully developed by Lemmons. We could think of this subplot in the form of a question: Will Eve's aunt break the curse and go on to remarry?

In *The Great Debaters*, screenwriter Robert Eisele's main plot about winning the debate is neatly intertwined with a parallel plot that serves up the plot question: Will the characters be able to free themselves from the mental shackles of racism? In addition to the

main plot lines, several subplots are threaded throughout the script. One of these subplots follows the conflict within the group caused by the fact that the two male debaters, Henry and James, both have feelings for the female debater. This subplot ties in nicely with the main plot by providing a logical obstacle to the team's goal of winning the debate. The tension that the jealousy between the team members creates within the team threatens to pull the group apart. Another subplot in the script, the participation of their debate coach in union organizing activities, also works to reinforce the development of both main plot lines. By including this subplot, screenwriter Eisele has the opportunity to throw an additional obstacle in the struggle of the team to reach their goal to debate Harvard. The coach's leftist beliefs and union organizing activities cause one of the debaters to leave, creating a logical opportunity for the screenwriter to move Samantha to the top of the eligibility list. The coach's leftist activities also end up putting young James at odds with his parents. The coach's organizing activities eventually land him in jail which leads to the Dean of the college removing him as debate coach and the local authorities barring him from leaving the state. Because of this situation, Henry must be put in charge, and as a consequence, James ends up on stage at the Harvard debate. The subplot generates an effective obstacle and makes the dramatic tension more palpable.

THEME

Beyond the necessity of linking your main plots and subplots together in a way that they reinforce the protagonist's quest for a goal or create obstacles to obtaining that goal, your plots and subplots should also do the work of developing a theme. Take the film *Do the Right Thing* (DTRT) where all of the storylines revolve around the theme of race in America. In DTRT, the main plot question is: How will the neighborhood deal with racial tension and police brutality? The theme of race in America is echoed in the subplot created via the character of Radio Raheem and manifests itself in Raheem's famous "love versus hate" monologue. The theme of racism is also dealt with in the subplot of the story of the two Italian brothers—one who wants to befriend Mookie and the other who resents Mookie. In this way, each character's story or subplot effectively complicates

and defines the theme of race in America. All of these subplots fit together thematically.

In *A Soldier's Story*, Charles Fuller skillfully carves out two main plot lines and several subplots to develop his theme of struggle against self-hatred. The main plot follows a military investigator as he solves the murder of a black Army Sergeant on a racially segregated military base in a racially segregated Southern town. This is paired with the story of an army private, Peterson, who delivers his own brutal justice upon his superior officer. Fuller interconnects these tandem plot lines with two subplots. The first subplot is the story of the Sergeant's hatred toward an uneducated private from the rural South who the Sergeant thinks belittles the race. The second subplot involves the white officers on the base as they try to sabotage the investigation. Each of these storylines makes it possible for the screenwriter to say something in relation to theme of racism. Additionally, these multiple storylines strengthen the obstacles that confront the protagonists and heighten the dramatic tension. In this way, the theme of racism and self-hatred is approached from several perspectives and is made to run deep throughout the script.

PLOT AND CONFLICT

You may have caught on to the fact that phrasing the story in the form of a plot question helps a writer to think about his or her story in terms of a *struggle towards a resolution*. The struggle is the essence of the storyline. The struggle can be against an external or internal problem or a struggle against an entity that opposes the protagonist. Here are some examples of external obstacles your own protagonist might face: evil influences threatening to break up the family, aliens invading the earth, dirty cops exploiting the neighborhood, a guy trying to move in on the protagonist's lover.

The central struggle in your screenplay can also be a personal one, where the main character must deal with some inner obstacles such as self-doubt, a troubled past, too much pride or any other character flaw a protagonist might have that prevents her or him from achieving a goal. Remember, whether it's drama or comedy, your story must have at least one central conflict, either an interior struggle or one that's external to the character.

Just having a conflict is not enough either. It has to be a credible and compelling conflict worthy of the viewer's attention. A student movie about a college student's struggle to get up in the morning, go to work, take care of his kid, find time to study, and then go another day without enough sleep or enough money would not be so interesting to watch. Why? Because the central conflict as described here, is true to life, but it's not exciting. The plot problem for such a story would be: Will the student survive another day? Well, we expect that he will, since most people do, and so we probably won't care much about the protagonist's struggle in this movie. A screenwriter must ask, "What is the true nature of the obstacle the main character is up against?" In this case, the obstacle is the character's own ability to manage his life. Your average movie viewer can reason that if the protagonist takes only one course a semester rather than a full course load, he can work more hours and sleep a little longer. It'll take him more time to graduate, but the problem is easily solved.

Now, what if we ratchet up the same premise a couple notches higher by making the obstacle for this character more difficult to overcome? Let's say this student is incredibly smart and dreams of becoming a successful stockbroker. Let's say he's a single father who will lose his son if he doesn't succeed. Let's say the father is divorced and has no sources of income and must go to the extremes of sleeping in a subway bathroom to keep his son with him while at the same time complete his training as a financial manager. Let's say that he is the first African American to be admitted into this prestigious financial training program, and if he fails, he and other African Americans will be kept out of the industry by discriminatory employment practices for a long time to come. The obstacles faced by the protagonist are now tremendous. The stakes in this revised plot line are extremely high. The elements of conflict and tension are at such a compelling level that we truly care about what is happening to our protagonist. This is, of course, the plot conflict in *The Pursuit of Happyness*. Remember that the obstacle your main character faces must be palpable and difficult to overcome, or the conflict will not register with your viewer and your story will have no dramatic tension.

THE INITIAL DRAMATIC INCIDENT

Have you ever watched a movie, and about twenty minutes into the story, you feel like leaving the theatre because you still don't know what's going on? That usually happens in scripts in which the screenwriter fails to create an *initial dramatic incident* that hooks the viewer into the story early on in the movie. The initial dramatic incident is a plot development technique used by storytellers to let the audience know what type of story they will be watching. It works by placing enough plot information in the first ten minutes of the movie so that the viewers can start to formulate the plot question in their own minds. In television, it is plot information that keeps you wanting to find out what will happen and makes you not want to change the channel. Of course, we viewers don't consciously formulate the plot question. Rather it is a function of narrative structure, that when posed with an interesting unresolved dramatic situation, we keep watching to find out how the situation will be resolved.

In *Eve's Bayou*, the initial dramatic situation comes during the opening voice over for the film when the character, Eve, says, "The summer I killed my father I was ten years old..." After hearing that line, who doesn't want to keep watching to find out who this brazen child is, and how she will end up killing her father? In *A Soldier's Story*, Charles Fuller does a similar thing, by showing us the dying Sergeant Waters calling out to his own killers who are unknown to the audience because they appear off screen. The Sergeant's dying words to his killers are simply "They still hate you." By the end of this opening scene, the plot question begins to be formulated for the audience. Who killed the Sergeant, and what is the meaning of his dying words? This scene is followed by the introduction of a second main character, Captain Davenport, the African American army investigator. The dramatic situation is established through a few brief scenes that let us know that the base is located in the South during WWII and is a training facility for African American soldiers who are being commanded by racist white officers. With this additional few minutes of plot information, the audience has another plot question brewing: Given the racial tension on the base, will the African American investigator be able to get at the truth of what happened?

Within the first ten minutes of the film, *Devil in a Blue Dress*, we're skillfully hooked into the story by screenwriter Carl Franklin, when Easy, a man who's just lost his job and has a mortgage to pay, is asked by a white man to find a white woman who frequents a bar in an African American neighborhood. "Who is the woman, and why does this man want to find her?" we ask ourselves. More centrally, we want to find out what is going to happen to Easy when he accepts this job. From the suspicious nature of the white character, we know it can't be good.

In *The Wood*, the movie has two strong plot lines that are firmly established in the opening ten minutes of the movie. In the first scene, set in the present, the screenwriter gives us a dramatic situation where two life-long friends find that their best friend is having doubts about getting married, and he has two hours before the wedding ceremony to make up his mind. Naturally, we want to keep watching to find out if the friend will get married. The second plot line, which is the main plot line, is then immediately introduced as the screenwriter flashes back to the main character, Mike's, first day of school in Inglewood. Young Mike meets two other teens on the playground, and we find out that he is developing a crush on the cutest girl at the school. What will be the circumstances that lead these three young men to become life-long friends, and will Mike get the girl? We're hooked by the initial dramatic incidents, and we can't stop watching.

CHAPTER TWO EXERCISES

Choose three films out of the following list of movies to watch and evaluate: *Eve's Bayou, A Soldier's Story, Devil in a Blue Dress, The Wood, Love and Action in Chicago, Love and Basketball, Malcolm X, Do the Right Thing, Boyz in the Hood, To Sleep with Anger, Antwone Fisher, The Great Debaters, Talk to Me,* and *Miracle at St Anna.*

1. Main Character Exercise: For each of the movies chosen, count the number of scenes in each film that include the main character either directly in the scene or by mentioning him or her in the dialogue of another character. Also count the number of scenes where this is not the case. Compare them.

2. Plot Structure Exercise: For each of the three movies chosen, create a one-page plot structure breakdown sheet for each film. This exercise is to help you think of movies in terms of their structure. Don't worry about detailed descriptions of characters or subplots. Concentrate on retelling what happens within the main plot.

 a. Write in present tense only. Stick to the following sentence limits when doing this exercise. This will help you to become accustomed to writing concise plot summaries.
 b. In no more than six sentences, describe what happens in the first act.
 c. Now, in no more than three sentences, describe what happens during the turning point at the end of Act One.
 d. Next, in no more than ten sentences, describe what happens in Act Two. Use only three sentences to describe the turning point at the end of Act Two.
 e. Finally, with no more than ten sentences, tell what happens in Act Three including the climax and the resolution to the story.

Creating Characters

As a writer, when you create a character, you become that character. As you develop him or her on the page, you will enjoy entering the fantasy world of your screenplay. It's fun to allow your imagination to run wild. One good way to help you gain the ability to do this is to study acting. It is the actor's craft to lose oneself in the character. Actors are taught to pay attention to the motivations of the characters they portray, the body language, the way the character speaks, the emotional responses of the character. Actors are also taught how to interact with other actors, how to listen, how to channel their character's energy into a believable reaction. These are techniques that screenwriters can draw upon as well.

THE BACKSTORY

Just as you must outline your plot before you start writing your movie, you must also do some background work on each of your characters before you ever write a word of their dialogue. For screenwriters, the method used to construct a character's profile is called creating the *backstory*. The backstory of a character is, essentially, a biography of everything that has happened to your character up until the moment when the character first appears in your movie. The purpose of creating a backstory for your central characters is to help you understand the reasons behind each character's point of view before you write any dialogue. Some writers create the backstories in the form of notes. Other screenwriters write down their characters' backstories in tremendous detail, while still other writers prefer to develop their backstories in their heads. For the most part, a character's backstory is only meant for the screenwriter to see. It is not presented with the screenplay to a producer or agent. An

exception to this comes into play when you are creating a new series for television. A producer may ask to see character bios along with a pilot. At the end of this chapter, we will guide you through an exercise in writing detailed character backstories for your feature-length screenplay. The chapters in the section on television will provide you with exercises for constructing character bios for TV.

Here's an example of how to construct the backstory for your protagonist. Let's say your character is a woman named Dette who, over the course of your movie, will become a world champion chess player. Let's say you decide you want her to be a brilliant intellectual but also shy and somewhat naïve about the world. Her chess coach, James, a former world champion who has lost his edge and no longer competes, becomes her lover and her manager. Secretly, James can't stand the fact that Dette is actually a better chess player than he is, so James is sabotaging her game by undermining her confidence before each match. You've decided you want the film to end with Dette finding the strength to break it off with James and go on to become the first female world champion.

If you were writing this script, before you would go any further with constructing the details of the plot for this story, you would create Dette's backstory. This would help you explain why she does certain things and makes certain choices in your movie. You want to start the character backstory process by asking yourself a series of questions about her past. By past, that means everything that happened to her up until page one of your screenplay. What happened in her family life to make her naïve and submissive towards James? Was her mother a factor? If so, how? Was her father overbearing and manipulative like James? Did she have any siblings, or is she cut off from her family and, therefore, feels vulnerable and alone as she travels the world to play chess matches? What was school like for Dette? Did she learn to play chess at school? Was school the only place where her gifted intellect was recognized and encouraged? Or was school boring? Was it her father who taught her to play chess while all of the other children were jumping rope or riding bikes? Did her father pass away and leave her with no one of her intellectual caliber to train with? Is this when James stepped into her life? Where did Dette go to college, and was college where she began playing chess competitively? What is Dette's economic situation? Does she

come from a wealthy family? If so, she would have traveled a lot already, and it would not make sense that she would be naïve about the world. Maybe that needs to be scratched from her bio? Perhaps she is middle-class, but had to care for a terminally sick father, causing her to become sheltered and introverted. Without her father, does she have no one to trust but James? As you can see, creating a logical backstory for a character is a brainstorming exercise that, by extension, will help you create a logical direction for your storyline. Development of plot and development of character go hand in hand.

Besides asking yourself basic questions about your character's family, religious and educational background as well as the social institutions that shape his or her identity, you should also create a history of emotional experiences for your character. Ask yourself, what were some of the character's happiest experiences growing up? Also, what were some of the character's saddest times? What was it like for your character, the first time he or she went to school or became sexually active or was approached by a bully in the neighborhood? Has your character experienced childbirth, serious illness or the loss of a loved one? Has your character ever lied or betrayed someone? If so, how did he or she justify that act of lying or betrayal? These are but a few of the questions you can ask about your character as you construct the backstory. You will find that, the more you know about each of your characters, the easier it will be to write believable, emotionally viable dialogue.

THE CHARACTER FLAW

When Spike Lee was asked if African American filmmakers have a moral responsibility to bring positive representations of African Americans to the screen, he responded: "I think 'truthful' would be a better word than 'positive.' I think you're truthful when you show that African Americans have bad qualities and good qualities. I have always found that to be more interesting—people who are flawed."[1] Take Spike Lee's central character in *He Got Game*. Denzel Washington's character is someone who is trying to reconnect with his son. However, the sympathetic protagonist has killed his wife. The contradiction embodied in the character makes this character more intense and engaging for the viewer.

Our flaws cause our lives to be a struggle, rather than a piece of cake. Our flaws cause us to make bad decisions and often get us into tough situations. Our flaws can be major, such as a self- destructive addiction, or our flaws can be minor, such as a weakness for junk food or expensive shoes. And, since movies are essentially stories of characters who struggle towards something or against something, adding a flaw to your main character's backstory will make him or her a richer piece of dramatic material around which to write.

Let's take the character of Eve, in *Eve's Bayou*. Kasi Lemmons presents us with an intelligent and precocious girl who is a flawed protagonist, in that, despite her intelligence, she is still only a child. Despite her powers to see the future, Eve still sees life in terms of childlike absolutes. Eve, being only nine years old, can't see that life is complicated. She is unable to accept that there may be other points of view and, therefore, comes to a hasty conclusion, as most children would, about her father's actions. This flaw, being only nine years old and too quick to judge, leads Eve to make the decision that her father must die. The complex dramatic situation created by Eve's character flaw, keeps us in suspense throughout the movie.

If we take a look at the three central characters in *A Soldier's Story* and compare them in terms of their flaws or personal defects, we see that Waters' character is highly flawed. Decades of racism have caused him to feel a strong self-hatred that he, in turn, takes out on African American soldiers under his command. The flaw of self-hatred gives him a god complex that leads Waters' character to go as far as falsely imprisoning one of his own men. The character of Private Peterson is also flawed in that he suffers from *hubris* or too much pride. This excess of pride leads him to shoot Waters in cold blood as revenge for the actions that Waters has taken against the platoon and, on a larger scale, against these men who are more secure than Waters in their African American identities.

The third major character in the film, Lt. Davenport, has no apparent flaws. He is truly heroic throughout the film. He is not swayed by any inkling of self-doubt or encumbered by an excess of pride about his own self-importance. Lt. Davenport always does the right thing. In essence, he is the least complex of the three characters. However, the screenwriter, Charles Fuller, places Davenport in an incredibly complex plot situation that still makes him a satisfying

character to watch. The goal of this African American character is to find the killer, black or white, on an Army base full of racist white officers, in a racist Southern town, in a racist 1940s America. As a character with no flaws, he is the least interesting of the three, but as a heroic figure, he fits the bill.

The Struggle: Obstacles and Antagonists

A good screenplay takes its protagonist on a one hundred minute struggle towards a goal. Your job as a screenwriter is to get the audience caught up in that struggle, to make them care about the protagonist achieving the goal, and have the audience root for the protagonist to get what she wants. One of the best ways to engage the audience in the protagonist's struggle is to make the obstacles or antagonists who are impeding the protagonist's progress towards the goal just as believable and strong as your protagonist is. If your antagonist is not a formidable opponent, then the dramatic conflict that drives the plot will be diminished. A weak opponent will cause the audience not to care about the protagonist's struggle. Therefore, it is imperative that you spend just as much effort developing your obstacles or antagonist as you do coming up with your protagonist.

Obstacles can be anything: bad guys or outside social forces, such as racism or sexism or homophobia; or they can be internal flaws within the personality of the protagonist that prevent her or him from reaching a goal. In *Antwone Fisher*, the obstacle is an internal one. Antwone's own self-destructive behavior stops him from becoming a whole person. The screenwriter does such a good job foregrounding the nature of Antwone's internal problems that he maintains intense levels of suspense throughout the film. The suspense in the movie comes because we believe Antwone's self-destructiveness to be almost insurmountable. When, in the end, Antwone does overcome the negative power of the internal forces impinging upon his life, we feel a sense of satisfaction as great as when Will Smith kills the alien invaders in *Independence Day*. Similarly, evil alien invaders are only effective antagonists if they are really hard to keep out and off the earth.

In *Miracle at St. Anna*, the screenwriter, James McBride, and director, Spike Lee, who collaborated closely with McBride on the

script, constructed a complex set of opponents confronting the African American servicemen who are the protagonists of this well-written World War II genre film. The primary obstacle is, of course, the German Army, a powerful military force greatly outnumbering the small unit of African American soldiers. The story follows the black unit as they have become separated from their division and find themselves trapped in a small Italian mountain village. Coupled with the frightening external threat of the German Army is the threat of the inner ambivalence these characters feel towards their own situation as U.S. soldiers because of America's history of enslavement, prejudice and discrimination towards its black citizens. This historical knowledge permeates the consciousness of these men and threatens to weaken their resolve and possibly lessen their ability to fight the enemy. In an interview Lee tells us, "James [McBride] captured the ambivalence of these young black men who are patriotic, who are willing to die for their country, yet their country does not love them back the same."[2] The ambivalence McBride brings out in the characters is embodied in the villainous persona of the antagonist, Axis Sally—the Nazi counterpart of Tokyo Rose—an American woman who broadcasts to U.S. military men on behalf of the enemy. Axis Sally taunts the protagonists of Lee's film in the very midst of battle, reminding the Buffalo Soldiers of how they are poorly treated back home.

> Even though it was Nazi propaganda, a lot of that stuff's not lies. She's talking about slavery, talking about being treated as second-class citizens, about how you're still being lynched, about how you can't vote. You know, this is very effective propaganda… it had those guys thinking, 'What the hell are we doing here?'[3]

A look at one of Axis Sally's speeches from the script underscores the internal condition of the soldiers as they come under siege. In this battle scene, the character, Train, is taken aback when he hears Axis Sally's broadcast:

EXT. SERCHIO RIVER - AMERICAN SIDE

From the looming ridges, a scratchy P.A. system
suddenly leaps to life. WE HEAR a white woman's
voice, AXIS SALLY. She speaks good English.

> AXIS SALLY (O.S.)
> Good morning 92nd Division. Buffalo Soldiers,
> welcome to the war. We've been waiting for
> you. Do you know our German Wehrmacht has
> been here digging bunkers for six months
> on the Gothic line? Waiting? Your white
> commanders won't tell you that, of course,
> why? Because they don't care if you die. But
> the German people have nothing against the
> Negro. That's why I'm warning you with all my
> heart: Save yourself, Negro brothers. Get out
> while you can...[4]

In this way, McBride constructs an emotional obstacle—the soldiers'
ambiguous feelings about their country. McBride also places another
antagonist in the script, a white officer in charge of their unit who is
the external embodiment of the negative racial attitudes Axis Sally
is preaching about. In the film's third act, the white officer wrongly
accuses the Buffalo Soldiers of misconduct and attempts to put them
under military arrest. McBride's protagonists now find themselves
facing serious peril, and they react in the most heroic of ways by
confronting the emotional and external threats to their freedom and
well being. They fight valiantly for their dignity, for the country that
has forsaken them and for each other against the Nazi onslaught.

Let's look at the obstacles and antagonists that create the dramatic
struggle driving the plot of *Boyz in the Hood*. Singleton's coming of
age film develops the story around the main character, Tre's, journey
to become a self-respecting African American adult. The first obstacle
Tre faces is peer pressure. Singleton opens the film by showing us
a bullet-riddled corner of a city block. Hanging out with the "boyz"
means living in close proximity to crime, drugs and ultimately death.
We see this ever-present danger and temptation to lapse into a
gangster mentality as an extremely credible and powerful obstacle

for Tre to deal with. Singleton couples this threat with the burdens of racism and the nihilistic attitudes racial inequality produces in Tre's friends. Through the power of these obstacles, the audience is drawn into what plays out as an epic struggle to reach manhood.

In *To Sleep with Anger*, Charles Burnett draws upon African folklore in constructing an antagonist to be reckoned with. Harry, played by Danny Glover, is a character based on the Hairy Man legend brought to America by Africans centuries ago. An old friend of the family from "back home" in the deep South, we first meet Harry at the end of Act One via the appearance of his foreboding shadow at the front door. Burnett then sets up a series of scenes through which we begin to feel that Harry's bad nature may be rooted in more than just a wild past. Soon, we believe that Harry may be the devil incarnate. We know that right before Harry appears at their doorstep asking for shelter, Gideon loses his toby, a charm given to him by his grandmother to protect him from evil spirits. When Harry meets Gideon's grandson, the child sweeps Harry's shoes with a broom, which sets Harry off into a superstitious panic that can only be relieved when Harry tosses salt over his own shoulder. Later, when Harry meets Gideon's pregnant daughter-in-law, the baby jumps as if the unborn child knows the devil is approaching. This is followed by another scene that establishes the evil nature of Harry's character as a powerful threat to the family. The scene is set in the kitchen. Harry lures Babe Brother into a card game and pulls out a knife in front of Babe's son. This scene is intercut with scenes of the rest of the family in church. The point is made that only God can fight the corrupting influences of this demonic presence in the family kitchen.

As Harry's power over Babe Brother steadily increases, and Gideon (who we believe to now be cursed by Harry) is befallen by a serious illness, we are drawn into the family matriarch's struggle to get the devil out of her house. In a cleverly written ending to the third act, Burnett stages an earthquake right at the moment that Harry's soul, the evil spirit, leaves his body. A formidable antagonist, Harry stirs up a plot conflict of biblical proportions. Burnett's script delivers a most satisfying resolution when the family comes back together after vanquishing the devil from their midst.

IMAGINATION AND RESEARCH

To be good writers, we must push ourselves to know all of our characters intimately, to put ourselves in their shoes. That means, if you are a man, you should challenge yourself to spend time learning about how women think, so that as you create your female characters, you can adopt a feminine point of view. If you are constructing a Latino protagonist for your story, and have no experience with the Latino culture, you need to do research so that, again, you will have the wherewithal to write the Latino character from a "truthful" point of view. The same goes for young people writing about other generations, straights writing about gays, women writing about men, and old writing about young, etc. The need for research also applies to writing about professions you might never have experienced or socio-economic situations you are unfamiliar with. Research with the goal of understanding the point of view of someone other than yourself will help you avoid inadvertently stereotyping your characters.

James McBride and Spike Lee did this with the German characters in the film *Miracle at St. Anna*. McBride studied German culture for his original story. Based on their research, McBride and Lee worked hard to avoid constructing the German characters as purely villainous and one-dimensional. They created a range of German characters with varying points of view. In the film, one German officer carries out a brutal massacre, executing hundreds of Italian civilians outside of a church. At the same time another German soldier risks his life to save an Italian boy who is a witness to the horrible crime. In the third act of the film, McBride and Lee cleverly undermine the WWII movie stereotypes of Germans that predominate in previous Hollywood films by showing a German Commander who we see earlier in the movie complaining about Hitler and the wrongfulness of the war, give his own pistol to the last surviving Buffalo Soldier so that he can defend himself against the imminent German siege.

The best way for a writer to research his characters is to spend some time in the world of each character. Speak with real people who live the life you are representing on the screen. Take notes. How do these people move? How do they speak? What do they want out of life? How do they spend their days? What do they have in common? How are they individuals? What is their history? Of course you

cannot stand in someone else's shoes, but as a writer you can learn to understand the differing perspectives of anyone if you are open-minded and devote your research time to the goal of understanding.

On the other hand, not all movies need to have realistic characters. Certain genres demand non-realistic characters, such as ones that are totally pulled from the writer's imagination. The monsters in horror films, for instance, and the silly archetypes in slapstick comedies work because the characters are not realistic. *Love and Action in Chicago*, by screenwriter Dwayne Johnson-Cochran, is a great example of how a cleverly written satire can push the limits of our expectations of a character. In *Love and Action in Chicago*, the main character, played by Courtney Vance, is a professional hit man who has taken an oath of celibacy as an offering of penance for his sins. Playing against the classic depiction of the character of the hit man as someone who is emotionally detached, unreflective and immoral, Johnson-Cochran gives his character the qualities of a priest and makes him a man of principle who works for an agency that assassinates certifiable bad guys without trial. The irony of this priestly character being stuck in this unholy employment situation creates a wonderful comic undertone throughout the film.

THE CHARACTER ARC

Once you've come up with a protagonist and prepared a backstory for your character, you should focus on the character arc. The *character arc* is the trajectory of psychological changes that your main character undergoes as he or she struggles to overcome the obstacle or conquer the antagonist in order to get what he or she wants. In most films, the audience expects to see a change in the protagonist by the end of the movie. In *Do the Right Thing*, the character of Mookie goes from being the neighborhood intermediary between Sal (who is a white business owner) and Sal's black customers, to the instigator of a rebellion against Sal and the racist police who uphold the system of economic exploitation in the neighborhood.

In *Boyz in the Hood*, Tre's character arc is manifest in the change he undergoes from being a naïve young boy living with his mother to a proud young man who is strong enough to resist the negative ways of the hood. If we look closely at Antwone Fisher, we see a very

clear arc for the main character when we witness his transformation from an angry, emotionally damaged person at the beginning of the film, to the calm, self-confident person he becomes at the end of the movie.

In traditional genre films most character arcs are predetermined by the conventions of the genre. For instance, in *The Wood*, which is essentially a romantic comedy, the expectations created for the viewer by the genre are that the main character, Mike, will come to the realization that he should be married to his childhood sweetheart. If the movie ended with Mike not coming to this realization, then audiences would leave the theatres disappointed. Why? Because the conventions of genre for an audience run deep and seem to satisfy our need for closure in narrative.

Don't confuse closure provided by a character arc with a happy ending. Most people know the story of how the movie studio tried to get Spike Lee to change his ending to *Do the Right Thing* from an unresolved confrontation between Mookie and Sal to a happy one. The studio wanted Lee to provide more closure. Apparently, they thought an ending in which the characters of Sal and Mookie shake hands and make up would be a more satisfying arc for the audience. Lee insisted that his open-ending was right and stuck with it. Lee wanted *Do the Right Thing* to provoke his audience with the more realistic yet unconventional ending he had written so that the viewers would be forced to think about issues of police brutality and racism. As it turns out, the audience did like Lee's ending and left the theatres with a sense of narrative satisfaction, because Mookie did undergo a transformation—a transformation from a guy who tolerated too much oppression to a guy who became an agent of protest in the neighborhood.

How to Develop a Character on Screen

In film, characters can really only act or react. In novels and in the theatrical plays, you can have what's called an aside or an interior monologue where the character in the novel or play, basically, steps outside of the story and speaks directly to the audience to communicate his or her feelings. In film, you have a similar technique called the character voice over and the technique of direct address

where the character turns and speaks directly to the audience. For instance, there is an example of direct address during the opening of *The Wood* when Mike speaks directly into the camera to start the movie or in *Do the Right Thing* when the different characters shout racial slurs directly at the camera. But most screenwriters dislike using these voice over or direct address techniques for more than a few lines, because voice over and direct address break up the story and disrupt the imaginary space between the camera and the audience. Too much voice over or direct address will pull the audience out of the narrative, and violate the magical experience of losing oneself in the world of the characters. But, as we said, that is precisely why Spike Lee chose to use the direct address technique for the racial slurs sequence in *Do the Right Thing*. It was an effective way to assault the audience and make us feel uncomfortable.

Because voice over is the easy way to get the character's thoughts out to the audience, many novice writers rely too heavily on it as a primary approach to character development. While a little voice over might work perfectly in the film, too much first person voice over slows down the pacing of a screenplay.

Using Visuals for Character Development

So what do you do besides writing good dialogue to develop characters for the big screen? Let's look at some examples of how the pros use visuals—images without dialogue—to delineate their characters. For instance, Charles Burnett has received accolades for the masterful way he utilizes visuals to achieve character development in *To Sleep with Anger*. Among the many striking scenes in the film that crystallize the character of Harry in the minds of the audience is the scene that occurs soon after Harry's arrival. The family has gone to church, and Harry is left alone in the house. He walks through the living room and begins to slowly and deliberately touch the family photos and other special objects Suzie and Gideon have displayed on their mantle. When Harry comes to the old clock on the mantel, he turns back the hour hand, and then moves it forward. The metaphor created by Harry's action of "turning the hands of time" works perfectly to communicate to us, the character's mental state, one of nostalgia, and from his facial expression, possible regret. Then suddenly, Burnett

uses a jump cut, and Harry is in Suzie and Gideon's bedroom going through the things on Suzie's dressing table, again, in a creepy, slow and deliberate manner. The effect of this is to show that Harry is more than just a sad nostalgic character, but also a bold, intrepid, perverse threat to Suzie's nuclear family. It is a brilliant visual way, without using dialogue, to signal to the audience that this character may have bad intentions and no limits as to how far he will go as he pries into the personal lives of his old friends.

Many times visuals of a simple gesture or action can be used to bring out the certain something about your character that cannot be revealed as well through dialogue. For instance, take a look at the scene in *Love and Action in Chicago* in which the characters Eddie and Lois are falling for each other. They have just gotten out of a cab in front of her bungalow after their first real date, and the screenwriter, Johnson-Cochran, wants to communicate to the audience the pure elation Eddie feels at this moment. Instead of having Eddie say something along the lines of, "I feel like I'm in love," Johnson-Cochran has Eddie say goodnight to Lois and forget to get back into the cab. Instead, Eddie turns and walks down the street. This action by the actor is an outward visual way to communicate the interior emotions of Eddie's character as he is falling in love.

Let's look at *Eve's Bayou*. When Lemmons wants us to understand that the mother in the movie is angry at the father for his acts of infidelity, one way she does this is by showing Eve's mother's character chopping vegetables so roughly that she cuts her own finger in the process. The tension in the mother's soul comes through on screen in the action of cutting herself.

Another way to understand the technique of character development is to think of character development as creating a character through a series of her actions. In *Eve's Bayou*, when Eve puts the snake in her brother's bed or steals a pineapple at the market, this shows the audience what type of child she is; a bold little tomboyish girl who is not afraid of most consequences.

Character actions are also used in the clever opening sequence of *Eve's Bayou*, when screenwriter, Lemmons, constructs the complicated character of Louis Batiste, Eve's father. First Lemmons shows Louis at the party. We see from his actions with his children and his guests that he is the lifeblood of the community; handsome,

charming, attentive, a successful doctor and man of significant stature and wealth. Then, during the party, Lemmons has Louis slip out to the garage for a brief sexual encounter with Matty, who is one of the guests and a married friend of the family. From the way Lemmons constructs the scene, we assume that the couple have been cheating together for a while. What Louis doesn't know is that his nine year old daughter, Eve, has snuck out from the party and is napping in the garage. She suddenly awakes to find him having intercourse with the other woman. What follows is a tense scene in which Louis tries to convince Eve that she was only dreaming that she saw him and Matty together. The act of the father betraying the wife and then lying to his daughter says a tremendous amount to the audience about his character. Right after this, Lemmons adds the mother to the situation. She comes out of the house and approaches Eve and Louis. What does the father do? He flirts with Eve's mother moments after he's been with the other woman. Thus, in the first ten minutes of the movie, Louis' character is developed for us through his actions: first through the act of conveying his love for his family at the party, then through the act of sexually betraying his wife, and, finally, through the acts of lying to his daughter and covering up the betrayal.

At the same time, Lemmons creates a strong sense of contradiction in Louis' character. Louis, the pillar of the community is really not what he seems to be. Contradiction in a character is always a satisfying thing to watch and is an especially powerful ingredient to add when creating any antagonist. Take the character of the Honorable Elijah Muhammad in the film *Malcolm X.* On the one hand, he is literally the man who gave Malcolm X his salvation. He is the man who appears to Malcolm in prison and converts him to Islam. Elijah Muhammad blesses Malcolm and sends him out to proselytize Black America. Yet as the story develops, and as Malcolm's character develops to the point where he gains a global perspective on Islam, Lee shows us the cracks and the contradictions in Elijah Muhammad's character. Lee shows us that Muhammad is threatened by Malcolm's growing influence within the Nation of Islam. Lee shows us that Muhammad has impregnated several young Muslim women and left them to live in questionable circumstances. These contradictions in Muhammad's character cause Malcolm to be caught in a push-pull

relationship with his spiritual mentor. The contradiction in Elijah Muhammad's character ultimately leads Malcolm to second guess his own beliefs and loyalties. The dramatic situation produces a compelling self- struggle that drives the narrative arc of the movie.

In the director's commentary for the DVD release of *Malcolm X*, Spike Lee mentions that, in addition to showing contradiction in the Elijah Muhammad character, he also wanted to show contradiction in the character of Malcolm. To do this Lee says he recreated the incident in which a young liberal Caucasian woman comes up to Malcolm and asks how she can help his cause. Malcolm abruptly says there is nothing she can do to help his cause and walks away from her. Lee then cuts to a scene where Malcolm is speaking about racism to a group of white liberal college students in a manner that suggests he does indeed want to engage them in the struggle. Lee points out that the juxtaposing of the two scenes helps to generate a truthful depiction of the contradictions in Malcolm's character.

Of course, as a screenwriter, you have the ability to use dialogue in the service of developing your characters, and we will discuss dialogue writing later in the book. In this chapter, we will spend a moment to cover dialogue in terms of how it supports the development of your protagonist. Remember, if you want a character to express his or her feelings in dialogue, you need to have another character to bounce his or her feelings off of during the scene. Writers refer to that character as the *sounding board character.*

In *Eve's Bayou* several of the characters function as sounding boards for the other characters. Eve's sounding board is Cisely. It is Cisely with whom Eve can reveal her raw emotions about her father and vice versa. We know what the two girls are thinking because they confide in each other. When Cisely has to leave the house and is sent away to live with a relative, Eve no longer has a sounding board character. At that point, the tone shifts, and Lemmons lets the audience know what Eve is thinking solely through Eve's actions and reactions and via snippets of voice over. Eventually, Cisely returns. Eve has her sounding board character back and confides in her sister.

It is also interesting to look at Lemmon's use of Eve as Aunt Moselle's sounding board character. Lemmons gives Aunt Moselle a number of intense dialogue scenes in which she explains to Eve what she is feeling about the death of her husband. Aunt Moselle speaks of

the fear she feels about having the power to see the future. Eve, being a little girl, does not confide in Aunt Moselle in the same fashion. This reinforces the theme of the movie, the divisions between the child world and the adult world. Ironically, Aunt Moselle, the adult, tells Eve, the child, of her deepest fears and emotions. But Aunt Moselle doesn't coax Eve's fears and emotions back out of her niece in similar conversations. Aunt Moselle is not Eve's sounding board because she speaks to Eve as an authority figure.

DEVELOPING CHARACTER THROUGH REACTIONS

Finally, you can develop your characters on screen through the use of their reactions. Remember, actors are paid to act and also to react. As you are writing your characters on the page, you have to always consider what the characters are doing when they are listening or responding to what the other characters are doing and saying. In *A Soldier's Story*, when Private Peterson is brought into the brig right after his buddy has confessed that it was Peterson who murdered Sergeant Waters, Peterson's reaction shot, the look on his face as he realizes he has been caught, functions as the silent climax of the movie. You don't need a long dialogue scene or monologue there. The cut to the character's reaction makes the most impact in this particular film.

In *The Great Debaters*, there are several points at which screenwriter, Robert Eisele, uses the reactive moment in the scene rather than dialogue. Take, for instance, the scene in which the character of James Farmer Sr. gives his paycheck to the two racist white men whose hog he has accidently killed. The white man intentionally drops the check he has been handed by Farmer Sr., expecting Farmer Sr. to stoop down and pick it up. The tension generated as we wait for Farmer Sr.'s reaction is intense. When Farmer Sr. decides to stoop down in front of his children and his wife to give the check to the white man, the scene brings home the magnitude of race-based oppression on the psyches of the African American characters in the film.

In a later scene in *The Great Debaters*, the son, James Farmer Jr. arrives with the school band to pick up his teammate, Henry, from Henry's cabin. When Henry opens the door, James Jr. sees their teammate, Samantha's, shoes on the floor and realizes, without saying a word of dialogue, that Henry and Samantha have spent

the previous night together. The young men exchange a glance that communicates a multitude of emotions: betrayal, embarrassment, jealousy, disappointment, frustration and loss—an excellent example of how you can use a reaction shot to convey a character's state of being with no need for dialogue.

When done right, reactive moments in the movies can open a window to the soul of a character. Effective screenwriters understand this power. Look at the scene in *Malcolm X* where Lee has Malcolm and Betty Shabazz arguing over the fact that he is never home with her. What is Malcolm's character's reaction? He leaves. He walks away from her without speaking. Malcolm's character's reaction says a lot about who he is and makes him real for the audience. In the director's commentary to the DVD, Lee mentions that Betty Shabazz wanted Lee to cut the scene because she contended that it wasn't real. Lee, nevertheless, had the foresight to keep the scene. He knew having the character silently walk away would make the scene truly compelling, showing Malcolm X as a complex individual who lived with many responsibilities and pressures in his life. The reaction gives the character a truth-value that words cannot express.

SUPPORTING CHARACTERS

The purpose of a supporting character is to support the protagonist or antagonist in moving the story forward. As you add supporting characters to the roster, you should have a clear reason why each and every supporting character is appearing in your script. If you are not sure why you are putting the supporting character in the movie, you should ask yourself if you really need the character. Ask yourself, if you cut that character, would the plot suffer or would the development of your principal characters be hindered?

As we mentioned earlier a supporting character can serve as a sounding board for the main character or other character. Additionally the supporting character can serve as a foil for the protagonist or other characters. For instance, in *Do the Right Thing*, Sal's sons are foils—one son befriends Mookie and respects Black culture while the other son antagonizes Mookie and regards Black culture as inferior.

A supporting character can be added to your screenplay as a storytelling device to strengthen your movie's story structure or

bring out certain themes. For instance, in *Do the Right Thing*, Lee uses the Radio Raheem character to provide crucial story beats by deploying Raheem to provoke violent reactions from Sal, the antagonistic. The Radio Raheem character also provides an organic way of discussing the theme of race relations in America via the love versus hate scene where Raheem delivers the famous brass knuckle monologue.

In *Antwone Fisher*, the character of the girlfriend, Cheryl, enhances the story in several ways. First, Cheryl's character functions as a device to bring out the fact that Antwone has trouble relating intimately with women. This allows the story information about sexual abuse to develop naturally within the movie since it flows from his initial inability to go on a date with her character. Cheryl's character also serves as a counterpoint to Antwone by juxtaposing her supportive family upbringing with Antwone's tragic absence of family support. The comparison between her happy life and his disastrous one makes Antwone's story ring even more tragic and underscores his driving need to find intimacy and familial connections. Later in the film, Cheryl's character takes on a key function as the sounding board for Antwone to express his inner thoughts as he searches to find his mother.

Chapter Three Exercises

1. Write a five-page backstory for each of your main characters including your protagonist and antagonist.

2. Create a two-page backstory for each of your secondary characters.

3. In one sentence, describe what your protagonist's goals are and what his or her main obstacles will be in your movie.

Keep a notebook full of ideas about your characters. If ideas for great scenes occur to you as you are writing your backstories quickly jot them down. You can note down any actions and reactions you might want your characters to have in your movie. If you want, you can also, write down lines of dialogue that occur to you. Keeping these details in notebook form will allow you to go back later and add them to the script as you write it. For now, however, we recommend that you just keep this dialogue and scene information in the form of notes. Do not start writing your script yet.

CHAPTER FOUR

Synopsis, Treatment, And Pitch

Now that you have your backstories for your characters, you are ready to construct the plot for your original movie. Given that you already worked out who your protagonist is and what he or she wants to achieve and the obstacles that are stopping that from happening, we assure you that you are prepared to take this next step. This stage of the scriptwriting process is the most demanding and difficult, because this is when you clearly define the beginning, middle and an end for your film. A good way to approach the challenge of building a plot is to ask yourself, "How will the protagonist get what he or she wants?" In answering this question the plot structure will develop and become the blueprint you will use for scene writing and character development. By knowing how the story will progress from the initial dramatic incident to the turning point at the end of Act One to the turning point at the end of Act Two and on to the climax and resolution, your scene writing will be more effective and purposeful. You will be controlling your story rather than allowing your story to control you.

The One-Page Synopsis and Logline

As you construct your plot, your goal should be to create a one-page *synopsis* of your movie. The one-page synopsis is a summary of your story that clearly establishes who the main characters are and, generally, what will happen with the plot in the beginning, middle and end of the film. Writing the synopsis is a task that will help you clarify the direction of your plot and move forward to the next step in the writing process. Once your screenplay is finished and you are

at the point that you want to sell your script, you will go back and polish up the synopsis so that it can be given to producers and agents in conjunction with your pitch.

Some writers prefer to skip the synopsis and create an outline first. If they find they need a synopsis later, they will go back and write the synopsis after they've finished the *spec script* (a script written on speculation that is not yet under contract). We always advise first time writers to come up with a synopsis before they go to outline, because we find this exercise helps the emerging writer to really think about story structure at a fundamental level. An additional advantage of putting your film idea in a nicely flowing one-page synopsis, is that you can more easily catch any gaps in your storyline that you may not yet have realized were problems before you start writing the actual script.

The one-page synopsis is always written in *present tense*. The synopsis must include the title of your movie and may start with a logline. The *logline* is a one or two sentence description of the movie. Think of a logline as a *TV Guide* summary of your movie. It's also your sales pitch, your one-liner sound bite that anyone can remember. For examples of loglines, you can check out the descriptions on Netflix or read the TV Guide previews on your cable channel. A logline for the *Lion King* might read: A young lion must avenge the murder of his father to become the new lion king. The logline from the sleeve of *The Great Debaters* reads: "When African-American poet Mel Tolson…creates a debate team at historically black Wiley College, he pushes the team to a level of excellence that allows them to challenge powerhouse Harvard in 1935." In your logline, be careful not to compliment your script as if you are reviewing your own production. For instance, don't say it is "a gripping story" or "a spellbinding mystery" or a "superb drama." Just summarize the idea in the clearest manner possible.

After you've come up with the logline, you should write the one-page summary for the synopsis of your story. If it's a genre movie say what genre it is. Next, give a description of the main characters. Remember to use their names and give some very brief background on each of the central characters so the reader knows who they are. You won't have enough space on one page to describe all of your secondary characters, so just mention the most essential ones. Also,

tell where the movie is set. As you are describing the characters and setting, be careful to use adjectives that distinguish your writing from the other thousands of screenwriters out there. Use a thesaurus if you're having problems finding just the right adjectives. For example, don't say, "Nona is a beautiful woman." Say, "Nona, 45, is beautiful with effort."[1]

Next you can go on to tell what happens in the beginning of the story. Be sure to start with an initial plot incident that will occur within the first ten minutes of the film to hook your audience into watching the rest of your movie. Remember, the initial plot incident is that thing that happens to start your story going. In *Eve's Bayou*, the initial incident occurs when Eve awakes to see her father having intercourse with another woman, followed by the father's lie, to convince Eve that she was only dreaming. In, *A Soldier's Story*, the initial dramatic incident occurs in the first ten minutes when Sergeant Waters is murdered, and the investigator arrives on base only to discover that he will be blocked in his investigation by the white racist commander of the base.

After you've stated the initial incident, you can go right into a couple of sentences describing what happens in the remainder of Act One, and then quickly describe your first turning point. Tell what happens in a sentence or two. You don't have space to put any dialogue into the one-page synopsis. Focus only on the plot information.

In the subsequent paragraph you should describe what happens in Act Two, the longest act of your screenplay. If any new significant characters will be introduced, be sure to describe them. Again, in the synopsis, be sure you are telling your story in present tense. Even flashbacks, if you intend to use them, should be described in present tense. A movie synopsis is meant to let someone else see and hear your movie in his or her mind. Present tense does this better than past tense. So go ahead and tell what major incidents occur in the film during Act Two. Follow this with another paragraph describing what happens at the turning point of Act Two, and finish with a paragraph that describes the plot of Act Three. Don't forget to explain your movie's climax and the film's resolution, and you're done! You've got your basic story hammered out on one page!

THE TREATMENT

At this point in the writing process, some writers prefer to go ahead and expand the synopsis into a much longer summary known as a *treatment.* Treatments can run five to ten pages or as long as twenty pages or more. Obviously, a treatment contains much greater story detail than a synopsis and can be thought of as a short story version of your movie. Some writers like to write the treatment before the spec script. They feel this helps to guide them in preparing the overall structure for the story. Some writers choose to finish the treatment after they write the actual spec script. They may use the treatment as a tool for selling the screenplay.

In any given year, it is estimated that more than 10,000 scripts are circulated around Hollywood. You can imagine how many hours of reading development executives need to do in order to sort through the 10,000 scripts to find the limited number of scripts that are ultimately made into movies each year. For that reason, during the first phase of the selection process, a producer might elect to look at the treatment before accepting the actual script.

Beginning writers usually feel intimidated by the idea of writing treatments before they have written the script. In this book, we recommend that you wait until after you're finished with your spec script to write a treatment. Instead, we advise you to do a scene outline before you write your screenplay. The scene outline will serve as a very precise outline of your plot. It will supply you with your ultimate writing roadmap. In the next chapter, we'll cover the mechanics of constructing scene outlines.

If you generate interest in your completed spec script, you might get an assignment to write a treatment from an idea that the production company gives you. Be advised that there is no particular industry format that is used for a treatment. Basically, a good treatment is one that gets your story across to the reader in a highly visual and logical manner. A great treatment is easy to read, with short sentences and brief paragraphs. Like the synopsis, it's written in present tense so that the reader feels like he's in the theatre watching the film. Unlike a synopsis or outline, a treatment can contain lines of dialogue. One of the best books on treatment writing is *Writing Treatments that Sell* by Kenneth Atchity and Chi-Li Wong. These authors recommend that you think of your treatment as a "vivid and intense letter to

your best friend relating a series of amazing events that you've just experienced."[2] They also recommend that, when you are ready to sell your screenplay, you write up treatments of varying lengths; a three to five pager, a ten pager, a fifteen to twenty pager. That way you'll have the right treatment ready for any agent, manager, development person, producer or studio exec wanting to read it at the length he or she prefers.

EXAMPLE OF A SHORT TREATMENT

LAUGHING THROUGH THE TEARS

A film based on a true story

Written by
C. M. Houston
WGA # 2175

C.M. Houston
0000 S. Shore Drive
Chicago 00000 - 773-555-5555

LOGLINE:
Laughing Through The Tears is a character- driven story about a couple who, after thirty- five years of an almost conflict-free, love- filled marriage, are suddenly faced with the challenge of coping with the debilitating disease, dementia.

PRELUDE:
Crystal (Mid 50s), believes her husband Eric (Late 60s), who is in stage three of dementia, is sitting in the den of their spacious mini-mansion watching television. Instead, he is upstairs sitting in the bathtub splashing playfully in the warm, fragrant, bubbly water she prepared earlier for herself. As

Crystal attempts to coax Eric out of the tub, he grabs her arm causing her to fall and hit her head, losing consciousness.

Four Years Earlier:
Crystal and Eric are getting dressed for the elegant retirement party Crystal and her friend, Sherry, have planned for nearly two months. After twenty-five years of working as a CTA (Chicago Transit Authority) el-train motorman, Eric, is retiring to enjoy a carefree existence for the remainder of his life. Crystal, who is a professor teaching drama at a local city college, is not quite ready to retire but agrees that her husband has worked long and hard and has earned the right to hang up his uniform for good. They have raised three sons, Mark (30), Shaun (28), and Jay (25) and one daughter, Anna (30), who have all left the nest but, of course, they return home for what friends and family call "the retirement party of the century." At the retirement party, Leonardo, Eric's best friend and protégé, meets, and is immediately smitten with, Sherry. A long distance romantic relationship between the two begins. It is during this time that Eric displays his desire to see his youngest son Jay settle down and get married. Eric and Crystal both realize they are still madly in love and begin to plan the first of the many vacations and trips they have been longing to take. Upon arriving in Las Vegas, Crystal witnesses a strange and unusual incident involving Eric. Although it upsets her and leaves her perplexed, Eric does not show concern, so she puts it in the back of her mind, vowing she would forget it ever happened. Upon their return, they are summoned to Doctor Winter's office where they learn the results of tests Eric has taken prior to their trip. When Doctor Winter tells them that Eric might be suffering from dementia, Crystal refuses to accept his diagnosis and immediately slips into a severe state of denial. Since Eric is

in the early stages of the disease and is his usual self most of the time, it becomes easy for Crystal to continue to believe love, determination and commitment will be enough to prove the diagnosis inaccurate.

Two years pass as Crystal still refuses to believe another diagnosis made by a neurologist. Eric acts somewhat normal but now he is beginning to show unmistakable signs of the disease. He insults Sherry and on numerous occasions, wanders out alone and has trouble differentiating between his clothes and Crystal's. All efforts to connect Eric with people experiencing the same challenge fail. Sherry tries, but to no avail, to convince Crystal she is in denial and should accept the obvious signs that there is a serious health issue going on with Eric. This causes several incidents between the two extremely close friends. For the next few years, Crystal is faced with the challenge of caring for her husband whose health is deteriorating as the disease progresses. There are many comedic episodes but still, Crystal refuses to believe that all the wonderful blissful years, all of the wonderful experiences of raising their children, will soon be erased from Eric's memory. At the same time, Sherry is experiencing her ups and downs with her long distance love affair with Leonardo.

While Crystal is determined to surmount each challenge, Eric enters into the beginning of stage four of the disease. Sherry convinces Crystal to throw a thirtieth wedding anniversary party which turns out to be somewhat disastrous but allows family and friends to become aware of Eric's physical state and allows Crystal to come out of denial and accept the inevitable. It is Crystal's friend Sherry, her son Shaun and her next door neighbor, Mrs. Robertson, who, after a serious incident involving Eric, finally succeed in convincing Crystal that laughter is sometimes the "Best Medicine." In the

end, despite his dementia, Eric realizes his life-
long dream, seeing his son get married, and Crystal
learns to laugh right through her tears.

THE LIVE PITCH

Most screenwriters are rather introverted people. They have the ability to spend weeks at a time sequestered in their offices with little outside interaction. Ironically, these introverted screenwriters have to sit in a room full of extroverted producers and development executives and convince these outgoing people to buy their work. What a challenge.

So if you are one of those introverted writers, you might be wondering, "How will I ever get up the nerve to pitch my screenplay, let alone pitch it with confidence and enthusiasm?" Most writing workshops help writers get over their fear of pitching by having the writers pitch their stories to the other writers in the workshop before they even start writing a line of dialogue. We also recommend this type of live pitching exercise. The experience of putting forth your idea to a group of writers will help you learn to clarify your storyline and communicate it effectively.

You should prepare a two-minute version and a ten-minute version of your movie that you can pitch to a potential agent or producer. Why? Well, let's say you have the foresight to approach a producer after she has given a talk at your university or local film festival. You've got this two-minute window to interest her in your movie. Your pitch better be short and sweet. Later, let's say she likes it and invites you to have a meeting with her company to hear more about your project. At this point you need a longer pitch, a ten-minute version of your idea.

So what do you do to prepare? For the two-minute pitch, you can take your synopsis, and then add a hook. A hook is a line or two that is easy for your listener to remember that lets him know what makes your film unique. It's the best part of your idea, the part of the pitch that makes your potential buyers instantly excited about your movie. For example, the hook to selling *The Pursuit of Happyness* is it's a true story about a single dad who went from living on the streets to owning his own brokerage firm. Development people respond to

hooks when they feel they have a screenplay they can turn around and sell to the next person in the development chain.

We recommend that you write up the two-minute pitch for your original spec script and revise it. Revise it again, and make it pop off the page. Memorize it, and practice saying it with enthusiasm. Rehearse the pitch with anyone who will listen. After someone has heard it, ask him or her for feedback. Did your listener understand what happens in your movie? Does the ending make sense? Does your listener like the characters? Did you sound excited about the story as you were explaining it to them? As you delivered the pitch, did you do anything strange with your facial or physical gestures that became distracting? Can the listener repeat your hook back to you? If not, work on your hook. Ask the listener who he or she thinks would go to watch your movie. Take your listener's comments into consideration, and then rehearse the pitch in the mirror at least ten more times. Once you have confidence in the fact that you know what you are going to say, you'll be more at ease in the pitch meeting.

SAMPLE SYNOPSIS FOR
LOVE AND ACTION IN CHICAGO[3]

Logline: A satirical comedy about an assassin who tries to retire from this line of work.

A satirical take on the hit man genre, the film opens with Eddie, a devout Catholic and professional hit man, as he meets with his boss, Ms. Middleman, to inform her that he's leaving the agency. Middleman reminds Eddie that no one ever leaves, but Eddie insists he'll find a way. Middleman brushes off Eddie's demand and suggests that he get a girlfriend to ease his restlessness. Middleman wants to fix Eddie up with someone she knows. Eddie, who has sworn himself to celibacy until he finds a way to change careers, does not want to get involved with anyone. Nevertheless, Middleman convinces Eddie to meet Lois, a sincere, vivacious woman. Lois ends up taking a strong

liking to Eddie without knowing what he actually
does for a living.

In Act Two, Eddie misses a hit on a major bad guy
when Lois turns up unexpectedly and grabs him for a
long, sensual kiss in the middle of a stakeout. For
this mistake, Middleman docks Eddie's pay, which
happens to be the money Eddie was intending to save
to finance his retirement. A new character, Frank,
Eddie's former boss and now independent contractor
to the federal agency of assassins, invites Eddie
to a party at his estate. At this event, Frank
offers Eddie a raise if he agrees to leave the
federal agency to come to work for him as a private
contractor. Eddie, however, has a history of bad
blood with Frank. It now appears that everything is
conspiring to keep Eddie from getting out of the
profession. Meanwhile, Eddie is falling for Lois
and takes the risk of telling her the truth about
his career. Lois is disturbed by the revelation and
leaves him.

In Act Three, Lois decides she can actually
accept Eddie for what he does. They get hitched,
and Eddie finally puts an end to his vow of
celibacy. Now happily married, Eddie is more
determined than ever to retire. He abruptly
leaves the federal agency and flees with Lois to
his cottage in Michigan. When Middleman discovers
that Eddie is gone, she is forced to inform her
supervisor who sends the other government agency
assassins to "eliminate" Eddie and Lois. Being an
expert marksman with a wife, who, it turns out,
can handle a weapon as well as her husband, Eddie
and Lois kill their coworkers in self-defense and
embark on their new lives together in the North
Woods.

Chapter Four Exercises

1. Write a one-page synopsis for your spec script. Be sure to write the entire synopsis in present tense. Start with a one to two sentence logline, and mention the genre, if applicable. Be sure the logline contains your hook. Now describe your main characters. Next, explain the initial incident that starts your story moving forward. After that, describe what happens in the middle of your movie. This will include the two major turning points and the story complications that occur, along with any new key secondary characters that appear. Finish the synopsis with a short paragraph explaining how your screenplay will end. Be sure to describe the climax and the resolution to your story.

2. Using the synopsis as a guide, prepare a two-minute pitch for your movie. Be sure to include a hook in your pitch. Practice giving the pitch out loud to at least three different people. Ask them for feedback as specified earlier in this chapter. Revise your pitch, taking into consideration the suggestions you receive from your listeners. Now rehearse your pitch ten more times. If you are in a writing workshop, make your pitch to the workshop, and ask them for feedback.

3. After you finish your entire screenplay, you should go back and revise both your one-page synopsis and pitch to reflect any changes you have made to your storyline as you were writing.

4. After you finish your entire screenplay, you should write a five-page treatment for your movie. The treatment should tell the story you tell in your pitch, but with much more detail. Write the treatment as if you were writing a letter to a friend. Use present tense. Describe characters, setting and what happens in the film. It's okay to include snippets of dialogue as well as all of the secondary characters in the treatment.

Creating The Scene Outline

The next step in the scriptwriting process is to create a scene-by-scene plot outline for each of your three acts. The type of movie you are writing will determine the number of scenes in each act. A slower paced film will have fewer scenes in each act, and each scene will tend to be longer than the scenes in a quickly paced film and vice versa. The best way to gauge how many scenes you should have is to watch films that are from a similar genre or with similar tone and pacing to the film you intend to write, and count the scenes in those films.

PLOT ELEMENTS OF YOUR SCENE OUTLINE

Don't be intimidated by the outlining process. You can let yourself brainstorm as a method of creating the scenes. Later, you can go back and edit the order of these scenes and fill in any story gaps. Once you've finished reading this chapter, we hope you'll be ready to come up with all of the scenes for your three acts.

Even though you won't need to do the outline until you get to the end of the chapter, we've provided a series of questions for you to review now so you can begin to internalize the elements of a strong scene outline for your screenplay. When you are done with your outline, you'll want to go back and ask yourself these critical questions about your story structure. If you can't say yes to all of these questions, it's an indication that you need to go back and rework the outline.

Act One:
Does every scene matter to the story?
Does your story grab the audience within the first ten minutes?
Have you introduced the major characters including your antagonist?
Is your protagonist's goal clear?
Is the plot question evident?
Is there an obstacle facing your protagonist?
Do all scenes lead to the first turning point at the end of the act?
Does the turning point initiate a change in direction of the story?

Act Two:
Does every scene matter to the story?
Do the obstacles become more difficult to overcome?
Do all scenes lead to the second turning point?
Does your second turning point initiate a change in the story?
Does this act develop the themes of your movie?

Act Three:
Does every scene matter to the story?
Do all of the scenes lead toward the climax at the end of the movie?
Are all of the plot questions answered in the climax and resolution?
Has your main character undergone a change or experienced a
revelation by the end of your film?

HOW TO WRITE A SCENE OUTLINE

The scene outline consists of a one or two sentence description of what happens in every scene in your movie. Some writers prefer to write these descriptions on a stack of index cards. This allows them to organize the cards on a wall or lay them out on the floor to gain an overall sense of the trajectory of their story. Other writers prefer to just type the scenes and then cut and paste to change the order of the scenes as needed.

The scene description should only cover plot information and should be written in present tense. A slug line (or scene heading) can be included if you like. Don't include dialogue or too many details in your descriptions. That information will eventually make it into your

script at a later point. At this step in the creative process such details may hinder your ability to focus on plot.

When outlining the scenes, don't worry about proper screen-writing format. Instead, think of the scene outline as a "beat sheet." The scenes in your outline will function as story beats in which the essence of the action and character information is listed. As an example, let's say you are writing the scene outline for *Talk to Me* (screenplay by Michael Genet and Ken Famuyiwa), and you want to summarize the sequence where Dewey and Petey are in jail and then confront each other in the police station lobby. You don't have to write up both locations (the cell and the police station lobby) as sepa-rate scenes, you can collapse the two separate scenes into one beat in your outline and describe them as follows:

```
INT. JAIL CELL/POLICE STATION LOBBY -
NIGHT

Petey tells Dewey he's not cut out to
be the world's greatest comic. Dewey
accuses Petey of being no better
than an ex-con like his brother. The
relationship between the two men is
destroyed. Petey's girlfriend bails them
out of jail.
```

In your outline you should use the slug lines for each scene. In caps, you should state the location and then indicate whether the scene happens during the day or at night. Some writers prefer not to use slug lines in their outlines or beat sheets, but we believe it helps emerging writers to clarify the locations and timeframes in the story. Using slug lines also assists others to understand the beats of your plot more clearly.

The key to creating a useful scene outline is to sift the scene information down to its most basic elements. Simply tell what happens in the scene. Briefly introduce new characters and give only the essential plot information.

For instance, if you were describing this scene for an outline of *Talk to Me,* you wouldn't say:

```
EXT. PRISON YARD - DAY

One of the cons takes over the guard
tower. He is naked. All the inmates are
at their windows shouting at him. It is
a sunny day. The naked convict challeng-
es the warden and the guards. The war-
den tells the guard to shoot the con-
vict, but the guard says that would not
be legal. Petey Greene is brought out
into the yard. The warden wants to know
if Greene can do anything. Greene makes
a joke, and then negotiates a deal with
the warden.
```

Though an accurate description of what happens in the scene, it's too detailed for the purposes of an outline. If particular details about characters or setting occur to you as you are writing up your outline, you can put them on the back of the scene index card or make a scene notebook where you can jot down details and bits of dialogue for future reference. For now, brevity is your friend.

A more concise outline description for the same scene in *Talk to Me* would be:

```
EXT. PRISON YARD - DAY

Petey negotiates his early release by
convincing the warden that he can talk
an irate prisoner down from the guard
tower to prevent a prison riot.
```

This description gets at the heart of the scene. Boiling everything down to its function as plot information forces you to be sure you know what the point of the scene really is. Looking at each scene in a nutshell helps the screenwriter determine if the scene will move the story forward. You can tell from the description that the point of this scene from *Talk to Me* is to accomplish two things; first, to get Petey out of prison, and, secondly, to develop Petey's character. From this scene description, we learn that Petey is someone who is not your

average hustler, but rather a master negotiator. We learn that he is also someone who can command the respect of not only the entire prison population, but the respect of the warden and the guards as well. We need this character information to entice the audience to identify with him, and we need Petey out of jail in order for the rest of the movie's story line to occur.

Let's look at another example of a bad outline description for a scene from *Talk to Me.* This description contains too much detail:

```
WOL CONFERENCE ROOM - DAY

Dewey is in a meeting with the head of
the station where he works. Around the
table are a bunch of white men in suits.
The head of the station asks how they
can improve their ratings. Dewey suggests
that they expand their format to bet-
ter reach the black audience in D.C. The
white men give him a hard time by insist-
ing that the station's advertisers don't
consider the black audience as a viable
market. The station head sides with Dew-
ey, however, and makes Dewey the new Di-
rector of Programming.
```

Boiling the scene description down to the essential elements, this version of the same scene is more to the point:

```
W.O.L. CONFERENCE ROOM - DAY

Amid objections from the white employ-
ees at the station, Dewey convinces the
station owner that the format should be
changed to reach a greater number of
their urban listeners. The owner agrees
and makes Dewey the Programming Direc-
tor.
```

Finally, be careful not to be too brief. The following scene description leaves out important plot information. Someone reading this would not know that Dewey becomes the Programming Director:

```
W.O.L. CONFERENCE ROOM - DAY

Dewey talks to the station owners and
other employees.
```

SCENE OUTLINE FOR
ANTWONE FISHER

Now let's look at a scene outline we've created for the film *Antwone Fisher*. We've chosen this movie because of its strong story structure. Based on the screenwriter's own life (with some fictionalized events and characters added to enhance the story structure), Fisher organized his saga into a tightly constructed narrative of self-discovery. As you read the scene summaries below, take a close look at how the outline condenses the story information so that the reader can easily follow the thread of the plot. Notice that when a major character is initially introduced, the character's name is put in caps, followed by a brief description of that character. Also notice that quick transitional scenes such as shots of exteriors that establish a change in the location are left out of this outline (whereas they would be included in the actual screenplay). All the scenes in which major story beats occur are included in the outline.

```
ACT ONE

BARN - DAY - DREAM
A child, ANTWONE FISHER, is lead into a barn by
a man with a broad warm smile. Inside, a WOMAN,
in a white dress and headscarf, welcomes Antwone
to sit at a bountiful table. The woman in white
places a large plate of pancakes in front of
Antwone.
```

Around him stands a community of proud Africans, representing a dozen generations of family elders. Suddenly we hear a gunshot.

NAVAL SHIP SLEEPING QUARTERS - MORNING
Twenty-four-year-old Antwone awakes from the dream in a nervous sweat.

SHIP SHOWER ROOM - MORNING
A WHITE SAILOR makes a joke about Antwone. Antwone overreacts and violently attacks the white sailor.

SHIP - DAY
Antwone is demoted for striking the sailor. Antwone is ordered to undergo a psychiatric evaluation.

NAVY PSYCH OFFICES - DAY
Antwone meets his naval psychiatrist, LT. DAVENPORT, (40), African American, compassionate, yet authoritative. Antwone notices the photo of Davenport's lovely wife on his desk. Antwone is standoffish and rude. When asked by Davenport about his parents, Antwone replies in an abrasive tone that he never had any parents. Davenport orders him to come back in a week.

NAVY EXCHANGE STORE - LATER THAT DAY
CHERYL, twenty-something, attractive and also a naval shipmate, is working at the store on the base. She invites Antwone to a party. Shy and nervous, Antwone tells her he can't go with her because he's on restriction. He lies to her about why he was at the psychiatric clinic.

DAVENPORT'S OFFICE - DAY
Antwone is dragged into the office by military police because he missed his last appointment. Antwone refuses to talk, so Davenport makes him sit there until his time is up. Davenport tells

Antwone that Antwone has to keep coming back for every session until he starts talking.
MONTAGE of Antwone refusing to talk to Davenport.

DAVENPORT'S OFFICE - DAY - MONTAGE
Another couple of sessions go by without Antwone talking.

DAVENPORT'S OFFICE - DAY
Antwone finally breaks down and begins to talk to Davenport. He tells Davenport that his father was killed at the age of twenty three by an ex-girlfriend. Antwone's mother gave birth to him in prison at the age of eighteen. He was sent to an orphanage as an infant. When his mother got out of prison soon after Antwone's birth, she never returned to claim him. Antwone shows little emotion. He tells Davenport he has never thought about finding his mother.

DAVENPORT'S DINING ROOM - EVENING
Davenport eats dinner with his wife, BERTA. She awkwardly tries to have a conversation with him. He is polite but distant.

STOREFRONT CHURCH/TATE'S HOUSE/DAVENPORT'S OFFICE (CLEVELAND 1984) - DAY
CUT between adult Antwone and a FLASHBACK of young Antwone as he narrates to Davenport the story of the horrible beatings and psychological abuse he suffered at the hands of his foster mother, MRS. TATE. He tells Davenport that, if Mrs. Tate made pancakes, he was happy, because he knew she would not beat him that day.

SLEEPING QUARTERS - NIGHT
Antwone's shipmates joke about what they will do during an upcoming leave. Antwone sketches a grasshopper.

RAILROAD TRACKS (CLEVELAND 1986) –
DAY – FLASHBACK
Young Antwone catches grasshoppers with his best
friend JESSE. The two boys tease their friend
KENNY. This episode is narrated to Davenport by
Antwone in flashback.

DAVENPORT'S OFFICE/TATE'S HOUSE –
DAY– FLASHBACK AND PRESENT
Antwone tells Davenport the story of why Mrs.
Tate threw him out. Mrs. Tate begins to beat
teenage Antwone with her shoe. He takes the
shoe from her, but resists the urge to hit her
back, insisting he will never allow her to do
that to him again. Davenport gives Antwone a
book entitled *The Slave Community* and tells him
it will help him to understand the historical
circumstances that caused Mrs. Tate's abusive
mentality. Davenport then tells Antwone that
their sessions are over and that he will
recommend that Antwone not be discharged from the
Navy. Antwone is disappointed that Davenport can
no longer see him.

FRONT OF PSYCHOLOGY OFFICES – DAY
Antwone exits in an aggravated state. He sees
Cheryl. She attempts to start a conversation, but
he runs off, intent on avoiding her.

SHIP'S FLIGHT DECK – DAY
Antwone's shipmates harass him for reading *The
Slave Community*. He gets angry and starts a fight.

DAVENPORT'S OFFICE – SOON AFTER
Antwone creates an angry scene in front of the
other patients.

DAVENPORT'S OFFICE — CONTINUOUS
Antwone confronts Davenport about the fact
that he opened up to Davenport only then to be
rejected by him.

Davenport is unresponsive.

DAVENPORT'S HOME - EVENING
Berta tries to converse with her husband, but he
shows little interest in her.
SLEEPING QUARTERS - DAY
Antwone and his buddies prepare to go on leave.
Davenport shows up and tells Antwone that he
will make special time to counsel him after his
regular hours.

ACT TWO

NAVAL EXCHANGE STORE - DAY
Antwone goes to see Cheryl. She invites him on a
date. He nervously accepts.

DAVENPORT'S OFFICE - LATER
Antwone asks Davenport to help him prepare for
his first date with Cheryl. Davenport and Antwone
role-play the dating scenario.

SEASIDE - EVENING
Cheryl and Antwone talk. She tells him that she
joined the Navy to make her father proud of her.
Antwone and Cheryl begin to bond over dinner, and
she later gives Antwone a kiss goodnight.

DAVENPORT'S HOUSE - NIGHT
Berta confronts her husband about distancing
himself from her. She wants to know how long he
is going to continue to avoid talking to her.
Suddenly Antwone knocks at the door and tells
Davenport about the kiss.

MEXICAN DANCE CLUB - NIGHT
Antwone ships out to Mexico. While on leave with
his shipmates, Antwone gets into a fight after one
of the guys accuses him of being gay.

BRIG - NIGHT
Davenport compels Antwone to tell him why he's never been with girls his own age.

TATE'S HOUSE—DAY FLASHBACK
Mrs. Tate's older teenage daughter, NADINE, sexually molests young Antwone.

JESSE'S HOUSE — DAY FLASHBACK CONTINUOUS
Young Antwone runs away to his friend, Jesse's, house. Jesse says Antwone can stay at his house.

DAVENPORT'S HOUSE - DAY
Antwone has a few words with Berta who invites Antwone to Thanksgiving dinner.

DAVENPORT'S OFFICE - DAY
During their session, Antwone tells Davenport that, after being kicked out of the Tate's house, he was homeless and then joined the Navy.

LIGHTHOUSE - NIGHT
Antwone confides in Cheryl that he is seeing a psychiatrist. She expresses understanding of Antwone's situation.

NAVY BATHROOM — DAY
Antwone nervously rehearses what he'll say at dinner.

DAVENPORT'S HOUSE - DAY
Antwone feasts on Thanksgiving dinner with Davenport's family. Later he reads Davenport a touching poem he has written for him.
Davenport tells Antwone he needs to find his real family in order to make peace with himself.
Antwone says he doesn't need his real family because he has Davenport.

BEDROOM - NIGHT
Berta tells her husband that Antwone invited
her to come to his Japanese class graduation
ceremony.

NAVAL SHIP WASHROOM - DAY
Berta doesn't come to the graduation. Davenport
shows up and tells Antwone that his counseling
sessions are really over. Davenport advises that
Antwone not reenlist and, instead, go and find his
real family. Antwone feels distraught, and tells
Davenport about how his friend Jesse abandoned
him.

JESSE'S HOUSE — DAY - FLASHBACK
Teenage and homeless, Antwone reunites with his
friend Jesse.

STORE — DAY
Antwone is surprised when Jesse begins to rob the
store owner. Antwone watches as Jesse is shot at
point blank range by the store owner. We notice
that the sound of the gunshot and the store
bell are the same sounds that we heard in the
dream sequence with the bountiful table at the
beginning of the movie. END FLASHBACK

NAVAL SHIP WASHROOM — DAY
Antwone has finished narrating Jesse's story.
Davenport convinces Antwone that he is a survivor
and tells him he loves him.

ACT THREE
 NAVAL STORE - NIGHT
 Antwone convinces Cheryl to take emergency leave
 and go with him to Cleveland to search for his
 relatives.

SERIES OF SOCIAL SERVICE AGENCIES –
DAY — MONTAGE
Antwone and Cheryl get the run around from the
government workers. After waiting all day,
Antwone finally gets access to his personal file.

HOTEL — NIGHT
Antwone finds nothing useful in the file. Cheryl
suggests they go see Mrs. Tate, but Antwone says
he won't do it. Cheryl and Antwone make love for
the first time.

TATES' HOUSE – DAY
Antwone overcomes his fear and confronts Mrs.
Tate and Nadine about the abuse. The two women
are afraid of him. Mrs. Tate tells him the name
of his deceased father, Edward Elkins.

HOTEL ROOM – NIGHT
Antwone and Cheryl call all of the Elkins in the
local phone book and finally reach Edward Elkins'
sister, ANNETTE. She invites them to her home.
Antwone is overcome with emotion.

ANNETTE'S HOUSE – DAY
Antwone and Cheryl meet his aunt, Annette, and
his uncle, JAMES. They agree that Antwone is
their nephew. James figures out that he may know
Antwone's mother and offers to take Antwone around
the corner to see her. Antwone says okay.

EVA'S APARTMENT – DAY
James introduces Antwone to his mother EVA. James
makes sure Antwone is in no danger and then
exits to wait in the car. Eva shows no feelings
for Antwone. He tells his mother how all his
life he had imagined her coming for him and that,
in spite of her abandonment of him, he grew up
to become a good man. He kisses her. Eva is
emotionally distant and does not respond to him.

ANNETTE'S HOUSE — DAY
James takes Antwone back to Aunt Annette's house where he is surprised to find that the house is full of his father's relatives. They warmly greet Antwone and tell him that, if they had known about him, they would have come for him. Then they take him to the dining room where he is welcomed by the family elders who are seated around a banquet table filled with luscious foods and a giant plate of pancakes.

PLANE — NIGHT
Antwone flies home with Cheryl. He tries to contain his emotions.

DAVENPORT'S OFFICE — DAY
Antwone, still in the Navy, wearing his full-dress uniform, meets up with Davenport to thank him and let him know that he found his family. To Antwone's surprise, Davenport counters by thanking Antwone for helping him save his own troubled marriage. The audience sees that finally Antwone and Davenport are at peace with themselves.

PLOT ELEMENTS OF ACT ONE OF *ANTWONE FISHER*

As you can see from this scene outline, screenwriter Antwone Fisher, has set up the storyline of his first act in a way that every scene matters. There are no extraneous scenes in this movie. Every scene leads towards the turning point at the end of the act. You can feel the momentum of the story steadily build toward a climax and resolution.

As we said earlier, a good Hollywood screenplay should grab the audience within the first ten minutes of Act One. Fisher does this by opening the film with the intriguing dream sequence and then moving right into present time with the story of his protagonist's unexplained violent behavior. Within a few short minutes, the

screenplay sends us directly to Davenport's office where we find out that Antwone Fisher probably had some terrible experiences that now cause him to unemotionally declare himself, "a man who had no parents." At this point in the storyline we are hooked. We unconsciously formulate the plot questions; "Will Antwone make peace with his past? Will Davenport be instrumental in his cure?"

After Fisher makes sure that he's grabbed his audience, he devotes a number of scenes in Act One to establishing the setting and developing the characters. Fisher makes sure that we realize from the beginning of the screenplay that the Navy milieu is important to the meaning of the story. It is the code of military discipline that shapes the doctor/patient relationship between Antwone and Davenport in the first act. As the first act progresses, we understand that Davenport's approach and demeanor are heavily steeped in years of military training. A working class African American neighborhood in Cleveland is the other important setting in the film. Fisher uses the Tates' home as a metaphor for the American plantation system and the self-destructive elements imposed upon African American culture by centuries of a brutal slave system.

The plot structure of the film focuses on two central storylines that reinforce each other. Davenport's storyline parallels Antwone's storyline. In each of the scenes that the two characters have together, screenwriter Fisher is careful to bring out aspects of both men's personalities. In the first couple of counseling sessions, we see that Antwone is stubborn, and, at the same time, we see that Davenport is just as stubborn. However, Davenport's stubbornness is tempered by patience. When Antwone gives in and starts talking to Davenport, we see that this young man is indeed vulnerable and that Davenport has some measure of understanding. Davenport's character is further developed in the two brief scenes with his wife. The point of these scenes between husband and wife is to show that Davenport is emotionally distant in his personal relationship and could use a bit of therapy himself. This storyline serves to echo Antwone's dilemma and gives us a more complex portrait of Davenport.

The character of Cheryl is also introduced in Act One. We learn from her two scenes in the first act that Cheryl is friendly and that she likes Antwone. Beyond this basic plot information, these scenes with Cheryl serve as an opportunity to display Antwone's shyness

around girls and make his character that much more intriguing as the audience begins to wonder why this handsome twenty-four-year old is so awkward around women.

As you construct the scene outline for your Act One, you want to make clear to the audience the protagonist's goal and the obstacles preventing him or her from attaining that goal. Antwone Fisher's goal, as it is revealed in Act One, is to overcome the emotional pain caused by his troubled past. We learn in Act One that the obstacle Antwone faces is substantial. He must overcome a legacy of rejection by his birth mother and a lifetime of abuse by his foster mother. We also learn one of the themes in the film; that the source of the dysfunctional personalities of these two matriarchs has its roots in American slavery. Antwone's troubled past is personified in the villain, Mrs. Tate. The emotional scars she caused serve as one of the obstacles in the film. By giving us a number of scenes in which Antwone relives the beatings and psychological torture she inflicted upon him, we see why he is at the breaking point. She is terrifying, and his struggle to overcome the deep psychological wounds she has inflicted makes for compelling dramatic conflict.

As you construct your own scene list for Act One, ask yourself, *"What is your first act about?"* Act One should be about getting to the turning point. The first act of Antwone Fisher is about reaching a point of trust between the two men. In the turning point of the first act, screenwriter Fisher gives us a moving scene in which Antwone begs Davenport to help him. Antwone has moved from the opening of Act One where he refuses to speak to Davenport, to the turning point where he's pleading with Davenport for treatment. Ironically, Davenport won't do it, but then has second thoughts and decides to cross the boundary between professionalism and friendship by agreeing to continue to help Antwone. In allowing this counseling to continue, Davenport is making himself a little more vulnerable too. Again, Davenport's emotional journey parallels that of Fisher. Both men require healing.

Remember that a turning point should show a change in the direction of the plot. In *Antwone Fisher*, the turning point occurs when both doctor and patient learn to trust each other. With this trust, the new direction of the story development in Act Two becomes the tale of the commitment of both men to finding a cure for Antwone.

PLOT ELEMENTS OF ACT TWO OF
ANTWONE FISHER

Act two is the hardest act to write. It's a long act, usually lasting between fifty and sixty minutes. It's also the act where your plot line becomes much more complex, and the obstacles faced by the protagonist intensify. Often, new characters are introduced in the second act and the themes of your story become stronger and more evident for the audience. Let's look closely at a scene outline of the second act of *Antwone Fisher*.

Act Two of *Antwone Fisher* is about the patient and doctor going beyond the professional relationship and developing a personal relationship. Ironically, we learn that in order for the patient to be cured, the doctor sends Antwone away. The prescription Antwone is given is to find his family. As you can also see, the screenwriter, Fisher, complicates the story by revealing that Antwone was sexually abused by his foster family. The abuser is Nadine, a new character introduced in Act Two of the movie. Beyond this, we learn that Antwone saw his best friend, Jesse, shot and killed during a robbery. We now realize in this act that that the emotional damage to Antwone's psyche is dangerously severe and perhaps impossible to overcome. At the end of the act, right at the point when we think that Antwone may be taken in by Davenport and treated as a surrogate son, the doctor turns the tables and will not let that happen. Instead, Davenport gives Antwone an even bigger challenge to overcome, a mandate to find his family. The scene creates the second major turning point in the story.

The theme of reconciling with one's past is expanded in Act Two to include more than just the concept of the individual person reconciling with his personal past. When Davenport gives Antwone the copy of *The Slave Community* to read, it cues the audience that Antwone's quest for redemption is symbolic of the broader quest of the African diaspora to find peace in spite of the violence and abuse exacted upon black people over centuries and across continents.

Plot Elements of Act Three of
Antwone Fisher

As we said earlier, in the third act your screenplay should again switch gears. The stakes should become higher. The tension should be more pronounced. The pace quickens. In Antwone Fisher, this certainly happens. Antwone suddenly gets his leave, hops on a plane and finds his long lost family.

The sequence of story beats in this act steadily builds towards the ending. First, Antwone must ask Mrs. Tate for information about his family. The tension in the scene is right at the surface. The manner in which Antwone handles his former abuser is satisfying for the audience to watch. This escalates into an even more intense situation, where he meets his paternal aunt and uncle only to discover that they know where his mother is. The scene with his mother is beautifully crafted and takes the audience on another portion of the emotional roller coaster ride of this storyline. Then, just when we feel the screenwriter cannot raise the level of intensity any higher, we have the climactic banquet scene where Antwone is finally reunited with his own loving family. Antwone is encouraged by his elders to see a new vision of his past, one that is nurturing, and one that gives Antwone a self-actualizing view of history. The movie then ends with a quick resolution. In the final scene we find out that Davenport's own personal conflict with his wife is now resolved, and the two men thank each other for their love and understanding. The main plot question: "Will Antwone make peace with his past?" and the secondary plot question, "Will Davenport heal is patient and himself?" have been answered in a most satisfying way.

SCENE OUTLINE FOR
DEVIL IN A BLUE DRESS

Now let's look carefully at the scene outline for Carl Franklin's screenplay, *Devil in a Blue Dress*.

ACT ONE

JOPPY'S BAR - DAY
Just after the end of WWII, EASY ROLLINS, 35,
African American veteran, scans the newspaper. He
needs a job.

CHAMPION AIRCRAFT - BENNY GIACOMO'S
OFFICE - FLASHBACK
Easy has just been fired by GIACOMO, his racist
white employer, for not working a double shift--
something the white guys at the place refuse to
do with no repercussions. Easy begs for his job
back. He needs to pay his mortgage, but won't
stand for Giacomo's patronizing attitude. Easy
leaves with no job.

BACK to BAR - END FLASHBACK
JOPPY, a friend of Easy's, introduces Easy to
ALBRIGHT, 40, Caucasian, and an old friend of
Joppy's. Albright has work and tells Easy to meet
him tonight.

EASY'S HOUSE - DAY
Easy explains, in voice over, how he moved from
Texas and now loves to come home to the house
he owns in LA. Easy has a bad feeling about
Albright.

CAR - NIGHT — FLASHBACK
Easy remembers driving one night with his old
friend MOUSE, unaware that Mouse would commit a
crime.

OFFICE BUILDING - NIGHT
Albright asks Easy to find Daphne Monet, the white
fiancé of mayoral candidate Todd Carter. He says
they had a fight, and Carter wants to make up with
her. Albright pays Easy $100 to go find her. He
says Daphne hangs out at a black nightclub.

JOHN'S BAR - NIGHT
JUNIOR, a big and burly doorman, throws a drunken
WHITE MAN out of the entrance to John's bar.
Junior asks Easy when he is going to admit he
helped Mouse kill a man and his stepbrother back
in Houston. Easy sits with ODELL, CORETTA and
her boyfriend, DUPREE, and asks if they've seen
Dahlia. Coretta knows her and says Dahlia's real
name is Daphne.

CORETTA'S HOUSE - NIGHT
Easy carries Dupree home to Coretta's house.
Coretta seduces Easy while Dupree is passed out
in the next room. During sex with Coretta, Easy
finds out that Daphne is shacking up with a small
time black gangster named Frank Green.

EASY'S HOUSE - DAY
Easy's NEIGHBOR drives by with all of her
belongings. She says she's going back to Texas
because LA is too fast for her. Easy stops
the WOODCUTTER, a vagabond from back home,
from cutting down his neighbor's lemon tree.
A newspaper is thrown on the porch with a
headline that indicates that Terrell is a leading
candidate for the mayoral race, and Carter has
dropped out. Albright calls and tells Easy to
meet him in Malibu in an hour.

MALIBU PIER - NIGHT
Easy waits at the end of the pier. A group of
WHITE MALE TEENAGERS threaten Easy for speaking
to a 17-year-old WHITE GIRL. Albright shows up
and viciously beats the boys. Easy tells Albright

that Daphne's hanging out with Frank Green.

EASY'S HOUSE - NIGHT
White detectives, MILLER and MASON grab Easy
as he gets out of his car. They won't tell him
what's going on.

INTERROGATION ROOM - NIGHT
Miller and Mason beat Easy and accuse him of
killing Coretta.

ACT TWO

LIMO - LATER THAT NIGHT
As Easy is walking home after being jailed, a
limo stops him. The CHAUFEUR tells him to get
in. Easy enters and is questioned by TERRELL, a
sleezy politician, who says that Coretta worked
for him. He knows Coretta was killed and wants to
know if Daphne Monet was there with Coretta last
night. Easy says no and gets out of the limo.

EASY'S HOUSE - BEDROOM - NIGHT
Easy is dreaming of his last night with Coretta
when the phone RINGS. It is Daphne. She tells him
to meet her at the Sunridge Hotel.

HOTEL ROOM - NIGHT
DAPHNE, strikingly beautiful, is there. She
wants to know what Coretta told Easy. Easy tells
her everything. Daphne says she had to pay
Coretta not to tell anyone where she was. She
asks Easy to drive her to Todd Carter's house
and to stop along the way to pick up a letter
that was delivered to the wrong person. Daphne
reveals that she arrived at Coretta's house soon
after Easy had left. She also implies she is
dating Frank Green.

EASY'S CAR - NIGHT
Easy is nervous driving through a white
neighborhood, because he has Daphne, a beautiful
white woman, in his car.

RICHARD MCGEE'S CABIN - NIGHT
They enter to find the place trashed. RICHARD
MCGEE'S freshly murdered body is on the floor.
Daphne is horrified and runs out. Easy finds a pack
of cigarettes — the Mexican brand we saw Junior
smoke in the earlier bar scene — next to the dead
body. Easy realizes that this man is the guy who
Junior threw out of the bar last night. Suddenly,
Daphne speeds away in the dead man's car leaving
Easy stranded at the scene.

EASY'S HOUSE - DAWN
Easy arrives home to find Albright at his house.
Albright demands that Easy tell him where Daphne
is staying and says he has three days to find
Frank Green. Albright reminds Easy he now is
connectable to two murders. Easy decides he will
contact his friend, Mouse, for help.

STREET - DAY
Terrell campaigns.

JOPPY'S - BAR
Easy confronts Joppy. Easy realizes Joppy was the
one who gave his phone number to Daphne.

TODD CARTER FOUNDATION
Easy demands to see Todd Carter.
CARTER, 40, white, the richest man in town,
reveals that he didn't hire Albright and doesn't
know who Richard McGee is or was. He pays Easy
a thousand dollars to find Daphne, but he won't
tell Easy why he dropped out of the mayoral race.
Easy realizes that it's Terrell who paid Albright
to hire him. Easy decides he needs to find Frank
Green for some answers.

MONTAGE
Easy asks around town for information on Frank
Green. No one will talk.

INT. EASY'S HOUSE - DAY
Easy is jumped by a knife wielding FRANK GREEN.
MOUSE, trigger happy and thuggish, shows up just
in time to save Easy's life but, in the process,
recklessly shoots Green in the shoulder. Green
gets away before Easy can question him. Mouse
begs to be let in on Easy's high paying search
for Daphne. Easy agrees if Mouse will listen to
what he says and not lose control like he used
to do in Texas. Easy discovers from Mouse that
Daphne phoned the house asking for him.

ACT THREE

EASY'S PORCH - DAY
Detectives Mason and Miller say McGee had a note
from Coretta in his pocket. They give Easy until
the next morning to prove his innocence and find
the killer, or they will arrest him for both
murders. Mouse and Easy head out to find some
answers.

JUNIOR'S APARTMENT - DAY
Junior admits to Easy and Mouse that he drove
Richard McGee home but says that he left him
alive. Junior says McGee paid him $50 to deliver
a letter to Daphne. Junior says he
gave the letter to Coretta to give to Daphne.

DUPREE'S SISTER'S HOUSE - DUSK
Dupree tells Mouse and Easy that the last thing
Coretta said to him before she was killed was to
keep her bible. The bible is still at their house
where the police have restricted access. Mouse
fills Dupree's glass to the top with whiskey,
and they drink together until they both pass out.

BEDROOM - CONTINUOUS
Easy has slipped away and finds the bible in
Dupree's dresser drawer. He discovers Daphne's
letter inside. It contains pictures of Terrell
with naked boys.

KITCHEN - CONTINUOUS
Easy leaves a drunken Mouse to guard Dupree who
has passed out.

EASY'S HOUSE - NIGHT
Daphne is there when Easy arrives. She tells
him that the black gangster, Frank Green, is
her brother and that her mother was Creole. Her
father is white. She says Coretta threatened not
to give her the pictures. Daphne purchased the
photos so she could give them to her boyfriend
Todd Carter to expose Terrell as a pedophile.
With Terrell out of the mayoral race, she
believed, Carter could become a candidate again.
She tells Easy she sent Joppy to scare Coretta
into returning the pictures, but he went too
far and killed Coretta. Daphne explains she was
supposed to marry Todd Carter, but his family
wouldn't allow that because she is black. The
parents asserted that the romance would ruin
Carter's political career. Suddenly, Albright
bursts in and kidnaps Daphne. Easy realizes
Albright intends to kill her. Easy knows he is
being left alive to take the fall for Daphne's
murder.

JOPPY'S BAR - NIGHT
Easy kidnaps Joppy at gunpoint.

EASY'S CAR - CONTINUOUS
Joppy tells Easy and Mouse where Albright has
taken Daphne. Mouse wants to shoot Joppy, but
Easy says no.

ALBRIGHT'S CABIN - NIGHT
Daphne is being interrogated and tortured.
Easy and Mouse storm the cabin, killing Albright
and his men. Easy discovers that Mouse has
strangled Joppy.

EASY'S HOUSE - NIGHT
Mouse gets in a taxi to return back to Texas with
his half of the $7000 of Daphne's money.

EASY'S CAR - NIGHT
Daphne tells Easy that she is confident Todd
Carter's family will approve of their marriage
once they know that Terrell will never reveal
Daphne's black identity. She says Carter will be
able to use the incriminating pictures to keep
Terrell from exposing her secret. Daphne reveals
that the $7000 she used to pay for the pictures
came from a larger sum she had been paid by
Carter's family to leave town.

OBSERVATORY - NIGHT
Easy takes Daphne to meet Carter. Carter tells
Daphne it's over. He loves her but will never
marry her. She is devastated. Easy gives Carter
the pictures. Carter pays him and says he will fix
Easy's case with the police.

FRANK GREEN'S APARTMENT - DAWN
Easy drops off Daphne at her brother's place. Voice
Over: We find out that Daphne was from Louisiana
and came to LA hoping to fit in. Easy says he went
by her place a few days later to return his half
of the $7000 to her, but she and Frank were gone.

EASY'S YARD - DAY
Headlines indicate that Carter is back in the
race. Easy tells his friend, Odell, that he is
going to start a detective business. Easy surveys
the block and is content to be a homeowner trying
to live the American dream in LA.

PLOT ELEMENTS IN
DEVIL IN A BLUE DRESS

Once again, let's look closely at structure. In the opening sequence of scenes in this film, screenwriter Carl Franklin throws us head first into the story. Don't forget, you need to hook the audience into the narrative in the first five to ten pages of your script. In *Devil in a Blue Dress* our protagonist, Easy, is just back from WWII. Easy has a mortgage to pay on a home he loves, but he has just lost his job. Albright shows up and offers him some fast money to find Daphne Monet, a white woman who frequents the black clubs in town. Easy agrees to take the job. We are hooked into the narrative and want to know: Who is this Daphne Monet, and will Easy be able to find her, get paid and keep his house?

A vivid setting for the story has also been established effectively in these first few minutes of the script. It's the forties, and it seems that practically the entire African American population of Houston has migrated to a neighborhood in Los Angeles in search of a better life. We have a clear picture of Easy's block: neatly manicured lawns, freshly painted California bungalows, shiny new cars, palm trees. It's a safe and supportive place, and Easy likes it here. Juxtaposed with this sunny serene suburban-looking setting is the rougher side of town. Joppy's bar, the speakeasy, and Coretta's house are noisy, smoky, darkly lit places where bad things are more than likely to happen.

Through his use of setting, Carl Franklin also recreates the tone of racial tension that pervades post-war Los Angeles and establishes it as a central theme in the screenplay. For example, early in Act One, Easy finds himself summoned to meet Albright at Malibu Pier, a location that is essentially coded in the script as a white space. For a black man in the forties, venturing into a white space is painted as a risky undertaking. White teenage boys on the pier show up from out of the darkness. They address Easy as if he were a child and threaten to kill him for engaging in an innocent discussion with a white girl. Then, Albright appears and brutally beats one of the white teens, almost killing him. This pier is a place, which, in the light of day, would typically be used as a setting for a tranquil scene, but in this screenplay, the slug-line reads NIGHT. In *Devil in a Blue Dress*, the pier takes on an intensely ominous characteristic and becomes the perfect setting for a scene of palpable violence and hatred.

Act One continues as Easy finds himself forced to go to his friend Coretta to ask her what she knows about this mysterious woman named Daphne. Easy ends up in Coretta's house making love to her while her husband is passed out in the next room. During sex, Coretta admits she knows Daphne. Franklin then creates a perfectly timed turning point in the story to end the act. Easy returns home from his night of lovemaking and is arrested. He is taken to the police station and beaten. He finds out Coretta is dead, and the police say he was the last person to be seen with her. Easy now has to solve Coretta's murder and, at the same time, find Daphne Monet before Albright kills him. As we enter Act Two the tension is ramped up considerably.

In Act Two, Franklin introduces several new characters—mayoral candidates Carter and Terrell. The plot thickens when Daphne calls Easy and asks him to drive her to Richard McGee's cabin to pick up a letter. They arrive to discover that McGee is dead, and now Easy can be placed at the site of another murder. Easy goes straight to Todd Carter to confront him about the situation and learns that Carter did not hire Albright. Carter says he will pay a large sum of money to Easy to find Daphne. Easy figures out that Albright is actually working for Terrell. In the following scene Frank Green tries to kill Easy, but Mouse shows up in time to save his friend's life. Easy now has to find Green if he wants to find Daphne, get the money, and also prove his innocence. This is the dramatic turning point of Act Two.

In Act Three, the clock is ticking. The police show up and say they plan to charge Easy with the murders of Coretta and McGee. They give Easy until the next morning to find the killers. Mouse and Easy locate the pictures of Terrell. The pictures provide proof that the mayoral candidate is a pedophile. Daphne shows up at Easy's house and tells the truth about the pictures and confesses that she and Todd Carter are being blackmailed by Terrell because she is Creole and not white. She reveals that Frank Green is her brother, not her boyfriend. Albright bursts in and kidnaps her. Easy realizes that Joppy killed Coretta when Daphne asked him to get her pictures back because Coretta was trying to extort money from Daphne. The climax of the film occurs when Easy and Mouse storm Albright's cabin, kill Albright, and rescue Daphne. In the final sequence of scenes that serve as the resolution to the story, Carter tells Daphne

he can never marry her and assures Easy that all murder charges will be dropped. Daphne moves away. Easy pays his mortgage and decides he's going to open a detective agency.

The initial plot question is answered: *Will Easy find the mysterious woman in the blue dress so he can get the money to keep his house?* Yes. The storyline we follow to get to this answer is brilliantly constructed by Mosley in his book and later by Franklin when it was adapted for the screenplay. What starts out as a simple obstacle, not having enough money to pay the mortgage, grows into a series of progressively more threatening challenges. By Act Three, Easy must overcome the threat of being killed by Albright, the threat of being charged with two murders he did not commit, and he must also save Daphne. This is a screenplay with a plot structure worth studying over and over again, a prime example of classic Hollywood storytelling.

CHAPTER FIVE EXERCISES

1. Practice Outline: Watch a favorite movie that is similar in genre or pacing to the screenplay idea you plan to outline. Create a scene outline for that movie, and then count the number of scenes in each act. Now evaluate the film's structure by answering the list of questions at the beginning of this chapter.

2. Create a scene outline for your original feature spec script. Follow the guidelines in the chapter. Be sure to limit each scene description to a sentence or two, and write in present tense. Use slug lines for each scene. Briefly tell the point of any conversations. For example, don't say, "Cheryl and Antwone talk." Say, "Cheryl and Antwone talk about her strong family life." Be sure the number of scenes in your outline is comparable to the number of scenes in the movie you've just analyzed in the first exercise.

3. Now test the strength of your outline by applying the outlining questions listed at the beginning of this chapter to the evaluation of your own spec script outline. Revise your outline if you find you cannot answer yes to all of the questions.

Scene Writing

I f you've completed your scene outline and are satisfied with it, you are ready to start writing your screenplay. Your outline will give you a good idea of where each scene is going. This chapter will help you understand the mechanics of writing the descriptive passages and dialogue at the fundamental level of the scene.

WRITING DESCRIPTION

Remember that a screenplay is a movie that is envisioned as it is being read. Your job as a writer is to make the story come alive for the reader, to make the reader see and hear the film. The way you do this is not so much through the dialogue, but rather through the description, or what's also called the body copy. Good description or body copy requires precise and economical use of language that makes the writing pop off the page. Your goal in writing the body copy will be to try to get the most impact out of the least amount of words. Too much description slows down the read. Too little description might prevent the reader from visualizing the story. Compare these two versions of the same descriptive passages:

```
[Version One]
INT. CHURCH (CLEVELAND 1984) - DAY
```

```
REVEREND TATE (50) is leading the congregation
comprised of DWIGHT (8), KEITH (10), who are fos-
ter children that also live with Antwone (7); MRS.
TATE, who is fifty-three and is wearing a purple
dress, watches the boys and then looks at COUSIN
NADINE (25) who is average weight and is wearing a
pink dress. A PIANO PLAYER is smiling and also in
the church. They are all singing.
```

[Version Two]
INT. REV. TATE'S STOREFRONT CHURCH PULPIT
(CLEVELAND 1984) - DAY

The bald REVEREND is giving a heated, theatrical
sermon. He has a large, electric guitar strapped to
his chest and a microphone clipped to his lapel.

There is a glass pitcher of grape Kool-Aid on the
tray next to the podium with a glass half full.
Foster siblings DWIGHT (8), KEITH (10), Antwone (7)
are reluctantly clapping. Mrs. Tate, COUSIN NA-
DINE (25), is beating a tambourine and a BLIND PIANO
PLAYER plays the piano.

Mrs. Tate, Antwone's foster mother, is hitting a
big bass drum that sits at the side of her seat.
Everyone participates in a way that heightens the
drama of the Reverend's sermonizing.[1]

The first version of this description is mediocre at best. The language is bland and uninteresting. We get no sense of what type of a church this is. For all we know, the first passage could be set in a mega-church. There are no adjectives or descriptive verbs in this passage that would give a good sense of who the characters are, what the setting is or what's happening as the scene begins. The information we do get from the first descriptive passage does not add to our understanding of the characters. For example, telling us the color of the dress is pink adds little to our knowledge of the plot or the characters. Remember, every word in the description should be necessary. If this were the screenplay for *Devil in a Blue Dress*, telling the reader that the character is wearing "a blue dress that's plain, cutting just below her knee with a ceramic pin just over her left breast," is indeed necessary. Screenwriter Carl Franklin's description of what Daphne is wearing establishes both the intense sexualized tone of the scene and tells the reader that this female character has a sense of her erotic power over men. Similarly, if you're a writer introducing the character of Shorty in *Malcolm X*, and you say that he's dressed in a zoot suit, the descriptive language does give the reader a feeling of the setting, the

forties, and signals that this character, Shorty, is preoccupied with the hip street culture of that era.

The second version of description used here as an example of the church in *Antwone Fisher* is the one written by the actual screenwriter. The language Fisher deploys is more vivid than the "how-not-to write" example of description. Notice Fisher's skillful use of adjectives to visualize the scene for the reader. Fisher says the Reverend gives "a heated, theatrical sermon." This is much more effective than saying "leading the congregation." Fisher goes on to describe that the Reverend is playing his own guitar and has a microphone pinned to his lapel, Fisher writes, "Mrs. Tate is hitting a big bass drum that sits at the side of her seat." Fisher also says the boys are "reluctantly clapping." He adds that, "Everyone participates in a way that heightens the drama of the Reverend's sermonizing." Fisher's precise use of details creates a strong sense of real people in a real place. We can see and hear all of it. We can even smell the grape Kool Aid.

WRITING THE OPENING

The opening of your movie is one of the most important descriptive passages you'll write. It's the first thing the reader will experience in your film, so it's got to be good. Remember economy of language is what you want. Get the most visual impact with the least amount of words. Let's look at some great opening passages from *Devil in a Blue Dress* and *Malcolm X*.

INT. CHAMPION AIRCRAFT - BENNY GIACOMO'S OFFICE

A battered wooden desk drawer groans open and
light brown skinned hands with dirty fingernails
twist the cap off a pint of rye whiskey and pour
liquor into a coffee cup.

 O.S. VOICE
 You know, when you fire somebody
 You have to stick to your guns.

They screw the cap back on and lay the bottle in
the drawer.

> O.S. VOICE (CONT'D)
> The men might get to thinkin' that
> I'm weak if I take you back.

The cup rises to the face of BENNY GIACOMO, late
forties, with salt and pepper hair that was once
jet black. Skin darker than a Louisiana Creole.

He takes a sip and bares his teeth in a grimace
from the whiskey. As he talks we gradually see
more of him — feet kicked up on the desk, fully in
charge.

A Betty Grable like pin-up girl is giving us back-
ground in more ways than one in a swimsuit and high
heels on a calendar tacked to the wall: May, 1948.[2]

This excerpt from the opening of *Devil in a Blue Dress* truly jumps
off the page. The screenwriter, Carl Franklin, also directed the film.
You can feel the power of Franklin's background as a director as
we see and hear this scene unfold in close-ups; the hands with dirty
fingernails opening the groaning "battered wooden desk drawer" to
pour rye whiskey into a coffee cup. Without giving camera directions,
we see the white pin-up girl on the wall letting us know it's the
1940's. With just a few sentences, Franklin has transported us back
in time and established the milieu. Notice that the description in
the screenplay is written without references to camera shots. When
you're writing your spec script, you don't need to put specific shot
information in the screenplay. The director does that when he or she
is preparing the shooting script. Your job is to describe the setting
and the actions in such a way that your vision unfolds in the reader's
head as if one is watching it through a camera's lens.

Now let's look at the opening of *Malcolm X*:

```
EXT. ROXBURY STREET - DAY (WAR YEARS)
```

```
It is a bright sunny day on a crowded street on the
black side of Boston.  People and kids are busy
with their own things.
```

```
SHORTY makes his way down the street. He is a
runty, very dark young man of 21 with a mission and
a smile on his face. He wears the flamboyant style
of the time: the whole zoot-suit, pegged-leg, wide-
brim bit.
```

```
Shorty turns into a grocery store.
```

Screenwriters Lee and Perl go on to show Shorty shopping for potatoes, eggs, jar, lye, a rubber hose and Vaseline. He takes this to the barber shop.

```
INT. BARBER SHOP - DAY
```

```
Shorty has his jacket and hat off, his sleeves
rolled up. He is like a surgeon preparing for an
operation. His equipment is spread out on the
table; can of lye, large Mason jar, wooden stirring
spoon, knife, the eggs. His actions have the
character of a ritual: each thing being done just
so, in time-honored fashion.
```

```
He slices the potatoes and drops the thin slices
into the Mason jar. He adds water and makes a
paste of starch.
```

```
Behind Shorty is a spirited barbershop conversa-
tion. One man is getting a haircut; two others are
watching (TOOMER, JASON), one of them behind a
newspaper. A middle-aged barber, CHOLLY, is doing
most of the talking.
```

```
              CHOLLY
      After I hit the number that
      woman wasn't no good to me at all.
```

The sequence continues, and soon we meet Shorty's patient:

```
His hands full, Cholly opens the door with his feet
and MALCOLM comes out, a big, gawky, bright-faced
country boy, wearing down-home clothes and an ex-
pression of apprehension.³
```

The screenwriters, Arnold Perl and Spike Lee, give us a fast-moving opening with strong visuals and precise details that draw us into the initial dramatic event— straightening Malcolm's hair. As screenplays go, an entire page of description is usually difficult to read and tends to slow the pace of the reading process way down. However, in movies with a lot of action, long descriptive passages cannot be avoided. The best way to keep the story moving is to do what Perl and Lee have done: be as clear as possible as to where your characters are in the scene and what they are doing on screen. For long descriptive passages, be sure to break up your description into paragraphs no longer than four lines. Again, you do not have to use camera information.

Notice how the introduction of Malcolm's character is written—a perfect one-sentence portrait of the protagonist, "a big, gawky, bright-faced, country boy, wearing down-home clothes and an expression of apprehension." Introducing characters effectively is critical to your read. You should look for the right adjectives to give just enough information to get the basic traits of the character across to the reader. This is how screenwriter, Kasi Lemmons, introduces Eve in *Eve's Bayou:*

```
      EVE BATISTE, age ten, is a skinny, tom-
      boyish girl with red hair and freckles.
      A black, female version of Tom Sawyer.⁴
```

Writer Charles Fuller introduces his antagonist, Peterson, in *A Soldier's Story*, in this way:

```
Private First Class PETERSON clears his
throat. He is bespectacled, young black
man in his early 20's.  He is tall and
thin — surprisingly even at this hour
of the morning Peterson is militari-
ly sharp. His fatigues are pressed and
starched, boots shined, brass polished,
and as he steps forward, his bearing is
crisp, his manner direct.⁵
```

Not all characters need to be described. Any character that is used in your script more as a type rather than as a developed character can be introduced by giving the character a generic name without any need for description, i.e. POLICEMAN, SECRETARY, WOMAN #1, TAXI DRIVER.

Avoid Overwriting

Many beginning writers have a tendency to write too much description. This is called overwriting. There are four ways you can overwrite a scene:

1. You give away the scene by telling the reader what's going to happen before the scene plays out on its own.

2. You include too many unimportant details, rather than getting to the heart of the drama.

3. You go on too long at the end of the scene which diminishes the scene's effectiveness.

4. You include too much exposition.

Here is an example of an overwritten scene:

INT. HOTEL ROOM - NIGHT

Angela enters the bedroom and gets undressed. She
begins to count the money from the robbery she just
committed. She looks at the clock to find out what
time it is. We see a CLOSE UP of the clock. CLOSE
on ANGELA as she takes out a gun from her purse and
places it underneath her pillow. Angela was trained
at the Police Academy five years ago. When Agent
Miller shoots at her door, she defends herself by
shooting back. Then as she is trying to escape out
the window, Agent Miller forces the door open and
falls down dead in the room.

 ANGELA
 Who's there?

 AGENT MILLER
 Open the door, Angela!

SHOTS are fired from the hall through the door.
Angela grabs the revolver. She fires two SHOTS at
Miller behind the door. Miller is still trying to
force the door open. From Miller's side, another
SHOT comes through the door and grazes Angela. She
turns and runs to climb out the window. The door is
forced open. Angela shoots. Agent Miller falls down
dead on the floor. Angela GASPS and goes to see if
Miller is dead. She covers him up with a blanket
and then gets dressed.

Notice how the writer gives away the scene before it occurs. This
ruins the real-time experience of suspense for the reader and stops
the flow of the read. The scene also drags tremendously, because
the same action is described twice. Remember, through the magic of
editing, you have a cinematic shorthand you can use to increase the
impact of your story. Rule of thumb is to go through every scene that
you write, and see if you can cut out some of the beginning and some

of the ending, while still keeping the meaning of the scene. This will help you maximize the impact. Here's a better version of the scene:

INT. CHEAP MOTEL ROOM - NIGHT

The glare of electronic billboards outside the window casts a florescent green haze across the room. Angela is on the bed. Next to her is a pile of one thousand dollar bills. She takes out a HAND GUN from her purse and slips it underneath her pillow.

A KNOCK at the door.

The doorknob SHAKES violently.

 ANGELA
 Who's there?

 AGENT MILLER (O.S.)
 Open the door, Angela!

GUN SHOTS EXPLODE through the door shredding the pillows on Angela's bed. Angela grabs her revolver. She fires off two SHOTS back at the door.

Agent Miller RAMS the door. The HINGES STRAIN...

Another shot RIPS through the door and grazes Angela's arm. She looks down. The sight of her own blood stuns her.

Angela panics, runs to the window and frantically tries to force it open.

The hinges on the hotel room door SNAP off the frame. Angela turns and fires repeatedly at the door.

The door SLAMS to the floor under the weight of Agent Miller's enormous body. He is dead.

This version of the same scene creates a much more suspenseful experience for the reader. The first sentence adds texture and a sense of place to the scene. It gives us just enough information so that we feel that we are part of the space our character inhabits, and we can also easily visualize the placement of the actors within the scene. Note that the paragraphs are broken up into small groups of sentences to increase the speed of the read. The camera instructions have also been removed. The reference to Angela's past training at the Police Academy has also been deleted. That information is part of her backstory. When backstories appear in a screenplay it is referred to as *exposition*. The only way a screenwriter can communicate exposition in a script is by having a character say it in the dialogue or by showing it visually in the movie. It is up to the writer to decide how much exposition the audience needs to truly understand the story and the characters. Reading through the second version of the scene you can see that the background information about Angela's police academy training in the first version of the scene is unnecessary and distracts the reader from getting into the dramatic moment of the scene.

WRITING ENTERTAINING DIALOGUE

All of us have our favorite lines from the movies. As screenwriters, we strive to come up with those great lines; lines that actors would want to speak and that audiences will remember for generations to come. What makes the dialogue memorable is often a subjective thing, but it does seem to have a lot to do with a combination of what a character says and the subtext of what that character is saying. By *subtext* of the dialogue, we mean the implied or hidden meaning of the words that communicate more than the face value of the words. Take the famous line from *The Godfather*, "I'm going to make him an offer he can't refuse." On its face, this line refers to a request for a favor, but as subtext, it's obvious to the viewer that this line is a not-so-subtle death threat.

How can you learn to write great dialogue? First, you need to read a lot of screenplays. Second, watch and review scenes from movies that you love. Third, become a professional listener. Make it your job to listen. Listen to everyone, everywhere. At home, at work, on the streets, at the mall, in the beauty shop, in the doctor's office,

in church; take a notebook and jot down little bits of conversation that you hear. You will start to notice that people speak differently in different contexts. They use subtext all the time. They say something but mean something else. They say things that are confusing. They mask their emotions with words, and also express their emotions with words.

People of African American descent often code switch. You may have heard of the term. It describes the bilingual talent and ability that many African Americans possess to switch speech patterns from what linguists call Standard English (a more formal version of English) to Ebonics (what linguists refer to as Non-standard English).[6] It is important to keep the practice of code switching in mind when you are writing dialogue for African American and other non-European American characters. For instance, if you are creating a scene for an African American character who is the president of a corporation, you would most likely want that character to use Standard English in a corporate board room meeting. However, that same character might use Ebonics in a scene where she is interacting with African American relatives at a family picnic.

People of all cultures also adjust their language to acknowledge their relationships towards others. Mothers often speak endearingly towards their children. Doctors often speak paternalistically towards patients. Children often speak respectfully to their elders. Capturing these ways of speaking in your dialogue is your job as a screenwriter. If you understand the conventions of speech and manipulate these linguistic conventions to your advantage, your characters will be complex and engaging for the audience.

As you get more into your study of the way people speak, you'll notice that most Americans don't speak grammatically correct English. They speak in imperfect phrases rather than full sentences. They cut each other off. They say one thing when they mean something else. Every person has a slightly different way of saying the same thing. Like a fingerprint, our speech patterns make us who we are, so it is crucial for you, as a writer, to be sure that each of your characters speaks a little bit differently from the others.

Additionally, good dialogue maintains the tone of the genre. That means, if you're writing a slapstick comedy, the dialogue should echo the style of silly absurdist humor familiar to those who know the

genre. If you are writing a mystery set in the 1940s, your dialogue should reproduce the way people spoke in that period.

Let's look at a clever bit of dialogue from the original draft of *Love and Action in Chicago*.

```
EXT. OUTDOOR CAFÉ - DAY

Eddie waits at a table. He has dark glasses on.
Then he takes them off. Then he puts them on again.
He's in a dark suit and white shirt. No tie today.
He looks down at his chest hair. He buttons his top
button. Doesn't want to look too sexy. Then he un-
buttons it again. As he waits, we HEAR...

              MIDDLEMAN'S (V.O.)
          She's nice, has a good job. And she's cheery.
          Very cheery.

              EDDIE (V.O.)
          What's cheery?

              MIDDLEMAN'S (V.O.)
          Eddie, the truth is, I had a loner working for
          me a while back and he gave me the goddamn
          creeps.

              EDDIE (V.O.)
          Profanity is not necessary, Middleman. So what
          is cheery?

              MIDDLEMAN'S (V.O.)
          Shut up, Eddie. I'm trying to make a point.
          Eliminators work hard, and they need to get
          laid. Meet her. That's an order.

Around the corner comes LOIS. Thirty, cute, moving
quickly. Her smile is radiant. Eddie SEES her in slow
motion. Then he sees... she's pregnant. Very pregnant.
She walks over to Eddie's table and shakes his hand.
Eddie can't stop looking at her large belly.
```

It's a great scene. Writer Johnson-Cochran injects the perfect dose of irony in his dialogue to establish the right tone for this satire. The humor comes out of the rather familiar way Eddie and his boss, Middleman, address each other and culminates with her ordering Eddie to "get laid." Also notice how Johnson-Cochran sets up the scene with a visual of Eddie prepping for the date. It's a wonderful way to establish a subtext of meaning that can be juxtaposed against what is being said in the dialogue. Eddie speaks like he's not that interested in dating. Nonetheless, from his actions, buttoning and then unbuttoning his shirt, we see that he might, indeed, be yearning for a romantic encounter.

Often the best parts of a dialogue scene come from what is left out or not said. Take the scene we discussed in the previous chapter between Malcolm and his wife Betty in the film *Malcolm X* where Betty is begging her husband to spend more time with the family. Instead of yelling at her or cutting her off with excuses, Malcolm spends most of the scene just listening. The scene ends with him walking away. He essentially dodges a confrontation with his wife. The absence of dialogue in the scene says a lot. This scene makes Malcolm real and identifiable for the audience. It shows how he handles his struggle on the home front and gives us a glimpse of his weaknesses.

How Not to Write Dialogue

Learning how to write dialogue is often best taught from the perspective of what not to do. Here is a list of seven questions you can use to diagnose problems with your dialogue. These questions are followed by examples of incorrect and correct ways of constructing your dialogue.

1. Is the dialogue too obvious?

INT. KITCHEN - DAY

Demetrius enters the kitchen. His mother is seated at the table and is looking worried. There is an open letter on the table.

> MOTHER
> This is the letter from
> the draft board.
> They are drafting you, son.

This dialogue says the obvious and sounds stilted and repetitive. Always ask yourself if the scene feels wrong? Can you create a better scene? Be sure the dialogue conveys the point of the scene. Here the focus of the scene is not supposed to be that the letter arrived, but rather that the moment the mother and son have been dreading is now upon them.

Let's look at another way of approaching the scene.

```
INT. KITCHEN - DAY

Demetrius enters the kitchen. His mother is seat-
ed at the table.  Her mind seems to be elsewhere.
There is an open letter in her hands. She looks at
her son, in her eyes, the pain of a thousand ages.
Demetrious knows he's been drafted.

                    MOTHER
           I will not give them another son.
```

We feel her desperation. The pain of her loss resonates in the minds of the audience as the next scene begins.

2. Can you say it better without dialogue?

```
INT. KITCHEN - DAY

Demetrius enters the kitchen. His mother is seat-
ed at the table.  Her mind seems to be elsewhere.
There is an open letter in her hands. She looks at
her son, in her eyes, the pain of a thousand ages.
Demetrious knows he's been drafted.

CUT TO:
```

EXT. BATTLEFIELD - DAY

Demetrius lands on Omaha Beach.

Often times, dialogue undermines the emotional impact of a scene that can be better achieved via reaction shots. When your dialogue feels wrong, try to rethink your scene from a visual perspective.

3. Can you rephrase and trim any monologues?

INT. BEDROOM - NIGHT

Tyrone turns to his wife, Kelly.

 TYRONE
 I've had to leave work early five days
 in a row. That's five days of lost wag-
 es because of you. You know it's you.
 You are the reason we don't have a nice
 place to live. You keep making me leave
 early because you want me to do this,
 and you want me to do that. If I didn't
 have to leave work early to pick up the
 kids every night, I could get that other
 position, and we could have some extra
 cash for a change.

Most long monologues can be cut down. Although a lot of people in real life are, indeed long-winded, it's your job as a skilled writer to craft the dialogue, cut to the chase of each scene and move the story along. That means stay away from long monologues. Let's look at another way to say this.

INT. BEDROOM - DAY

Tyrone turns to his wife, Kelly.

 TYRONE
 You know it's you. You didn't pick up
 the kids one day this week. You're the

reason they don't make me a manager.
You're the reason we can't get ahead.

4. Can you rephrase any of your asides and voiceovers?

Many beginning writers have a hard time getting the feelings of
their characters across to the audience in cinematic ways and resort
to awkward voiceovers.

 TRACY (V.O)
 I miss Tommy so much. I should have
 never left him.

This type of overt talking-to-oneself sounds amateurish. A well
trained actor can get this information across to the audience with a
gesture or a facial expression. Here's one way to rewrite the scene
using visuals rather than dialogue.

Tracy goes to close her bedroom shade. As she does
this, she looks out her window across the yard to
Tommy's bedroom window. Tracy is struck with a
tremendous feeling of regret.

5. Does each of your characters have a distinct way of speaking?

Dialogue is the conduit for creating separate personalities for each
of your characters. If you can't differentiate a character through
what he or she says, you should ask yourself if you really need that
character in your script. In this sequence, these characters are not
differentiated.

 MICHAEL
 You need to take some responsibility for
 your life.

 KEENAN
 I need to take some responsibility for
 my life?

> MICHAEL
> That's what I said.
>
> KEENAN
> That's what you said. I need to take
> some responsibility for my life?

Let's adjust the dialogue to enhance the essence of these characters.

> MICHAEL
> You need to take some responsibility
> for your life.
>
> Keenan gives his brother no response other than an
> ironic smile.
>
> MICHAEL (CONT'D)
> Do you hear what I'm saying to you?
>
> KEENAN
> Don't you know, nobody ever listens to
> you?

6. Are you paraphrasing a scene that should be written out in dialogue?

In your rush to get through the scene, be sure you aren't just writing a summary of the scene rather than truly writing out the scene in real time. Here is a scene that suffers from paraphrasing.

> EXT. MICHIGAN AVENUE – DAY
>
> Vonita, determined to win the bet, goes up to
> a strange man and asks him for a date. The man
> is taken aback, but agrees to meet her at the
> restaurant tonight.

Here is one way to write out the scene so that it develops for the reader as he or she is reading it in real time.

EXT. MICHIGAN AVENUE - DAY

It's lunch time, and the streets are packed with
CABS and PEDESTRIANS. Vonita, determined to find a
date, angles her way through the crowd. She spots a
MAN (29) in an expensive suit walking in front of
her. He will be her target. She marches directly at
him and taps his shoulder from behind.

 VONITA
 Excuse me.

As the man turns, Vonita crashes into him.

 VONITA(CONT'D)
 (brushing off his suit)
 Oh, snap. Are you okay?

He is flustered by her forwardness.

 MAN
 Uh...

 VONITA
 (cutting him off)
 Listen, I made a bet with a coworker
 that I could get a date for tonight,
 but everyone, including my baby brother
 Sean, his friend James and my uncle Fra-
 zier have backed out on me, and, well,
 you look like someone who could use some
 company. I mean, can I take you out for
 a nice dinner?

INT. ELEGANT RESTAURANT - EVENING

Vonita and the man are seated at a table staring
awkwardly at each other.

EXTERNALIZING THE INTERNAL

Dramatizing the internal condition of a character is always a challenge for a writer. How do you let the audience know what a character is feeling without resorting to long monologues or too many first person voiceovers? This was the challenge faced by James McBride as he was writing *Miracle at St. Anna*. In the original novel, he had the luxury of the being able to simply state what the characters were feeling, literally letting the reader know what the consciousness of each of the characters was at various moments of the story. However, in a screenplay, a character's inner being must be externalized in another way. In the screenplay *Miracle at St. Anna*, Lee and McBride came up with the idea of using the character of Axis Sally as a dramatic device to help the audience identify with the ambivalence the Buffalo soldiers felt during the war. The timing of Axis Sally's speeches about the real discrimination that the African American soldiers were experiencing within their own U.S. military division brings out the irony of their situation and crystallizes the internal thought process of the soldiers for the audience to easily comprehend. According to McBride, Axis Sally's speeches were strategically incorporated into the script at particular junctures in the story:

> It's key that [the taunts] are delivered at a moment where they are frightened for their own lives. They're getting ready to make this crossing. They know the Germans are waiting for them. They know some of them are going to die. And these are the last words that some of them are going to hear.[7]

Ask Yourself: Does Each Scene Advance the Plot or Develop a Character?

As we've said in earlier chapters, each and every scene in your film should serve to advance the story either by delivering vital plot information or crucial character development. If you write a scene and it does not deliver one or both of these elements in your screenplay, then consider rewriting or cutting the scene.

SCENE EVALUATION CHECKLIST

Here is a checklist of questions to help you evaluate your writing at the level of the scene.

- ☑ Does the scene advance the plot through either story action and/or character development?

- ☑ Is the scene tightly written and not overwritten?

- ☑ Does your scene use description in a visually engaging way?

- ☑ Does your scene use dialogue in an interesting and entertaining manner?

Chapter Six Exercises

1. Read ahead to Chapter Seven on screenplay formatting to prepare yourself to properly format the opening scenes of your script. Now, write the first five pages of your screenplay. If you belong to a screenwriting group, make a copy of the five pages for each member of your writing group. Do a group reading. Have each person cast as a character and read the dialogue aloud for that character. Assign someone to read the body copy. Don't allow yourself to read anything. Your job is to sit back and listen. It will be an invigorating and eye-opening experience to hear your material reenacted. If you don't currently belong to a writing group, consider signing up for a course where you can have the experience of hearing your scenes come to life.

2. Now finish the first ten pages of your screenplay. Bring copies for each member of your writing group, and listen to the scenes read aloud. Take note of any comments and suggestions your group members make about the script, but don't worry about changing things right now. Use the momentum you'll feel from hearing your work read aloud to keep writing.

3. Using your scene outline as a guide, complete the first act, including the turning point. Bring copies of your entire act—approximately thirty pages—to your screenwriting group, and enjoy listening to the table read.

4. Using your scene outline as a guide, complete the second act. Take copies for a group reading. At this point, if you don't have serious misgivings about the script, don't stop writing. Don't risk losing your muse. Finish the third act. You should have approximately 110 pages written for a completed feature. Savor your accomplishment. You are now done with the first draft!

Screenplay and Television Formats

If you want someone in the industry to read your script, you've got to type your screenplay in proper industry format, otherwise it could go right in the garbage can. The potential buyers of your screenplay have stacks of scripts sitting on desks, nightstands, bathroom shelves, back seats of cars. They don't have time to look at a script that is not typed according to industry standards, and they find it an insult to be given a script that contains spelling and grammar errors.

The Importance of Proper Formatting

Industry standard screenplay format is an easy thing to master. You can type your screenplay in proper industry format using Microsoft Office, or you can purchase a professional formatting program that will do most of the work for you. Two programs that are popular with writers are *Final Draft* and *Movie Magic Screenwriter*. Students can purchase them at a discounted rate. Even at full price, these programs are not expensive for what they give you, and you don't need to worry about buying upgrades. Screenplay formatting hasn't changed significantly in a number of decades and probably won't for a long time to come. Nevertheless, if you do decide to purchase upgrades, you will get access to additional screenwriting templates. These are plug-ins for your program that allow you to format your spec script according to the exact style used on a particular television show. For example, Final Draft has dozens of templates for all of the top shows including series like *Grey's Anatomy*, *CSI*, *The Simpsons*,

etc. Once you purchase the software, you can download the templates from the software company's website. These screenplay software programs contain additional tools to help you organize your ideas and analyze your work. You can download the software for a brief free trial period. However, be careful not to use it for any writing you intend to keep. The test software will expire after a few weeks, and so will all your work. There is also a freeware program available called Celtx that is widely used by students and works similarly to *Final Draft* and *Movie Magic.*

In general, there are two basic narrative screenplay formats to learn. These formats correspond to the method of production. Feature films and dramatic television shows are shot in a format called **single-camera style**. Comedies that are shot film-style, like *Arrested Development,* also use the single-camera format.

The second scriptwriting format is a television format called **multi-camera style.** Situation comedies like *The Game* or *Meet the Browns* are shows that were shot with at least four cameras placed in front of a set. These sitcoms are dialogue intensive shows. The camera work does not add a lot of visual interpretation to the story, but rather is meant to capture the theatricality of the performances. The scripts for multi-camera sitcoms use double-spaced dialogue to make it easier for the camera crew and other production staff to follow the swiftly paced dialogue scenes.

Fonts/Paper/Binding

Industry readers expect you to turn in a clean **hard copy** of the screenplay or to submit electronic copies. If electronic submission are allowed, be sure to send it as a PDF file rather than as a Word document.

You should use only one **font; Courier, 12-point.** Courier resembles the look of the old Pica typewriter font. In this chapter, we've placed all of our script excerpts in Courier 12 -point to get you used to the look of the professional format. Be sure the page numbers of your screenplay are printed in Courier 12-point as well. Use clean white 8.5 by 11 inch paper, printed on one side only (to leave space for notes). Punch each page with a three-hole puncher, and then bind it with brass brads or screw posts in the top and bottom holes only.

(The brads are hard to find these days. You can still get them at the writersstore.com.)

Don't try to make your script look pretty. Don't decorate it. Don't use any other fonts besides Courier or Courier New. Don't copy the show's logo on to the cover of the script. Don't use colored ink or colored paper. Don't use a cover.

In this chapter, we explain the formatting rules. If you want to purchase a screenplay formatting reference manual, there are several excellent ones out there with detailed explanations of anything you'd ever want to know about formatting. One is *The Screenwriter's Bible* by David Trottier. Another is *The Complete Guide to Standard Script Formats* by Hillis Cole Jr. and Judith Haag. Either book is a good investment.

Spec Script Versus Shooting Script

Your *spec script* is the script you will sell. A *shooting script* is a version of the script that has already been sold and is marked up for production purposes. Shooting scripts have scene numbers in the left and right hand margins so that the producers can break down the project for scheduling and budgeting purposes. Shooting scripts also contain numerous references to the camera work such as shot descriptions (i.e. CLOSE ON). Spec scripts, to the contrary, do not contain scene numbers or camera information.

Feature Screenplay Format

Margins: The left margin should start 1.5 inches from the edge of the paper. If you're using Microsoft Word, the default left margin setting is already 1.5 inches. Left justify within the margins. Never right justify. Leave right margins uneven.

Tabs:

Description:	Starts at left margin, 1.5 inches from left edge and ends 1 inch from right edge.
Character Name:	Tab over 4 inches from the left margin.
Parenthetical:	Tab over 3 1/4 inches from left margin.

Dialogue: Tab over 2 1/2 inches from left margin, and be sure dialogue does not go beyond 6 1/2 inches from the right margin.

Note that, if you are looking at other screenplays, you will find slight variations in these tab settings from script to script. These various approaches all conform to industry standards.

The Cover Page: Centered and in CAPS, your title goes on it's own page, a couple of inches from the top. Type, "Original screenplay by" and put your name, address and contact info either in the center or bottom right. Don't put the date on your script. You want the reader to think it's a fresh commodity instead of something that's been circulating around L.A. for a while. As we said earlier, you don't need a fancy cover for your screenplay. If you insist on using a cover, use only white card stock (heavy weight paper). Don't use fancy fonts, colors, plastic or anything decorative. Don't include character lists, set descriptions or any additional pages in your screenplay.

Page Numbers: Place page numbers at the top right of the script, in Courier font, flush with the margin, followed by a period. Don't number page one of the actual screenplay. Begin numbering on page two.

First Page/Transitions/End Page: It is traditional to start your script with the transition command FADE IN: typed in caps, justified against the left margin. Sometimes you'll start a scene with a dissolve. The command should be written as DISSOLVE TO: The dissolve is a transition effect that looks like a cross-fade between two shots. A FADE IN: is a dissolve that goes from black to the scene. Transition commands such as CUT TO: and FADE OUT: are also found at the end of scenes. These words should be typed in caps followed by a colon and right justified at the edge of the margin. Note that these are the only words in your screenplay that should be right justified. On the last page of your screenplay you should type FADE OUT: or you can finish the script with the words THE END centered on the last page.

Scene Headings/Sluglines:

Scene headings are also known as *sluglines*. Scene headings indicate to the reader where and when the scene is set. You should start every scene with a scene heading. Begin by indicating if the scene is set as an interior or exterior location. Use the abbreviations in caps: INT. (for interior) or EXT. (exterior). (This information is used in the budgeting process when the film is in preproduction.) To finish the slugline you add a space and then, in caps, put the name of the location—unabbreviated. Then space again. Add a dash, space, and then tell whether the scene is set for DAY or NIGHT. Remember to always capitalize the entire slugline.

Use the term CONTINUOUS when you want to indicate that a character is moving through a space from one location to another without any change in time. For example, you'll use CONTINUOUS when a character walks from a bedroom to a bathroom or from the living room to the hallway or from the interior to the exterior of a location.

Here is an example:
```
INT. KITCHEN - DAY

James puts two slices of toast on a plate and danc-
es with it to the kitchen door.

INT.  DINING ROOM - CONTINUOUS

James enters the dining room and places the toast
in front of Leslie who is seated at the head of the
table.
```

Abbreviated Sluglines

Instead of using CONTINUOUS, another way to move a character from one location to another is to use an abbreviated slugline. Here is an example:

```
INT. KITCHEN - DAY

James puts two slices of toast on a plate and danc-
es with it to the kitchen door.
```

```
DINING ROOM
```

```
James dances into the dining room and places the
toast in front of Leslie who is seated at the head
of the table.
```

Never Underline. Never Bold. Never Italicize.
Never underline, bold or italicize anything in your feature film script. An exception to this rule happens with certain television scripts that sometimes include a bolded word or underline because of the personal preference of the showrunner for the particular television show.

Line Spacing
Single space description and dialogue. Double-space between paragraphs, after sluglines and between character headings in the dialogue sequences.

Sound Effects and Major Props
Use upper case letters for all sound effects and also the introduction of important props.
```
The phone RINGS.
John takes a DIAMOND RING out of his pocket.
```

New Characters
The first time a character is introduced in the script, write his or her name in caps. After that, lower case type can be used when referring to that character.
```
MARGE, thirty-something and haggard, limps down the
street.  A limo pulls up.  Stops.  Marge gets in.
```

Never Center Character Names
Do not center any character names. Instead, tab over from the left margin.

Use Parentheses Sparingly
Directions given right before the dialogue that instruct the actors how to interpret the lines should be placed in parentheses just below the character's name. Be warned that if you include too many of

these dialogue instructions in parentheses you will slow down the read. Use them only when absolutely necessary, and use no more than five words in the parentheses. Any description longer than five words should be treated as body copy and formatted as part of the description, starting at the left hand margins.

When Dialogue is Broken Up Between Pages

When a character's dialogue starts at the bottom of one page and continues on to the top of the next page of the script, you type (MORE) in parentheses at the bottom of the first page, centered under the last line of dialogue. On the top of the next page you type (CONT'D) in parentheses next to the character's name to finish the dialogue passage.

Only Right Justify Page Numbers and Transitions

Right justify only the page numbers and end transitions (FADE OUT:, CUT TO:, DISSOLVE TO:). Do not right justify the dialogue.

FEATURE FILM FORMATTING EXAMPLE

Let's take a look at a few pages of *Love and Action in Chicago*, a feature-length screenplay, by Dwayne Johnson-Cochran. The numbered notes that follow explain the formatting rules.

EXT. STREET - LUNCHTIME [2]

Eddie, coffee in hand, walks the beat. It's busy.
Eddie wears dark glasses and holsters a city-issued
gun. He looks around. His eyes follow a SHARP YOUNG
WOMAN eating her lunch on the steps of the museum.
She makes eye contact with him.

Eddie, feeling a little hesitant to walk over,
smiles slightly. Just when he's about to walk over,
to say something to her...

Lois steps over and grabs Eddie by the side. She hugs
him tight, laughing. She's so excited. Next to Lois,
her three girlfriends. SUE, LINDA, and AMY. [3] All
slightly overweight, all with paper bag lunches.

 LOIS [4]
 (excited) [5]
 Eddie, I was out here for lunch and
 I said to my girls, "Is that
 Eddie?" I didn't know you were on
 the force. Girls, this is Eddie.
 And he's a cop!

 AMY, LINDA AND SUE
 Hi Eddie.

 LINDA
 We heard a lot about you.

 SUE
 Lois didn't tell us you were a cop.

 EDDIE
 Well, I'm...

> LOIS
> (feeling the fabric)
> Eddie, your uniform...it's so nice.
> Sit down. Have lunch with us. Do
> cops make good money? I was
> thinking about being a cop once.

Eddie looks nervous. He looks around.

> EDDIE
> I really need to walk this beat.

Eddie turns to look at Lois. She walks over to him, then moves him far away from the rest of her group who continue to giggle.

LOIS AND EDDIE [6]

> LOIS
> Do you have any idea how much you
> turn me on, Eddie. The uniform. So
> cute...

BEEP. BEEP. [7] Eddie's pager goes off. He has to make his hit now. Lois smiles. Eddie has to respond to a call. Lois holds his arm, keeping him very close to her. And from leaving.

Eddie has to go. He gulps, then looks at Lois. She closes her eyes. She's literally in a free fall swoon over him.

Eddie doesn't know what to do. She starts to hum, her eyes still closed, she holds his jacket tightly, not letting Eddie go. [8]

BEEP BEEP BEEP. Again. Lois is close to Eddie, still humming. Her face so giving.

> LOIS (CONT'D) [9]
> Kiss me, Eddie.

```
                    EDDIE
                 (terrified)
           Out here? I have to work.
```

She lunges at him, kissing Eddie hard on the mouth,
pulling him close, around the neck. A real embrace.
We HEAR shouts from her girlfriends in the back-
ground. Eddie's eyes are wide open, looking around.
This is a looooong kiss.

[1] Page numbers: Place the page number, justified, in the top right hand corner of each page. Use Courier 12-point font, and follow with a period.

[2] Slugline: Be sure to use a slugline with each change of location. Note that there is a hyphen between the place and the time of day. Be sure that the name of the place is short and easy to comprehend. Use caps and double-space after the slugline.

[3] New characters: Put the names of new characters in all caps the first time they are introduced.

[4] Character name: Tab over. Never center the character name.

[5] Parentheses: Only use parentheses if they are absolutely necessary to clarify what is going on in the scene. Too many parentheses slow down the read. Limit their content to five words. Descriptions longer than five words should go on the left margin and be treated as body copy.

[6] Location shift/Abbreviated Slugline: When a character moves to a particular location within a location as one continuous action without a shift in time frame, an abbreviated slugline can be used. In this case, Eddie and Lois move a few feet away from her girlfriends, so their new location is described as EDDIE AND LOIS. This shorter slugline is commonly used when a character moves continuously from room to room such as from the living room to the kitchen or from the outside of a vehicle to the inside of the vehicle.

[7] Sound effect: Capitalize all references to sounds in your script.

[8] Separate descriptive passages: Long descriptions should be broken up into paragraphs no longer than three or four typed lines.

[9] Continued: When a character speaks, and then there is description followed by the same character speaking again, you must use (CONT'D).

Other Screenplay Formatting Situations

Texting and E-mailing in a Script: There are several different ways to format texting. The simplest way to show a character texting is to put the text message in quotes in the descriptive passage as follows:

```
INT.  CAFETERIA - DAY

Donda looks at her cell phone.  It reads, "Call me
now!"
```

Intercutting between Locations Simultaneously: If you are writing about two characters that are in different rooms at the same location you can use INTERCUT to indicate this:

```
INTERCUT - JEROME'S ROOM/MONICA'S ROOM

Jerome picks up his phone to dial.
Monica picks up her phone to dial.
```

Montage: To move the story along quickly by showing time passing or characters traveling between multiple locations you can use a MONTAGE sequence.

```
MONTAGE - JEROME AND MONICA PREPARE FOR IRAQ

- - IN JEROME'S ROOM - - Jerome fastens the top
button on his combat uniform.
- - IN MONICA'S ROOM - - Monica fastens the top
button of her dress uniform.
- - AT THE BASE - - Jerome salutes his commanding
officer.
- - AT THE PENTAGON - - Monica shakes hands with
the President.
```

Split Screen

```
INT. MARTIN'S BEDROOM - NIGHT

Martin dials his cell phone.

SPLIT SCREEN - MARTIN AND JUDI

Judi is asleep in her room.  She opens one eye and
answers.
                          JUDI
            Leave me alone.  Go back to sleep.
```

Flashback

```
INT. THE PALACE COURTYARD - NIGHT - FLASHBACK - 1789

Charles is dressed in full, eighteenth-century
military regalia, a la Napoleon.  He rides up to
the palace gate on a black stallion and draws his
sword in defiance.

END FLASHBACK

INT. VIETNAMESE PRISON CELL - NIGHT - PRESENT

Charles sits alone in the corner of a concrete slab
cell.  A mouse scurries across the floor.
```

Off Screen: Something that happens outside of the frame. (O.S.)

Without Sound: A scene without sound. (M.O.S.)

Voice Over: Narration that runs over the scene. (V.O.)

TELEVISION SINGLE-CAMERA FORMAT

All dramatic television and certain comedies that are shot on location or with one camera on set (i.e. shows like *Bernie Mac, Arrested Development, Entourage, Law and Order, Grey's Anatomy*) are scripted in the single-camera format which follows most of the rules of the feature film format. When writing a spec for single-camera shows

you can use the feature film format discussed above with a few added rules for your scene headings and your act headings as follows:

- Spell out the act number at the beginning of each act as ACT ONE.
- Start each new act at the top of a new page.
- Type the act title in caps, centered and underlined.
- Follow the guidelines above when labeling a TEASER, COLD OPENING and TAG. (These are designations used in television scripts for the short scenes at the beginning and end of a program. They are further explained in the next section of the book.)

Scriptwriting Templates for Dramatic Series

Sometimes television showrunners will have their own formatting preferences for their particular shows. For instance, some shows use bolding or underlining in certain parts of their scripts where it normally should not be used. If you want to reproduce the screenwriting format of a particular show exactly as it's done by the showrunner, you should purchase scriptwriting software and download the show template. However, it is not mandatory that you mimic the quirky formatting preferences of a television show. As long as you follow proper dramatic television screenwriting format on your dramatic television spec, you will not be penalized for not knowing the variations in the format used on a particular show.

Cover Page for an Original Television Pilot

The cover page for your television show should be the same as for your feature film unless you have written an original pilot. If you have created a pilot, you should include the title and then the category or genre of the show (sitcom, dramedy, crime thriller). Type this information centered midway down on the page. Below that, type "Written By" or "Created By." Place the contact information, including an agent's name (if you have one), at the bottom right.

What Not to Include in Your Television Script

Don't include your Copyright or WGA Registration Number. Don't date the script or refer to what draft it is. You want the reader to think it's virgin material. Do not include any other top sheets such as cast lists, references to sets or materials that you might have seen

included with sample scripts that you've read. Just use a cover page and then go right to page one with the dialogue. Remember, sample scripts you may find on-line tend to be shooting scripts with scene numbers, page headings, draft numbers and other elements you should not be including in your original spec script.

TELEVISION MULTI-CAMERA FORMAT

As we mentioned earlier, situation comedies shot in the studio are filmed with numerous cameras mounted on pedestals. The scripts for these shows tend to have very little description beyond entrance and exit cues for the actors. Because these shows are dialogue intensive and fast-paced, the dialogue is always double-spaced, not single-spaced, on the page. As a result of the double-spacing, multi-cam comedy scripts are often twice as long as dramatic television scripts. You will also discover that multi-camera formats will vary slightly from show to show. Later in this chapter you will find examples of the formatting rules in the form of sample script pages.

Font
Courier, 12-point:
`Courier, 12-point.`

Spacing
Everything is double-spaced except for the description and a list of characters that appear in the scene. The character list is written under the slugline.

Uppercase
Use caps for the following: act and scene titles, (MORE) and (CONT'D), sluglines, description and character names placed above the dialogue, and for any directions in parentheses placed within the dialogue.

Sluglines and Numbering of the Days
Type the slugline in caps. Underline the slugline. Use INT. or EXT. Name the location, and then add a space. Next include a dash. And space again. Type DAY or NIGHT. In parentheses, specify what day it is in the story. Single-space and type under the slugline a list of all the actors who will appear in the scene.

Sound Effects

Any sounds are considered effects. This includes doorbells and phones. Abbreviate the word effects as SFX, and follow this with a colon. Underline the sentence:

`SFX: DOORBELL.`

Acts, Teasers, Cold Openings, Tags, Scenes

At the beginning of each act, in caps and underlined, type the number of the act, and center it at the top of the page. Sometimes these headings are bolded, depending on the personal preferences of the series showrunner.

Every new act and every new scene will start on a new page. Some shows leave ten or more lines of empty space at the top of a page before they start the new act.

The same rules apply to teasers, cold openings and tags. A cold opening is another name for a teaser. A tag is a short scene at the end of a show.

Scenes are typed in caps, underlined and centered. Scenes are usually labeled with letters rather than numbers. Letter the scenes in alphabetical order. However, do not use the letters F,G,I,N or O as scene headings. Skip them and go on to the next letter. The reason for this is explained in the chapter on sitcoms. Follow this example for act and scene lettering:

<div align="center">

ACT ONE

SCENE A

</div>

End of Acts, End of Episode

Certain multi-camera series announce that the act is over by typing END OF ACT in caps, underlined and centered after the last line of the act.

Only Right Justify Page Numbers and Transitions

Right justify only the page numbers, transitions (FADE OUT:, CUT TO:, DISSOLVE TO:) and opening credits. Never right justify the dialogue.

SAMPLE SITCOM SCRIPT

NAME OF YOUR SHOW

"EPISODE NAME"

<u>ACT ONE</u>

<u>TEASER</u>

<u>INT. TIM AND DEBORAH'S BEDROOM - NIGHT (NIGHT 1)</u>
(TIM, DEBORAH)

TIM AND DEBORAH ARE IN BED. TIM SITS UP UNABLE TO
SLEEP. HE SWITCHES ON THE T.V. AND SHAKES DEBORAH
TO WAKE HER.

> TIM

Hey are you up?

> DEBORAH

What do you think?

> TIM

I think we should postpone the

wedding.
> (MORE)

 TIM (CONT'D)

I think we should wait until we're

absolutely sure about this.

 DEBORAH

We already paid for your mother and

father to fly out here Tim.

SFX: PHONE RINGS. THE BEDROOM DOOR OPENS AND TIMMY
JR. ENTERS WITH THE PHONE. HANDS IT TO TIM. ALWAYS
SINGLE SPACE YOUR BODY COPY AND WRITE IT IN CAPS.

DEBORAH TAKES THE PHONE AND LOOKS AT THE NUMBER.

 DEBORAH (CONT'D)

It's your mother.

 CUT TO:

 OPENING CREDITS

<u>ACT ONE</u>

<u>SCENE A</u>

<u>INT. TIM AND DEBORAH'S KITCHEN - DAY (DAY 2)</u>
(TIM, DEBORAH, TIMMY JR., GRANDMA, GRANDPA)

GRANDPA STANDS AT THE STOVE COOKING. EVERYONE ELSE
IS SEATED AT THE TABLE. <u>GRANDMA ENTERS.</u>

 GRANDMA

 So it's settled. You're getting

 married.

TIMMY JR., DEBORAH, GRANDMA AND GRANDPA ALL GLARE
AT TIM. A BEAT THEN

 TIM

 More pancakes son?

AND THE SCENE CONTINUES...UNTIL WE

 FADE OUT:

4.

SCENE B

START EACH NEW SCENE AT THE TOP OF A NEW PAGE.
CENTER SCENE TITLE AND USE LETTERS TO LABEL THE
SCENE. FOLLOW THIS FORMAT FOR EACH SCENE UNTIL THE
END OF THE ACT. THEN CENTER THE WORDS:

END OF ACT ONE

Writing An
Alternative Screenplay

Alternative screenwriting is a hard thing to explain in the affirmative and better understood by what it is not. An alternative screenplay is not a mainstream film. It's a script that breaks with the conventions of the typical Hollywood screenplay. The film that is shot from an alternative script is often made independently, without Hollywood studio financing and usually, though not always, has a considerably lower budget than a Hollywood film. In contrast to the typical distribution deal used to circulate a conventional Hollywood film, an alternative film is often made available to viewers via alternative distribution networks such as film festivals, educational distribution companies, international distribution companies or self-distribution via the Internet.

If you have never seen good alternative narrative films, you need to start watching them. There are thousands of excellent examples of alternative work out there. A great alternative narrative will delight your sensibilities and might even rock your world. It can challenge your expectations of what cinema is as an art form. You will be pleased to know that you can watch all kinds of alternative films and videos right now on your home computer. In this chapter, we will take a look at a handful of important alternative films.

The popularity of Internet video has not been lost on Hollywood. Alternative, short-form entertainment is usurping Hollywood's hold on the market. Film and television production companies are looking for ways go viral. Web series like *Awkward Black Girl* reach a vast audience hungry for short form and quirky content for their entertainment. Familiarizing yourself with the alternative films in this chapter will inspire you to take your writing in a new direction.

Breaking with Conventions

Most screenwriters and filmmakers believe that to make a great alternative film, you need to understand the conventions of classical Hollywood screenwriting. This implies that a screenwriter who writes an alternative screenplay consciously manipulates or deviates from the conventions of the Hollywood form. But if you've ever written an alternative screenplay, you know that the creative process is often not entirely conscious and intentional but rather, to some degree, organic; a free flowing burst of self-expression.

The extent to which a script is unconventional or experimental sometimes determines how popular the film will be with an audience. At the more experimental, more unconventional end of the creative continuum, an alternative screenplay can become so radical in its form that no one other than the filmmaker can appreciate it. The potential for popularity with an audience is a huge factor in finding financing for films. Since many alternative screenplays are hard to sell and distribute, it is tough to find financial backing for most radically alternative movies. As a consequence of this, many alternative screenplays are produced and directed by the writers themselves and are often highly personal expressions of their creators.

Moreover, because alternative films are films that are seen as deviating from the conventions of mainstream cinema, it is difficult to say exactly what makes a good or a bad alternative film. The more alternative films and mainstream movies you watch, the better you will become at judging what makes an alternative screenplay something great and what is just mediocre writing. If alternative writing is what you want to do, understanding Hollywood conventions and being able to articulate how the conventions are being broken will help you build an intellectual foundation to forge ahead with your own work.

So what are the conventions that we are referring to? Essentially, the rules of Hollywood cinema are the fundamental guidelines we've discussed in the book up to this point. First, there is the Hollywood preference for the three act structure with two turning points and a forward moving plot that culminates in a climax. Second, as we mentioned in a previous chapter, Hollywood is a stickler for a screenplay with a resolution and closure. All plot questions must be answered, and all problems must be resolved. Third is the need to focus

the story on one main protagonist who is actively moving towards a goal. Fourth, Hollywood stories need conflict to keep them moving, so there has to be a strong villain or obstacle impeding the forward progress of the protagonist towards getting what he or she wants. A fifth convention of the Hollywood screenplay is the expectation that the protagonist will undergo a character transformation that ties into the narrative arc of the story. A sixth rule is that the dialogue will be better than your average conversation, supercharged with meaning and subtext and always on point. A seventh standard of a great Hollywood screenplay is that it will have a strong sense of place. The visuals are an integral part of the storytelling and the development of the characters. Finally, the genre of the script will determine many aspects of the storyline: how it will begin, unfold and end; who the characters will be; what the elements of setting will be. The tone of the entire project will be determined by the conventions of the genre.

If you carefully analyze a significant number of Hollywood films, you'll find that, once in a while, some of them do break with one or more of these conventions. With the box office success of alternative films like *Pulp Fiction, Run Lola Run, Momento* and *Do the Right Thing*, many of the particular alternative writing techniques deployed in these films are now considered acceptable in the mainstream. As a result of this fluidity between the conventional and the alternative writing strategies, the boundaries between what is conventional and what is alternative are becoming increasingly blurred. For example, in *Pulp Fiction* Tarentino structures the story to start at the end and then circles the storyline back to the opening. It's really a conventional narrative line just one that starts is a different place.[1] *Momento* and *Run Lola Run* replay a set of plot incidents over and over, adding meaning, bit by bit, until the ending is finally revealed.

In *Do the Right Thing*, Spike Lee spends only a marginal amount of screen time developing his main character, Mookie, choosing instead to use an ensemble cast of characters inhabiting the entire block as a communal protagonist. The film's ending gives us little closure, and the unconventional dialogue is often improvised and repetitive, sounding almost hyper-real. The tone of the film shifts between didacticism to pathos. Lee uses direct address to disrupt the forward movement of the narrative, demanding that we stop

our dreamlike involvement in the storyline every so often and think about the situation of race in America.

Examples from Alternative Screenplays

Compensation
One of the more experimental examples of alternative screenwriting examined in this book is seen in Zeinabu irene Davis' narrative *Compensation* (1999) written by Marc Chery. Chery's script juxtaposes the stories of two African American couples. One story is set at the turn of the nineteenth century, and the other story is told in contemporary times. The two couples are played by the same two actors, Arthur Jones and Malindy Brown. The story revolves around a romance between a deaf woman and a hearing man, chronicling the connections and disconnections in their relationship. The plotlines are developed in a cryptic manner reminiscent of the style of storytelling found in silent films. This approach, in a way, mimics the feel that American Sign Language (ASL) has for a hearing person, distancing the viewer as an outsider in the deaf world.

During the turn of the century storyline, Davis and Chery use intertitles that serve as a perfect metaphor for the experience of deaf people in the hearing world. The hearing world is a place where the spelling and reading of words, coupled with broad gestures and demonstrative facial expressions of the deaf characters are often negatively regarded as simplistic modes of communication. Through moving visuals and powerful close ups, Davis and Chery lead us to identity with the struggle of the deaf protagonist to represent herself in her own self-actualizing manner. We identify with the beautiful young protagonist, hoping that she will find love and contentment in the hearing world that marginalizes her.

Chery's screenplay also underscores the theme of self-representation in terms of ethnicity. In a brilliantly clever way, Chery writes a scene in which the turn-of-the-century couple goes on a date to the movie theatre to see William Foster's comedy *The Railroad Porter*. The film is considered the first Black-produced movie in U.S. film history. The scene places the couple amongst an all-Black audience, and we see that everyone thoroughly enjoys the show. This

positive viewing experience is juxtaposed with the second plotline in which the contemporary Black couple goes to a multiplex cinema, only to discover that there are no African American- produced films to watch. Chery captures the irony of the times. The contemporary African American couple has less access to self-representation in cinema than the turn-of-the-century lovers.

By allowing the same story to play out in two different time periods, Davis and Chery also have the opportunity to examine the changes in attitudes experienced by the African American deaf female protagonist over the span of nearly a century. What results is an interesting character profile of an archetypal woman who redefines herself in the present era by situating herself in a much more politically astute and self-sufficient deaf community than existed at the turn of the century. Rather than join in with the hearing world that denigrates and oppresses her, the contemporary protagonist ultimately chooses to search for a lover from her own deaf community.

Chery and Davis' experimental narrative structure allows them the advantage of taking the same set of characters through similar situations in two different time periods. This approach affords them the ability to do different things with character development than if they had used a conventional Hollywood-style narrative storyline. Also the themes of representation, race, deafness, and the concept of love between the hearing world and the deaf community could probably not have been expressed in the same intellectually engaging way if the film had been scripted for a Hollywood sale.

Sankofa

Independent filmmaker and screenwriter Haile Gerima has created a number of alternative feature films and is regarded as a major innovator of the cinematic form. Gerima was born and raised in Ethiopia and was trained in filmmaking at UCLA where he was exposed to filmmaking styles from all over the globe. *Sankofa*, Gerima's most well-known feature, follows several storylines and uses rapid transitions between these stories to create a mythological viewing experience for the audience. The primary story of Sankofa focuses on a group of West Africans who are kidnapped and sold as slaves to European plantation owners on the American continent.

Gerima skillfully develops a number of characters that struggle to liberate themselves from under the brutal system of plantation slavery. Focusing on these main characters, Gerima concentrates the story primarily on the struggle of Mona and her lover Shango who becomes the initiator of a heroic rebellion against the European slave masters.

What is alternative about the script of *Sankofa* is the way in which Gerima injects an African sensibility and point of view into the story. Hollywood tends to seek out screenplays that present a mainstream view of history. In the opening sequence are a series of scenes which show a black woman dressed as a Western-style model appearing to be alienated from her own history. She is on a photo shoot with a White European photographer. He is photographing her on the grounds of Elmina Castle on the coast of Ghana, one of the ancient headquarters of the international African slave trade. Also on the grounds of Elmina Castle is an African Elder—a drummer, painted in white—who confronts the black model for desecrating the sacred space of the castle by using it as a backdrop for promoting Western-style tourism and consumerism. This space, says the elder, is a place of horror and death, the portal to the African Holocaust and a place where the spirits of those who were sent on the middle passage must be honored and remembered. Gerima then has the Elder lead the model down into the underground holding cells where she hears the cries of the ancestors who were brutalized there. Suddenly the dark spaces come to life with the story of the past. The model sees her ancestors approaching her and is transported to their reality. She then becomes a prisoner along with them. Gerima cuts to the next scene, and the model, our protagonist, is now the enslaved African woman, Mona, who will go on to love Shango and eventually rebel against her European captors.

Gerima's script then follows the story of Mona's enslavement. A powerful rebellion scene serves as the climax of the movie. As a resolution, Gerima cuts back to the frame story set in Elmina castle in the present. There, we see that Mona, who is now also living in the present but no longer as a model, has been redeemed by her historical experience of rebellion and liberation. She is seated near the Elder drummer. The black tourists who have

congregated at the castle sit alongside Mona. They are all listening intently to the Elder and watching for the Sankofa bird. The Sankofa bird appears, and we realize that is it the African symbol of spiritual return. We learn that the Sankofa bird has transported the character of Nunu, who was the spiritual leader of the slaves during the central story of the movie, back to her African homeland. Nunu too sits in contemporary garb amongst a group of tourists who surround the Elder.

The Sankofa mythos congeals around Gerima's storytelling devices. His theme, that all people of African descent must share the horror of the African Holocaust and witness the spiritual homecoming of the ancestors, is brought to the forefront of our consciousness as viewers. Gerima's unique method of storytelling embeds tremendous meaning into his historical tale of redemption.

Daughters of the Dust

Filmmaker Julie Dash's masterpiece, *Daughters of the Dust*, is a sumptuous celebration of African American women. Her script is layered with so many levels of meaning that one can go back to the film dozens of times and experience new revelations. On its surface, *Daughters of the Dust* tells the story of the Peazant family. It is 1902, and five generations are about to leave their home in the South Carolina Sea Islands to migrate north. The voice of the family matriarch and great-grandmother, Nana Peazant, comes up and over the visuals. She reflects upon the impending separation from her family. Nana Peasant has decided not to go. She must stay on the land where her ancestors are buried. Several pages later, Dash gives us another voice over. It is the voice of the character of "The Unborn Child" whose perspective is set in the future. Over the course of the film, these two perspectives—the past and the future—will merge to create a sense of cosmic circularity between the historical past and the living present. Take a look at the opening page of the script to understand the timelessness of Dash's writing.[2]

FADE IN:

EXT. SHAD PEAZANT'S FIELD, 1860 - DAY (SUNSET)

The rough, INDIGO, BLUE - STAINED, hands of an
African American woman. YOUNG NANA PEAZANT. She
is wearing an indigo-colored dress and holding Sea
Island soil within her hands. There is a great
WIND blowing. The soil, like dust, blows from her
hands and through her fingers.

 CUT TO:

EXT. IBO LANDING, 1902 - DAY (SUNRISE)

A place where barges and small boats from larg-
er ships can land. A decaying SIGNPOST READS: IBO
LANDING

We hear the sound of cicadas RUSTLING the Palmetto
forest.

NANA PEAZANT, now age 88, the great-grandmother
of the Peazant family is rising out of the water.
She is fully dressed. Nana is wearing TWO BELTS,
one around her waist and another belt strapped low
around her hips.

 WOMAN'S VOICE (O.S.)
 I am the first and the last.
 I am the honored one and the scorned.

 CUT TO:

INT. PEAZANT SHANTY - ELI & EULA'S BEDROOM - DAY

As the camera explores this bedroom, WOMAN'S VOICE
continues.

```
            WOMAN'S VOICE (O.S.)
    I am the whore and the holy one.
    I am the wife and the virgin.
    I am the barren one, and many are my
    daughters.
```

Considered a classic work of "oppositional cinema" because of its clear break from the Hollywood screenwriting tradition, *Daughters of the Dust*, nevertheless, received a theatrical release and quickly gained status within both the film community in general and within the community of African American women who flocked to see it. As inspiration for this project, Dash completed a great deal of research before writing the script. She learned that the islands off the Carolinas and Georgia coast were the main centers for the transatlantic slave trade and the region in the U.S. that retained the strongest legacy of our African heritage. Running especially deep in the culture of the Sea Islands was that of the Ibo people—a nation of millions located in the West African Niger Delta. Dash used the details of her historical research to inform every scene in the script. She even studied the language patterns of the region and scripted the dialogue in Geechee dialect.

Unlike the plot-driven screenwriting that typifies classical Hollywood cinema, or the character driven cinema of Europe, *Daughters of the Dust* is structured around short scenes that capture moments of historical revelation and immense cinematic beauty. The approach sounds random, but the final product is satisfying to watch. By piecing together personal thoughts, gorgeous images, historical details and intimate experiences of a family on the day of their journey north, Dash creates her own brand of poetic narrative. We can drink in the richness of her lyrical dialogue:

```
BACK TO BEACH

Iona and Myown have been taken into a spiritual
possession.  We continue to hear Nana's voice over
their actions.
```

 NANA PEAZANT (O.S.)
 (to Eli)
 Call on those old Africans, Eli.
 They'll come to you when you least expect them.
 They'll hug you up quick and soft like the warm
 sweet wind. Let those old souls come into your
 heart, Eli. Let them touch you with the hands
 of time. Let them feed you here with wisdom
 that ain't from this day and time.
 Because when you leave this island, Eli
 Peazant, You ain't going to no land of milk and
 honey.[3]

The tone of this monologue and many of the other interior monologues in the film lends itself towards epic poetry rather than the more realistic tone we are accustomed to in Hollywood cinema. The characters who speak this way become timeless goddesses, symbols of all African American women. Through the eloquence and heroic nature of the speeches structured often as monologue rather than as dialogue, Dash's scenes have a denseness and depth that cannot be fully understood with only one viewing.

Killer of Sheep
Named one of the "100 Essential Films" by the National Society of Film Critics, *Killer of Sheep* (1975), written and directed by Charles Burnett, is considered a masterpiece of experimental narrative filmmaking. The project was Burnett's thesis film at UCLA and was conceived as a reaction to the negative images that permeated the Blaxploitation narratives of the sixties and seventies. Loved by cultural critics, *Killer of Sheep* has been lauded as an example of the blues aesthetic in cinema. Writer, Armond White, sums up the experience of viewing Burnett's landmark film as follow:

How do we watch *Killer of Sheep* in the context of today's cinema? It requires a hard-nosed sensitivity. It necessitates an unsentimental awareness of beauty. It demands a tough confrontation with social truth reflected in art. Burnett's vision of daily life—random scenes of stasis and anomie, built from the accuracy of honest observation and enactment—produced a work of singular rhythm and integrity. The Los Angeles setting where Stan, his wife and two children reside among other desperate folk chronicles the pace of America's working class and underclass life; it offers no lyrical passages to suggest poetic grace. Rather, numerous scenes accrete a recognizable sense of reality—snapshots of truth about the post-Watts riots ghetto; hapless men who toil or plan robberies; women like Stan's wife (Kaycee Moore) and others who scoff at their mates with the ire of fatigued romanticism; and children who fill their time with play and interaction that unknowingly repeats the larger world's chaos.[4]

One aspect of *Killer of Sheep* that is particularly effective is Burnett's alternative use of tone. Burnett's scenes play out in a matter-of-fact way, in part, due to the scriptwriting, and, in-part, due to the camera framing and duration of the shots which dwell a little longer on the scenes than you typically would find in a narrative. This causes the narrative film to have a slight documentary feel. The long takes and matter-of-fact tone of the dialogue create a realism reminiscent of the Italian neo-realist films of the 1940s—films which focused on the effects of war and poverty on the post-fascist Italian society. Burnett's American realism presents an intense portrayal of American African poverty.

Dialogue in *Killer of Sheep* is noticeably sparse. Rather than moving the action along in conversations, Burnett opts to have his camera linger on characters whose interaction is limited to a few words while their actions and inactions tell the story. The technique creates a world of feckless relationships where characters are unable to connect in meaningful and productive ways. Along these lines, Armond White points out that Burnett's montage of boys jumping across roofs, at first seems like innocent play, but the longer we stare at the scene, we begin to wonder if it is not somehow a suicidal act.[5] Later, in another scene, again with little scripted dialogue, the boys play in a train yard. They pelt each other with rocks, and then one of the boys lays down on the tracks, conjuring up for the audience the image of his own violent death.[6]

As the story progresses, these moments of disconnection and potential violence come to a head. Burnett scripts for us a purely visual scene in which a group of boys throws mud on freshly washed sheets being hung out to dry by one of the girls in the neighborhood. There is very little interaction between the boys and the girl, only the seemingly senseless act of destruction of the girl's careful labor. Dialogue in this scene would diminish the impact. In *Killer of Sheep*, an incident that would be brushed off as a boyish prank in another film takes on the impact of a major tragic turning point.

Another alternative screenwriting strategy to look at carefully in this film is the way in which Burnett develops themes. In *Killer of Sheep*, Burnett uses the metaphor of the slaughterhouse to signify the destruction of the African American community of Watts. In his inaction and complacency, Burnett's main character, Stan, is a silent witness to the decay of his neighborhood. His relationship to his community is echoed in the scenes at his workplace. Stan bears daily witness to the mass executions of passive sheep during his job at the slaughterhouse.[7] Such poignant use of metaphor is not necessarily an alternative screenwriting strategy. What is unique in the screenwriting of *Killer of Sheep* is the way Burnett goes deeper with his construction of his metaphor. Burnett structurally mimics the inaction of Stan's character by intentionally subverting the throughline of the plot to his screenplay. Stan is a protagonist without a goal, and *Killer of Sheep* is a story without a plot. By refusing to adopt a traditional forward moving plotline, Burnett makes a most profound and ironic point: his character, Stan, needs a goal. Stan's goal should be to exist as a self-actualized man with meaningful, unambiguous relationships. He should take some sort of action in this morass of characters who cannot take a positive step towards communal transformation. It's a tribute to Burnett's skill as a filmmaker that he can turn the conventions of Hollywood filmmaking inside out. With no plot and no character arc, he tells a story that is compelling and heartbreaking.

INTERNATIONAL CINEMA
BLACK GIRL

Scripted in French under the title *La Noire De...* (1966) by the Senegalese writer-director, Ousmane Sembène, *Black Girl* is considered both a key work of both African Cinema and of World Cinema. The script follows the story of a young Senegalese woman who is working as a governess for a wealthy French family when she is tricked by this couple into going on vacation with them to the French Riviera. Once she gets to the Riviera, the African protagonist finds herself forced by this White couple to work as a common maid. She ends up living like a virtual prisoner in their vacation home.

The film highlights issues of racism and colonialism in a particularly effective way. The story is focused on the point of view of Diouana. We also see her European employers. Their personalities are filtered through Diouana's non-Western consciousness. *Black Girl* is set, ninety percent of the time, inside the confines of the vacation home, utilizing the claustrophobic space of the single location as a metaphor for the imprisonment of the African consciousness by the false promises of European Colonialism—the false assurances of the colonizers to provide prosperity and equality to their African colonies.

Donald Bogle[8] and others have pointed out the long history of Hollywood stereotyping of African American characters as Black maids and childcare workers portrayed as "mammies" in the mainstream media. Characters like Prissy and Mammy (yes, that's the only name she has in the script) in *Gone with the Wind* and Nell Carter's character in "Gimme a Break" are typical examples of the female stereotypes that have pervaded American movie and television culture. The negative mammy stereotype was perpetuwted to make it easier for European Americans to justify their exploitation of African American slave women and later African American domestic workers.

The mammy character in Hollywood films was scripted as selfless, unattached to her own family and happy to have the job of watching over white people and their children, whatever the pay. Contrary to this stereotyped view of the Black domestic worker, *Black Girl* scripts a series of interior monologues for Diouana that work by confronting the audience, forcing us to question these absurd mammy

characters perpetuated by Hollywood and European culture. The juxtapositioning of the outwardly passive Diouana with her angry and dissatisfied voiceovers creates a forceful and penetrating subtext in the film. The slow pacing and absence of much action in the script underscores the monotony of the protagonist's life as a maid. The lack of action on the part of the secondary characters, the European couple, also captures the malaise of their existence, signifying the inability of Europeans to act within their own culture and hence their need to colonize and exploit others.

The films of Ousman Sembène and many other works of African and international film directors and screenwriters can be a fruitful source of alternative cinematic grammar for your own screenwriting. There are many movies created with the experimental brilliance similar to what one finds in the scripting of *Black Girl* readily available for you to view. Force yourself to read subtitles. After a couple of films, you'll notice that you have learned to enjoy movies from other cultures. Moreover, as a screenwriter, you will discover that you actually appreciate seeing the written dialogue on the screen. Watching international cinema will help you to expand your understanding of film as an art form and as a powerful social medium that will push you to find your own creative voice.

WRITING THE SHORT FILM
THE BOY WHO PAINTED CHRIST BLACK

Writing a truly excellent short narrative is an extremely difficult task. As viewers, we have been programmed to expect the longer hundred-minute format of the feature. This expectation tailors our desire for a well-developed plot with complex characters and multiple storylines. In a short film, let's say ten to twenty minutes in length, the writer has very little time to complicate the plot and develop characters. Therefore, the best writers working in shorter formats tend to produce scripts that are very tightly written and that have strong, clever endings. If the script is a drama, the short film will often convey a profound concept. If it's a comedy, the screenplay will generally pack a great punch line at the end.

Many writers who also aspire to direct, begin the process of learning their craft by scripting a short film that they can produce themselves on a reasonable budget. Writers who see themselves

primarily as writing for the feature market may not want to delve into the short script format. However, with the tremendous popularity of short videos on the Internet, even the aspiring feature writer may want to dip his toe into the uncharted waters of short format scriptwriting.

To get a handle on the cinematic elements of the short form narrative, you'll want to view as many short films as possible. There is an excellent trilogy produced by HBO called *America's Dream* that contains three shorts directed by Bill Duke, Paris Barclay and Kevin Rodney Sullivan. *The Boy Who Painted Christ Black* was adapted from a short story by John Henrik Clarke. Set in the first half of the twentieth century in a Southern town, the script follows the character of George Du Vaul (Wesley Snipes) as the successful principal of the local Black elementary school. As the movie opens, a white state school board official comes to town and implies he will promote Du Vaul within the state school system if he continues to tow the line for the white school board. As a sign of goodwill, the school board official sponsors a painting contest for the children at Du Vaul's school. Among the many talented entries is a painting by a young boy depicting a black Jesus Christ. Du Vaul knows that if he picks the black Jesus painting as the winner, he will risk falling out of favor with the school board official. This set of circumstances launches Du Vaul into a personal conflict. Should he chose the work of this talented and deserving young student or succumb to the pressures of racism to get a promotion?

The film is beautifully done, and the script stands solidly on its own. Like a feature film, the story has a beginning, middle and end. It starts with the promise of a promotion for the teacher. It's complicated by the problem of the boy painting Christ black, and the story climaxes with Du Vaul's decision to choose to support the boy's beautiful self-affirming vision of a black Jesus. Like a feature film, the story follows one main protagonist, the principal, Du Vaul. The protagonist has a fully formed backstory and his character shows considerable depth of development. We learn that Du Vaul is not totally satisfied with his administrative position and upwardly mobile lifestyle. We discover that he has forsaken a career as a musician to please his wife and feels he is losing his sense of personal identity.

The protagonist also has a transformative moment. He finds the meaning that has been missing from his life when he takes a stand

against the racist culture that threatens to undo the positive aspects of black pride he has instilled in the students. In the end, Du Vaul realizes his work at this local black elementary school is meaningful and that he has made a positive impact on his students. The character arc is definitively drawn as Du Vaul's character experiences transformation by the end of the story. The dual antagonists of the white school board official coupled with the lure of the money and prestige of the promotion prove to be formidable obstacles for Du Vaul to overcome. Du Vaul's final decision to risk his promotion and encourage the black child to affirm his black identity lead to a truly heroic ending.

As you can see from this example, although a good short film cannot have the same depth of story and character development as a feature, it can still have strong structure and well drawn characters. Certainly, the message and concepts brought forth in a short film can be just as compelling as those in a feature. *The Boy Who Painted Christ Black* is a simple and eloquent script that you will not easily forget.

Chapter Eight Exercises

1. Watch at least three alternative films, preferably from those mentioned in this chapter so that you can use the analysis provided in the chapter as a starting point for your own film. After watching each film, ask yourself, "What you like and dislike about the film?" Discuss these likes and dislikes with your writing group. Compare opinions. You may discover new approaches to writing and filmmaking that you had previously not considered.

2. If you are interested in writing a short film, approach it the same way as you would the feature film. With your short film in mind, go back and do the exercises in each of the previous chapters in this book. Create a synopsis, character bios, scene outline, and then start writing the actual script. Estimate the length of your movie at one page of script for each minute of screen time.

PART TWO
WRITING FOR TELEVISION

CHAPTER NINE

Writing For Television

If you have read, studied, and performed the exercises found after each chapter in Part One, you have already prepared yourself with much of the necessary knowledge to become a successful television writer. Like film, television requires a strong story, great dialogue, and well-crafted characters. Although the same basic writing skills are used in both film and television, breaking into the television industry requires even more intense networking than breaking into the film industry. In order to unravel Hollywood television's tight-knit system, your work and your people skills must both be top notch.

Unfortunately, from the late 1960s up to the present, African Americans have had to struggle long and hard to ease the racial barriers set up by television production companies, the networks, and advertisers. In 1950, Ethel Waters became the first African American to star in a network television series called *Beulah*. The program was based upon a popular radio situation comedy. The radio program starred Oscar-winning actress Hattie McDaniel who reportedly fought hard to play her role of domestic servant to a white family in a non-stereotypical manner. In fact, it is said McDaniel had a clause written into her contract giving her final script approval. However, when Ethel Waters was cast to play the Beulah character on television, she found she quickly grew frustrated with the one-dimensional way the television writers had scripted her domestic servant role. After the second season, Waters left the show in protest. McDaniel was cast to replace her, but tragically, died during the filming of the third season. McDaniel was then replaced by Louise Beavers who, like Waters, resigned from the show in protest over the demeaning mammy stereotype she was being forced to play by the white writers and producers of the show.

In 1951, CBS broadcast the television version of another top-rated radio comedy series, *Amos 'n' Andy*, which became the first television show with an all black cast. The series proved to be a big money maker for the network, but many African Americans were insulted by the way the television show depicted black culture and lifestyles. The National Association for the Advancement of Colored People (NAACP) initiated a nation-wide protest, which ultimately led to the canceling of the series. Despite the accolades for the talented black cast members, not one single script included the knowledge and expertise of a black writer.

Here is the list of grievances published in a paper by the NAACP, entitled, "Why the *Amos 'n' Andy* TV Show Should Be Taken Off the Air":

It tends to strengthen the conclusion among uninformed and prejudiced people that Negroes are inferior, lazy, dumb, and dishonest.

Every character in this one and only TV show with an all-Negro cast is either a clown or a crook.

Negro doctors are shown as quacks and thieves.

Negro lawyers are shown as slippery cowards, ignorant of their profession and without ethics.

Negro women are shown as cackling, screaming shrews, in big-mouth close-ups, using street slang, just short of vulgarity.

All Negroes are shown as dodging work of any kind.

There is no other show on nation-wide television that shows Negroes in a favorable light. Very few first-class Negro performers get on TV and then only as a one-time guest.

Amos 'n' Andy on television is worse than on radio because it is a picture, a living, talking moving picture of Negroes, not merely a story in words over a radio loudspeaker.

Millions of white Americans see this *Amos 'n' Andy* picture of Negroes and think the entire race is the same.

Millions of white children learn about Negroes for the first time by seeing *Amos 'n' Andy* and carry this impression throughout their lives in one form or another.

Since many whites never meet any Negroes personally, never attend any lectures or read any books on the race problem, or belong to any clubs or organizations where intergroup relations are discussed, they accept the *Amos 'n' Andy* picture as the true one.

An entire race of 15,000,000 Americans is being slandered each week by this one-sided caricature on television, over the Columbia Broadcasting System, sponsored by the Blatz Brewing Company, to advertise and sell Blatz beer.[1]

Unfortunately, decades later, many of the same complaints launched against television networks and television advertisers by the NAACP in 1951 can still be applied to the current American media industry. While there have been a number of excellent roles written for African American actors over the years, television is still lacking in the variety of African American characters it shows, and TV falls short in terms of the variety of genres it broadcasts with African American protagonists at the helm. While stereotypical images are starting to go by the wayside, one need only look at any African American actor's resume to see there is still a tendency on the part of the networks to marginalize black actors into supporting roles and away from leading roles.[2] A great number of African American parts are relinquished to guest roles as "crack-whores" and "drug dealers." To underscore the extent of the problem, one must realize that, during the fall season of 2012, there were no prime-time dramatic television series on the air created by an African American that featured a predominantly African American cast.

Of course, we do not want you to imply from this book that we think African American writers should only write for African American characters or that European Americans cannot write for a series with a predominantly African American cast. In the next section, we look closely at the work of African American television writer Shonda Rhimes. With her long-running series *Grey's Anatomy* and other successful prime-time series, Rhimes has earned her place among the most successful showrunners in television history. Her shows feature Caucasian and African American women as central

protagonists. Rhimes also includes strong leading male characters and storylines.

Following the chapter on dramatic television writing, we will deconstruct the writing on two classic African American-scripted sitcoms: *The Bernie Mac Show* and *Girlfriends*. As models of outstanding television writing, the entertaining characters and storylines created by the writers on those shows offer enduring multi-dimensional depictions of African American culture while at the same time giving us an honest laugh on every page.

Chapter Ten
Writing The Television Drama

Writing for episodic television is a different experience from writing for film. In film, unless the screenwriter has a producing deal, he or she is usually not involved in the production and postproduction phases of the project. In television, it is often the case that the writer who creates the show will be assigned to work with several Executive Producers while learning the ropes, and then eventually that writer/creator will be the one who is given the responsibilities of showrunner. As a showrunner, he or she will be in charge of a team of writers and responsible for every aspect of the production.

Starting your career in episodic television usually begins with a freelance writing gig. Unlike an "in-house" writer, the freelance writer is paid to write a single script. Sometimes, as a freelance writer, you will be paid to write the story but not the teleplay. If you are an unknown writer, the contract you are given will often include an option to allow the producer to take your story and have someone else write the teleplay. Don't get discouraged if this happens. Consider any writing job you land as a step closer towards reaching your goal of having your work produced.

To get your foot in the door you'll need to write a television "spec" script, remember, that's a script written on speculation. Though most showrunners will be willing to look at a variety of types of writing samples from prospective writers, such as plays and short stories, they will also want to see at least one sample television script from you. This spec script will be a script you will write to demonstrate your writing talent in order to land your first job, so it must be your very best work. It's normally the case that no producer will offer to buy your television spec script, but due to the labor you've put into

your spec, you might be offered your first chance to be paid to write a script for an existing episodic series.

When choosing what show to spec, you should pick a hit show, one that is currently in production (not in reruns—even though it might be a classic). Be sure the television series you choose to spec hasn't been around for too long, because it might go off the air before you can get your spec into the hands of a showrunner or producer. Remember, Hollywood wants to hire writers who can write for what's current. Also, you should love to watch the particular show you are going to spec. You should watch every episode of the series and make yourself an expert on the characters and storylines.

Another way to approach selecting a series to spec is to contact someone at the show you want to write for. You can get a contact number from *IMDB Pro*, or you can look through the trades to find the phone numbers of production companies. Call and ask an assistant if the showrunner is accepting spec scripts, and, if so, what shows, are currently on the air, would they like to see you spec? Not many showrunners will want to see a spec script for their own show. They have inside information about the direction of the story arcs, themes, and the characters that you are not privy to. There are exceptions to this. On rare occasions, some showrunners do accept scripts for their current series and welcome the new insight your spec could bring to their series. In any event, the best approach is to politely ask what the showrunner might want to see from you. If the assistant says the producers are not accepting spec scripts, be courteous. Thank him or her. Don't be discouraged. Just call another show.

The WGA recommends before you start writing a spec script for a particular show, you should also request from the show copies of synopses, story outlines, character biographies, a show bible, and/ or sample scripts. The *show bible* is a document that is kept by some shows to explain to new directors and writers the internal style and logic of the show. Many shows don't keep a bible. Some have bibles that are only a few pages long. Soap operas that have been around for years might have bibles that are nearly a hundred pages long. The bible breaks down the show in terms of backstories, arcs, ambiance, sets, structure, and anything else the showrunner wants to be consistent from episode to episode.

Also, don't try to send a half-hour situation comedy script to a serious dramatic show and vice versa. Your spec script should be selected from the same genre of dramatic television you want to write for and should be absolutely the best possible example of your writing ability. If it's not good enough, write a couple of more episodes, and then see if one of those is sparkling enough to send out. You must not put substandard work out. Your professional reputation is at stake.

For a firsthand account of the way the writing positions in television are structured, check out the interviews with television professionals in the last section of this book. We also recommend you look at a book by Pamela Douglas called *Writing the TV Drama Series* which give great tips for dramatic series writing. Additionally, the WGA website contains a useful booklet under the writer's resources link called "Writing for Episodic TV: From Freelance to Showrunner." Created by guild members, the booklet will give you a concise overview of what the television industry writer does on a day-to-day basis at each level of the writing hierarchy.

WHAT SERIES SHOULD YOU SPEC?

As we mentioned above, ideally, when you write your television spec script, you need to watch all past episodes over all of the seasons of the television serial to be able to write well for that series. This is because you need a complete understanding of the backstories, narratives, and character arcs in the show before you write. You want to avoid missing a crucial aspect of the arc of the show. Knowledge gaps in your understanding of the narrative will make your script irrelevant before you even start writing. Also keep in mind that the number of episodes in a dramatic series changes from season to season, from network to network and from show to show. While a typical television drama on the networks used to run for an average of 22 episodes, there is no longer a set number of episodes that constitutes a season for a dramatic series.

Dramatic television series also vary greatly according to genre. Some dramatic series consist of stand-alone episodes: stories that are essentially independent of one another. *Law and Order: Criminal Intent* is a good example of this type of show. Each episode is self-

contained and ties up all of the plot development in a single hour time-slot. This sort of crime genre is known as a "procedural." Other dramatic television programs like *Grey's Anatomy* use character arcs that are continuously updating, much like the character arcs you find in soap operas. The showrunner of this type of series will create an outline for the entire season, generating a roadmap for the arc of each primary character and each major storyline. The outline will specify what needs to happen in every episode with the character development so that each character ends up at the right place emotionally by the season finale. The showrunner of such open-ended serials will give the season outline to the staff writer. The staff writer brings back the draft of the completed episode to the showrunner who subsequently goes over the draft either alone or with the help of the writing staff. The showrunner's goal is to unify the dialogue and plot details so that the tone and theme of the series is cohesive and maintains the distinctive voice of the showrunner throughout the series.

ANALYZE YOUR SERIES BEFORE YOU WRITE

Just as it's important to learn to write feature films by studying a variety of feature films by category/genre and outlining the act structure, turning points, climax, and resolution, it's crucial to understand the structure of a television show by examining several episodes in careful detail. Remember that, unless you are writing a pilot, in television you are always trying to reproduce the showrunner's writing structure, her story template, her voice. As a staff writer, your individual voice will be secondary. You will be paid to write like the showrunner. After all, the series is the showrunner's baby. You need to always be aware that showrunners are looking to hire writers who can write for the show, not against it. This means you want to write within the organic creative boundaries of that particular program. Audiences tune in to a show expecting a signature framework and tone that makes the show interesting and enjoyable for them. You don't want to introduce anything new in your spec script that the audience has not been accustomed to expect from the show.

DRAMATIC TELEVISION STRUCTURE

In television, the length of your script will depend upon whether or not you are writing an hour or half hour show. Dramas typically run in an hour-long time slot. Certain shows, like *Entourage*, which is considered a "dramedy," or *In Treatment*, which utilized its own original type of formatting, are examples of dramatic serials written for a thirty-minute time slot. Another difference between film and television to consider, unless it's premium cable you're writing for, your show's time slot will also be filled with commercials. On average, the one-hour drama will run closer to forty-two minutes. The script for an "hour-long" episode can run anywhere between forty-two to sixty pages of single- spaced dialogue, depending on the genre and pacing of the show. A half-hour drama will run around twenty-one minutes, and the script will be approximately twenty-one to thirty pages with single spaced dialogue.

The hour-long drama will often have a five-act structure, depending on how many commercial breaks the series has. Most shows will include a *teaser* that is a short scene or series of scenes that open the show. Teasers are intended to get the audience locked into the story before the first commercial break. *Grey's Anatomy* has five acts and a teaser. Each of the five acts of a television drama should end with what is known as an *act break* or an *act out*, a narrative turning point or moment of reflection that happens before a commercial. The act out is a clear-cut example of how industry demands dictate artistic structure. As the Internet becomes more dominant as a distribution venue for programming, it may happen that the artist/screenwriter will have more control over the structure of television shows and that commercial breaks will no longer exist, eliminating the need for act breaks.

Unlike a feature-length screenplay for a film where the three separate acts are implied by the narrative structure but not explicitly listed on the page headings, a television script lists the beginning and end of each act clearly on the paper. For most television formats, it is a given that the commercial breaks will drive the narrative structure of your episode. Therefore, you will need to structure your story even more carefully for television than for your feature. You cannot be over or under the timing requirements for each act. For a one-hour drama, each act is about ten minutes long. You can determine

the exact length by timing actual episodes of the series you intend to spec.

Nevertheless, the best way to discern a show's act structure is to acquire an actual script from the series and study it carefully. If you're writing a script for a television drama, it is advisable to watch all the episodes and closely analyze at least three episodes of the show. Pick three "typical" episodes to dissect. Don't use an unusual or "rogue" episode, such as one where a central character is killed off during ratings week or a "to be continued" episode airied to capture ratings. As you watch, write down the number of scenes in each act and whose storyline is followed in each scene. A dramatic television show will typically follow several story lines in each episode. The 'A' story will be for the central character or other series regulars. On *Grey's Anatomy* the central character is Meredith. The series regulars on that show are the other interns and the teaching physicians.

Sometimes a show will follow the A storyline and the B storyline with equal weight. With other shows, the B and C stories might be relegated to the supporting characters. You will find lots of variation as you study the story structure of different episodic television series. As you watch, you'll notice that structure is what makes a show distinctive. For ensemble shows there may be no central character. On *Lincoln Heights*, the showrunner traded off carrying the A plot from week to week between the ensemble cast of characters. Some shows may only have a single A plot. *Law and Order* follows only the crime storyline each week.

Another thing to watch for as you analyze your series are the standing sets. Hour-long television dramas have limited production budgets. Typically the director will shoot for only one week using the same sets throughout the season with a minimum of new locations. Therefore your spec should not include new sets or locations that are not normally used in the series.

We recommend that you count the number of minutes in each act of the episode you are analyzing. To help you with the analysis of your episode, we've included a breakdown of the pilot from *Grey's Anatomy* according to page-lengths for each act

.

Part of Episode	Pages	Duration
Teaser	1-3	2-3 min
Act One	4-15	8-11 min
Act Two	16-26	7-10 min
Act Three	27-33	4-6 min
Act Four	34-41	6-7 min
Act Five	42-49	6-7 min

BREAKDOWN OF ACT ONE OF *GREY'S ANATOMY* PILOT

Act/ Scene Number	Location	Recurring Plots and Subplots	Characters in
I/1	Surgical Suite	#1= Will Meredith make it through her first shift?	Meredith
I/2	Meredith's Living Room	#2= Will Meredith and Derek find true love?	Meredith and Derek
I/3,4,5,6	Seattle Streets/ Surgical Suite	#3=Which interns will make it through the seven year internship?	Richard, Meredith, and all the Interns
I/7,8,9	Lockers, Nurse's Station, Hallway	#3, #1= Plot expanded to— will Meredith's new friends, Izzy, Cristina, and George, also make it through the shift?	Meredith, Cristina, George, Bailey, Izzy
I/10,11	Helipad/ Patient Room	#1, #3, #4 =Will they cure patient Katie Bryce?	Bailey, Doc, Nurse Tyler, Burke, George, Meredith, Cristina, Patient Katie
I/12	Patient Room	#5—Izzy—Can she handle giving the rectal exam?	Izzy, Patient

I/12	Patient Room	#6 Will Cristina get to scrub in?	Cristina, Bailey
I/13	Tony's Hospital Room	#7 Will they cure patient Tony?	George, Gloria the Wife, Tony
I/13A	Elevator/ Tunnels	#4	Meredith, Katie
I/13A	Patient Room	#5	Izzy, Patient
I/13B	Patient Room	#7	George, Tony

You can also create a chart to track the recurring use of various plots in the series. This chart demonstrates one approach to systematically analyzing the structure of the pilot for Grey's Anatomy. Read through the chart, and then extend it to cover the entire five acts of the show you are analyzing. Then use it to analyze at least two more episodes scene-by-scene, act-by-act, of the series you intend to spec.

THE INTERNAL RULES OF YOUR SHOW

Every successful dramatic series has its own internal logic—a set of rules that determines the essence of the show. Beyond the dramatic structure and pacing, a successful show will contain key elements that appear in every script. For instance, certain locations or standing sets will be fundamental to every episode of a show. In the first season of *Grey's Anatomy*, we are at the hospital for at least 90 percent of each episode. These are interior locations with an occasional scene taking place outside somewhere on the hospital grounds. Other locations that might appear briefly in an episode of the first season of *Grey's Anatomy* include the homes of the main characters, the bar across the street, and, sometimes, places where the characters go for a date. There is also an occasional visit to the nursing home where Meredith's mother lives.

In *Lincoln Heights*, the neighborhood is completely integral to the development of every episode. Plots revolve around the underlying theme of community and family represented by the main character's ongoing motivation to stay in this working class predominantly African American neighborhood. Over the four seasons that the show aired on the ABC Family network, the series explored many interesting storylines and themes that arose organically from the type of conflicts that are generated by the setting. As an example of how important location can be to a series, consider the season four opener of *Lincoln Heights* called "Home Again." In that episode, Kathleen McGhee-Anderson created an "A" story line around the family's decision whether or not to move out of Lincoln Heights into a more affluent predominantly white community. McGhee-Anderson set up the story with intense dramatic conflict by intersecting a number of ongoing story threads around the main character's decision whether or not to move his family away from the community where he grew up and worked. The underlining themes of the protagonist's commitment to the individuals on his block and to the African American community in more general terms are carefully explored. For her writing on this well-crafted episode, the NAACP nominated McGhee-Anderson for an Image Award.

Other internal rules for writing on a particular television show might also include common stylistic elements you find in every episode. For example, a typical *Grey's Anatomy* script incorporates a voiceover by the character Meredith. The voice over is used to open and close most episodes and consists of brief moments of self-reflection on a theme that is developed throughout that particular episode. For instance, in the pilot episode, Meredith speaks in voice over about her surgical training as "a game." The pilot develops that theme of learning to play the game, turning it into a metaphor for learning to trust oneself and one's colleagues in the highly competitive environment of Meredith's surgical internship.

The point of view of a series can also be considered a mark of its internal logic. The stories on *Grey's Anatomy* focus on the point of view of the doctors. The scripts rarely dwell closely on the stories of the patients, but rather on what the residents, interns, and other professionals at the hospital learn professionally and personally from their interactions with these patients.

The point of view on *Lincoln Heights* always includes both that of the two parents and of their various children. By shifting the points of view between these diverse age groups of characters, the show appeals to both young people and to adults, effectively creating a broad audience.

THE ESSENTIAL STORY STRUCTURE OF YOUR SPEC

In television writing you need to pay close attention to structure. As we discussed in the film section of this book, the first step in structuring your story is to map out the major turning points. Television writers call this process "breaking the story." Let's use *Grey's Anatomy* as an example. If you were writing a spec for *Grey's Anatomy*, you would have to come up with an initial dramatic incident, the A storyline introduced in the teaser. In episode one of *Grey's Anatomy*, Rhimes sets up her premise—Meredith's first day on her surgical internship. We learn that the stakes are high—it will take seven years of training for Meredith to become a surgeon and, in the end, only a couple of the interns will actually succeed. The plot question for story A is introduced—will Meredith survive this shift? And a plot question for the entire series emerges as well—will Meredith survive the seven-year surgical training period?

After the writer knows what the initial incident will be, he or she comes up with the turning points for the A storyline. In this sample episode of *Grey's Anatomy*, the basic premise of getting through the shift is complicated by the fact that a guy Meredith has a one-night stand with in the opening scene of the pilot turns out to be her supervisor. This plot point serves as the act out incident at the end of Act One and becomes the first turning point for story A. In Act Two, Meredith tries to squash any ideas Derek, the one-night stand, has about continuing their dating relationship. In the second act, Meredith also meets the parents of her first patient, an annoying teenage girl named Katie who suffers from unexplained seizures. By the end of Act Two, Meredith is faced with another turning point—her first big medical decision. She must take action to save Katie during a massive seizure. In Act Three, Meredith saves Katie's life. This is followed by a scene in which Meredith runs outside and suddenly vomits from the pressure of the emergency

she just faced. In Act Four, the intensity is ramped up a notch higher. Meredith confesses to fellow intern, Cristina, that she slept with her supervisor, Derek. Meredith goes on to solve the medical mystery of what's causing Katie's seizures, but then offends her friend Cristina (who now knows her embarrassing secret) by breaking a promise Meredith made to let Cristina have the opportunity to assist Derek with a brain surgery case. In Act Five, Meredith is present in the operating room for her first surgery. Any misgivings she had about her career path and making it through her first shift seem behind her now. Meredith realizes that she loves surgery and performs admirably in the surgical suite as Derek's surgical assistant. Meredith also makes up with Cristina by apologizing. At the same time Meredith goes on to achieve a level of comfort in her ambiguous romantic relationship with Derek. In the coda or tag ending, we see Meredith visiting with her mother, who we have learned was a famous surgeon who is now in a nursing home. We discover Meredith's mother suffers from severe dementia.

If you were the showrunner writing this script for *Grey's Anatomy*, you would next develop the other storylines for the supporting characters, act by act. Several subplots or secondary storylines— like the patient cases—would need to be resolved within the episode, and other storylines—like the romantic storylines (i.e. Derek and Meredith)—would be left open as longer term arcs for the rest of the season.

It is easiest to beat out the major plots and subplots separately, and then weave them together according to acts in the form of one overall outline. Some writers use colored index cards—one color for each story thread as an organizing tool. They line up the cards in rows corresponding to the act structure of their show. By doing this, they create a visual diagram of which story beats happen during which act of the episode. You will find the index card system convenient because you can rearrange your diagram of cards so that it matches the chart you made when you analyzed the three episodes of your show. First color-code the chart of the episodes you analyze. Then when you outline your own original spec, you can simply add, shuffle, and/or subtract cards until your diagram for your spec appears similar to the analysis of the three episodes of the show you watched.

ACT BREAKS

Now let's study an example of how Shonda Rhimes uses act breaks in the pilot episode of *Grey's Anatomy:*

Teaser Break: Meredith wakes up with Derek, who we learn is her one night stand. She says goodbye, rushes off to work. It is her first day on a surgical internship. Before going to commercial we learn that only two out of the 20 interns will go on to become surgeons.

First Act Break: Meredith discovers that Derek is her boss.

Second Act Break: Meredith's first patient is seizing. Meredith must make a decision but can't seem to react fast enough.

Third Act Break: Meredith's character becomes increasingly more exhausted and frustrated in this act until Derek creates a competition among the interns. As the act ends, Meredith learns that the winner gets to scrub in on an advanced surgical procedure with Derek.

Fourth Act Break: Meredith realizes she has betrayed Cristina and offers to let Cristina scrub in on the surgery with Derek, but Cristina refuses the offer. George has to tell the wife of his patient that her husband died during bypass surgery.

End of Episode/Act Five: Cristina and Meredith reconcile. Meredith and Derek's romantic relationship has possibilities. The interns survive their first shift. We learn that Meredith must manage her mother's dementia in upcoming episodes.

CREATE THE SPEC STORY OUTLINE/THE BEAT SHEET

The *story outline* is also sometimes known by other names such as *beat sheet, beat outline* or *step outline.* The story outline maps each important narrative incident and turning point. Television writers refer to the incidents in the story as story beats. Like a scene outline of a feature-length screenplay, the story beats are listed in chronological order to create an overview of your plot structure. A beat outline differs

only slightly from a scene outline in that a beat can happen over several scenes. However, don't get too hung up on the difference between a detailed outline and a beat sheet/ beat outline. They are both essentially a diagram of your plot: a functional roadmap of what happens at what time in the story.

Let's look at a beat sheet for the pilot episode of *Grey's Anatomy*.

Teaser
- MEREDITH'S LIVING ROOM: We meet our protagonist MEREDITH GREY who has just awoken from a one-night-stand with DEREK—a guy she picked up at a bar the night before.
- SEATTLE GRACE HOSPITAL: It is Meredith's first day at work. She arrives at Grace Hospital in Seattle to discover that she is one of 20 surgical interns, in a mostly male cohort.
- SURGICAL SUITE: The chief of surgery, RICHARD WEBER, scares the interns with his welcome speech. He lets them know that, while these next seven years will be some of the most rewarding years of their lives, they will also be some of the worst. He tells the interns that most of them will fail or decide to leave. Few will ultimately become surgeons.

Act One
- HOSPITAL LOCKER ROOM: The interns—GEORGE, CRISTINA and IZZY—introduce themselves to Meredith.
- NURSES' STATION/FLOORS: The interns are assigned to work under more senior surgeons for forty-eight hour shifts. We meet the supervising surgeons. BAILEY is tough. BURKE is abrasive.
- ROOFTOP/PATIENT'S ROOM: The first patient, KATIE, a teenager, arrives. She has severe seizures. The interns fumble around as they try to sedate her. Izzy is assigned to spend the day doing rectal exams.
- SURGERY ROOM: Cristina approaches Bailey to get Bailey to appoint her as the first intern in the OR. Bailey dismisses her request.
- PATIENT TONY'S ROOM: Second patient is introduced, TONY, who needs heart bypass surgery.

- ELEVATOR/TUNNELS: Meredith is badgered by Katie who tells her that she competes in teen beauty pageants and that she fell while performing at a gymnastics competition.
- LUNCH ROOM: The interns discuss the fact that Meredith's mother is a famous surgeon. Meredith joins them and complains about her teenage patient. Burke walks by and insults George. Burke selects George to be the first intern in surgery.
- NURSES' STATION: Bailey tells Burke to go easy on George because he was the weakest applicant for the internship program.
- PATIENT'S ROOM: Meredith comes face-to-face with Derek and discovers he is a surgeon and one of her new supervisors.

Act Two
- STAIRWELL: Meredith tells Derek she wants to put an end to any future romantic involvement with him, but he says he is still interested in her.
- GALLERY/SURGERY: The interns watch as George fails at his first attempt at surgery, almost killing the patient. ALEX calls him "007," meaning George has a license to kill. Burke humiliates George in front of all the other interns. Burke saves the patient.
- TUNNELS: The 3 interns discuss their views on surgery with each other. Meredith receives an emergency page.
- KATIE'S ROOM: False alarm. Meredith scolds Katie for summoning her.
- PATIENT'S ROOM/HALLWAY: NURSE TYLER tells Izzy that she'll need to wake Bailey to show Izzy how to do a procedure on a patient. Bailey, tired and annoyed, does the procedure.
- POST-OP: Alex shows disdain for a patient and insults Meredith by referring to Meredith as a nurse.
- KATIE'S ROOM: Katie is violently seizing. Meredith chokes under pressure and does not know what to do.

Act Three
- KATIE'S ROOM: Katie's heart stops. Meredith grabs the crash cart and gets Katie's heart going again. Derek comes in and takes over.

- EXTERIOR HOSPITAL: Meredith exits the hospital and throws up from the pressure of almost losing her patient's life. Cristina sees this. Meredith asks Cristina not to tell anyone. The women bond.
- LOBBY: Derek is now Katie's doctor but does not know what is causing Katie's seizures. Her parents want Derek off the case.
- TONY'S ROOM: Tony, the bypass patient, is prepped. George assures Tony's wife that her husband will be fine.
- CONFERENCE ROOM: Derek calls a meeting of all the interns. He tells them that the intern who solves Katie's case will get to scrub in with him on an advanced procedure.

Act Four
- POST-OP: Alex speaks badly about a patient, saying she is too old to matter to him. Cristina and Meredith agree to work together to solve Derek's case.
- LIBRARY/ELEVATOR/ANGIO SUITE: Meredith tells Cristina that she had sex with Derek. Meredith figures out that Katie could have an aneurysm, and she and Cristina both tell Derek. Derek picks Meredith to scrub in. Meredith does not turn down the offer. Cristina feels betrayed.
- OR/SCRUB ROOM: Burke's bypass patient dies on the table. When he finds out that George had promised the wife that the bypass surgery would be without risk, Burke assigns George the task of breaking the news of the death to the family.
- POST OP: Meredith offers to let Cristina scrub-in in her place. Cristina declines the offer.
- WAITING ROOM: George tells the family of the bypass patient that he is dead.

Act Five
- OBSERVATION ROOM: Meredith wants to know if the reason why Derek picked her for the surgery is because she had slept with him. He says she earned the right to be in surgery through her work at the hospital.
- EXTERIOR HOSPITAL: Meredith and George talk about what their parents think of their son's and daughter's decisions

to be surgeons. We find out George's parents are proud and that Meredith's mom told Meredith she thinks her daughter doesn't have what it takes to be a surgeon.

- POST OP: Richard is angry with Alex for not knowing the proper procedures to care for the older patient in post-op. Meredith shows she does know exactly what to do for the older patient. Richard tells Meredith he recognizes her, and we find out Richard knows Meredith's mother.
- OR: Meredith experiences the exhilaration of her first surgery.
- OUTSIDE THE OR: Cristina and Meredith make up. Cristina leaves. Meredith and Derek have a bonding moment.
- PARKING LOT/NURSING HOME: Meredith leaves work with the other interns. She then visits her mother in the nursing home. We discover her mother has dementia and does not remember that she was a great surgeon.

Signature Characters For Television

If you look at the *Grey's Anatomy* pilot, you'll see that the creator and showrunner, Shonda Rhimes, establishes the essence of the central characters in the first few pages of the script. George is naïve and awkward, but endearing, exceedingly honest, and compassionate. Cristina is driven and will do anything to be on a surgical case. Cristina lacks a bedside manner, and her blunt nature can get her in trouble. Meredith is vivacious and smart. She is somewhat fickle, but has a good heart. According to the *Grey's Anatomy* website, "She [Meredith] is the glue that holds the emergency room together."

In addition to creating likeable characters, Rhimes develops interesting flaws for each one of her regulars. We see right at the top of Act One of the pilot that George has a tendency to put his foot in his mouth, and we also learn that Cristina's drive can lead her to be too pushy. We realize that Meredith's penchant for risk- taking and sense of adventure—in this case exemplified by the one night stand she has with a stranger—can have a tendency to lead her to mess up her personal and professional lives.

What makes Rhimes' characters so interesting is that their weaknesses are as integral to the narrative as are their strengths. According to the show's website, Meredith's weaknesses are that

"Meredith doesn't understand that it's okay to ask for help which sometimes can lead her to getting in over her head. She claims she's fine, but I sometimes can't help but wonder." This aspect of Meredith's character—independence bordering on loneliness—is the subtext of her character's personality that runs throughout the entire series. You'll find that all compelling characters on television have some sort of flaw that creates subtext and dimensionality in their interactions with other characters. Subtext gives characters viability over several seasons and makes them popular with viewers.

How To Write A Dramatic Television Plot

A television pilot is one of the most difficult things you will ever write and one of the toughest you'll ever try to sell. Nonetheless, you shouldn't let that stop you. If you have a great idea for a dramatic series, you would be crazy not to go ahead and put it on paper and copyright it. Here are the steps you need to follow when writing your original pilot.

Select a Format

Just like with your feature, when you write your pilot you need to go through a very deliberate process of organizing your ideas before you put any dialogue on the page. First, you'll need to figure out what type of format you'll be working with. Will it be a more traditional hour-long show or something with an unusual structure, such as 24, where the premise of the show is to tell a story that takes place over 24 hours with each episode happening over a single hour of real time? Another example of an atypical drama is the HBO series *In Treatment.* This series was structured around a format where the individual episode consisted of an approximately twenty-five minute therapy session between a troubled middle-aged therapist and one of his four patients. The episodes were developed in groups of five. The therapist sees each patient individually, one each day, and then on the fifth day, the therapist, himself, goes for counseling to talk about how he feels about his own life and his reactions to his patients' problems.

CREATE CHARACTERS

After you have a basic idea of structure, you'll want to do detailed character bios for all the central characters as well as for the supporting characters. Go back to Chapter Three on creating characters in films in Part One of this book and use the information in that chapter to help you get started. Each bio should be at least five pages long or longer. Keep writing until you feel as if you are living in the skin of that character. Do this for all of the central and supporting characters.

You will probably never be asked to show your extended bios to anyone, but writing them will force you to thoroughly develop all your characters. With well-developed characters, your pilot will glisten.

OUTLINE THE FIRST SEASON

If you are writing a long-form serial where the story will be open-ended, you'll need to construct an outline of all the major narrative arcs you will be developing over the course of the entire first season. An easy way to organize this is to list each character and then plot the major events that will happen to each one of them during the first year of the show.

For instance, if you were plotting out Meredith's narrative arc on *Grey's Anatomy*, you would mention the following plot points:

- Meredith meets Derek in the first episode, and there is chemistry between them.
- When she finds out he's her boss, she tries to end the relationship, but a few episodes later decides to throw caution to the wind and gets involved with him anyway.

- They date, but soon Meredith starts to realize the relationship feels one-sided, so she pushes for more intimacy from Derek.
- Just when she feels like she's starting to really trust him, Derek's wife shows up and tells Meredith that Derek has been married all along. Meredith ends season one confused and devastated.

Each of the other interns on *Grey's Anatomy* also has his or her own arc to be mapped out over the course of the first season. Cristina and Burke have an intense romantic narrative. Burke and Derek have an on-going professional rivalry. George has a crush on Meredith that he tries to sublimate, and so forth.

If your episodes are going to be completely closed-ended, meaning they can each stand alone without the need for the audience to follow any on-going narrative from show to show, then you will not need to outline the whole season. A series like Law and Order, which is also known as a procedural crime drama, has this type of structure. Closed-ended serials such as this sell well in syndication because broadcasters can run episodes of a close- ended serial in any particular order without fear of losing the audience.

WRITE A ONE-PAGE SYNOPSIS FOR EACH OF THE FIRST SIX EPISODES

This is where your series idea is truly tested. You need to come up with the general plot information for at least six additional episodes of your original series before you write your script for a pilot. The concept for the show must be strong enough that you can easily come up with subsequent episodes. Your characters must have sufficient dimensionality, and your underlying narrative premise for the series must be deep enough to allow for long-term show development.

Shonda Rhimes had these essential story and character elements well thought out for *Grey's Anatomy*. Rhimes based her dramatic series on a perfect premise. Meredith and the other interns need to complete a seven-year surgical internship. Thus, from the very start of the serial, Rhimes blessed her show with a minimum of seven years of narrative momentum. The characters also embody the right amount of internal conflict, giving them enough depth to keep the show interesting over numerous seasons.

CREATE A BEAT SHEET AND SCENE OUTLINE FOR YOUR PILOT

Based on the act structure you've come up with, create a beat sheet for the show. Take the beat sheet and expand it to a scene outline. Follow the instructions in the earlier chapter on constructing scene

outlines for feature films. List every scene in the episode, starting with the slugline, then follow it with a description of plot information. Do not include any dialogue at this point. Show your outline to other writers, and get feedback on your story. Revise the outline.

WRITE AND REWRITE THE PILOT

Go ahead and write your pilot. Once it's written, you should go through the script carefully and do a thorough critique of the first draft. Be prepared to do an average of three "page-one" rewrites (start rewriting from page one until you've gone through the entire script, trying to make it better). Ask yourself these questions as you are writing and rewriting:

1. Are the central characters introduced in the beginning of the pilot?
2. Does the audience learn enough about the central characters to care about them?
3. Do you give away too much backstory about your characters so that it slows down the episode?
4. Do you introduce the narrative premise of your episode within the teaser or first five minutes of the opening act?
5. Is the structure of storyline A strong enough?
6. Do you have strong B and C stories? If not, should you add them?
7. Is the premise of the series clearly established in the pilot?
8. If this is a pilot for an open-ended serial, do you end certain plots while leaving others open for future episodes and season-long arcs?
9. Have you used your locations effectively?
10. Do you have too many major characters for the audience to follow in the pilot?
11. Do you need additional characters to bring in additional points of view?
12. Does your pilot bring out both the strengths and weaknesses of the main characters?

PREPARE THE PROPOSAL

Now you should put everything you've done together to create a proposal. On the cover sheet put the title of the series, the type of show (i.e. dramedy, crime story, medical drama) and your contact information. On the top of page one put your logline (see Chapter 2) and then follow with a three to five page sales pitch for your show. Mention possible springboards. A *springboard* is a story idea that is generated by the concept of the show. Springboards read like log lines and are normally very general story ideas. Cleverly sell your idea by explaining how your locations, ambiance, the style, structure and tone will appeal to the audience in a unique way. Also sell those great characters you've created. Make them come alive and convince your producers that you can get five years of stories out of your serial. Include a short paragraph-long synopsis for each of the first six episodes of your series. Write one- page character bios for the main characters and a sentence or two about supporting characters, and, if your series is in an open-ended narrative style, you might want to include short paragraphs that explain how the arcs will develop for each central character during the first season. Along with this proposal, you should attach your completed pilot script.

FURTHER ANALYSIS OF PILOT FOR *GREY'S ANATOMY*

After many successful seasons, the award-winning prime time drama *Grey's Anatomy* became a "franchise" by spinning off one of its most popular characters on to another original series called *Private Practice.* Series creator and executive producer, Shonda Rhimes, started it all with her amazing pilot episode for *Grey's Anatomy* entitled, "A Hard Day's Night."

Pilots are difficult to write because the television audience is a hard group to please. The networks can cancel you even before you have time to build a following. In television, the opening of your show has to be totally engaging. Remember you have only a minute or two to lock in the home audience before they decide to change the channel. Many shows use what's called a TEASER to grab that audience. The teaser is a scene or series of quick scenes at the opening of an episode where the writer will typically introduce a major plot question. In the *Grey's Anatomy* pilot script, Rhimes introduces the

protagonist, Meredith Grey, whom Rhimes says is "smart, awkward, irreverent, hard-working and ...well, *naked*" (*Grey's Anatomy*, Episode 1, page 1). Rhimes describes Meredith rushing around to get dressed for her first day on a new job. Meanwhile, her one-night-stand, the handsome thirty-something Derek, is lying naked by the fireplace.

Once dressed, Meredith's dialogue creates an unexpected and humorous role reversal. She shakes Derek's hand goodbye— giving him the brushoff—and leaves for work. Meredith arrives at a hospital and immediately finds herself lined up with 19 other interns where she is welcomed by the Head of Surgery, Dr. Richard Webber:

```
                 RICHARD
Each of you comes here today hopeful. Wanting in
on the game. A month ago you were in med school
being taught by doctors. Now you are the doctors.
The seven years you spend as a surgical resident
will be the best and worst of your life. You will
be pushed to your breaking point. Look around
you. Say hello to your competition. Eight of you
will switch to an easier specialty. Five of you
will crack under the pressure. Two of you will be
asked to leave. This is the starting line. This
is the arena. How well you play, it's up to you.
```

Rhimes follows this with Meredith's sarcasm:

```
                 MEREDITH (V.O.)
Like I said, I'm screwed.
```

The show goes to commercial. We have to keep watching. Rhimes has already placed us in the center of her compelling narrative. The plot question: Will Meredith win the game or even be allowed to continue playing? The writing gives us, not only a narrative to follow for the pilot episode, but also a narrative to follow for the entire series. We want to know if Meredith will make it through her first day on the job. At the same time we're wondering if she will make it through her seven years of surgical training.

In the commentary section of the DVD, Rhimes mentions how

hard it was for her to write the teaser, because she had to get the personalities of the characters across in a brief amount of time. In "A Hard Day's Night" Rhimes introduces George's character through a funny awkward moment where, on the first day of the residency, he mentions to Meredith in front of the rest of the interns the exact details of the sexy outfit she was wearing at the mixer the night before. The scene is played in such a clever way that, instead of coming off as lewd, George comes off as socially awkward and boyishly endearing. Meredith and the other female intern, Cristina, give him a challenging look. Suddenly George says, "Now you think I'm gay." It is an honest, non-threatening line that reveals this character to us in a way that makes us want to know more about him.

The *exposition*—the backstory we need to know to understand the characters—is given to us in a way that seamlessly moves the story forward rather than slowing it down. Finding clever ways to introduce exposition is always a critical part of writing the pilot. In *Grey's Anatomy*, the backstory of Meredith's mother is given in the tiniest doses throughout the episode. Starting with the teaser, we learn that Meredith's mother doesn't live at the house any longer. Rhimes later reveals to us that Meredith's mother is a famous surgeon. She does this by setting up a scene in the cafeteria where the other interns gossip about the mother before Meredith gets to the table. The revelation is an opportunity for a bit of jealousy to surface in Cristina. It is clear that Cristina thinks this gives Meredith an unfair advantage at getting the best surgical experiences during the internship. On the other hand, George has never heard of Meredith's mother. This cues the audience in to the fact that George is the slowest one of the group. He's someone who is out of the loop. The scene plays naturally. It builds on the theme of competition and adds dimensionality to the characters.

The same lunch scene works as the perfect set-up for the next bit of plot information. Dr. Burke walks by the table and announces that the privilege of being the first intern allowed in surgery customarily goes to the intern with the most promise. He then picks George. The irony is not lost on the viewers or any of the interns at the table. Everyone, including George, is surprised at Burke's choice. At this point, the audience is already deep into the characters and the narrative, and we're only ten minutes into the show. In your pilot,

you should strive to manipulate your exposition in a similar fashion to what Rhimes has done here. Look for ways to reveal character, establish point of view and advance plot with each bit of background material you reveal in your story.

At the top of Act One Rhimes introduces both of the two patient storylines: there is a teenage girl with unexplained seizures, and there is a husband who needs heart bypass surgery. As we said earlier, *Grey's Anatomy* is about the experiences of the doctors. The patients are there as narrative devices to elicit dramatic or comic responses from the interns. One of the signature characteristics of the show is that Rhimes allows us to see moments where the doctors speak badly about their patients, even making fun of them behind their backs. (Rhimes did this before *House* premiered.) In Act One of the *Grey's Anatomy* pilot, Rhimes shows the protagonist, Meredith, experiencing frustration with the superficial statements and self-absorbed attitude of the aspiring junior beauty queen patient she must care for. As she sits down at the lunch table, Meredith announces: "Katie Bryce is a pain in the ass. If I hadn't taken the Hippocratic oath, I'd Kevorkian her with my bare hands."

Rhimes also gives us a crowd pleasing act break at the end of Act One when Meredith sees Derek, the guy we met in the teaser, appears in front of her at the hospital in a position of authority. It turns out he is the attending surgeon, and the doctor she'll be working for during the next seven years of her internship. This dramatic situation becomes an even juicier plot complication when he insists that he and Meredith should continue dating while she insists that to do so would be inappropriate. Add the fact that they are clearly both attracted to each other, and you have a nice big narrative problem between two central characters. This, of course, is what every great serial needs, and dreams of, by the end of Act Two.

This scene is followed by George's first surgery. Put yourself in Rhimes' shoes. There have probably been thousands of hospital operating scenes done in film and television prior to *Grey's Anatomy*. How does Rhimes make this operating scene original? She gives us a fresh take on the situation by putting her own unique point of view into it. Keeping within her theme of "the game," Rhimes conceives of the operating room scene from the point of view of the interns sitting in the surgical viewing gallery. What are the other interns

thinking as they watch the surgery from above? They are all part of "the game," so some of them are thinking they are better than George. What does Rhimes have them do to illustrate these emotions for the audience? Her characters begin to wager amongst themselves that George will fail. The gallery takes on the flavor of an ancient Roman coliseum where George is the gladiator and the other interns are the bloodthirsty citizens of Rome betting for and against the slaughter of one of their own. Now Rhimes adds another layer of tension to the scene by placing another source of conflict in the O.R—the menacing Dr. Burke. Not only must George prove himself to the other interns, more importantly, he must prove himself to Dr. Burke or risk being harassed by the interns in the gallery and possibly thrown out of the program. Ultimately, Rhimes laces the scene with a third layer of risk—the risk that doctors face every day they walk into the O.R.—the risk of harming their patient.

Moving on to another well done aspect of Rhimes' pilot, we learned in the chapter on writing scenes for film that every scene must advance the story and that every scene should somehow relate to the protagonist's goal. Another way to think about the concept of goal is to break down the goal in terms of risk. As a writer you can ask yourself: What must my character risk in order to attain his or her goal? In storytelling, one must remember that usually it's the case that the greater the risk, the more meaningful the journey towards the goal becomes. In her amazing O.R. scene from *Grey's Anatomy*, Rhimes has George risk nearly everything to obtain his goal of becoming a surgeon. If he messes up, he could kill the patient, lose his internship and, worst of all, leave with his dignity in shreds. The scene ends with Burke pushing George away from the patient just in the nick of time. Burke calls George a "pansy ass idiot." The interns in the gallery begin to collect their bets and someone nicknames George "007," joking he's "licensed to kill." The sardonic and irreverent tone of the scene is a repeated motif of the entire series. The ability to write incredibly well-crafted, multi-layered scenes with an original point of view is clearly Rhimes' gift to television.

The mid-show act break of the pilot provides the next turning point. Dr. Derek Sheppard will allow the intern who correctly diagnoses the seizure case to scrub in with him for surgery. This

story beat provides Rhimes with the opportunity to slow down the pacing. She opens the next act with Cristina and Meredith in the hospital library having a heart to heart conversation as they try to solve the case together. Meredith reveals that she had sex with Derek Sheppard. By sharing this secret, the two women grow closer. But the closeness is short-lived when Derek chooses Meredith to scrub in with him instead of Cristina. Meredith accepts his offer, reneging on the promise she made to Cristina to allow Cristina to scrub in ahead of her. Cristina feels betrayed by Meredith. The dramatic tension is heightened as this storyline now reaches its climax. Meredith decides to decline the opportunity offered to her by Derek, but Cristina says it's too late and refuses to accept Meredith's change of heart. This plot line between Meredith and Cristina is resolved in the next act when the two women realize they were wrong and extend an olive branch to each other.

Another plot we follow in the pilot is the conflict between George and Dr. Burke that escalates when George mistakenly tells a patient's wife that the bypass surgery Burke will perform will be free of risk. The patient dies, and when Burke finds out what George said to the wife, Dr. Burke comes down hard on George for handling the situation improperly. Burke dumps the task of breaking the bad news about the husband's death on George. The conflict between the powerful and intimidating attending physician, Burke, and the naïve intern, George O'Malley, is left as an ongoing storyline for future episodes.

Maintaining its classic story structure, the *Grey's Anatomy* pilot ends by focusing on the two characters that appeared in the opening. There is a wonderful monologue in which Meredith talks about the thrill of being in surgery. Surgery is like a powerful high, she says. She has just witnessed Derek saving the life of her seizure patient. Derek and Meredith face each other after surgery. Rhimes tells us in one of the descriptive passages at the end of her screenplay, "There is still heat between them." Derek leaves, and we cut to an exterior of the hospital. We see that all the interns have made it through their first 48-hour shift.

In the final scene, Rhimes takes us to a nursing home. Meredith's voiceover intersects with a conversation she is having with her mother. The mother, it turns out, is suffering from Alzheimer's, a disease that no amount of surgery can cure. Meredith's mother cannot recognize

her own daughter and does not remember that she, herself, was once a great surgeon. The scene works thematically, adding another level of meaning to the premise of the show. *Grey's Anatomy*, we learn, will also be about the struggle of these characters to find balance between their personal lives and their professional lives. The characters in the series will constantly be tempted to neglect their families in favor of the power and prestige that comes with being a surgeon. The ability to cure is like an addictive drug. The specter of Meredith's mother, Ellis, a woman who neglected her family in exchange for a powerful career, a career that she ironically can't remember having, will serve as an omen for episodes to come. The last lines in the pilot are:

```
          ELLIS
What's your name?

          MEREDITH
It's me, Mom. Meredith.

          ELLIS
Oh. Right.
```

A beat. Then...

```
          ELLIS (CONT'D)
Are you the doctor?
```

Ellis has Alzheimer's—something no amount of surgery can cure. Meredith shakes her head, tired.

```
          MEREDITH
No.

          ELLIS
I was a doctor, I think.
```

Meredith struggles, a little sad. Then:

```
          MEREDITH
Yeah, you were. A surgeon.
```

SAMPLE STORY OUTLINE FOR *LINCOLN HEIGHTS* "HOME AGAIN."

To help you solidify your story outlining skills, we've included an outline for "Home Again," the NAACP Image Award-nominated episode and season four opener from the prime time series *Lincoln Heights*. In the outline, we've included brief introductions for each character. This is for the readers who are not familiar with the show. The entire series is available on DVD. Please note that you normally would not need to include the character introductions for an outline for an ongoing series unless you are writing the outline for a pilot.

Teaser

SUTTON'S TEMPORARY APARTMENT: The family is living in an apartment because their home in *Lincoln Heights* was damaged in a quake at the end of last season. Cassie (high school age) creates a collage of her memories of seeing the abusive father of her boyfriend, Charles, die during the quake.

The family is preparing for a new year at school and to visit the new house that their maternal grandfather, Coleman, a wealthy judge, has bought for the family in an upscale suburb of LA. The grandfather's push to move the family out of Lincoln Heights irritates the family patriarch, Eddie Sutton, a police officer with a limited income and a love for Lincoln Heights, the community where he grew up and works.

Also we learn that Nate, Eddie Sutton's grown son, has moved in with the family after Eddie discovered, at the end of last season, that Nate was his son from a teenage relationship. Tay, the youngest son (middle school age), does not like Nate.
Lizzie, the middle child, is preparing for her first day of high school. The three kids do not want to leave the Heights (a working class, predominantly black community) and are bothered by the fact that their mother, Jenn, is working a lot of overtime to pay for the expenses the family has incurred after the quake.

CHARLES' APARTMENT: Charles (around 18 years old) is home alone while his mother is in Maui looking to relocate. We see him take hundred dollar bills from a box full of money he stole last season.

CHARLES' CAR: Charles tells Cassie he will not move to Maui because he loves her.

NEW HOUSE: Jenn's father, Coleman, shows the family the expansive home he has purchased for them in a predominantly white suburb. Coleman offends his son-in-law Eddie.

Act One

CHARLES' CAR STREET: Two guys ram Charles' car and hurl racial slurs at Cassie. Charles throws a punch at them. The cops arrest him.

CONDEMNED HOUSE: Eddie responds to a call from his old neighbors and discovers an injured child alone in a house inhabited by homeless people.

HIGH SCHOOL LUNCH ROOM: Cassie complains that Charles should have ignored the guys that hit his car. Lizzie sees Tay is sleeping during lunch.

CLINIC: Jenn bandages the homeless child's arm. A neighbor arrives and agrees to take the child into her home. Eddie gets a warning call that the police are going to question Cassie and Charles.

Act Two

SCHOOL OFFICE: Police question Charles and Cassie about the death of his step-father. Cassie tells the cops that Charles and the stepfather argued, contradicting Charles' story that there was no argument that night.

SCHOOL HALLWAY: Charles gets angry at Cassie when she tells him what she just told the police. Eddie shows up and tells Charles he needs to control his temper.

BUS STOP: Lizzie sees Tay working at a Chinese restaurant for money to help their mother.

APARTMENT KITCHEN: Coleman harasses Eddie about Jenn working too many double shifts. Jenn brings Bryanna, the homeless child, to spend the night with them. Bryanna refuses to eat or talk and begins to cry. Tay gets angry at Nate when his mother tells him to sleep in Nate's room in order to make room for Bryanna.

MASTER BEDROOM: Eddie and Jenn discuss the troubled state their family has been in since the earthquake. Eddie wants Cassie to leave Charles.

APARTMENT: While everyone sleeps, Bryanna steals Tay's insulin and runs away.

Act Three

APARTMENT: The next morning they see that Bryanna is gone and has taken the insulin. Tay is going into diabetic shock. They rush him to Jenn's clinic but it's locked; Jenn doesn't have her keys. Nate breaks into the clinic to save his brother.

CONDEMNED HOUSE: Eddie responds to a call, enters the house, and shoots a man in self-defense. Outside the neighbors complain that the police are letting drug addicts inhabit the buildings that were condemned after the earthquake. One of the neighbors knows Eddie and gets on his case for not staying in Lincoln Heights.

CLINIC: Tay is okay. Tay tells his mom about his job and that he was working to help her. She is touched.

PRECINCT OFFICE: Bryanna's mom's drug habit relapsed after the quake. The neighbor volunteers to keep her. Eddie finds out from the Detective that Charles has a sordid past and that he thinks Charles is hiding something about the death of his stepfather.

Act Four

POLICE CRUISER: Eddie drops Cassie off at school, telling her that he is concerned about Charles.

OUTSIDE SCHOOL: Cassie tells Eddie that she thinks they should tell the detectives the entire story of what happened. Charles says he wants her to choose between him or her dad.

CASSIE'S BEDROOM: Cassie works on the collage while she reflects on what both Charles and her dad have said to her.

APARTMENT LIVING ROOM: Nate tells Tay he plans to move out on his own once the family moves out of the apartment.

NEW HOUSE: Eddie meets his new neighbor and realizes that the new environment in his new neighborhood is too quiet and sterile.

SUTTON'S OLD HOUSE: As Jenn packs up, Eddie reflects on the great times they had at the old house. They drive by the condemned house in Lincoln Heights to discover that the neighbors have taken it upon themselves to bulldoze it away.

Act Five

CASSIE'S BEDROOM: Eddie confronts Cassie about Charles's past. She sticks up for Charles.

CHARLES' APARTMENT: Cassie asks Charles about what happened at the Army base when he lived in Germany. Charles says he defended his mom from his abusive stepfather. Cassie feels close to Charles.

OLD NEIGHBORHOOD: As they are driving away with boxes of stuff from the old house, the Sutton family sees the neighbors creating a garden in the lot where the abandoned house used to be. The Sutton kids all get out of the car and volunteer to help. Eddie and Jenn decide to stay in Lincoln Heights.

IN THE OLD HOUSE: Everyone is there for a housewarming party. Coleman refuses to pay off the loan for the house. Nate offers to pay rent. Tay is upset that Nate is still going to be living with them. Lizzie defends Nate to Tay. Cassie tells Charles she is on his side. Bryanna happily tells her foster mom that she'll have some pie. The neighbors toast the Suttons. The detectives show up to question Cassie and Charles about the stepfather's death.

CHAPTER TEN EXERCISES
DRAMATIC TELEVISION SPEC SCRIPT EXERCISE

1. Watch Season 4, Episode One "Home Again" of the series *Lincoln Heights* (available on DVD and as a download on iTunes). Now watch the episode again, stopping the program at the end of each scene. Recreate the chart in the "Dramatic Television Structure" section of this chapter on your computer and fill in the information in each column for each and every scene in the episode. Once you have done this, turn to questions in the "Write and Rewrite the Pilot" section of this chapter and answer them based on your analysis of the episode.

2. Pick a dramatic television series currently on the air in a genre similar to the one you have chosen for your own spec script. If possible, watch every episode of every season of the show. Now, choose three typical episodes from the show to analyze. If possible get scripts for these episodes. In your analysis for each of the three episodes do the following: summarize each plot and subplot in one sentence; break down the script according to acts and scenes (cold opening and tag also); map out each plot according to when the initial incident, complication, climax and resolution occur. If your serial has long-term narrative arcs, several of your plots will be open-ended and will not reach a climax or resolution in the episode. Identify these in your analysis.

3. Create your central storylines for your original spec script. Summarize each story line in a sentence or two. Be sure each summary communicates the initial incident, the complication, climax, and resolution if applicable.

4. Create a scene outline/beat sheet for your spec script using the format like the one included earlier for *Lincoln Heights* in this chapter. Be sure to write in present tense. Be sure your scene outline is similar to the structure of the three episodes you analyzed (i.e. the same number of acts, scenes, and storylines). Be sure that a significant moment of reflection or compelling incident occurs before each act break.

4. Reread Chapter 4 on pitching. Create a pitch for your spec and deliver your pitch at least ten times or until you perfect it.

5. Now write the script. Reread Chapter 7 to be sure that your script is formatted in correct dramatic television screenplay single-camera style with single-spaced dialogue and description.

6. Take your script to a writing workshop, and hear it out loud. Keep track of the running time of each act. Ask the group for comments and notes ("Notes" is industry terminology for a critique). Your writing colleagues should give you feedback on anything that occurs to them, good or bad, about your writing, but especially the following:
• Are the characters true to the show?
• Is the story structure typical of the show?
• Is the tone right for the show?
• Is your spec script entertaining?

7. Now with your critique in hand, go back and rewrite the script. Be sure this is your best work. Also don't forget to check the format, grammar, and spelling.

Chapter Eleven
Writing The Situation Comedy

If you have a flair for comedy, the sitcom should appeal to you. Sitcom is short for "situation-comedy." To be a sitcom writer, you must be quick-witted and possess a keen sense of humor. Originally, the word "sitcom" was devised to define comedy that stemmed from a particular situation. Soon the format changed, and jokes were inserted into the script that had nothing to do with the story or situation. This was done in order to cause the viewer to laugh at a rate of three jokes per page! Jokes ultimately overtook the basic story premise. The best comedy writers should be able to find humor in any given situation and be able to write jokes. Some writers have a natural talent for humor, while others enroll in classes and study a process that enables them to develop a broader sense of humor. Some sitcom writers are hired for their ability to "break a story" (come up with an idea). Some writers are hired for their ability to write jokes or "punch up" the script. As a comedy writer, you should expose yourself to a variety of different comic forms. High comedy, low comedy, parody, satire, irony, slapstick, farce, romantic, and situation are some of the genres of comedy writers have used over the centuries.

The comedy writer must also recognize the particular group of people he or she is writing for—in essence, the target audience. There is comedy for children, teenagers, young adults, and the thirty-five and older group. People of different cultures, genders, and ages laugh at different things.

From their inception, African American scripted sitcoms were successful among a broad-based audience and appealed to a variety of demographics. *Good Times* aired in 1974. It was a series about the struggles of a black family living in the projects in Chicago, Illinois, and was written by Eric Monte who also is famous for writing the screenplay for the classic film, *Cooley High*. In 1976, Norman Lear, the show's creator and producer, held a playwriting contest, sponsored by the

American College Festival based at the Kennedy Center in Washington D.C. The first winner, Judi Ann Mason, an African American student from Grambling State University in Louisiana, was later hired as a staff writer on *Good Times*. As a result, Miss Mason was the first African American woman to join the Writer's Guild Of America West with a full television writer credit.[1] Other black writers were soon hired as staff writers on various shows produced by Mr. Lear.

The Jeffersons aired from 1975 thru 1985, and at that time, was said to be the longest running series of its genre. The show was a spin-off of *All in the Family*, another Norman Lear production.

Two Twenty Seven created by Christine Houston, was originally written for the stage, and later developed into the NBC hit television sitcom *227*. The series is notably the first television sitcom developed from a play and written by an African American playwright. The series ran from 1985 thru 1990 and has been in syndication for more than twenty years.

The Cosby Show, which aired in 1984 and ran through 1992, has won critical acclaim and is said to be the show that changed the views of millions of Americans about blacks and their life styles. The show's enormous popularity was due to the talented cast of actors and writers. The spin-off, *A Different World*, about a group of African American students at a historically black college, was also produced by Cosby.

There have been many successful sitcoms written and/or created by African Americans. Helen Thompson was the first African American to join the WGA. She worked as a script constultant on the television show Julia. Here are some you may recognize: Tyler Perry's *House of Payne, Meet the Browns, Martin, The Bernie Mac Show, Living Single, Half & Half, The Jamie Fox Show, Fresh Prince of Bel-Air, The PJs, The Parent 'Hood, Amen, The Wayans Brothers, Sherri, The Steve Harvey Show, Hangin' with Mr. Cooper, Sinbad, My Wife and Kids, Moesha, Sister Sister, One on One, Minor Adjustments, Family Matters, My Wife and Kids, The Parkers, Girlfriends*, and *The Game*, among others. If you look at the resumes of the writing and producing staffs of these shows (which you can find on the Internet Movie Database website), you can trace the career paths of their showrunners back to the first generation of black sitcoms. For instance, Sara Finney-Johnson got her start writing on *The Jeffersons*. From there, she wrote for *227, Family Matters*, co-created *Moesha* and eventually became the co-creator and executive

producer of *The Parkers*. Along the way, she wrote episodes for other shows as well. In 2007, she was nominated for an NAACP Image Award for her episode entitled "The Big Chill" which she wrote for the popular sitcom called *The Game*. Needless to say, the writers on the shows we've mentioned here wrote many scripts and diligently worked at their craft to get to the top of the industry.

EVOLUTION OF YOUR OWN COMEDY WRITING

The half-hour situation comedy format is evolving in several directions. There are now shows like *Curb Your Enthusiasm* that have little scripted dialogue. Instead of a script, the dialogue for this sitcom is improvised by the actors, who are provided with a detailed story outline written by the showrunner. The outline maps the story beats of the episode. The actors fill in the dialogue in rehearsal and improvise during taping.

Also highly popular with viewers are shows like *Entourage* and *Hung*. Their format is referred to as "dramedy." Their scripts contain many comic moments and funny situations, but the stories are not played exclusively for laughs.

Working in sketch comedy provides a great way to prepare for a career as a comedy writer. Shows like *Saturday Night Live, Madtv, Chapelle's Show, In Living Color,* and *Chocolate News* contain brilliant comic bits and hysterical characters. A lot of sketch comedy writers train in improvisational comedy techniques with comedy groups like Second City in Chicago. Many other situation comedy writers get their start as playwrights working in traditional and experimental theatre. Any way you can get your writing out to an audience is productive for your career. You should seriously consider producing short comedy pieces for the Internet. The networks have full-time development people surfing the web for talent. Remember, Hollywood can't find you if your work isn't out there on YouTube or Facebook or some other social networking site.

HOW TO WRITE A SITUATION COMEDY SPEC SCRIPT

Let's look at the structure of the more traditional half-hour sitcoms. After breaks for credits and commercials, the half-hour sitcom runs about twenty-one minutes. In terms of structure, the half-hour

sitcom can be divided into two different categories based on the shooting style of the show. If the show is shot with one camera, film-style, it is called a single-camera style sitcom. *The Bernie Mac Show*, *Curb Your Enthusiasm* and animated serials like *The Simpsons* or *The PJs* are single-camera style shows.

If the show is taped on a sound stage and shot with many cameras at once, the style is referred to as multi-camera sitcom. *The Parkers*, *Fresh Prince of Bel-Air*, *Martin* and *The Game* are examples of multi-cam shows.

As we mentioned in the previous chapter on writing the television drama, to understand the structure of the show you want to spec, you need to read scripts from that show, and you also need to watch as many seasons as possible. Next, you need to deconstruct and carefully analyze at least three episodes of the show from the most recent season. Be sure these episodes are typical. Don't use "to be continued" episodes or special guest star episodes. If you're doing a multi-cam show with studio sets, don't use an aberrant episode such as one in which there's a set that has never been seen on the show before.

You can break down the structure of the episodes of your show as described in the previous chapter. List every scene in every act. Track how long each scene is and who appears in each scene. This will give you a good idea of the weight each character has in the series. Remember, there will typically be a central character on the show, unless the series uses a true ensemble-style cast. For instance, on *The Bernie Mac Show*, Bernie was the focus of every story. The three kids initiated the plot conflict, but the story was framed around the problem of how Bernie would deal with that week's particular situation. On *Girlfriends*, there was an ensemble cast in which all the central characters carried equal weight, and it was acceptable for any of the friends to have the A story.

Next, track the storylines. How many are there? How many scenes does each storyline appear in during the episode? What typically happens with each storyline in the cold opening, the act break, and the tag?

Search for any episode summaries posted on the web. Most shows that are currently on the air have an official website where a synopsis of each episode is posted. You can also go to the Internet Movie Database to get episode summaries. These summaries usually give you enough information that you can put together a good overview

of the backstories of the characters. Also note any internal rules of the series. For instance, on *The Bernie Mac Show* every episode contains numerous "confessional" scenes where Bernie speaks on-camera directly to "America."

ANALYSIS OF *THE BERNIE MAC SHOW*
(SINGLE-CAMERA SITCOM)

The Bernie Mac Show ran for five seasons. The single-camera style half-hour family-oriented sitcom was based on the standup comedy of the late great Bernie Mac, and was created by Larry Wilmore. The episode we will be dissecting is called "Lock Down" and was written by Teri Schaffer. Terri Schaffer's credits include executive producing for *The Soul Man* and writing and producing on numerous shows including *The Bernie Mac Show, Reed Between the Lines,* and *Just Jordan.* The script is written film-style, single-spaced, and is 26 pages long. It has a three-act structure broken up into 44 scenes:

Act One: scenes 1-17 pages 1-7
Act Two: scenes 18-29 pages 8-17
Act Three scenes 30-44 pages 18-26

During the opening three pages, Schaffer sets up the story with the initial dramatic incident. First we see Bernie in his den directly addressing the camera in what the showrunner calls Bernie's "confessional." Bernie tells us how happy he is that no one else is home, and he's glad his house is quiet. Suddenly, his moment of peace is disrupted by the sound of an intruder. Bernie nervously moves through the house until he reaches the bathroom where Bernie witnesses the intruder escape out the window. We cut back to Bernie's den for another confessional. He tells us that he can't believe someone tried to rob him when he was sitting at home in his house. The police arrive. Wanda and the kids come home. Bernie ends the sequence with another confessional. He tells America he is going to protect his family "by any means necessary." The writer has set up the plot question: How will Bernie Mac deal with his need to protect his family from another possible intruder? The next sequence of scenes shows Bernie becoming more and more paranoid. He thinks he hears an intruder

in the back yard. He thinks he hears an intruder in the kitchen. He sneaks around the house to investigate and almost clubs his little niece, Bryanna, with a baseball bat. Act One ends approximately five minutes into the show with another confessional. Bernie says he feels violated. He says he can't go on like this. His hands are trembling. This is a cliffhanger moment. Just as is the case with the structure of dramatic episodic television, the act break for a sitcom demands the act to go out on a moment of tension or reflection so that the audience will come back to the show after the commercials.

Act Two opens the evening of day two in the dining room. Bernie is looking through a gun catalog. Wanda sees this and tells him no guns are allowed in the house. The writer then adds a surreal element to the scene. The camera pulls back to reveal Charleton Heston (who was then a nationally known gun advocate and the President of the National Rifle Association). Heston engages in a conversation with Bernie that logically supports Bernie's desire to purchase a gun. Again, Wanda insists there'll be no guns in the house. Heston disappears. Bernie takes the next best course of action: he buys an expensive alarm system.

Once the alarm is installed, there are a series of scenes in which the alarm goes off unexpectedly. The alarm continues to cause problems for Bernie and the family, until finally one day when Bernie comes home and forgets to turn the alarm off, the police show up and grill him for the password that Bernie can't remember. The act ends with another confessional in Bernie's den. Bernie boasts to America that "this place is so secure, it's keeping me out." All of a sudden Bernie hears a sound off- screen, and then another sound. His hands start trembling again as the episode goes to another commercial.

Act Three begins on day seven. Bernie and his poker friends are in the den playing cards. The guys begin a discussion of how they all feel paranoid about crime and have a compelling need to protect themselves and their kids from outside threats. We cut to Bernie seated on the couch with the kids, saying, "From now on, we're doing everything together." His healthy fear of the intruder has escalated to a ridiculous level. This is a common technique used in comedy writing — escalate a situation to its most outrageous point.

Bernie first decides to go everywhere with the kids. Then he decides they should never leave the house. Then he decides that they should not have their friends over. The untenable situation created

by Bernie's reaction to crime reaches its climax when, with everyone locked inside the house, Bernie hears a news report about a little girl who dies from a gas leak inside the family home. We cut to the den, and Bernie's final confessional is where Schaffer gives us the resolution. Bernie Mac says, "You know something, America? You try to protect your family as best you can, but in the end, there's not really much you can do." The writer throws in a final joke at the end of this confessional, and the third act ends neatly as the story is resolved.

In summary, this episode has a single A storyline which can be outlined as follows:

> *The Initial Incident/Act One:* Bernie's house is broken into. Bernie's scared and compelled to find a way to protect his family.

> *Act Two:* Wanda won't let Bernie get a gun, so he installs an alarm system that creates more stress and chaos for Bernie when the family keeps setting it off unintentionally.

> *Act Three/Climax/Resolution:* Bernie's paranoia over the intruder incident escalates to the point where he won't let the kids leave the house. But in the end, Bernie hears a news report about a child who dies from a gas leak in her own home. He decides that he's overreacting, and life returns to normal for Bernie and the family.

Analysis of *Girlfriends*
(Multi-camera Sitcom)

Girlfriends is a multi-cam format sitcom created by Mara Brock Akil. Packed with poignant humor and long, interesting character arcs, the show ran for eight seasons and now is in syndication. The episode that we will be analyzing is called "Loose Lips Sink Relationships" and was written by Mark Alton Brown and Dee LaDuke. The revised table draft (an early draft) was 42 pages. The shooting script was cut down to 39 pages for the twenty-two minute episode. Remember that

multi-camera sitcoms are usually shot with four or more cameras mounted on pedestals in front of a set. The scripts are double-spaced. Also, each scene of the multi-cam sitcom starts at the top of a new page. Scenes are labeled with letters. However, some of the letters are not used. This is because when the camera movement is blocked and marked for the scene, a letter is placed on the studio floor corresponding to the letter heading of the scene. Since some letters look very similar to others, those letters are skipped as scene headings. That is done to help prevent the camera operators from missing their marks by accidently misreading a scene heading letter. The letters that are *skipped* as scene headings are F, G, I, N and O.

Let's break down "Loose Lips Sink Relationships" into a scene outline.

COLD OPENING
INT. JOAN'S GREAT ROOM - (NIGHT 1)
(JOAN, MAYA, LYNN)

Maya is on the phone with Darnell. Maya lies to him, saying she has to work late, then confides in Joan and Lynn that she's been avoiding intercourse with Darnell because she's lost her sex drive.

ACT ONE SCENE A
INT. CLAY'S HOUSE - EVENING (NIGHT 1)
(TONI, CLAY)

Clay proposes to Toni with a giant diamond ring, and she accepts.

SCENE B
INT. JOAN'S GREAT ROOM - NIGHT (NIGHT 1)
(JOAN, TONI, MAYA, LYNN)

Maya comes over and tells the girls about the en-gagement. They question her motives and remind her that she loves Greg, not Clay. Joan makes Toni promise to look into her heart before she breaks it off with Greg.

SCENE C
INT. WILLIAM'S BEDROOM - NIGHT (NIGHT 1)
(WILLIAM, YVONNE)

William tries to convince Yvonne to stay with him for the night, but she insists on leaving to work her shift on the police force.

SCENE D
INT. JOAN'S GREAT ROOM - NIGHT (NIGHT 1)
(JOAN, GREG)

Greg comes over to commiserate with Joan about being rejected by another art gallery. Joan, however, thinks Greg is upset about the news of Toni's engagement and accidently tells Greg about it when he actually hadn't heard about it yet. Greg is upset and leaves before Joan can make things right.

ACT TWO SCENE E
INT. JOAN'S OFFICE - MORNING (DAY 2)
(JOAN, MAYA, WILLIAM)

Joan can't focus on the case she's working on with William. Joan is trying to decide if she should tell Toni about what happened with Greg. Maya enters and tells William that Yvonne has been shot.

SCENE H
INT. CLAY'S HOUSE - EVENING (NIGHT 2)
(TONI, CLAY)

Toni breaks off the engagement with Clay, telling him she needs to work out her problems with Greg. Clay takes back the engagement ring.

SCENE J
INT. JOAN'S GREAT ROOM/847 RESTAURANT - EVENING
(NIGHT 2)
(JOAN, TONI, MAYA, LYNN, GREG, EXTRAS)

Joan creates a hypothetical situation to get advice from Maya and Lynn about whether or not to tell Toni. Maya says she faked an orgasm with Darnell the night before. Continuous scene in the restaurant. Toni calls Joan and thanks her for advising her to break up with Clay and says she is going to get back together with Greg. Greg shows up at the restaurant and breaks up with Toni.

SCENE K
INT. WILLIAM'S BEDROOM - EVENING (NIGHT 2)
(WILLIAM, YVONNE)

William brings Yvonne home from the hospital. Worried that her job is too dangerous, he gives her an ultimatum: it's him or the force. She tells William if he doesn't drop his ultimatum, she'll give away his ticket to the "Lion King" and break off their relationship.

SCENE L
INT. JOAN'S GREAT ROOM/GRAVE SITE - EVENING (NIGHT 2)
(JOAN, TONI, MAYA, LYNN)

Joan is trying to keep her secret from the other girls when Toni enters crying. The girls make it worse for Toni by saying that Greg is truly her soul mate. Maya panics thinking Darnell, her own soul mate, may know she faked her orgasm. Joan has an aside to the CAMERA where she promises the audience that she will tell Toni the truth (that she spoke about Clay to Greg) when the time is right.
CUT TO: Joan kneels at Toni's tombstone and confesses.
BACK IN REAL TIME: Joan does not come clean. Instead she hugs Toni, assuring her that they'll get through this.

TAG
INT. POLICE STATION - DAY (DAY 3)

(YVONNE, POLICE CHIEF BERNARD PARKS, EXTRAS)

Yvonne receives an award for bravery and remarks
that this moment is the culmination of her
childhood dream. William is not present, so Yvonne
gives away her ticket to the "Lion King" to the
Police Chief.

THE STORY STRUCTURE OF
"LOOSE LIPS SINK RELATIONSHIPS"

As you can see from the scene outline, this episode of *Girlfriends*
weaves four storylines together in only twenty-two minutes.

Story A: When Joan accidently reveals to Greg that Toni
 accepted an engagement ring from Clay, Joan must
 wrestle with the decision of whether or not to tell
 Toni and the other girlfriends what she did.

Story B: Toni gets engaged to Clay, but she breaks it off with
 him when she realizes that Greg, not Clay, is her true
 soul mate. Unfortunately, Joan accidentally tells Greg
 about Clay, and he dumps Toni.

Story C: When Yvonne is shot in the line of duty, William gives
 her an ultimatum to leave the force. She decides to drop
 him and stay on the force.

Story D: Maya suffers from the loss of her sex drive, causing
 complications in her sexual relationship with Darnell.

Girlfriends is similar in pacing and structure to other multi-camera
sitcoms. The script contains eleven scenes, including the cold opening
and tag. Most scenes run between one to three minutes. The initial
incident occurs in the first five minutes of the show. Toni gets engaged,
and Joan tells Toni that she is making the wrong decision. There is a
major crisis that occurs at the end of Act One: Joan spills the beans
to Greg about Toni's engagement. The predicament escalates in Act
Two: Not realizing that Joan told Greg about Clay, Toni breaks it off
with Clay and goes back to Greg who now rejects her. The climax

occurs in the last scene when Joan must decide if she will admit what she's done. Then the resolution follows with Joan's decision not to tell. The two major plots, A, and B, complement each other. The C plot is handled in three scenes. William loves Yvonne. However, William's love for Yvonne becomes overprotective to the point where he gives her an ultimatum, saying that it's him or the force. Yvonne chooses the force. The D storyline works in the overall theme of the show of finding a soul mate when Maya realizes that Darnell knows her so well that he's probably aware that she's sexually frustrated.

Writing Sitcom Characters

Characters on television tend to work best if they have a recognizable human quality about them. They should have feelings and react emotionally. They should have flaws. Television characters sometimes tell lies or have trouble admitting they are wrong. To summon this humanity in a character, TV writers and showrunners put a lot of themselves into their characters. They call up incidents in their own lives and the lives of their friends and family as the raw material for the show. For comedy writers, often this raw material from real life is ramped up and exaggerated to the point of the ridiculous in order to produce the comic effect. In the "Loose Lips Sink Relationships" episode of *Girlfriends*, Joan's character flaws—a tendency to meddle and inability to admit she is wrong—not only cause Toni to break off her engagement with Clay but also result in Greg's break up with Toni. Joan's struggle to make a decision about whether or not to keep the whole thing a secret is a very human response. Joan's response becomes funny as she grows more and more obsessed with the moral decision of whether or not to tell the truth. At first, Joan can't concentrate at work, but eventually Joan becomes so paranoid that she convinces herself that she can only confess what she's done once she's standing on Toni's grave.

Yvette Lee Bowser, the creator of another long-running television sitcom *Living Single*, has said: "I feel characters are not people, they are metaphors for people. So they have to be more interesting than real people."[2] As we mentioned in the chapter on creating characters for film, real life is not dramatic. It is the writer's job to take moments of real experiences and turn that reality into entertaining, yet highly precise,

story beats. The characters in a situation comedy need to play on screen in concentrated doses. In a situation comedy, that means the characters need to be funnier, more insecure, more successful, more of whatever fundamental traits are represented by the character, than someone would be in real life. The character of Bernie Mac in *The Bernie Mac Show* is more dedicated to raising his nieces and nephews than your average guy, cleverer in his confessional scenes and, in the end of each episode, displays more patience than your average child-rearing man.

On *Girlfriends*, each woman represents a different set of character traits that can be found in real women, but in order to heighten the narrative possibilities of the television show, these traits have been intensified within each character. The Maya character is a highly sexualized wife and mother. Lynn is a musician obsessed with finding out the true nature of her ethnic identity. Joan knows her own clock is ticking. She is successful in her professional life, but hopelessly awkward in her personal life. Toni, an ambitious girl from the wrong side of the tracks, is constantly derailed by her materialism. The personalities represented by these characters allow for many different situations to arise and many comic reactions to be played out. *Girlfriends'* perfect mix of characters gives the writers a rich blend of story possibilities to draw upon, the kind of foundation that gives a situation comedy longevity.

SITCOM DIALOGUE

As we mentioned earlier, situation comedies are much more dialogue intensive than dramas and feature films. This means that sitcom writers have to be quick-witted and closely tied into the norms of popular culture so that they can replicate contemporary speech and reach current audiences with their humor.

One of the best dialogue writers out there is Sara Finney- Johnson. Her episode of *The Game* called "The Big Chill" was nominated for an NAACP Image Award. Let's look closely at a dialogue sequence from the final scene of this episode. Tasha's character is a powerful, sharp-tongued sports agent who routinely goes off on angry tirades. Her boyfriend has just told her he can't take her constant rages, so he ends their relationship. It's the morning after the break up. Tasha is scrubbing the kitchen counter when her twenty-something son, Malik, enters:

 MALIK

Mom, what's wrong?

 TASHA

Why's something got to be wrong?

 MALIK

Cause I smell the powerful sent

of Pinesol all the way upstairs,

now. Either Grandmama's coming to

visit or you're upset.

 TASHA

Am I too angry, Malik?

 MALIK
 (laughing)

Are you serious?

 TASHA

What? Am I that bad?

 MALIK

It's all good. By you being you,

it made me tough. You don't take

no mess from nobody. You the man,

mama!

 TASHA

And I guess men don't want to

sleep with other men, huh?

 MALIK

Well, uncle Terry does.

 TASHA

Antwone is his friend, hear.

 MALIK

What's this all about, mom?

Did something happen between you

and coach T?

A BEAT

 TASHA
 (Tearing up)

He dumped me.

 MALIK

No, uh uh. Don't you cry over that

fool. Listen, if he don't appreciate

you for what you are, he can kick

rocks. He ain't the one for you.

 TASHA

I'm not sure there is one. I been

by myself for so long, maybe I

don't know how to be with anybody.

 MALIK

Mom, this is the first guy you've

been out with in a long time. Give

yourself a chance. Al right. The

right guy is out there for you. I'm

sure there's a man who will put up

with you.[1]

The actors play the scene in a very touching manner. In a brief two pages, Sara Finney-Johnson communicates Tasha's pain and insecurities and shows us the tight and soothing bond that exists between the mother and her son. The tone feels very real and natural. What the writer has managed to do here in relatively few words is to let us know the innermost vulnerabilities of Tasha's character—the fact that she doubts her own capacity to be in a relationship with a man. This is a feeling that so many women in the viewing audience can identify with. Yet in this very dramatic moment, comedy writer Finney-Johnson injects some perfectly placed sarcasm to keep us laughing. Malik's honest reaction to Tasha's question about being too angry is to burst out laughing. His response is funny and heartwarming. Malik's line, "You the man, mama," is so tragically ironic, it effectively sums up the dilemma felt by many strong woman—how strong is too strong? This is the overarching theme of Finney-Johnson's poignant episode. Take a look at the entire program, and you will find many examples of the highest quality dialogue writing combined with excellent story structure.

Chapter Eleven Exercises
Sitcom Spec Script Exercise

1. Pick a situation comedy currently on the air. If possible, watch every episode of every season of the show. Choose three typical episodes from the show to analyze. If possible get scripts for these episodes. In your analysis for each show do the following: summarize each plot in one sentence, break down the script according to acts and scenes (cold opening and tag), and map out each plot according to when the initial incident, complication, climax, and resolution occur.

2. Create your storylines for your spec script. Summarize each storyline in a sentence or two. Be sure each summary communicates the initial dramatic incident, the complication, climax, and resolution.

3. Create a scene outline for your spec script. If your spec is a two-act multi-camera series, use the outline for *Girlfriends* in this chapter as a template. If your spec script is a three-act single- camera sitcom, follow the outline format found in the film chapter of this book. Be sure to write in present tense. Be sure your scene outline is structurally similar to the structure of the three episodes you analyzed (i.e. the same number of acts, scenes, and storylines).

4. Reread the chapter on pitching. Create a pitch for your sitcom and deliver your pitch in the mirror until you perfect it.

5. Now write the dialogue. Be sure that your script is formatted using the correct sitcom style (single-camera or multi-camera) and formatting guidelines found in this book.

6. Take your script to a writing workshop and hear it out loud.

Time it. The read-through should take approximately 22 minutes. Ask the group for notes (a critique).
Are the characters true to the show? Is the story structure typical of the show? Is the comic situation right for the show? Is your spec script funny and entertaining?

7. Now, with your critique in hand, go back and rewrite the script. Be sure there are comic moments on every page. Be sure that the running time is close to 22 minutes. Be sure that the format, grammar, and spelling are perfect.

Sitcom Pilot Proposal and Script Writing Exercise

1. Write a 10-page proposal describing your show idea. The proposal should include the following information:
 • The format. Will your pilot be single-camera or multi-camera?
 • Your concept for your show (For instance, the concept description for *Everybody Hates Chris* would be: "A show about Chris Rock's family life growing up in New York in the eighties.").
 • Your central characters (one long paragraph describing each of the central characters and a short paragraph about each of the supporting characters).
 • Your locations. You'll want to limit these. Remember, too many locations can make a show costly to shoot.
 • A synopsis of five to ten episodes. You need to convey that your series has legs and that your idea can last for at least one hundred episodes (the magic number for syndication).

2. Follow steps two through seven of the sitcom spec script writing exercise listed above to write your pilot episode.

Getting Started In The Film and Television Industry

You'll need to start your writing career in an organized manner. Although your journey will not be problem free, we've outlined certain steps here to assist you in making a smooth, relatively problem free transition. Hard work, steady focus, and concentration on your ultimate goals will lead you to the success you are striving for. We will call it the eight-step plan.

Step One: Copyright Your Work

Any original written work can receive a copyright. The copyright is a legal designation, protecting you as the author of the material you have submitted to the United States Library of Congress as of the effective date of registration. You can submit your script, synopsis, treatment, or a paraphrased version of your story idea to the Copyright Office in the Library of Congress by using their online application. The cost is reasonable. Your application can take about six weeks to process. You'll receive a Certificate of Registration back in the mail, but you don't have to worry about waiting to receive your proof of registration before you send your script out to readers. The date that the Library of Congress receives the script is the date for validating your rights as the author. Once you have submitted the materials, you can safely state on the cover page of your script that you have copyright protection.

If you wish, you can also protect your work by registering it with the Writers Guild of America. They charge a nominal fee for non-members and provide you with a dated receipt that serves as a record of when you submitted your script to them. Though you will still need to eventually copyright your script, the WGA registration

is another way to make a case that the work is yours. No one at the WGA reads or evaluates any of the submissions. The WGA does not return any registered scripts either, so remember to keep a copy for yourself. The registration is good for five years and can be renewed. You can send the WGA a script, treatment, synopsis, outline, and/or written idea specifically intended for radio, television and film, or interactive media.

One final note, neither the WGA nor the Library of Congress can copyright movie titles. However, sometimes movie titles can be trademarked for use with promotional items such as toys, tee shirts, and other merchandise. For precise legal advice, we recommend you consult an attorney who has experience in media law. A Chicago organization called Lawyers for the Creative Arts provides low-income artists with low cost or free legal services. Check with your local Bar Association to see if similar services are provided in your community.

STEP TWO: PREPARE FOR THE MOVE

Once your spec scripts and writing samples have been registered for a copyright, you'll need to move or plan to travel regularly to Los Angeles, which is the locale that will best provide you with the easiest access to potential agents, managers, producers, directors, and writing partners (if applicable). Moving is more so a reality for television writers, due to the demanding and rigorous nature of the writers room and the fact that most writers rooms for episodic television produced in the United States are located in California. Feature writers have more flexibility and do not always have to move to LA in order to be successful. Transportation will play an important role in making your decision. If you already own a car, this will be helpful, since public transportation can be a real hassle, if not time-consuming, in Southern California.

Also playing an even more important role in your decision whether or not to move is the ever-rising cost of living. Los Angeles is one of the most expensive cities in the United States to live in. For this reason, we recommend that you put off moving until you have your spec scripts and other writing samples ready.

You might want to work a while to "save up" for the move. This would also give you time to watch your favorite television shows, learn the characters, and test your ability to write several episodes for your portfolio. If you know someone or have a relative living in L.A., you might want to talk to him or her about assisting you with the move. They may even agree to take you in until you land a job and can afford your own living quarters. At any rate, preparing in advance will leave you more time for your writing.

You should include in this preparation plan the amount of money you will need to tide you over until you find work. You've probably already guessed that it's more than likely you will have to work outside the industry until opportunity "knocks." Just as an outline aids in the writing process, a budget will assist in laying out the probable cost of the eventual move. Don't forget to be prepared for the unexpected by creating a miscellaneous fund. Remember, "It is better to have it and not need it, than to need it and not have it."

When you do make the move you will find that many of the cheaper apartments are usually located in the "Valley." The Valley is competitively priced and works to a writer's benefit because many of the studios that you aspire to work with and for are located there. Housing aside, there are other benefits to living in LA that will have a positive impact on your pocket. Food is cheaper in LA and more readily accessible because of the volume of local growers. This move will also save you money on some costly utility bills. No more below zero weather and astronomical heating bills. Also, entertainment in LA is inexpensive and in some cases free, due to the fact that many venues, studios, and events utilize live audiences for taping purposes. Also, there are many opportunities to review films prior to their release at no cost. Studios will simply want your feedback. Finally, there are an abundance of performers of all walks of life and endless open mics for every type of artist known to man; musicians, spoken word artists, singers, actors, and comedians who are always looking to "work out" new material. This also works to your benefit. Even though you are a writer, cast your network wide and save money by taking advantage of all of the amazing opportunities that will come your way.

Step Three: Network

After settling down in your new location and acquiring steady employment, hopefully in a production/development office, your next step is networking. Seek out the places where people within the industry frequent. It would also be helpful to keep tabs on the various trade websites to keep abreast of new projects in production and media companies that are interested in hiring new personnel. Check the WGA website (wga.org) for helpful links to industry blogs and job postings and other opportunities. Don't allow menial positions to deter you. A lot of top executives started in the mailroom or as couriers. Any job that puts you near the key players is worth the low pay. Whenever possible, attend some the tapings of the different shows, especially your favorites. Many of them are looking for studio audiences. Remember, in Hollywood, assertiveness is in and shyness is out.

You should be sure to go to events at the Writers Guild of America and volunteer to help out. Consider doing the same for the Organization of Black Screenwriters and with local film festivals. Volunteering is a great way to make contacts and get close to the people who work in the industry.

Another great way to network is by joining a writers group, taking writing classes, and participating in writers workshops. Some writers workshops are hosted by the Writers Guild of America West and are open to non-members. Workshops and classes can also be found through UCLA, USC, your local community, or boutique writers studios that specialize in instruction and consultancy.

Step Four: Acquire an Agent or Manager

The job of a manager or agent is to find you work and negotiate your deal. A first timer on the Hollywood scene would do well to acquire an agent. Some established writers use both a manager and an agent. An agent arranges deals and sells your work. Managers help you to develop contacts within the industry and can also advise you on ways to develop your career. When seeking an agent and manager, you'll need to put together a resume stating your various writing experiences and educational background. It is also important not to lie about your experience, because if found out, future progress

may be hindered. Be thorough but honest. It is best if you keep your resume between one and two pages. Execs and readers often get turned off by long resumes from new writers who have not "broken in." A bio should not be more than one page. When writing your bio think about the genre that you plan to write in. If you are a comedic writer reflect that in the style in which you write your bio. The same goes for drama writers.

Also create a portfolio of writing samples so you'll be ready when a potential agent or manager asks. The samples should include a completed spec script in the genre you want to write for (i.e. television or film, comedy, drama, etc.) and also at least two other pieces of writing. Anything that shows off your literary talent will work as a sample—poetry, short stories, comics, graphic novels, or other spec scripts you've written from the same or different genres. What agents and managers want to read is ever-changing. What seems to be consistent is this: have at least two writing samples that reflect the genre that you'd like to write in. If your goal is television, most agents, managers, and showrunners usually want to see a spec script of an existing show and an original spec pilot. It is good to have two in each category. That way you can chose which work to submit based upon the reader. The spec script of a show that is currently on the air demonstrates your ability to mimic the writing style, characters' voices, and tone of the series. Meanwhile, a spec pilot offers the opportunity to showcase your unique voice and writing style. It also lets the reader know if you can generate bankable ideas and concepts that they can ultimately sell.

You may be one of the few writers able to get work without the use of an agent or manager. Procuring your agent is usually based upon individual situations. It is often recommended that new writers approach one of the smaller start-up agencies. The agents in these emerging companies are hungrier and will do more for an unknown writer than the agents in bigger companies who put all of their efforts into the well-established writers.

It is typically the case that, even with an agent, as an unknown writer, you will have to knock on doors and sell your work yourself. Your agent will get her ten percent cut regardless of whether or not she was involved in the sale you just made. Moreover, you might discover that your agent may or may not actually read your work

or believe in your talents. Therefore, it is good business practice not to tie yourself down to your first agent by signing a long-term contract. A short-term contract will give you the ability to get out of your contract sooner than later if you find yourself needing to look for someone who will truly work hard at representing you.

Of the two thousand or so talent agents working at the top Hollywood agencies there are still currently only a handful of African American agents and managers. Opportunities for people of color to work as agents began to open up when industry leaders like Bill Cosby and Spike Lee demanded that their agencies hire African Americans to represent them. Now, in addition to the African American agents employed at the top firms, there are agencies owned by African Americans. These black-owned literary agencies represent writers of all ethnic backgrounds and are working hard to expand their share of the talent market.

If you meet an agent, producer, or working writer in person or at a pitchfest, don't hesitate to politely offer to show them your work. You should expect them to ask you to sign a release form before they will read your material. The release form will say that you agree not to sue them or their companies. Go ahead and sign the release, and get them your script right away. It is standard practice to get a signed release form. It protects the readers from frivolous lawsuits.

Another way to get your work into the hands of an agent is to acquire a list of literary agents and contact them by mail or email asking if they are accepting unsolicited material. You can get the agency information from the WGA or you can look in the *Hollywood Creative Directory* or subscribe to IMDB Pro. Once you have a list of these agents, you should write a *query letter.* This is a one-page letter where you briefly state who you are and pitch your script. You should also ask in your letter for the agency to send you a release form. You can include a self-addressed stamped envelope. If they are interested, they will ask you to mail or email the script (WGA registered or with a copyright) along with your signed release form. Scripts sent via email should always be sent as a PDF.

Many new writers seem to find more success with by establishing relationships with working writers. If the writer likes you and respects your work, then he or she may suggest that their agent or manager read your work. This way the submission is solicited, and

in the eyes of that agent or manager they are reading work that has already been vetted by a credible source. Also, writers may consider submitting their work to writing contests. Most of the television networks have contests or diversity initiatives that are attached to them. There are also contests and fellowship opportunities for feature writers. If you are selected as a fellow for a studio linked writing, program, or you win a scriptwriting contest of note, then this truly separates you from the pack.

STEP FIVE: JOIN THE UNION

Joining the union is a must in order to write for the television and feature film industry. In fact, as a writer, you will quickly discover that you need the safeguards and benefits that the union provides. The union's fair hiring policy protects the writer on every level. Its health and dental insurance plans are ideal as well as its investment and retirement funds. The union also negotiates contract minimums with its signatories, distributes residuals, handles legal arbitration, and verifies your professional status at every level, making sure that you are receiving monetary increases with each move up.

Writers employed in Hollywood usually belong to the Writers Guild of America West (WGAW), while those working in New York and other eastern states may belong to the Writers Guild of America East (WGAE). Joining the Guild as a television writer can be a "catch-22." Your television script probably won't be read unless you're a member of the Guild, and you can't become a member of the Guild unless you sell a script. However, another chance exists. Since most production companies are required to accept at least one unsolicited script per season, a slim opening for new writers remains. You also may be one of the few writers who can get work without the use of an agent.

Screenplays for feature films can also be submitted to agents and producers who are accepting unsolicited materials. Many times a production company will option the right to buy your feature film for a very small percentage up front, locking in the future purchase price for the script and giving them right of first refusal in the contract. These types of contracts are known as *option agreements* and are usually valid for a six to eighteen-month period at which

time they can be renewed. The option arrangement is intended to allow a producer time to shop the project around without having to put much upfront money directly into the hands of the writer. Needless to say, we recommend you show any option agreement you receive to an entertainment attorney before signing.

The WGA has expressed its opposition to the practice of paying extremely low option rates; however, the option agreement continues to be the contract of choice for producers who wish to maintain financial leverage over screenwriters. If you'd like to check it out, the WGA has language on option agreements on their website. The WGA website also posts the Minimum Basic Agreement (MBA) negotiated by the Guild which sets the low end of the purchasing price for screenplays. You can, of course, negotiate for a higher purchase price than is stated in the MBA as well as for other contractual services such as rewrites, points (a percentage of the net profits), and screen credits. Using the Guild's MBA as a guide, your attorney will draw up an agreement that is in your best interest. Independent films with budgets below a certain amount are not subject to the WGA contract.

The WGA has also worked to bring more writers of color into key positions in the industry. The Guild helped establish the prestigious Showrunner Training Program. A past co-chair of that program was Yvette Lee Bowser, the creator of *Half & Half* and *In Living Color*. You must be a member of the Guild to apply. You can find out more about the program and other writing opportunities available for writers who do not yet have professional credits by going to the WGA website and checking out their "diversity programs" information link under the link for "writer resources." Such programs include the ABC New Talent Program and the Fox Writers Program.

Many writers are not aware that they are able to join the Guild through the Independent Writers Caucus (IWC) that allows writers to join the Guild at a reduced rate if they have had a feature length film produced independently or if they completed a feature length script while in an accredited writing program. This applies to many writing students. To learn more about this program check out the WGA website.

STEP SIX: DECIDE ON A WRITING PARTNER

Very few television writers in Hollywood write alone. Most have writing partners. The obvious reason for writing with a partner is as the old cliché states, "Two heads are better than one." And, of course you have someone to bounce your ideas off of. This is when an attorney really becomes a necessity, because whatever the studio pays will have to be divided between two people. When deciding on a writing partner, one needs to be aware of compatibility. Will the partner complement you? Does he respect your talent? Do you respect his or hers? Do you have the same aspirations? It is often said, "Opposites attract." Is this a negative or a positive for the two of you? Always remember, as you move on up the "corporate ladder," your partner can, but not necessarily will, move up with you. Just remember that breaking in with a partner is better than not breaking in at all. And just because you begin your writing career as half of a partnership does not mean that it always has to be that way. Later, you may chose to be independent, and there is nothing wrong with that. It is important that you and your writing partner have a clear understanding of each other's ultimate goals so, if you should ever decide to part, you are able to do so amicably.

STEP SEVEN: OBTAIN AN ATTORNEY

For the most part, an attorney is only needed when the writer is in the process of making a deal. If you are a new writer and selling a script you have written and created, you need an attorney, and that attorney should be in the entertainment field. While the Writers Guild has rules and salary scales that govern certain writings, an attorney should be hired to negotiate your contract. The attorney could get you more money than originally discussed, especially if you're not familiar with the "Hollywood game plan." For example, the studio might offer you a percentage of net, which you probably will never see, but your attorney negotiates you a percentage of gross. Since most entertainment lawyers have a game plan of their own, you don't have to discuss money with the studio. Just inform your attorney what kind of deal you want and instruct him or her to do the negotiating for you. As in the old saying, "Don't be caught with your pants down;" don't be caught without an attorney.

Most lawyers will provide an initial consultation with a potential client at no charge. However, as a new writer it is sometimes challenging to secure representation without paying a retainer or paying on an hourly basis. Be prepared for this, and don't move forward until you have material that is truly ready to be represented. The standard fee that lawyers in the industry charge for proven and established writers is 5 percent. Be strategic about when you move forward with selecting a lawyer, so that you don't waste money as a new writer.

Step Eight: Know the Film and Television Industry

Knowing the different positions—in other words, the chain of command—will help you stay focused as you strive for the top position. It takes a large group of personnel to produce each television series. Some studios employ more than a hundred people to produce one half-hour series; from couriers, tutors, (if children are cast as regulars) secretaries, and caterers, to the creative crew of writers, producers, costumers, hairdressers, set designers, directors, editors, stage managers, camera operators, etc. The following is a list of the different positions in which you may be hired as a television writer:

Roving Term Writer: A roving term writer is not assigned to any show, in particular, but can sit in on meetings and rehearsals. At one of the production companies Chris Houston worked with, the writer received a weekly salary for writing story ideas for the various shows in production. Today these shows are often referred to as *franchises* (i.e. *CSI, CSI: Miami,* and *CSI: New York*). If the writer chooses to, he or she can write a spec script for any one of these shows. If the executive producer of that show likes the script, the company will buy it. Once that happens, that writer is eligible to join the Writers Guild and possibly obtain the position of a staff writer on that show or a subsequent show.

Head Writer: Head writer is a term mostly used in soap operas. The head writer develops long-term story lines on a particular character. He or she oversees all of the scripts written by other writers for consistency and helps to create what is known as the "soap opera

bible." The "soap opera bible" contains storylines and situations for the core cast, written six to eight months in advance.

Staff Writer: A first time staff writer is usually paid scale. The Guild sets the scale (the least amount of money) the staff writer should be paid. These rates are posted on the WGA website. But, again, an agent or an attorney can negotiate the deal and sometimes will get the writer more money. Staff writers are usually under contracts that can be renewed every six weeks or can last the duration of one season depending upon the show.

The staff writer attends table reads, rehearsals, note sessions, and tapings. He or she must be able to revise scripts, improve jokes, and read other writers' scripts, making notes for improvements. Although the hours vary, the staff writer works five days per week but is on call twenty-four/seven. Staff writers may pitch a story idea, but it is up to the executive producer to reject or accept the pitch and send the writer to outline and eventually to first draft. This allows the writer to receive credit for that particular episode and later be entitled to receive residuals for that episode.

Story Editor: Story editors receive a substantial increase in salary as they advance from the staff writer position. The story editors also pitch story ideas, but the chances of having one approved are greater than those of a staff writer. Story editors are also expected to sit in on editing the final taping of each show.

Executive Story Editor: The duties of the executive story editor are basically the same as the story editor with an increase in salary. The executive story editor may also be assigned to oversee a staff writer's revisions.

Producer: Producers are hired by the executive producer and are responsible for all financial aspects involving the show's budget. Additionally, the producer can pitch and write scripts.

Supervising Producer: The supervising producer has the same duties as a producer with an increase in salary (and a longer title).

Co-executive Producer: The co-executive producer is usually the writing partner of the executive producer. He or she commands roughly the same amount of authority. They share duties equally, although sometimes the co-executive producer will be assigned to oversee the finances along with the producer.

Executive Producer/Showrunner: Also known as the "showrunner," the executive producer hires the writers and is responsible for overseeing every aspect of the production of the show including set design, costumes, art design, casting, etc. In fact, other than the network, the executive producer has the final word. He or she listens to pitches (story ideas from other writers) and says yes or no to the writer. He or she can be the creator of the show, and determines the direction of the show and who will get to write which episodes. The only entity that can override an executive producer is the network. Most importantly, the executive producer is also a writer who can, and most often does, write the majority of the episodes.

THE REGIMEN OF A TV STAFF WRITER

Regimens vary from show to show as well as from season to season and also may change depending on the style in which a show is shot: single camera or multi-camera. Using 227 as an example of a multi-camera show, the week began on Wednesday, which was the day the new script was read aloud by the actors. At ten a.m., everyone involved in the creative process had to be present. Following the read-through, questions from the various crew members were answered and the producers, writers, and main star settled into a note session while the director and the other actors started rehearsing the script. During the note session, the script was examined page by page and suggestions were made concerning jokes that didn't quite work and dialogue or situations that could be strengthened. The executive producer assigned certain writers to "fix" pages where problems existed. After the note session ended, the writers broke for lunch. Each writer knew what his or her assignment was and decided to either take lunch first or go right to the task of "fixing" the script.

Each writer was assigned to a particular secretary who edited and typed his or her revision. It was then left to the discretion of the

writer when the work day ended. Most writers put in at least eight hours, providing there were no major rewrites necessary. Another thing that will govern the number of hours a writer puts in each day is if he or she has pitched an idea that the execs have approved. After a successful pitch, the writer has to write an outline, a first draft, a second draft, and if necessary, a third draft.

On Thursday, the writers usually arrived between nine-thirty and ten. This day was spent writing, discussing revisions with the producers, and more writing. This was probably the only day, if any, that the writer could shorten for personal business. On Friday nothing was required until three o'clock in the afternoon. That's when all the writers and producers had to attend a run-through and take notes if problems still existed. After the run-through, a note session was again held. Sometimes, "fixing" the script could keep the writer at work until nine, ten, or even eleven o'clock that night. Whatever the time, the secretary had to type the revision and send it to the actors to learn over the weekend.

On Monday, the actors rehearsed in front of the camera but the show was not really being taped. The writers were on standby in case there were more revisions needed. Monday was basically an eight-hour day.

Tuesday was our tape day! The writers came in at ten as usual. The show was taped twice. All writers were expected to attend both tapings. The audience began to arrive around three p.m. for the first taping at four o'clock. A warm-up person got the audience relaxed and coaxed them in the mood for fun and laughter. The four o'clock taping usually ran straight through without much going back over a scene. If an actor missed a line, the Stage Manager might refresh the actor's memory by showing him or her the script, but if a mistake were made again, it would be allowed to pass because it could be corrected during the second taping.

After the first taping, a catered dinner was served to the entire crew. Most times it was a seven-course meal including dessert. It causes one to wonder how the actors could work afterwards.

The audience for the second taping was warmed up and ready by seven-thirty in the evening. The second taping could last well past ten or eleven o'clock, depending upon how many times the actors missed their lines or cues or how many times a scene had to be shot over

again. Of course, when this happened the audience was excused, but the writers had to sit through the entire taping. Television writers will agree tape days are probably their longest work days.

FROM PITCH TO DRAFT: THE PROCESS FOR TELEVISION

When the writer comes up with an idea that might be a good episode, he or she will pitch the idea to the executive producer. If the executive producer likes the idea, he or she will ask questions, and if the answers are satisfactory, the writer will be told to write an outline. The exec will give notes on the outline, and when the outline is satisfactory, the writer will be told to go to first draft. After more notes and approval of the first draft, the writer is sent to second draft. The amount being paid for this script is divided into three payments. So much is paid for the outline, another amount is paid for first draft, and a final payment is paid for the second draft. The bottom line is: if this is a spec script, the Guild has a minimum the writer must be paid. If the writer is already working under a contract for the production company, the amount could be higher or negotiable. Also remember, when a writer pitches a script and it is approved, there will be a time limit on how long it will take the writer to complete all three phases of the scriptwriting process.

CHAPTER TWELVE EXERCISES

1. Go to the WGA website at wga.org and familiarize yourself with the various sections of the website that are open to nonmembers. Be sure to check out the Minimum Basic Agreement (MBA). Also read the information about diversity programs and public events and be sure to look over the agency list under the resources heading, and listen to the podcast.

2. Go to the Library of Congress website and read through the information on how to apply for a copyright.

UP CLOSE
CONVERSATIONS
AND
INTERVIEWS
ON THE
FILM AND
TELEVISION
INDUSTRY

Interview
With Bill Duke

Bill Duke recently received a Lifetime Achievement Tribute from the Directors Guild of America. He is the Founder and CEO of Duke Media Entertainment, formerly Yagya Productions, which has been successfully producing film and television for over thirty years. Duke Media Entertainment is recognized as a worldwide leader in leveraging media via the new film industry paradigm of the Internet. The Bill Duke Web Network has established an international following that has proven viewers crave to be both entertained and educated. This "Edutainment" mission exemplifies Bill Duke and Duke Media. Trained in dramatic arts at Boston University and New York University's Tisch School of Arts, Duke got his start performing on Broadway. Later, Duke moved into television and enrolled at the American Film Institute. In the early eighties, Duke directed episodes of major prime time shows including *Miami Vice*, *Cagney and Lacey*, *Hill Street Blues*, *Twilight Zone*, *Crime Story*, *Falcon Crest*, and *Spencer for Hire*. He also directed made-for-TV movies including *The Killing Floor* (1985) and *A Raisin in the Sun* (1989), for which he earned several major awards, including a special jury prize at the Sundance Film Festival.

Bill Duke served as the Time Warner Endowed Chair in the Department of Radio Television and Film at Howard University in Washington, DC. He was then appointed to the National Endowment of the Humanities. Currently, Bill Duke serves on the Board of Trustees at the American Film Institute. Duke paved the way for African Americans in cinema beginning in the early 1970s. Duke's directing credits include *The Killing Floor*, *A Rage in Harlem*, *Sister Act 2*, *Deep Cover*, *Hoodlum*, *The Cemetery Club*, *Cover*, *Not Easily Broken*, *Black Diamonds: The Evolution of Blacks in Baseball*, and

the documentaries *Dark Girls* and *Light Girls*. Bill Duke's acting credits include *Predator, American Gigolo, Car Wash, Action Jackson, Commando, Menace II Society, Bird on a Wire, The Limey, Get Rich or Die Trying, X-Men 3, Henry's Crime, The Big Bang, Starsky & Hutch, Charlie's Angels, Fast Lane, Karen Sisco, Lost,* and more.

Bill Duke is a humanitarian and activist who devotes his time to charity and not-for-profit organizations. Bill established the Duke Media Foundation which teaches media and financial literacy to young people; and is on the Board of Directors of Educating Young Minds after-school program with the mission to help inner city youth in the United States excel in school and life. He is also extensively involved with the United Nations UNAIDS mission to eliminate AIDS globally.

☆ ☆ ☆

List: Mr. Duke, we'd love to know what films and television shows you admire from the standpoint of the writing.

Duke: I don't watch that much TV. But I can tell you that I think *House of Cards* is a pretty well-written show. There are a few others, comedies, etc. But I think that, basically, the art of writing is something that is fading in the distant sunset. Feature films are more dependent upon special effects, things blowing up, shock and profanity. So writing, as a craft, unfortunately is being lost, and I think it's tragic.

List: Yes, we agree.

Duke: Shakespeare said it best: "The play is the thing wherein I'll catch the conscience of king;" in the sense that you can actually engage people on an emotional, intellectual level, not only by putting something on a page, but how you put it there...You have to understand structure and plot and character and Act One, Act Two, and Act Three; their purpose, and its denouement; all of these technical aspects of writing.

List: In your opinion, what makes a well-written scene? For instance, at the level of a scene, when you're working through it, what do you try to get out of a scene?

Duke: Do I feel anything? Do I laugh? Am I challenged? Am I entertained?

List: Okay.

Duke: The words are tools to evoke thought and emotion. It's what you say and what you do not say. And that's what a lot of people don't understand. It's like music, you know.

List: Right.

Duke: You can't hear the notes if there are no rests.

List: Great example.

Duke: People don't know how to write the rests. You have to be able to give space to the occurrence not on the page. The page describes a reality that you're trying to create or recreate for someone. Within that reality whether it's violent, no matter what it is, there are moments of silence. And what do those silences say? And what do those silences define? On either side of any action there has to be pause or silence so that people can digest the experience of what you previously described. It's just like an ongoing sound that has no definition. Silence actually defines sound.

List: And that's something that students and beginning writers really always miss.

Duke: Well, as a young writer, I was in love with my words.

List: Of course.

Duke: I never wanted to cut anything I wrote, because I felt it so much. It was part of my soul. I lived it or I created it, and I thought

it was wonderful. And therefore, it was a mess.

Houston: Yes.

Duke: I mean, I wasn't doing my job. My job was not to communicate with myself. My job was to communicate with my audience, and that's a craft. You know, it's a distinction between new writers and writers who have been around the block. You use what you created to communicate something larger than your own ego to your audience. It takes time to learn that.

Houston: Yes, it does.

List: What type of involvement do you, as a director and a producer, typically have with screenwriters on a project?

Duke: It's a collaboration. I don't work with writers who tell me I can't change a word. You know, when the writer, the actors, and myself read that script out loud, we can tell whether or not something is true. If it's just words that kind of sound good, but do not hit the core of the emotional truth of the character, you can tell. If you're a good actor, director, or writer, you can tell it. But it's a very difficult process being a writer. You know, it's an isolating job—I write too. And right now, I write with a writing partner, and we sit in my house or someplace else for hours and hours in an isolated situation with nothing around us except our own voices. It's not a painless process.

Houston: Absolutely.

Duke: So you take it to somebody, and they critique it. It's like you have a baby, right. A woman has a baby. She takes it out for the first time, and her friends say, "That's a beautiful baby, but I just think you should take its left eye out." "Take its right foot, and turn it around." And you're saying, "No, that's my baby!"

Houston: Right.

List: Bill, when you direct, do you invite the writers to the set?

Duke: It depends on the writer. I mean, the writer and I never stop creating. My partner for 16 years, Bayard Johnson and myself, we're making a film. We're making it together. He's in the rehearsals. He's listening to what the actors say. We're constantly improving it. Even on the set, if there's something that we've missed, we go to the actors and tell them, "We apologize, but we want to change this a little bit." And if it's a great actor, he'll say, "Okay, let's make this work this way." It's a total collaboration. You know—a lot of directors, once they have the final draft, they cut the writer out, and I think it's a big mistake.

List: What tips could you give to writers on interacting with producers and directors?

Duke: A receptiveness to understanding that a movie is not the script. The script is the foundation and inspiration of a film concept. The writer gives the foundation and the process of understanding what it's going to be in terms of a film on a screen. The director creates, based upon what the writer has said, visual context. And that visual context is composed of everything that is not on the page. For example, a man, John, sits in a room and the blue walls surround him as he is crying about the loss of his mother. That's a pretty descriptive scene, but it's not the movie, because what is John wearing? And is the chair he's sitting in leather or wood? Is there carpet on the floor? Or linoleum? Is the window opened or closed? Is it storming outside? Is John sweating? What are the sounds that are coming into the room? Is the radio on? What is the score that's under this scene? Are all the lights off, except the light coming from the blinds that streaks through the room that line the room and turns into a prison-like element that makes you feel that John is locked into his emotional state? See, none of that was on the page.

Houston: Absolutely.

Duke: That's what directors do for a living.

List: You've directed so many great films and television programs, and a lot of them are projects that have strong female characters

and characters from different ethnic backgrounds, like *Cemetery Club* or *Rage In Harlem* or *Falcon Crest*. In your opinion, how can writers prepare themselves to write characters across genres and ethnicities?

Duke: Well, I think that, unfortunately, the bar has been lowered so low that what 25 years ago was mediocrity is now good. So we're no longer talking about the universal condition of the human experience. We're talking about Joe or Sally or Frank's experience. And people feel that Joe, Frank, or Sally's experience, since they haven't been exposed to anything else, is sufficient. I consider that toxic. That's why the *Sopranos* was so brilliant.

List: Exactly.

Duke: Because Tony's character is a dastardly murderous sinister, on some level, sociopathic being.

List: Who we all can identify with.

Duke: But he loves his daughter.

List: Right.

Duke: And he loves his wife. And he's afraid, and he's insecure; and he had to talk to a shrink about his fears. And he's human. He is a human being that does bad things. But in the description of his bad things, we simultaneously describe his humanity, and that gives us an entrée into who he is as a human being.

Houston: Originally, 227 was a play about my childhood, growing up in Chicago at the address. And to find out if it was universal, I removed all ethnic references.

Duke: That's great.

Houston: And they did it with an all-white cast in an all-white community, summer stock. And they got rave reviews. They never knew it was a play written by a black woman.

Duke: That's wonderful. Well, that means that you succeeded in terms of reaching beyond the surface reality of your characters and your theme that communicated to the audience that this is a human experience.

Houston: Absolutely.

Duke: I think too often, particularly black writers, all ethnic writers, are trapped by the limitations of their ethnicity. And I think rather than writing black plays or white plays, we should be writing human plays.

Houston: Absolutely, Bill.

Duke: Easier said than done, of course. But that's my goal.

List: So when you're looking for a script, what are you looking for in the script from a financial as well as artistic point of view? We know every script is part of a business, but it's also an artistic artifact. So as a producer, what are you looking for when you're looking at a script and thinking about purchasing it?

Duke: That's a very good question. From the script point of view, from the artistic level, I'm always looking for something that, as I read it, is emotionally compelling to me. I mean, whoever the hero or heroes are, I care about how things come out for them.

List: Sure.

Duke: I feel that if I care about that, I can create the experience whereby the audience will care about what happens to them. That's called the hook into the audience, because you hook them emotionally into whatever consequences your heroine or hero may be placed in. So, therefore they're emotionally hooked. And also, you look for the production value. Is this something that's going to fill the screen? And is this something that's going to attract the audience's attention visually, those kinds of things. You look for all of the aesthetics that are compelling, visually compelling and story-wise compelling to

the audience. From the business side of it, it's really a pretty simple formula. It's ROI, Return On Your Investment.

List: Right.

Duke: Now the basic truth of the matter is that you have to target what audience this film is going to be targeted to. And what are the costs, marketing and publicity-wise, to reach that audience? How many theaters is it going to be distributed in? And what are the costs of that, both domestic and internationally? And so that's going to tell you something about part of the recoupment, return on your investment. But then what does it cost to produce it?

So from the actors' salaries to the crew's salaries, to the locations, film equipment, film, wardrobe, makeup, hotel, travel—what does it cost to make the movie compelling to the audience you have intended it for? Then you look at what are the costs going to be for me to market it to that audience? And the past, what other films are similar to this one? What have they done in that market place? When you factor all that in, you make a decision. Either it's worth the risk of your investment or not. You can never guess totally accurately, because you're not just dealing with numbers. You're dealing with the human factor.

List: Right.

Duke: You're dealing with, you know, people may get it; they may not. You're dealing with the fact that, well, it's a great film. It tests well, but at the same weekend, unfortunately, that my film is coming out, *Iron Man* came out. Or you have a great film. The critics reviewed it. They loved it, but the person in charge of the marketing department doesn't get it and put out a trailer that does not work, does not tell the story of the film. He blew it, so no one comes to the theaters. Or the people who have booked the theaters misread the target audience, so the theater that the film is showing in is not in the vicinity of your target audiences.

Houston: Yes.

List: And how much does genre figure into this these days?

Duke: Well, it depends on what you mean by genre.

Houston: Comedy or dramatic.

Duke: Comedy or drama or whatever?

Houston: Yes.

Duke: Well –

List: I mean, there's more money for financing certain genres out there than others, right?

Duke: Right now, action, comedy, and horror, hardly any money for dramas at all.

Houston: Okay.

List: So for writers trying to sell a drama, they're going to have a much harder time?

Duke: Oh, yes, because the craft of writing is no longer appreciated. It's not about how good the script is. It's what are the elements commercially of the script? And the target is usually from the age of 13 to 30. What is going to get them to go to a theater? It's usually something blowing up—or taking clothes off or someone saying something profane or shocking, or a combination thereof. They don't care very much that Romeo or Juliet's love is such that they're willing to die for each other, unless it's under the context of something more digestible.

You have the illiteracy rate in this country approximately 24 percent or 28 percent. You have kids, a good 40 percent of kids, dropping out of high school before they graduate. You have book sales going down. You're not talking about marketing to a really literate consumer. So therefore, if you want your money back, you have to appeal to some of the baser—and I'm not being condescending—

I'm basically saying that it's hard to get a Shakespeare made as a feature film because the studio no longer trusts that the audience understands what Shakespeare is talking about.

List: I wanted to ask you a question about the industry. In addition to having an agent, would you recommend that screenwriters approach directors or actors directly about selling their work to them?

Duke: Well, I would suggest that screenwriters look and explore new paradigms. I mean, the chance of getting a great agent or getting a great person behind you or great attorney today, I mean, the competition is so fierce. You're in a pool of not 100 or 1,000 but millions and millions of people who believe they can write. But the thing is, is not to wait for the studio to make the movie. Look at YouTube. I mean, people are making films every day. A lot of them are crap, but some of them are good. So it's a time for pro-activity in terms of not only the creative process, but in terms of producing your own films, and filming your own film, and editing and writing, and doing the sale for your own film. If you have a script, and you know a director that you respect, and you can collaborate for hardly any money at all, you can make a movie.

List: Definitely.

Duke: When I was coming up, you couldn't do that. It's a totally different world. The only thing stopping young people from making films now is their own head.

Houston: Right.

Duke: If you want to make a movie, you can make a movie. You can experiment with scripts and concepts and new ways of thinking about how to tell a story. So it's a great, great time and opportunities are going to be unparalleled. Television is fading out and everything is going to the Internet.

Houston: Yes.

Duke: Once that starts to happen and you have your own channel and your own distribution portal on the Internet and have that money to market what you're creating there, you will become your own studio.

Houston: I really wanted to know what advice you would have for new writers who are trying to break into the industry?

Duke: It's about putting a business formula together. It's about—stop thinking of ourselves exclusively as artists and start thinking of ourselves in business terms—in terms of how to negotiate these very difficult waters: distribution, production, etc. And it's the best time to do it, because the tools are accessible. Fifteen, twenty years ago, they were not. I mean this is the time. It's a golden era.

Interview with Dwayne Johnson-Cochran

Dwayne Johnson-Cochran is a writer and producer on the film *Queen of War*, an international coproduction with Tengri Productions and Mandarin Entertainment, and a producing partner with Bassett Vance Productions. Johnson-Cochran's feature film, *Love and Action in Chicago* (currently in rotation on HBO), stars Kathleen Turner, Courtney Vance, Jason Alexander, and Regina King. Other feature film projects he has in active development include: *Book of the Year* with actor/producers Angela Bassett and Courtney Vance, *Bibi* with producer/director Sergei Bodrov, *Maria* with AR Films/ Universal, and *The Season* adapted from the novel *Going Blind* for Touchstone Pictures.

Johnson-Cochran's television writing credits include the sitcom *Minor Adjustments*, starring Rondell Sheridan on NBC & UPN, as a co-creator; the hour-long drama series, *Angel Street*, staff-writer at Warner Brothers/CBS; *Frederick Douglass*, a teleplay for director Charles Burnett at Turner Network Television, and *Slam the Night*, a teleplay for Fox Television Movies.

Johnson-Cochran's awards include DVDX Premiere Award Best Director nomination for *Love and Action in Chicago*, Gold Hugo Nomination for best first feature at the Chicago International Film Festival, 4 CBEAs, a Bronze Hugo at the Chicago International Film Festival for *So-Low but Never Alone* and *The Last Set*, a Cine award and a National Teacher's Association Award for best film (*Happy Birthday Dr. King*), and two Chicago Emmy nominations.

Before working in Los Angeles, Dwayne Johnson-Cochran produced and directed documentaries, music variety shows, and public affairs programming for the PBS station in Chicago, WTTW-

11. Johnson-Cochran also served as an agency producer with Burrell Advertising Inc., the largest black advertising agency in the United States, and as the director of the Blacklight International Film Festival of Chicago—at the time, the largest international black film festival in the United States.

Johnson-Cochran served for twelve years as an Adjunct Professor with the University of Southern California, teaching screenwriting for the Bill and Camille Cosby Writing Fellowship Program (aka the Guy Hanks Marvin Miller Film Writing Program) and taught screenwriting seminars in Nairobi, Kenya and Abbas Abada, Ethiopia. He wrote and directed *Side by Side*, a documentary about a leading woman's group in post-war Sierra Leone produced by former Secretary of State Madeline Albright; *Be Known*, a feature-length documentary about jazz percussionist Kahil El' Zabar; and *Story of a Village*, a film about a small village in Sierra Leone's diamond mining country, co-directed with the actress/producer Regina King.

Born in Chicago, Mr. Johnson-Cochran earned a BS in Geophysical Sciences from the University of Illinois at Chicago and attended the School of the Art Institute of Chicago. He chairs the Genre Committee of the WGA-West.

☆ ☆ ☆

Houston: Dwayne, could you briefly explain the development process?

Johnson-Cochran: In screenplay writing in Hollywood, the development process is an industry. I'll explain how the process works and then how we, as writers, fit into it. Writers are hired by the studios, producers, directors, or actors who also produce. Writers' agents also put them up for jobs or assignments. They show either their produced work or their last script as their sample.

A development exec will bring you into the office with other people in the room and say, "We love your work or your sample. We love your last film. We have a project for you. It's a book we were trying to adapt, or a movie we're trying to get a rewrite on quickly… or we'll take 12 weeks, whatever. We need your feel, your type of writing style, on this project."

Usually there's a creative executive, which is the lowest level person, or a story editor in the meeting. Then it goes Creative Executive, Director of Development, Manager of Development, VP, Senior VP, Executive VP, and President of the company in these production companies. This same model is also in the studio. All these people are readers. It just depends on what level of reader they are. They all read. They all try to find material. They all scour around looking for scripts they can get to a green light quickly.

What you, as a writer, have to deal with when you deal with the development process is the fact that if you're hired as a writer for the studio, you get twelve weeks to write your script. They will give you notes, probably before you write. But there's a certain level that you achieve in Hollywood where people want your first draft to be you. Your voice. So you go and knock it out.

Houston: Before a writer can get to that point of assignment writing, he or she would need an agent. How would the writer go about getting an agent if they'd never had one before?

Johnson-Cochran: That is the hardest thing to do now more than it has ever been, primarily because of two factors. Many agencies have downsized or merged and many have left to become managers. Also, agencies are basically cutting their rolls down.

Houston: What's the difference between an agent and a manager?

Johnson-Cochran: A manager is not licensed by the state of California, or the state of New York, or wherever managers are licensed to solicit work for you. Agents are. They have to get a talent license to do it, and they have to take tests and everything. It's a process to be an agent, to be trained. Managers come from all different walks. You could become a manager. But you cannot solicit work. You cannot do a contract to the studio, to a signatory company, and gather his money or her money. You have to go through an agent or a lawyer.

The difference I notice between a manager and an agent—managers will read your material, give you comments on your material, help you make connections to people that agents may not

have the time for or have the inclination to do in this new period. Managers tend to go deeper into your career than an agent would do for writers. I've also noticed that managers, if they are so inclined and you want them to do this, will take a producing credit on your project if they do something extraordinary in the process of you trying to get a film made.

Houston: Do you have an agent?

Johnson-Cochran: I have an agent and a manager.

Houston: Let's talk about the process of writing. When you write, do you use an outline?

Johnson-Cochran: Always. It helps me to write a treatment, a story. I think storytellers have to tell stories, so you have to write the whole story out, at least in your head, to know what it looks like. I also believe it's important to know the ending. You may not know exactly how the story ends, but you should have an idea of how far you want your story to go. You may not know the middle, but you know the end. And I think that sometimes you can have characters that are so compelling that you let the characters determine your ending, and that's a great thing. You've created your ending already. You wrote this great character and now the character and your story is leading you to this brilliant ending. To me, that's magic.

Houston: Right.

Johnson-Cochran: It makes it easier for you. You know the guy's going to spin out of control and die in the end or kill somebody, or whatever, but you have to have an outline. You have to draw the map. And sometimes, after I write my treatment, I take the paragraphs and push them up and take them off, all the stuff off the paragraphs and make them bullet points, and then write the scenes, knock them out one at a time, so I get eight or nine scenes done a day.

Houston: How much of your work comes from writing assignments versus the sale of spec scripts?

Johnson-Cochran: I would say it was 50-50. Maybe 60-40 spec. This past year 50-50 because I would write a spec, get an assignment, or write two specs, get an assignment.

Houston: Would you say most of your work came from your own creative ability, or someone came to you with stories they wanted you to develop?

Johnson-Cochran: I would say that most of it comes from me, where I had pitched someone a project and said, "What do you think?" And they said, "Oh, we want to get this," and it becomes an assignment then. You pitch something. They're like, "We're not buying that." And the tenth person says, "I'm buying it." Your idea becomes a pitch. A pitch becomes a sale, and a sale becomes money.

Houston: How would you advise someone who lives outside of L.A., like in Chicago, to go about getting into the film or television industry? Because when I went in, it was really an unorthodox way.

Johnson-Cochran: Yeah, same with me.

Houston: We would like for these struggling young new breed of writers to have a process, or know how to get through the process.

Johnson-Cochran: Okay. Things have changed so much since you and I started. I would really recommend, if someone is 20 years old, and they think they can write, if they can write, and don't know how to direct or produce, find someone who can illustrate their material and direct it for them. Get in front of the camera and shoot it, because what Hollywood wants now is almost finished people, finished work. There are writers who come from nowhere. The guy who wrote *Kingdom of Heaven* came from nowhere. He was a journalist from Boston. He wrote a movie called *Tripoli*, big historical epic, somehow it got to Hollywood and Ridley Scott said, "I'm making it." It didn't get made, but he gave him an assignment. Next thing you know, he's writing *The Departed* for Martin Scorsese. So you can come from nowhere if you have a writer's mindset. You're a newspaper writer or a novelist or something, and you just get a script to a guy, next thing

you know, some agent reads it and says, "This is huge. I'm going to give this to my A-list directors."

But we're here in Chicago. We have a lot of black, brown, white women, men, people with no money trying to make movies, and I'm saying to them if they don't have that level of inclusion, or an agent's phone number, or a friend of a friend, they have to finish their material. Shoot it. I'm not saying that to be the next Tyler Perry, you know, but I'm saying, *write* it, *shoot* it, *make* it *distinctly yours*, and then say to the agents in Hollywood, "Here's my film. Ten minutes, 100 minutes, whatever it is. Here's a film." And they'll say, "This guy has talent; this woman has talent." "We're going to represent this person." So I say right now, everyone has to become a total filmmaker.

List: Are all the studios looking regularly at YouTube for new talent?

Johnson-Cochran: Oh, yeah. There's a department at UTA, United Talent Agency that has four people right now who are scouring YouTube every day, and Google, looking for the next big filmmaker, looking hard. They're putting in names, looking for people. They're looking for people who have an eye, a comic eye, dramatic eye.

Houston: In your opinion, what do you think makes a great screenplay?

Johnson-Cochran: That it crackles on the page, that every page, almost every two or three lines you are surprised by the dialogue and the characterizations and the body copy. You read scripts and you know in four or five pages, this person can write. I don't know where this story's going, but I am totally hooked. It's the idea of using language in a way that engages you. And sometimes you can have a pretty pedestrian story, but the writing is so good that you just keep going.

Sometimes you read screenplays like James Ellroy's books, and he writes with these three line sentences. They snap at you. He said, "Go," and then a period. Well, some people write that way in screenplays. They just use an action word in a script, you know, and that action word is his style or her style of writing.

It's style, meaning this writer took time to create this style. That

is so telling to me that someone took time not to be lazy, to really delve into a style of writing. So you keep reading. You get to page 40, and the style is still intact. Now you're thinking, "He didn't get lazy." You get to page 80, still working. The style is working.

If you read *L.A. Confidential* that screenplay by Curtis Hanson and Brian Helgeland, you just keep turning the page. You keep turning, because you don't know what's going to happen. You're going to see a plot or story point that goes back on itself, then goes forward. You see things that go this way, that way. You know that they are trying to engage you but keep the story going forward. And when the writer tricks you a bit, that's very impressive. They throw red herrings in, misdirections and wrong paths. I think great screenwriting is where you read something, and you don't expect what will happen next. Like I said, some of these stories, you know the ending, but it's the way you get there, that's so amazing.

Houston: Is it a good idea to write things, especially for screen and television, for a certain actor?

Johnson-Cochran: Well, you know, it's good and bad. The obvious thing is that, it's good if you know the person, they can read it, and they say, yeah, I'm going to do it. See, I read scripts sometimes, and they say, "He's tall, dark, three-day growth, kind of Benicio- looking, but not quite." You know, those are funny scripts because, it's like somebody's giving you an image of a guy, but he's not quite him. So you tell Benicio, it's not for you, but somebody who can play somebody like you." And then he'll say, "Well, I want to do this role." I mean, you're messing up the whole situation. You know what I'm saying? I say don't write for anybody. That's a problem I think black writers have. We write screenplays, and we think, okay, we should write a black movie or a black screen story or a TV show, but I think funny is funny, drama is drama and story is story. And just drop in any character, because if you do a film that says "black cop, 35, good looking," well, there's four actors who are going to play that role. Four. You say "cop, good looking, 35," then you have 130 people who can play the role, because there are a lot more A-list actors out here looking for good roles. Hell, you'll have Javier Bardem come over here and do an American accent! Whatever.

You know for *The Things We Lost in the Fire*, which is that film with Halle and Benicio, the writer said we did not have a black woman and a Latin man as the leads. But the casting director said, "Let's go this direction." They went, and the film's turned out fine. So why harness yourself in, unless it's a period piece or a piece that says it has to be a black male or black female. If the essence of him is black or is Latin or Chinese, because the story is about that, then of course.

Houston: Can you tell us about your time with the Cosby Writing Program?

Johnson-Cochran: I taught on the film side, and there was a TV professor there also. Then there was another teacher that taught African and African American history.

I think what Cosby wanted to do, more than anything else, is be able to pull black writers from all over the United States. Five hundred to eight hundred people applied every year, and they picked twenty-five.

List: Are there some things that you found yourself consistently teaching to these students over the years? Tips that you always seemed to need to give writers that come into the class?

Johnson-Cochran: Yeah, over-writing.

List: Can you elaborate?

Johnson-Cochran: I tried to get students to crystallize exactly the idea of a scene, because every scene has a beginning, middle, and end. But also scenes can begin in the middle. Some scenes can begin in the end. So you have to see all of it. And some people write the absolute, the entire scene. So go ahead, do that for your first draft, for your own draft. But go back the next day and rewrite that, and you create a flow for your script. Find out what's really necessary. Maybe that line or only this line is necessary. Or maybe a look is all you need.

I was writing this script for [Angela Bassett and Courtney Vance], for their company, and the scene at the end of the second act is where things have been really bad in the story. This guy's mother

is in a mental institution, and she's got dementia, and she's falling apart. I had this whole scene with this lead actor and his girlfriend in bed thinking. He wakes up in the middle of the night, and they had a long conversation about what he's going to do with his mom. Cut it all out. Just wrote, he wakes up in the middle of the night and he says, "She wants me." Cut. He's right there in the hospital room with his mom.

You know, you get the fact that this is a movie. As a medium, it's different. And the medium is heightened because a character is doing things that you may do or you may never do. So as a writer you need to get us to that next place. Fly us there. So I try to do things that— as every writer does—that takes you out of your seat a little bit. But whatever I do, I always try to crystallize it.

Houston: Emerging writers tend to say something in three or four lines when they could have said it in one line.

Johnson-Cochran: That's absolutely right. That's exactly what I mean. A good example is this, and I'm sure you see this a lot. Greetings: "How are you? What's going on? Not much. Fine, good. What's going on with you?" The characters have history. Don't do all that. Or if they don't have history, say something that's interesting the first line. Don't say, "How are you? Where are you from?" Who cares? I mean, that's like rudimentary writing. It's also lazy writing. It feels as though the writers are gearing themselves up for what they really want to say, but they're as bashful as their character. But their character is not them.

Houston: Right.

Johnson-Cochran: So if you're bashful, make the character less bashful. If you are bashful and the character is bashful, then have him say nothing. You know what I mean? It's like this idea that you're mirroring yourself in the script. William Styron says it very well. He always talked about the fact that he writes about people that he wants to be.

Nat Turner was somebody that he had an incredible amount of respect for, so he wrote about this guy—a black slave in revolt. He

says, "That's not me." So he wrote just the opposite of himself. And I think that's very interesting. Good writers read other writers. They read a lot of work, and they say, "Oh, God, I can put that in my own work." Because all we do is steal. The best writers are thieves. We lift style, characterizations, intent, impact, and all sorts of juicy bits from other great writers, make it our own and create something wholly and completely different. But you have to steal well. You have to steal really well.

Houston: Well, that's how we learn.

Johnson-Cochran: Yeah, thievery is nine-tenths of the law.

Houston: Do you now or have you ever had a writing partner?

Johnson-Cochran: Yeah, I've written four movies with four different people. Two of them I sold. I had a great experience with Sergei Bodrov. He's a Russian director. He made *Mongol,* and it was nominated for an Oscar for best foreign film. Sergei is a good friend of mine. We met maybe eighteen years ago. He read a script I sold to Steven Spielberg called *My Tribe is Lost* and said, "We should work together." And before we wrote, he went off and made a film and got his Academy Award nomination for best foreign picture for *Prisoner of the Mountains.*

He came back from Kazakhstan, got the Academy Award nomination, says, "Dwayne, we're going to premiere my next film at Cannes. I have 15 days before I go. You and I should write together. I will sell the movie at Cannes."

He had this great story. He had bought the rights to this French story, so we decided we were going to write a movie in ten days. We sat down for ten days straight and wrote a movie, and we sold that movie to a French company. It shows when you have a good story, two motivated people in the room, you can knock out ten pages a day and get a good movie.

I wrote with another person, an action movie, years ago. He had never written before. He had a good idea. I had a good idea but writing was like pulling teeth. We couldn't do it. It just wasn't happening.

I wrote another movie, which is one of my favorite movies, with a

guy who had only written one script before. My good friend Tarquin Gotch. Tarquin is a producer, was one of the producers of *Home Alone, Home Alone 2, Home Alone 3*. He's a great friend of mine, this producer. We did twenty-eight drafts, and I wanted to kill him.

Houston: Twenty-eight drafts?

Johnson-Cochran: I wanted to kill him. Because he just wasn't ever, ever satisfied. But, you know, I look at the script now, and it's good. But it was twenty-eight drafts. I'm sure he'll laugh when he reads this, but producers are perfectionists, and that's a good thing.

Houston: Yeah, sometimes that's what it takes. When I first got to Hollywood, I know I was very surprised and aware that everybody had a writing partner, and I never had one, never worked with one. But I often thought it would be great, because you have somebody to bounce stuff off of who is in the profession, and not just somebody in the kitchen, or somebody in your family.

Johnson-Cochran: That's right.

Houston: Not just "your auntie, your church members." Yeah, they love it.

Johnson-Cochran: They loved it.

Houston: Because they don't recognize garbage when they see it.

Johnson-Cochran: Right. Garbage, you know, it will smell bad anywhere. And the thing is you have to think about it. You have to say, "What level do you want people to see this on?" Do you want this to be on your level or on her level or on his level or on studio production level?

Houston: Right.

Johnson-Cochran: And I'm always looking at the highest level possible. I tell my students, you know, bring me something in this

classroom that's going to sell, because we're going to read this out loud, and you're all going to hear it.

Houston: Mm-hmm.

Johnson-Cochran: I had a student that wrote something, and I hadn't read her final draft, but, you know, the scripts come in, they were kind of okay, I was like, "Okay, it's pretty good, pretty good." We've got to fix that, fix that. This woman came with this script. The first ten pages we were laughing so hard we were all crying. And she was like, "Do you think it's funny?" I said, "We're crying. If the rest of this script is this good, I want to make this film. I'm going to find a way to get it made." [*Laughs.*] She was amazing. She's like, "Cool." She knew how incredible her script was. She had confidence in her writing, and every turn, every page was amazing. She realized that she had put the time and the effort into it.

You have to watch movies. You have to watch good movies. You can't watch crap. You can't watch stuff that's easy and has easy resolutions. You have to watch stuff that's going to really challenge you and piss you off and upset you, or stuff that makes you cry or makes you laugh out loud, something that really affects you one way or another—just to get a style going, your own style. You have to do a lot of work in order to create your own work.

Interview with Robert Eisele

Robert Eisele wrote the original screenplay for *The Great Debaters*, which won four NAACP Image Awards and was nominated for a Golden Globe Award for Best Picture. Eisele's script received an Image Award nomination for Best Screenplay and won the Paul Selvin Award from the Writers Guild of America. *The Great Debaters* also received the African American Film Critics Association's Best Picture Award. Eisele's body of work includes the original screenplay, *Hurricane Season*, directed by Tim Story and starring Forest Whitaker. His cable television film, *3: The Dale Earnhardt Story*, which aired on ESPN in 2004, was the second highest rated basic cable movie of that year.

With Dennis Leoni, Eisele executive produced the Showtime series *Resurrection Blvd.* The dramatic series won the ALMA for Outstanding Television Series in 2001. The following year he received a Writers Guild Award nomination for his "Niño Del Polvo" episode of *Resurrection Blvd.* He was honored with a Writers Guild Award nomination (1995) and a PEN Literary Award nomination (1996) for his USA Event Movie, *Lily In Winter*, which he also co-executive produced.

Eisele's first Writers Guild Award nomination was for the Showtime Movie *Last Light* in 1993. He executive produced the movie and acted in scenes with stars Kiefer Sutherland and Forest Whitaker. He was Supervising Producer of *The Equalizer* (1987-1988) and served as story editor for Michael Mann in the premiere season of *Crime Story* (1986). Eisele received the Humanitas Prize in 1986 for his episode of *Cagney & Lacey*, which also won the Imagen Award that year.

Robert Eisele is a writer of European descent. He is included in this book because his work inspires us. He is a tremendous example of a writer who has been successful at representing African American and Latino stories in a way that shows understanding of the cultural realities of the characters.

★ ★ ★

Houston: Bob, we wanted to start out by asking a few questions about the business. You've worked as a writer in both television and film; can you explain to our readers what an overall deal is?

Eisele: An overall deal is when a studio pays you a salary to create television pilots exclusively for them. They also pay your overhead: your office, business lunches, assistant's salary, and other related expenses. When I was on overall deals in the 1990s, television studios were successful enough that they would offer you an overall deal where you were non-assignable. Remember those, Christine?

Houston: Yes. I worked with Norman Lear in one of those deals.

Eisele: Yeah. But now, the only way they'll give you an overall deal is if you agree to be assignable, which means to serve on any show they assign you to. I had non-assignable overall deals at Warner Brothers, Universal, and then Paramount. So that was kind of cool. It allowed me to raise my children and coach their soccer teams, but it also got in the way of getting my shows on the air. Producing an ongoing series while writing a pilot provides greater visibility for a writer, and a greater chance of getting your show picked up by a network.

Some of the pilots I wrote would've been groundbreaking had they gotten on the air. I wrote a pilot for Fox that received a green light to be filmed, but the production fell apart because our actor dropped out at the last minute. It would have been the first Latino drama on the air. As it turns out, I worked on the first Latino drama on the air. By "Latino drama," I mean one which has a Latino lead and content because, obviously, I'm not a Latino myself.

So I came very close to getting my own shows on the air, but it never quite happened. At the end of my last overall deal, the studio

said, "Look, if you serve on this show, we'll extend you." But it was a show I didn't like so I refused, and I wasn't renewed.

Subsequently, I helped launch the short-lived series, *413 Hope Street*, on Fox. After that, I wrote TV movies and features to make a living. Then I launched *Resurrection Blvd.* with Dennis Leoni for Showtime. When that show ended, I went back to features where my career had begun, even before *Cagney & Lacey*. I also wrote some television movies, including *3: The Dale Earnhardt Story*, produced on ESPN.

Houston: Bob, did you — at any time in your career and now — did you have a writing partner?

Eisele: I have had writing partners for a few specific projects. These partners were friends and talented as hell. Although the scripts we turned out were good, I never thought they were as strong as my partners' best work alone or my best work alone. What you want with a collaborator is synergy, where the two of you together equals something bigger than the sum of your parts separately. I never found that in collaboration, so I tend to work solo.

List: Can you describe the development process of *The Great Debaters* and how long it took you?

Eisele: It began in late 1997 with a friend, Jeff Porro. I taught martial arts to Jeff when we were both grad students at UCLA in the early 1970's. He was working for his Ph.D. in International Relations while I was studying for my Master of Fine Arts in Theater. Today, he's a speechwriter for corporate executives and political figures. He's written speeches for Jimmy Carter and Kofi Annan.

Jeff is also an avid reader, an intellectual who subscribes to a lot of arcane history magazines. In 1997, he was reading *American Legacy*, the black history magazine, when he found an article actually entitled *The Great Debaters*. The article, written by Tony Scherman, was only three pages long, yet it covered ten years of the Wiley College debate team's history, including information about the poet-teacher, Melvin B. Tolson, and his famous student, James Farmer

Jr. Scherman's article did not have a narrative or dramatic structure and was one piece of a myriad of research that we undertook. That's why *The Great Debaters* was considered an original screenplay by the Writers Guild, as opposed to an adaptation.

So in '97, Jeff sent me the article, because he thought the subject matter would make a great movie. I read it and agreed. We optioned the article as a selling point, and because we wanted to use the title. Subsequently, we began interviewing the primary sources that the original magazine writer had interviewed. We had the great, good pleasure of interviewing James Farmer Jr. before he died in '99. I believe we interviewed him in '98. We also interviewed Henrietta Bell Wells, Benjamin Bell and a few other debaters who were alive at the time. Henrietta just passed away. To my knowledge, she was the last of the real great debaters.

Jeff wanted to collaborate with me on the screenplay, but he'd never written a screenplay before, and we were living on opposite coasts. He lived in D.C. I lived in L.A., so I told him, "Look, if we do this, it's just going to take forever." I said, "I'll tell you what. We'll construct the story together. I'll protect you as best I can and make sure you get credit. Then I'll write the screenplay." And we agreed on that.

We took our time putting the story together because we thought this was an extremely worthy project. But we also feared it wasn't particularly commercial. As I worked away at it, my agents at CAA said, "Look, the only way you're going to sell this is if we attach our other client, Harpo," which, of course, is Oprah's company. So I pitched it to Kate Forte and Valerie Scoon at Harpo. Kate runs that company for Oprah, and I had worked with her before on a TV movie script. Valerie, who now teaches at Florida State, is a Harvard grad, an African American woman who was very helpful in the development of the project. I worked closely with her.

So I pitched *The Great Debaters* to them with Jeff in late '99, and they liked it. And then, in 2000, Harpo and I marched it into Miramax, which was the Weinsteins' company at the time. They bought the idea and paid me to write the screenplay.

List: Nice. Could you also tell us about your work on *Resurrection Blvd.?*

Eisele: Yes, that show meant a lot to me. I spent two years on *Resurrection Blvd.* and got my third Writers Guild Award nomination for an episode that I wrote, which, by the way, was the first WGA nomination that Showtime had ever gotten for any of their series.

List: That series is one of the most important pieces of work in the history of Chicano media.

Eisele: Thanks. It was the first episodic drama starring Latinos, created by a Latino, and largely run and directed by Latinos.

List: How did you end up on that project?

Eisele: Well, Dennis Leoni and I were personal friends. His wife, Deborah, was once a development executive at ABC, and she was one of my first Hollywood friends. She was one of my first fans back in the '80s. Dennis had never executive produced a show, and we were buddies. He needed somebody to cover his back, and I had executive produced a show. I helped run the writing staff on *The Equalizer* and launched *413 Hope Street*, so I was known as a showrunner. Viacom hired me to help Dennis run *Resurrection*. We were equal in terms of title, both of us executive producers. Dennis created the show and, the first year, he was off doing a lot of promotion and also handled much of the filmmaking chores. So I worked closely with the writing staff that first year. And then the second year, I also worked with the writers but became a consulting producer so I could finish my job on *The Great Debaters*.

The third year of the series I was off doing features, so I just wrote one episode, which got me a Writers Guild Award nomination. I did what I set out to do, which was to help Dennis launch the show. I'm very proud of *Resurrection Blvd.*, and Showtime felt I had a lot to do with its success. We won the ALMA Award, and we discovered some great writers. I had a lot of fun on that show.

But I got the *Resurrection Blvd.* gig right before I sold *The Great Debaters* pitch, so it took me a while to get to the first draft, because I was so busy executive producing. I also did a great deal of research before I wrote the screenplay to gain a better sense of both the

history and the people. When I delivered my first draft of *The Great Debaters*, everybody loved it, but it sat on the shelf for a while. The project wasn't seen as imminently commercial.

We had directors who wanted to do it, though. Among them were Kasi Lemmons, Joe Roth…

Houston: How did you get Denzel involved?

Eisele: Here's what happened. In 2004, his junior agent at ICM, who worked with Ed Limato, discovered the script and put it in his hands. Denzel read it, and he loved it. Now here's some irony. Denzel had coached my son Nick in basketball when Nick was eight or nine. And later, his son J.D. and Nick both went to Campbell Hall High School. So Denzel didn't really know me that well, but he knew my son. And he hadn't put two-and-two together yet regarding the fact that I'd written the script.

Denzel was walking into a gospel choir concert at Campbell Hall that my wife, Diana, and I were also attending. He hadn't signed on to do the movie, but I knew that he liked the script. And Diana said, "Bob, you got to go talk to Denzel." I told her, "I don't want to bother him." She said, "Look, he doesn't know that you're the guy who wrote *The Great Debaters*. He needs to put a face to the name." So I walked up to Denzel and said, "Denzel, we've got something in common besides the fact that you coached my son in basketball." He said, "What's that?" I said, "I wrote *The Great Debaters*." And the look on his face was priceless, because you could see disbelief, surprise, and then warmth in three stages. He looked at me and said, at first, "You wrote that?" I said, "Yes, I did." And he answered, "Well, I'll tell you something. It's a great script. And whether I do it or not, it deserves to get made."

List: I loved the storylines and the themes and the way you develop them in that film. Do you have a specific method that you use when you develop your plot?

Eisele: Yes, I do a very dense outline. But first, I do research and a lot of it. Once I feel I really own the period or the world that I'm writing about, then I journey into the outline. Almost like a method

actor analyzing a text, I try to understand my protagonist's primary objective or need. Then I follow the actions the character must take to confront obstacles and realize that objective – or fail in the process. That's how I weave a plot. The main character could be one person or a group character, like in *The Great Debaters*. The protagonist is really that team of debaters.

List: Yes, that's right.

Eisele: So the protagonist doesn't have to be one person, but it has to be that entity whose single, most important need drives the action of the script. You follow their want, their need, and that character will tell you where the story should go. Now, anybody can write a first act and a third act, but it's that middle act –

List: Act two is always the killer.

Eisele: It's what separates the women from the girls and the men from the boys.

List: Absolutely.

Eisele: Plot is really just sewing together the events that explore and illustrate and dramatize the action of that main character struggling to get what they want. So you present obstacles to the protagonist and devise events that best tell the story. The main character's central action, their struggle to realize their most important want or need, is the river of the movie. Every story event has to further that central action, flow into it like a tributary flowing into a river. In *The Great Debaters*, the protagonists' central action – the struggle of a debate team to beat the national champs – has to reflect the theme, which is people finding a way to believe in themselves.

I think what happened with *The Great Debaters*, what really attracted me to the material, was not just that it was a riveting story of David versus Goliath, but that it explored the intellectual lives of African Americans, lives which have not been represented nearly enough in media. I know there are plays that do it, and there are plenty of black writers who write novels about this, but you don't see

it that much in film. Producers always seem attracted to other aspects of the African American experience, mostly crime and punishment or sports stories or comedy.

List: You're right.

Eisele: And being raised among people of color, I was exposed to many incredible minds. So what appealed to me was the intellectual life of African Americans, the David and Goliath story, which was a natural to get your heart thumping and caring about these characters, and the deeper thematic issue of dealing with a self-doubt that, in the case of Henry Lowe's character, verges on self-hatred. The greatest evil of racism is that it can cause self-hatred in people.

That's why the Black Power Movement was so important in the '60s, the idea that "Black Is Beautiful" in and of itself. Understanding this helped me identify the external drama of *The Great Debaters* — Jim Crow. The external threat is Jim Crow. It is at every place lurking to defeat these kids. The internal drama is that there's something inside them that could defeat them as well. In this case, it's the self-doubt that in one character, Henry Lowe, verges on self-hatred. I found it ironic to discover self-doubt in these debaters who were, in many ways, magnificently gifted and came from a tradition that not only honored oral storytelling, but had a respect for rhetoric that flowed from the black Southern Baptist preacher all the way back to the eloquent speeches of abolition. And out of these young debaters would later spring the oratory and ideals of the Civil Rights Movement.

There's always been a respect for the spoken word in African American culture. And the eloquence that seems to surprise the majority culture is endemic, it's always been there. I mean, read the speeches of Frederick Douglass or Olaudah Equiano, the ex- slave and English abolitionist of the late 1700s. I have a book called *The History of Negro Eloquence*, first published in 1904, and the speeches are amazing. And listen to Martin Luther King and Jesse Jackson and Barack today.

Houston: Mhm-hm.

Eisele: It's deeply embedded in the culture. So these Wiley College students had such a leg up on the white folks they were going to debate. It's a wonder they doubted themselves at all. But then you see why they doubted themselves in the horrors of Jim Crow. They were surrounded by a culture that taught and preached inferiority, and they really wondered on some level about the truth of it all. And that's what they had to overcome.

I think that's the central struggle of the piece. You have these wonderful bright lights struggling in the darkness of Jim Crow. They're trying to get through this and believe in themselves. And therefore, every subplot has to feed that—for example, the love triangle.

List: I thought that was a brilliant subplot. It really enriched the story.

Eisele: Well, what it does is allow us to have a moment where we see Henry Lowe – his self-doubt, self-hatred, dragging him down. He basically degrades that relationship in a way that he shouldn't. But his betrayal of the relationship happens after they view the lynching. Jim Crow is a factor in this. And then Henry Lowe redeems himself by handing off the debate and the future to James Farmer Jr., his rival, as he tries to make amends with Samantha. So that struggle mirrors the larger struggle. That's what I'm talking about, about a subplot mirroring and, like a tributary or a stream flowing into a river, feeding the central action of the piece.

List: You know, often novice writers have a hard time understanding how a writer needs to dramatize reality in order to make it screen-worthy.

Eisele: Uh-huh.

List: Can you describe what types of dramatic license you took with these characters and the plot of *Great Debaters* to transform their real-life stories into an entertaining screenplay?

Eisele: There's a saying that you can't let the facts get in the way of

telling a good story. So you have to be true to something in spirit, but not necessarily in every detail. Life doesn't have dramatic structure, so you have to impose it.

Houston: Right.

Eisele: For example, we took ten years of a college debate team's history and boiled it down into one year, which gives us this sediment of great little dramatic morsels that you can pick up and place in a cause-and-effect continuous dramatic structure. In reality, the debaters didn't actually see a lynching, but they fled from what they thought was a lynching, or one that might actually happen.

I had a list of every known lynching victim on my bulletin board when I wrote this movie, just to remind me that at the core of this is the incredible hatred of Jim Crow. Eventually, the movie has to build to a point where it's not just subtle and sub-textual racism that they're dealing with, but the most direct hatred imaginable, which is the destruction of life itself just because of racial differences. So the lynching, I knew, was going to be part of it. And they didn't drive by it exactly as I wrote it. It didn't happen at the crucial moment that I made it happen. You engineer something like that.

Henry Lowe is based on the actual debater, Henry Heights. We know that the real Henry drank too much, that he was older than the other students, that he was intellectually gifted – and may well have been the smartest of them all. And the scroll over at the end says that he studied at UC Berkeley and got a degree in Divinity. But the only thing we know for certain about what happened to the real Henry Heights is that he disappeared. And from the things I heard about him, it made me think, you know what, maybe in reality the guy self-destructed. Who knows? So I used that as inspiration for the Henry Lowe character. And I wanted to make Henry a character who had suffered more than any of them. You know, he talks about how his granddaddy built the levees around there; and we see that he lives in a crappy little shack.

List: Yes.

Eisele: He was a sharecropper's son, and maybe he saw his family

starve, or maybe somebody was lynched in his family. So he's suffered more than the others. I can't know that about Henry Heights. I don't know that's his backstory. But I took liberties and tried to create reasons why the Henry Heights that I read about might have been the kind of guy he was. So in that way you take liberties.

Henrietta Bell Wells is not really the Samantha Booke character. Samantha is only loosely based on her. Henrietta never would have had an affair in college. And by the way, Wiley College never would have allowed the Samantha character to go out on the road with these guys without a chaperone. In real life, when Henrietta Bell Wells did go on the road with the team, there was a female chaperone with her.

List: One of the things that I consistently find problems with first time writers is their resistance to dramatizing references from their own lives to make the story more cinematic.

Eisele: Yeah, you've got to because you can't just follow the course of life. I think all human beings have the grammar of storytelling embedded inside of them. I think that's why we recognize good stories and bad stories. I think the reason we have the grammar of storytelling embedded inside of us is to shed light on our lives... things happen randomly. Wonderful people have terrible things happening to them. Terrible people have wonderful things happening to them. Life doesn't make sense in many ways. Life is boring at times. Life takes the course it's going to take, and not everything is cause and effect in life. But in drama, people pretty much are masters or victims of their fate. Ultimately, characters have to change or die in drama. And if it's not a literal death, it's an emotional death. In life, the people who cause us the most grief are people that don't change. They won't change. They won't change their opinion about a damn thing.

Houston: Right.

Eisele: So I think that's the crux of the matter – to realize that drama isn't life, it's a reflection of life. It's a selection of events. It's an artistic interpretation that shines light upon life and hopefully gives us a little meaning.

List: How would you recommend new writers get an agent or manager?

Eisele: This is a conundrum because you can't get your work to someone unless you have an agent, and you can't get an agent…

Houston: Unless you have sold something.

Eisele: Yeah, the agents don't want you unless you've got credits. It's a "Catch 22." But what I would say is this—the first thing I recommend to everyone is to make sure that you write with excellence. You've got to be patient with your talent. You've got to find the time to write, and you've got to find a way to support yourself so that you can have a little time to write. You can't say, "I give myself a year to do it." If you're really a writer and you write from an inner necessity, i.e. you must write and you would do it even if you weren't paid – that's the number one thing. That's the litmus test.

A lot of people want to be writers, but they really don't want to write. They like the idea of being a writer. So first of all, do you really have the inner necessity? Nobody necessarily loves writing, but do you have to do it? If you haven't done it for a year, you're going to feel like you've been cut off from some part of yourself.

If you have that bug, then the first thing to do is to say to yourself, "Even if I never make it, I will have a writer's life and make room for a writer's life." And by the way, you could be maybe self-publishing poetry and be a writer all your life. It informs your inner journey. It makes you a better audience for other writers who are published or produced. It's not anything to look down on. If you want to have writing as part of your life's journey, that's a noble thing. You don't necessarily want to sacrifice your life to it, though. You don't want to ruin marriages and not make a living because of it.

So that's why I say the number one thing is to make an internal commitment that you're going to learn to write with excellence, and you're going to eke out the space to write and give yourself time. You won't "make it" in a year. You've got to give yourself the time it must take. And be honest with yourself. Don't send your work out until it's ready. And like I said, find a job where you can carve out at least some writing time. I have great admiration for writers who

write on spec because I get paid for my work. It's a lot easier for me to write knowing I'm getting paid than it is for a person who is writing into the cosmos, into the void.

So write with excellence. That means going to school, polishing your work, listening to critics that you respect, not just the gentle ones. You need gentle critics to keep you going, but also the ones that will call you on stuff that isn't working. They will build you. And don't be afraid to rewrite your work. Once you get a script that most of your critics, gentle and otherwise, say is a good script, once you get that script, by all means, start sending it out.

Chapter Sixteen
Interview with Zeinabu irene Davis

Z einabu irene Davis is an independent filmmaker and Professor of Communication at University of California, San Diego. Since receiving her MFA in film and video production from UCLA in 1989, Davis has produced numerous award-winning works including *Mother of the River*, a drama about a slave girl; *A Powerful Thang*, a love story set in Afro-Ohio; and *Cycles*, an experimental narrative exploring the psycho-spiritual journey of a woman. Davis' dramatic feature-length film entitled *Compensation* follows two inter-related love stories that offer an intimate view of black deaf culture.

Davis' portfolio also includes her documentary, *Trumpetiste Extraordinaire: Clora Bryant* about a Black woman trumpet player who has been on the jazz scene for over fifty years; and the video essay, *Co-Motion: Tales of Breastfeeding Women*, which focuses on women of color and breastfeeding. Throughout her career, Davis has been awarded numerous grants and fellowships from such sources as the Rockefeller Foundation, the American Film Institute, and the National Endowment for the Arts. For her work on *Compensation*, Davis received the Gordon Parks Prize for Directing from the Independent Feature Project and the Reel Black Award from the Toronto-based Black Film Video Network. Her interests include altering and diversifying the terrain of mass media, film history, world cinema, and folklore. She frequently writes and lectures on African and African American cinema.

List: Zeinabu, how did you first become interested in filmmaking and screenwriting?

Davis: Oh, that's a long story, but the short version is I had gone to college with the intention of going to be an international voyeur and study international law. I failed an economics class, and I took it again and still didn't do that well in it. So at the same time, I had done an internship with Public Television in Providence, and I worked on a public affairs show called *Shades*. It just so happened that *Shades* was hosted by a wonderful and powerful African-American woman by the name of Gini Booth. She was the one who set my heart first on fire about media. I thought, after working with her, that I wanted to work in television.

My junior year I went abroad to Kenya, East Africa, and that was really where the fire to do film got lit, because I was working with the writer, Ngugi wa Thiong'o. I was going to school at the University of Nairobi, but after about three weeks of being at school—I'm trying to tell you the short version if it—the government shut the school down, because students were protesting for basically a better democracy or democratic processes. At that time, Kenya was pretty much a one-party state, so they wanted a two-party state. I kept working with Ngugi. He had written a play called "I Will Marry When I Want," and it was basically a play about the African peoples' struggle against British colonialism.

So it was a cool play in that we actually had elders who had lived through the experience and then actors who would perform some of the scenes. My job was to develop photos and use them as backdrops, so when the actors and the elders were on stage there was also something behind them. Looking back on it now, I can see how it was definitely a harbinger for me that this is what I was supposed to do, because it was something that combined community, activism, and history with media. We worked on that play maybe a month or so. We worked to build an outdoor theater, got cut lumber, made seats and all that. It was an amazing experience.

List: Sounds great.

Davis: The first night that the play opened we probably had about 1,000 people come to see it, and then the next night was pretty much the same thing. The third day the Kenyan government decided to bulldoze the theater, and Ngugi had to go back into hiding. He had

been arrested in the late '70s for writings which were said by the government to be seditious. He had been imprisoned for some time, so he had to go underground. I stayed on in Kenya for a few more months afterwards helping people to get the word out. But in the course of doing that, because we couldn't have them at the university, we had our classes with Ngugi at bars and restaurants. [In the bars] we would see these filmmakers from Europe, and we would ask them what are you doing, or what are you filming here? Almost invariably there were always filmmakers who were doing stuff on wildlife in Kenya. So I vowed to Ngugi that one day I would help him, come back, and we would make a film about the people of Kenya. That set me on fire. When I went back to the States, I wanted to go to film school and learn how to make films, participate in telling stories and revealing history of people of African descent.

List: So did you ever make it back to film in Kenya?

Davis: No. That's my life's dream goal. I have kept in touch with Ngugi. He's actually teaching here right up the road. He's at UC Irvine now. He has a son who wants to be an actor, so I told Ngugi as soon as I have some money together, I'm calling him up so his son can be in my film.

List: Besides Gini and Ngugi who else have been your major influences as a filmmaker?

Davis: Oh, without a doubt, it's the folks from what is called the LA Rebellion Filmmakers, and that would include people who went to UCLA in the '60s, '70s, '80s, '90s, and beyond. By the time I was at UCLA, which was in the 80s primarily, my biggest influences were the filmmakers who had come through there, and that would include people like Charles Burnett, Julie Dash, Haile Gerima, Barbara McCullough, Alile Sharon Larkin, all different types of filmmakers. Their work was so powerful and inspirational to me. Because what they were trying to do was really to make the community a part of what they were doing, and also to make sure that the community got to see and be a part of whatever it was that they were doing. So the idea was that you show the film wherever you have a space,

be it a church basement or a wall of a building outside in a suburb. That was totally cool. You tried to make filmmaking not be this kind of entertainment-only popcorn cinema that you just watch and then forget about. The idea was to make films that were reflective of what peoples' daily lives were and break down some of those stereotypes, particularly of African Americans. You know in the '80s, it was more like the pictures of black women were more as whores or as glorified mammy figures. It was important to understand where those stereotypes came from and try to break them down in terms of the media. So I was very inspired, and the only reason I got through film school was because of people like Julie [Dash] and Charlie [Burnett], who, in particular, mentored me, because they worked on my first narrative film that I did at UCLA.

List: How did you and Marc Chéry, your husband and screenwriter, get together and start collaborating on films?

Davis: Well, it was very fortunate. I met my husband on the first day I arrived in LA. I always tease him that my mom sent him to me, because my mom had passed in April of that same year that I started at film school. I think that she was looking out for me. We met at an African film festival that was happening at UCLA.

List: Destiny.

Davis: Right, but we were friends for a very long time. We did not start dating until at least maybe almost two years after. And the only reason it happened was because my best friend told me, "He's interested in you," and I was like, "Oh, really? Oh, okay." As a result of hanging out with our crowd, he had also gotten into film school. I think he had gotten into the screenwriting part of the program, but he decided that he wanted to work. So I was the one in school getting a degree, and he was helping me out financially, and also just in terms of screenplays and whatnot. So I had a hard time at UCLA. It was not an easy experience for me. When I went to UCLA, there were very few black women in the school. I think I ended up being the only black woman in my class. We started out with more black people. There were a few in the group, but they dropped out. So it was difficult.

One of the ways it was difficult was that the screenwriting instructors really didn't understand where I was coming from in terms of the kinds of stories that I was trying to tell. It really kind of shook my confidence in terms of my ability to tell stories, so I think it was just through Marc being there and going through that with me that we kind of worked together. A lot of the films that we have done together have come out a simple experience. *Cycles* was my best friend's journal entry that was adapted to a film. *Mother of the River* was a folktale that Mark heard his grandmother tell him growing up in Haiti. We adapted it to the South, because I had to do it immediately. That was a time when Halle Berry was in the *Queen* movie or mini-series on TV. One of the little girls in a workshop I was at who was African American said to me, "Ms. Davis, I don't understand why you're saying that slavery was such an ugly period, because Halle Berry looked so beautiful and everything is so grand. I would have liked to have been in that time period."

List: That's really troubling.

Davis: I just totally lost it, because Hollywood had glamorized slavery for this young girl. *Mother of the River* is actually a cathartic response to that anger that I felt from this girl not really understanding what slavery was like. But we wanted to make the story in a way that would still appeal to children, that wouldn't be something that would scare them or be too harsh. So that was the point of *Mother of the River* having all this stuff about the riddles in it.

List: I love the way you use the riddles in the film.

Davis: Yeah, and also being in black and white and having, hopefully, a sort of timeless feel to it, so that was really important.

List: It does. The film really does stands up over the years.

Davis: Good, thank you. And, I'm very proud of the lead actress in the film.
List: Yes, Monique Coleman from the High School Musical franchise.

Davis: Yes, it was her first film.

List: It was a great casting decision. She's wonderful in the movie.

Davis: I've had good luck on both of the last two films. Both of the actresses have done well after being in the films that I've made, which is great, because the whole point is for them to have a wider choice of goals or be able to expand their talents to play different types of women.

List: Your films have given these actors a chance to break in by creating well-written parts for them to play. I wanted to move on to the scripting aspect of your films. How do you and Marc go about your collaboration on projects—you as the filmmaker and Marc as the screenwriter?

Davis: Well, it's been different on different projects. I think if I could spend the rest of my life making historical narrative films I'd be really happy. A lot of history and research go into developing projects. I'll start to do the research most of the time, not all the time. *Mother of the River*, that was his, so I didn't really have much input in that, but *Compensation* was more of my baby.

List: When you were developing *Compensation*, did that start with the poem, or the character, or the story?

Davis: No, it was wholly inspired by the poem, because when I was teaching in Ohio, we went to the Paul Laurence Dunbar House. That poem is on a plaque outside of the home. I just read it, and it just really hit me.

List: It's an amazing poem.

Davis: Yeah, yeah. The lead actress in a *Powerful Thang*, Asma Feyijinmi, she was not an actress per se—she's really a dancer in real life. But I went with following what the LA Rebellion Filmmakers established, where they would often work with people who were non-actors and cast them, because they resembled the characters or

the values of what we were trying to get across in film. So one of the ways I was trying to help her get into character and understand more about what she was doing as Yasmine was to do a journal entry. I had given her that poem and asked her to respond to it as her counter.

List: What a great exercise.

Davis: Yeah. And she did, and so she talked about how the poem "Compensation" reminded her of the AIDS crisis. It was interesting.

List: Yes, because Dunbar died of tuberculosis just like the character in your film.

Davis: Exactly. That was what it was about, was Dunbar had died of tuberculosis at the beginning of the twentieth century, and now at the end of the twentieth century we have AIDS, which is ravaging the African-American community. So those were the links, and then Marc started to write about that. I was on the grant panel, or I was doing something on the East Coast. I came back from my trip, and there was a script laying on the bed, the script for *Compensation*.

List: Great.

Davis: Now *Compensation* is a little different in the sense that Marc had written a screenplay, which I think was maybe twenty-eight pages, but a couple of things happened. One, was I went on another grant panel, and I met Michelle Banks in St. Paul, Minnesota. She was in a production of *Waiting for Godot*. You know she's so expressive, and she's so powerful. I just totally fell in love and asked her if she might be interested in being in the film. And so Marc was with me on that panel. Luckily, we were able to go together, and he saw her too. He was also equally impressed. When we came back, we decided that we would try to learn as much about deaf culture and American Sign Language as we could. He did, and basically rewrote the script so that it would reflect deaf culture as much as possible within the story.

When we shot *Compensation* we still thought it was going to be a short film, but I realized, especially as we developed the period

characters more, which I still think is the strongest part of the film, that we'd have to expand it.

List: The period characters are really wonderful.

Davis: Also, I think having gone to film school and not having had the opportunity to be able to see black people in silent movies, that was always hard for me to take, so with *Compensation* I was determined to try to resurrect or at least give some version of what silent film may have been like with African Americans at the turn of the century. So it was important for me to find as much visual imagery as I could, and I spent maybe about two years off and on, whenever I was not teaching and had some time and some money, I was going to the Chicago Historical Society. I went to the Library of Congress, went to the National Archives. I went to Gallaudet University to do photo research, and research in general. So over time—because that's all independent filmmakers really ever have— we don't have money, but we've got time, so I basically thought this film is longer than twenty-eight minutes, and so it evolved. And then we did add a little bit more to the film after we shot principal photography. We had John come back, and we added a few more scenes to the contemporary section of the film that we didn't have in there before to make that a richer part of the film, like some of the library scenes of him.

List: When did you come up with the idea for the title cards? They worked so wonderfully. Was that Marc's idea all along, or did that come later after the screenplay was written?

Davis: No, that was me. He had written the text for the title cards, but I came up with the idea that they should be designed and that was again from watching silent films and seeing how beautiful and ornate those title cards were.

List: Your title cards are gorgeous in the film.

Davis: Thank you, thank you, and that was really a long time of researching African symbolism and Native American too.

List: The whole idea of writing the dialogue on the title cards was clever, and it added a lot to the texture of the movie.

Davis: It's not just writing. It's also the sound design too. One of the strongest scenes for me is when the character, Malindy, has the conversation with Tildy, the young girl.

List: Yes, at the beginning where she says, "My mother says you're deaf and dumb."

Davis: She asserts that she is not dumb.

List: Yes.

Davis: That was in the title cards, but when I showed it as a work in progress, people were glossing over it. It just has to be more emphatic, because the title cards don't have any sound. You're not shooting title cards with sound, because title cards, you're going to read. But what needed to happen was the sound effects of the chalk on the blackboard needed to be as emphatic and as percussive as they could be, so it could get across the dramatic impact of what was going on.

List: The audio really puts you in a time period and a sense of place.

Davis: Thank you. Good. I did my job. I did spend about three months on the sound with the guys at Maestro-Matic in Chicago, and they were very wonderful. Of course I did the independent thing and worked after hours, but we worked from six to midnight or something like that and sometimes later depending on what it was we were doing.

When you make a film the one thing that I love about the filmmaking process is it has to have the spirit of collaboration. You might be the one with the idea, but you have to be open to other people bringing their creativity and augmenting what it is that you're doing and try to say. And sometimes it's a fine line, because your story is not necessarily somebody else's story, but you need to be able to listen and take what you need and leave the rest if you have

to. I really enjoy working with other artists.

List: Is there anything else that you wanted to add about screenwriting in particular?

Davis: I think in terms of people interested in screenwriting, I think that people should be as versatile as possible and not just close their films off to one form. In other words, I think that a screenwriter who might write narrative feature films should also be able to, or have some background in, writing for television, for a sitcom, and also should have some facility with writing narrations for a documentary. So I really do think that you have no idea where media is going, and I think it would be best to make sure you knew a little bit about as many different aspects of writing or different styles of writing as you could because I think that it will serve you in the long run to be able to adapt things in whatever way it needs to be utilized. You just can't think, "I'm only going to be a feature film writer. I'm only going to be a sitcom TV writer or a dramatic TV writer or a radio news broadcast person."

List: Do you recommend that aspiring screenwriters go to film school?

Davis: I do, personally, because I think in a film school environment you get to experience all different aspects of production, get to know and understand what pre-production is, what production is, and what post-production is—whereas, if you're working in a job you may only see one aspect of it. Like if you work as an editor, you may only see what goes along in the editing process and not really understand that much about production. One of the few ways that you can do that is by knowing all the parts of the process. One of the few ways that you can do that is by going to film school.

There are too many filmmakers, unfortunately, that have good ideas, but don't really understand production values or don't really have enough background yet. They put together a film where you can't hear the sound or the images are too dark, where you can't make out the actors or the people in it. Those kind of things are not as well tolerated as they once were because the technology is so

much easier to know and learn. So I think that the idea of production value is very highly important now, whereas I think in the 80s and maybe the '90s you could get away with a good story but poor sound. Now I don't think you could. You have to pay your dues no matter if you do it in a school setting or you do it in a production company setting. You're still going to have to pay the dues.

But I'm really tired of seeing one-hit wonders. I want to see filmmakers that have bodies of work. That's one of the reasons why I keep going, because I want my daughters to have a legacy from me of my work. I want to keep making work so that they know that there are women and black women who have had careers as directors and media makers. I want to keep making work and leaving work for others to be able to learn from and enjoy.

CHAPTER SEVENTEEN

Interview with Charles Burnett

Charles Burnett is a native of Vicksburg, Mississippi. Burnett earned his M.F.A. from UCLA's School of Theater, Film & Television. His thesis film, *Killer of Sheep*, was his first feature and won Burnett the Critics' Prize at the Berlin Film Festival and shared first-place honors at the Sundance Film Festival. Recently, the Library of Congress has declared *Killer of Sheep* a national treasure. Due to its significance, it was among the first fifty films placed in the National Film Registry.

After winning a Guggenheim Fellowship in 1980, Burnett began work on his sophomore feature, *My Brother's Wedding*, completed in 1983. In 1990, he was the recipient of the prestigious MacArthur Foundation Fellowship, known as "The Genius Grant." Shortly thereafter, Burnett wrote and directed the family drama, *To Sleep With Anger*, starring Danny Glover. The film won three 1991 Independent Spirit Awards: Best Director, Best Screenplay, and Best Actor. *To Sleep With Anger* also won the National Society of Film Critics Best Screenplay Award, The Sundance Film Festival Special Jury Prize, and the Los Angeles Film Critics Association Special Award. His next film, *The Glass Shield* (2000), starring Lori Petty, Michael Boatman, and Ice Cube, was a drama based on a collection of true stories of corruption and racism within the police force in Los Angeles.

Burnett made his television debut with the acclaimed 1996 Disney Channel film, *Nightjohn*, starring Carl Lumbly, Lorraine Toussaint, Allison Jones, and Bill Cobbs. Based on the young-adult novel by Gary Paulsen, *Nightjohn* is a period piece about a slave's risky attempt to teach an orphaned girl to read and write. New Yorker's film critic Terrence Rafferty called *Nightjohn* the "best American

movie of 1996." Among its many accolades, the movie received a 1997 Special Citation Award from the National Society of Film Critics "for a film whose exceptional quality and origin challenge strictures of the movie marketplace." In 1997, Burnett was honored by the Film Society of Lincoln Center and the Human Rights Watch International Film Festival with a retrospective of his work, entitled *Witnessing for Everyday Heroes* (and included his documentary *America Becoming*, which he co-directed with Dai Sil Kim-Gibson).

Burnett continued to make projects that "witness everyday heroes." They included: a look at race relations during the 1950s in the ABC mini-series *Oprah Winfrey Presents: The Wedding* (1998) starring Halle Berry; the Civil Rights Movement in the ABC telepic, *Selma, Lord, Selma* (1999) that featured Martin Luther King's daughter, Yolanda; and interracial love found among the most unlikely of characters in *The Annihilation of Fish* (1999) with Lynn Redgrave and James Earl Jones.

Burnett's projects over the last few years have been high profile, such as Martin Scorsese's PBS documentary series *The Blues* (2003). He also directed an episode of the 2004 Emmy and Golden Globe-nominated PBS miniseries *An American Family: Journey of Dreams*, created and directed by Gregory Nava. In 2004, Burnett presented an innovative take on Nat Turner for the PBS *Independent Lens* project *Nat Turner: A Troublesome Property*, where the traditional documentary format included dramatizations of the various perspectives on Nat Turner and the slave revolt, featuring a different actor to represent Turner in each segment.

Burnett returned to his indie roots in 2007 by writing and directing the feature film *Namibia: the Struggle for Liberation*, about Namibia's fight for independence. The film stars Danny Glover and Carl Lumbly. That year, he was also the recipient of the prestigious Horton Foote Award for Screenwriting.

Burnett recently returned from Paris where Nobel Prize Laureate Toni Morrison organized and hosted a retrospective of his work at The Louvre. His classic film, *Killer of Sheep*, was re-released nationally in 2007 to critical acclaim. *Time Magazine* proclaimed it to be one of the "25 Most Important Films On Race."

☆ ☆ ☆

List: Charles, can you please tell us about how you became interested in screenwriting and directing?

Burnett: I think it started in a strange way. I was on my way home from junior high school. It was such an awful school. I remember walking home one day and looking back at the school and saying, "One day I'm going to write about this," because—it was so dehumanizing.

I saw how the system destroyed kids. I was in a class, and one day the teacher went down the rows pointing at individual students saying, "You're not going to be anything. You're not going to amount to much. And you're not going to be anything, and you may be something." And I thought that was just awful.

A few years later, the Vietnam War was going on. Nearly every kid in my neighborhood was drafted, and I knew I was going to be next. A friend of mine was going down to City College to enroll. I followed him down there, and registered, and found out if you took a full course load, you could get a draft deferment. So I started taking a lot of classes. I was majoring in electronics, but I got disenchanted with it. At the time, I was going to the movies a lot. I got interested in cameras, and I started thinking, "Maybe I can be a cinematographer." And so I went to UCLA. UCLA was a really good school at the time, because it didn't divide you up into categories. You were encouraged to write, shoot, and edit and mix your project. They said, "Here's a camera. Go out and make a film that we haven't seen before." So there wasn't a separation between the writer and director and cameraman. In the beginning you did everything.

I've always wanted to tell stories about my community, and so that's how it got started, really. It wasn't like I was going to be a writer. You wanted to become a filmmaker and that included all aspects of making a film.

List: How did you come up with the idea for *Killer of Sheep?*

Burnett: You know, at the time, in the '60s, the activism was part of life. Everyone was writing about something, arguing about

something, protesting something or whatever. The saying was, "You're part of the problem or part of the solution."

It seems everyone was engaged, active in some aspect of social change. People were writing poetry, political poetry, so it seemed. It was all around you. I was working with a group of filmmakers who were making films about the working class, but it was always the same story about the workers being exploited by management, and they formed a union, and that was the solution. That narrative didn't solve the problems for the working people in my neighborhood. I wanted to tell the story of the friends I knew and how they were living and trying to make sense out of the hand they were dealt. I was rejecting the distorted narratives and images that Hollywood had a history of producing.

At UCLA, one of the interesting things was that it was sort of anti- Hollywood at that time. Today, UCLA is totally opposite. But anyway, at that time, if you wanted to make a Hollywood film, you went to USC. At UCLA you were encouraged to look at film as an art form. I never thought it would be a way of making a living, and so I wanted to reflect the sort of things I experienced and the kids I grew up with experienced.

List: You've worked both outside of the Hollywood structure and within Hollywood. Can you speak about the role of alternative cinema in American film culture?

Burnett: The attitude, the reality, was there was not the option of going to Hollywood. The industry was closed to people of color. UCLA was, for many of us, the only place where you could make a film. Years later, in the '70s, there was Gordon Parks, Van Peebles, Sidney Poitier, and also Ossie Davis, but they weren't there as models or examples in the beginning. However, there were people like Spencer Williams and Oscar Micheaux who made feature films in the silent era; they did really have an impact on most of the filmmakers of color then. It was Elyseo Taylor, who could have been perhaps the first black teacher in the film department at UCLA, who really made an important impact, making us aware of an alternative cinema. He introduced us to Third World Cinema. We came to know African Cinema, Latin American Cinema.

It was the international film festivals that really fueled the earlier independent filmmakers. We were at last taken seriously. We were written about.

Most of the films at the time were personal films, films about what was going on. Now filmmakers have somewhat of a choice, but it's still almost impossible, I think, or virtually impossible, to make a personal film and get it marketed. I was just talking to someone the other day that's trying to do a small budget film and the financers said, "Well, it isn't big enough, and it doesn't pay us to get involved in something small."

List: Yes, it's unfortunate.

Burnett: And then they said, "If you have an actor who's a star, one or two actors, then maybe we may be interested in it." But even with digital cameras and things that make it easier, it's still difficult to get marketed and to get your film out there.

But there are people who manage to get films made and get them screened and maybe get distribution, but I would say a great percentage of them don't get that far.

Houston: My first introduction to you was *To Sleep with Anger*, which I thought was just incredible. I loved it. I loved the actors, especially Danny Glover. I would like to ask you to speak about the process of writing that particular piece.

Burnett: It came about in a strange way. I was working on a true story that happened in my community about this young girl who was killed by some gang members. She had seen one of the gang members kill a cab driver. The police found out that she had seen the incident and got her to be a witness. The police put her in a protection program. She was promised she would be a secret witness. However, the defendant's lawyer found out who she was. The lawyer told the press who printed her name and address in the paper. The defendant got his twin brother to kill her. She was killed on her way to school, and because there were no eyewitnesses, the defendant was freed. It was a horrible tragedy because the police failed to protect her. The system failed her.

It was to be a film for public broadcasting, but public broadcasting wanted to change it into something more Hollywood-like. I said no, because it's based on a true story, and it works better to treat it like it happened. The true story is dramatic enough. And so we got into a big argument, and we couldn't go any further.

So I said, let me do something that is not based on a true story. That way my investment emotionally would not be as strong. So I started writing this story, *To Sleep with Anger*. It was about little things that your family experienced and talked about, things like rumors, myths, and folk tales.

Again, however, they started to put their two cents in. I rejected their input, because the story became very personal. It was my story. The story I wanted to tell in the way I wanted to tell it. Even though it's fiction, you still have this allegiance to it, and you don't want anyone to just come and destroy something that's a part of your experience. They wanted to make it more accessible, they said, and take out all the folklore. And so I got this awful letter from them saying, "You'll never be a writer."

And so the same day that I got the letter, Cotty Chubb, whom Michal Token recommended me to, [contacted me]. I told him that I have a screenplay that no one wants. I was told it was a piece of crap, and I'll never be a writer. Anyway, he said let me see it, and that's how it came about.

Houston: How did you develop Harry? He's a very interesting villain.

Burnett: Well, he's based on a folkloric character, the Hairy Man. Tricksters come in different forms. It can be good or evil. However, Hairy Man, in evil form as the folklore goes, bargains for your soul like a Faustian kind of tale. In the Hairy Man tales, in order to regain your soul, you have to outwit the trickster. Danny's character, Harry, is based on the folktale of Hairy Man, but I wanted the character to have that ambiguity. I wanted audiences to be ambivalent about him. If one really looks at Danny's character in the film, you will find that you don't physically see him do anything wrong himself. Everything is circumstantial.

When you're a kid growing up and your family is from the south, there're all these superstitions that you don't believe in when you're

a kid. And you're told, "Oh, this person is evil. Don't let this person in the house." "What's wrong this person? Looks normal to me." As a kid, you reject all that stuff, but as you grow up, you start respecting these things and think, "Well, maybe they're right about this. Maybe there are evil spirits."

Houston: What are your thoughts on writing strong dialogue?

Burnett: I think that you have a literary sense and have an ear for dialogue and have to know the character and an understanding of the character and what he or she is really communicating or hiding. I'm very economical when it comes to dialogue. I don't want it to be a speech or consciously trying to be poetical. I know a lot of writers will get their cues from Hollywood films and things. I liked to listen to people tell stories. When I was coming up as a kid, there were a lot of good storytellers. I'm from Mississippi, lived in L.A where everyone was from the South, and there were a lot of storytellers who were good actors as well. I could see the world that they were describing. I also try to have meaning in it, not just to say anything, not only to get a sense of the character, but have the dialogue advance the plot or get some sort of insight into the character or the situation, make it meaningful, in a sort of poetical way as well.

Houston: When you wrote the script *The Glass Shield*, did you have to do a lot of research, and if so, how did you go about it?

Burnett: I went on a ride-along with the police. I was already doing research, in a sense, because when I was growing up as a kid, the police were a presence. I couldn't walk down the street without being stopped all the time and being called names. All my friends shared the same experience. A lot of my friends went to jail for unnecessary things. The story that the film was based on was a familiar case. The film was also based on several other real cases.

Houston: Did you have any films you can mention that might have influenced you as a screenwriter/director?

Burnett: Yeah. I think that Hollywood made some really interesting

films at one point, silent era and later. I really liked black and white film. I think because the earlier film depended on strong images and compositions. I also had seen a lot of European films at UCLA, fortunately. One of the films that had an impact on me was a film that Jean Renoir did. I saw it when I was not yet a teenager. It is called *The Southerner*. It is about two families, one black and one white, poor farmers who live in a period of depression in Texas. Renoir dramatizes the situation that brings the two families together in order to survive. They needed one another to survive. It was the first time you saw black people treated as human beings, literally as human beings and not just sort of superficial appendages of white folks. It took a freshly arrived European who didn't share the same prejudices and history that people who were born here had. This film has had a strong impact on me. Being from the South, this was the first time seeing a film that rang true. Both families were treated with dignity.

I had the good fortune of having taken a documentary class taught by Basil Wright, who was a very well-known documentary filmmaker. I was in my first year at UCLA, and couldn't figure out what to do, because I couldn't identify with the style and content of the UCLA students. I was at a turning point. I was not sure if the kind of films I wanted to make would be appreciated. It was in a conversation with Basil Wright that I found encouragement to explore the things that I believe in, and keep in mind the subject is humanity. "Respect the people in your film."

At the time, neorealism appealed to me. I shared their approach to filmmaking. Then later on, Elyseo Taylor, who I think was the first black teacher in the film department as I mentioned earlier, brought Third World Cinema to UCLA. It was in Elyseo's class that I became aware of Ousmane Sembène's films, which were very important at the time, and very influential.

A lot of the European films made before the mid-'70s were really key. It seems like all of the New Wave filmmakers had a strong influence. We shared more with them than what was being produced in the States. The New Wave films were branded art films. We went to art houses, which were everywhere at the time. When Fellini made a film, we were right there when it opened. Kurosawa and film directors like him were so much a part of our culture at the time.

Houston: Given these influences you've just mentioned, now when you sign on as a director, what are some of the things you look for in a screenplay?

Burnett: You look for good stories that are meaningful and relevant, either socially, politically, that say something about—I hate using a clichéd phrase—but the human condition. Film is so costly to be frivolous and indulgent.

We just made a film about the liberation struggle for Namibia. It was financed by taxpayers, Namibian people. It was a struggle making the film. There were many roadblocks, but we decided nothing would stop us from making the film. We felt we owed it to the people of Namibia; taxpayer's money could have gone somewhere else. It could have gone into roads. It could have gone into paying teachers. The money wasn't going to be wasted.

The same goes here. I mean, with schools the way they are, and people of color under the threat of losing everything, and when their right to vote is being challenged, I think as a filmmaker, you have to comment on what's going on. Films have to resonate. It's not just about entertaining people. It's to challenge them.

To make it in Hollywood, you have to be noticed by making a commercially successful film that they can understand. Making a dramatic piece about people of color is very difficult. Studios don't think there is a big enough audience worldwide to make it profitable. Art films are very difficult as well.

Houston: How would a novice writer go about looking for an agent or a manager? Or do they need both?

Burnett: It helps to have an agent and a lawyer. Most of the time you might have to make a name for yourself before you get an agent. You have to have something they believe they can help you sell. You have to show promise. It helps when you're successful; let me put it that way. That's the irony of it. One generally needs an agent to make complicated deals. You also need to be in the guilds, like the DGA or WGA. There are so many good reasons why one should join a guild. They look after your interests. There is the pension and

welfare. In terms of healthcare, the insurance really saved me and provided protection for my family.

Houston: Do you need both of them?

Burnett: It helps if you can, because they both work. You need a lawyer to look at the contract to make sure you're not really being ripped off, because agents don't do that. The managers don't do that.

Houston: Okay. Once a new writer has an agent or a manager or lawyer, what type of interaction should he or she expect to have with these reps?

Burnett: It depends on how successful your writing abilities are. If you can write something commercial, and if they know it's commercial, and they can see it's commercial, then they can sell it much easier, and you'll be working often. If the material is very commercial, that's what they look for. If it's personal and art like, agents have to spend a lot time and effort trying to sell you. It doesn't pay for them. You have to do a lot of the work yourself. You have to go to these events and parties to meet people, make contacts, and follow up with them. It is good to go to certain festivals. The Berlin Film Festival is an example. It has a market. Festivals that have markets are important because there are a lot of producers of all kinds, like foreign producers, looking to find films. There are certain festivals that they go to, like the Rotterdam Film Festival, and the Cannes Film Festival are big market places. It's the best place to meet these people. You really need to sell yourself there. I used to frown at that sort of thing, thinking that it will never happen. I was at Cannes one year, and I met this young lady. She said she was here to look for financing for her film. She never did a film before. I said to myself, "Yeah, good luck." So I don't know how long it was, but she called me and asked would I do her a favor? She wanted to watch me direct, mentor her because she found a producer at Cannes to produce her film. Needless to say, I was shocked.

I have seen that happen again, not often, but enough to make you always have to remember—anything can happen.

Interview with
Sara Finney-Johnson

Sara Finney-Johnson, award-winning playwright and television producer, began her career in Hollywood as a production assistant at Norman Lear's company, Tandem/T.A.T. She went on to write and produce various primetime sitcoms, including such hits as, *Married With Children, The Parent Hood,* and *Family Matters.*

For five years, Finney-Johnson served as Executive Producer of the UPN/CW comedy, *The Parkers,* which she also co-created. The series, starring Mo'Nique, ranked number one in African American households after just one season. It was created as a spin-off of the groundbreaking sitcom, *Moesha,* which Finney-Johnson co-created and executive produced with her writing partner Vida Spears. Finney-Johnson served as the executive consultant on the CW comedy, *The Game,* and was nominated for an NAACP Image Award for the episode she wrote entitled "The Big Chill." She most recently was co-executive producer on the BET series *Reed Between the Lines.*

Along with her friends, Gina Prince-Bythewood, Felicia Henderson, and Mara Brock Akil, Finney-Johnson endows the Four Sisters Scholarship in the School of Theatre, Film and Television at the University of California, Los Angeles. Finney-Johnson strongly believes in "reaching back to give back" and supports various charities, including the Lula Washington Dance Theater and the USC Black Alumni Association through the Sara Finney-Johnson Scholarship.

★ ★ ★

Houston: Sara, how did you get started as a writer?

Finney-Johnson: Wow. Let's see, well, I always wanted to write. So,

when I graduated from college—I was a Broadcast Journalism major at USC—I loved writing, but I honestly didn't know who wrote TV, and I certainly didn't know Black people were writing TV. So I thought I would have a career as a journalist and, on the side, I would write for magazines or short stories. When I graduated, I had a professor who found jobs for journalists in different cities, and he found me this job in Canton, Ohio. I would have been able to be on air and do everything, and I just thought, I cannot move to Canton, Ohio. Something had to be done.

Houston: [Laughing] Good decision.

Finney-Johnson: I wanted to find a job in LA. Once again, I was still thinking as a journalist, and I didn't know anybody in Hollywood, not a soul. So I had a friend at USC who knew somebody, who knew somebody at what was then KTTV Channel 11, which is now Fox. And so I got an interview, and the woman who was in Human Resources also worked for Norman Lear. I didn't have a real connection, but I used the little bit that I had, and on the same day, I got an interview at ABC here in LA. So it wound up, I got both jobs. Now, they were both entry-level jobs, so I had to make a decision—am I going to try to be a journalist, which is what I trained for? Or am I going to take the leap of faith and be a writer? So I took that leap.

You know in our business you start at the very bottom, and I was a PA, which is a production assistant, which is the hardest job, other than the showrunner. You know you deliver food, drop people's kids off. I mean you just do all the work except run the show, and I was happy. I mean I was excited just to get my foot in the door, and to be working for Norman Lear. I was fortunate to work: first not on a show, but I was in his office.

I was very fortunate that I only had to be a PA for three months. That's a tough, tough job, but while I was there working as a PA, I met, of course, Norman. I just remember he loved and respected writers so much. I was so impressed with that. Everybody around him that was writing that I saw—he just took care of them. He encouraged them. He promoted them. Maybe I was just young and naive, but I believed that I could get a writing job. I believed that I could run a show one day, because I saw it happening for people, and

these weren't all people of color. But then I met Judi Ann Mason, Kathleen McGhee-Anderson, Winifred Hervey, Christine Houston, and I'm saying, "Oh my God, there are black women writing for TV." And I met also Helen Thompson, who was the first black woman in the Writers Guild of America. She had her first staff job with *Julia*. I was just amazed to meet this woman too. So after I saw this—and of course there were other people around me, usually white men, who were running things and writing and doing great stuff, but Norman Lear embraced everybody. I think at that time especially, he was probably the only person who really was hiring black writers. There were a few black men who were working too.

Houston: Do you remember Michael Moye?

Finney-Johnson: Do I remember him? He was one of my mentors.

Houston: Right.

Finney-Johnson: He was brilliant. Michael helped me as much as he could. Michael won the contest that Judy won, and Norman brought him out to California.

Houston: And I won right after Michael, and that's how I got there.

Finney-Johnson: Michael was on *Good Times*, and then I met him at *The Jeffersons*. So anyway, I met these people and especially these women and the Judi Ann Masons of the world and the Christine Houstons, and I was encouraged and thought, "Okay, yes, I can make this happen some kind of way."

This is just a little sidebar about Judi. She's the reason I became a playwright. I mean, I loved theater, but I only went to the theater. I participated in high school. I didn't think I was a playwright, and I was talking about some idea and Judi said, "Write it." And I was like, "Well, I've never written a play," and she said, "Write it." You know how Judi was.

Houston: Yes.

Finney-Johnson: So I proposed a play, and then she said, "Okay now we're going to get this play up." I said, "What? I don't know anybody." She took that play, after, of course, she put her touch on it, marched it straight to the theater, and she said, "We're doing this play." That was my first play.

Houston: I remember, "Mens."

Finney-Johnson: Yeah, it was six women with music. It was about a homeless woman who was on the streets. We followed her life from the time she was a little girl to when she wound up on the streets, and why she was there. I did "Playwrights with Erwin Washington," which you came to, Christine.

Houston: I was in there with you.

Finney-Johnson: Huh-huh.

Houston: That's how I met you.

Finney-Johnson: Right. We did that for at least 7 or 8 years.

Houston: Right.

Finney-Johnson: My writing got stronger. It just opened up a whole new world for me. So that's how I started. Then I met Judi and everybody, because I went on *The Jeffersons* as a writer's assistant, which is a secretarial job. They call it writer's assistant now, which is a really great job to have, because you get your foot in the door, and you meet the producers. I was fortunate once again. It was a Norman Lear show, and I met Michael Moye there. I told all of them I wanted to write, so they encouraged me, and they just said, "Write specs. Write sample scripts," and I did. I wrote. I wrote. I wrote. Finally they let me pitch stories, and I didn't know anything about really pitching even though I was there for a few years. I went in and pitched like thirteen stories, which is crazy— nobody pitches thirteen stories— and so they indulged me, because they knew me. I think it was my thirteenth pitch. They bought it, and that was my first episode.

Houston: For what show?

Finney-Johnson: *The Jeffersons.* And I want to say it was the one with Sammy Davis Jr. I wrote two freelance *Jeffersons,* one with Sammy Davis Jr. I forget the other, and that was the beginning of my TV writing career. But during that time that I worked for Norman for three months, working in his office, I remember I was taking him somewhere, was on an elevator with him, and he said to me, "What do you want to do?" I mean, who gets the chance to have Norman Lear ask what do you want to do? So I said, "Oh, I want to be a writer." He said, "Tomorrow I want you in Alex Haley's office." And I'm like, oh my God! You know *Roots* was really hot then, and you know I bought my copy of the book. I was so excited. I couldn't believe this man just—that's the way he was, you know. If you wanted to do something, he wanted to help you do that.

Houston: Yes.

Finney-Johnson: And so I met with Alex Haley, and I was blown away and happy and excited and just honored. At the time he was working on an hour show for Norman.

Houston: *Palmer Town USA?*

Finney-Johnson: Was it about a little black child and a white child...?

Houston: Yes, because I wrote story ideas for that too.

Finney-Johnson: That's it. That was the show. And so I didn't get the job. I was just honored to just meet this man...so while I was at Jeffersons I sold those two scripts. Then I partnered with Vida Spears. Vida was a writer's assistant.

Houston: Our next question was going to be, "Is it advantageous to have a writing partner?"

Finney-Johnson: In comedy I felt it was, especially at that time; somebody to bounce things off of, you know, jokes and what-not.

So yeah, I thought it was a good idea. So we partnered, and then we became staff writers. We got hired on *The Jeffersons*, but I think we also did a *Silver Spoons* episode. Then we got on staff. And I think *The Jeffersons* may have been in the last two seasons, so then after that we went on to *227*. Of course, you know about that and then we went to *Facts of Life*. Then I think we got *Family Matters* where we stayed for five years, and we became producers on that show. And then *Moesha*. Then we split up, and I went on to do *The Parkers*, and Vida stayed at *Moesha*.

Houston: She didn't help you create *The Parkers*?

Finney-Johnson: Yes, Vida and Ralph Farquhar. All three of us created both *Moesha* and *The Parkers*.

Houston: When you went to *The Parkers*, what did you go as, what position?

Finney-Johnson: Executive producer, and Ralph was also exec producer/co-creator. After the first year, Ralph left the show. Then I ran the show as the showrunner for the last four years.

Houston: Did you pitch the concept of *The Parkers*?

Finney-Johnson: Yeah, we had to pitch it even though it was a spinoff. What happened? It's so funny; I ran into Larry Lyttle today. He was the guy who owned Big Ticket Television, which was a division of Spelling, and he had seen Mo'Nique at the Montreal Comedy Festival, or I guess his casting director had, and they loved Mo'Nique. They wanted to do a show with her. She'd never acted before in her life. They also wanted to find something for Countess Vaughn, and they said, "Can you guys come up with something? Let's put these two together"… and we came up with The Parkers. That's how it happened.

But *Moesha*—I had always wanted to do a show about a black teenage girl, and I wanted to do something that was universal, not just for us, but for everybody, because my favorite show had been

Wonder Years. I tell people I was never a twelve-year-old white boy, but I understand and loved everything that character went through, and I thought we could do the same thing through the eyes of a teenage black girl, just makes the scenes universal. I also wanted to do something about the neighborhood I grew up in, which I felt was underserved—the type of thing where you hear all the negativity about inner-city neighborhoods, but there're so many good people there.

You know my parents worked hard and tried to do the right thing their whole lives, and those are the people you never hear about. I know there are a lot of people like my parents in this community and a lot of kids who are not gangbangers or drug dealers that are doing something with their lives. We need to hear from them, so that's how *Moesha* came about. Brandy was just perfect for it.

Houston: Well can you tell me something about your responsibilities as the showrunner of *The Parkers?*

Finney-Johnson: A showrunner is like the CEO of a company, because you're in charge of budget and you're in charge of over two hundred people usually—that's the cast, crew, writers, everybody, stories of course, scripts. Every single script that comes through that office you have to have your hand on it. You had the final say on it. So even though it may have been written by somebody else, it's still your show and still your script. You can be exec producer and not be a showrunner.

Houston: Can you explain the process of taking the show from the table draft to the final draft?

Finney-Johnson: You know, of course, it starts with an idea. Sometimes it's from our life experience, something we've heard about, something about the Internet, the newspaper. You come into the writer's room. Everybody will usually pitch out ideas. Maybe the showrunner has a direction they want to go in or something that they're interested in, but we pitch ideas. Once you decide on that idea, then usually the showrunner, maybe the whole room, will sit with the writer and flush out the idea.

Also, I should add, what we did on the last show I was doing, and then I've done this before too, is map out the arc of the season, so that way you know where you're going and what you want to see from these characters, what kind of episodes you want to see and then you hone in on the ideas. Like, I know this season we need to have Moesha get a job. She's going to get a boyfriend. They're going to break up, and they're going to get back together. So you work out the arcs and the map for the whole season and then the ideas. Then you sit down with a writer.

First of all, you decide who is going to write what. If you're on staff, you usually get at least one or two episodes per season; there's usually twenty-two episodes total. Then whoever is writing an episode you sit with them, flush it out, have them go away and bring back a beat sheet or an outline, and then you give them notes on that. After you've given them notes on that, then you have to get approval from network-studio and get their notes. Then you go off and write the script.

I don't think we gave the network-studio a first draft. They would have to wait and hear it at the table, but they've already approved the story. They already know what it's about. But in the room, after we got a first draft, the showrunner exec producer goes over the script with maybe a couple of other producers, decides on the notes, goes back to the room, hears everybody's notes usually. Then it goes back to a second draft. Sometimes the writer will do it. Sometimes the showrunner and the producers will do it. Then it becomes a table draft. So you keep working on the draft. You keep trying to make it better, and then you get to what's called the table read. That's when, of course, the actors are there reading, and the network-studio—everybody is there. We hear the script being read. We go back to the room and do a rewrite based on how the script went, based on notes. That's the production week.

Houston: As the showrunner or executive producer do you hire writers or do you pick your writers before you start your show?

Finney-Johnson: No, you usually hire them, and of course most of us know each other. So you kind of know who is available, who is not available. Also network-studio may have writers they want you to

hire. That gets a little dicey, because then you know some of those people you may not want to hire, but at least you know you've got to meet with people. You never know. You can't just—and plenty of people do, trust me—just keep hiring the same people because they work.

I think you have to meet new writers and new people, especially writers of color. That's always been a big sticking point. When black shows go down or there aren't any black shows, black people don't work. That's crazy, because you know we can all write. You know we're all human beings. We all have pretty much the same experiences, but I guess most of Hollywood feels like, "Oh, it's the show with the white family..."

Houston: We don't know enough about the white family...

Finney-Johnson: Mainstream Hollywood feels they can write black, white, Latino, etc.

Houston: Right.

Finney-Johnson: And so that doesn't make sense.

Houston: But you and I both know that they don't know enough about the black lifestyle. They have to have somebody black to go to and ask questions.

Finney-Johnson: Sometimes, and sometimes they don't.

Houston: They just do what they think.

Finney-Johnson: It's crazy, but it's just the way it is, and it doesn't make sense. Well one thing they often say is, "We don't know any black writers." So what the Writers Guild has done, and other people have tried to do, is have these programs so you get to know people—programs where you hire at least one person of color—diversity programs. You know mix it up a little bit, and I don't see how that could hurt. So while I may know ten great black writers that I want to hire—trust me, I'm going to be pressured to hire Joe Blow that the

studio wants, because they don't trust the ten that I know.

I remember a reporter asked me one time, I think on *The Parkers*, there were six black writers, one white writer—yeah, we had one white writer, but the majority were black, and they were mainly black women, and a reporter said, "Well, why do you have all mainly black people?" And I said, "Well, why not? If they are talented, and they can do it—why not? You wouldn't ask Tina Fey that at *30 Rock*." You know it's just that nobody questions when the whole staff is white, but when they're black, they're like, "Hmm, what's going on here?" You know it's just weird, and that was a black show.

I think at *Moesha* we had a Latina writer, and she was wonderful. But you know, you do have to get to know people, meet different writers, see what they can do, give them a shot. Everybody doesn't work out, but I think it's a shame when there are showrunners who aren't even open to the idea of meeting new people.

Houston: Well, how would you say someone should network in LA, if they are unknown and they aspire to write for television?

Finney-Johnson: I'm going to tell you what I think they really need to do, and it's hard—it's a catch-22—you need an agent. A lot of showrunners are nervous about reading people they don't know, because people get sued. I've seen it happen, and you know I've always tried to mentor—like Judi. I have tried to help as many people as I can. One of the ways I help is by reading their script and giving them notes, because you've got to have really strong spec scripts. You've got to have some good scripts; otherwise you're not going to be taken seriously. So you need somebody to help you with that.

And not that I'm always right, you know. Writing is very subjective. What I may love, somebody else may hate, but I think I've read enough scripts and done enough writing to have a pretty good idea what might work.

Houston: What sort of spec scripts would you accept from a potential new writer?

Finney-Johnson: You should do a show that the people aren't doing, because they know that show better than anybody. Don't send a

30 Rock to *30 Rock*. Don't send an *Office* to *The Office*. Get two good half-hour specs, but also original material. A lot of times people want to read original material. It's good to have, I always say, one sample of a show that's hot, but also have an original. Have a half-hour single camera; have a half-hour multi-camera. Do an hour script if you want to do drama, and of course a movie script. I think for hour dramas, and I'm not into hours—I'm hoping to be—I think they prefer sometimes to read movie scripts.

The thing is getting your script to the right people. Like I said, people are a little nervous unless you come through an agent, come legitimate. Just sending it in the mail in a brown envelope, I wouldn't read it, because you don't know. That sounds unfair maybe, but you've just got to go about it as correctly as you can so people feel comfortable in dealing with you.

The good thing about Norman Lear, and people like him, is that he found ways to find fresh new talent and one way was through that contest. There are a lot of programs here in LA. ABC has an excellent program. What is it called?

List: ABC New Talent Development?

Finney-Johnson: Yes. ABC, CBS, Paramount, Disney. There's a young lady on our show who was our receptionist, and she wrote a script. Now that's another thing too—try to get out here and get a job on one of these shows. Then you get to know people, and they do feel comfortable. I felt like, I know her. I want to help her. Let me read her script; give her notes. She did an excellent spec. She got into the Cosby Program. So I just think you can't send it cold. Very few people are going to read anything just out of the blue.

Houston: How do you get an agent?

Finney-Johnson: Well, the way I got my first agent was from the Writers Guild of America. They have a list of agents, and on this list are agents who will read new writers. Now, they may not be CAA, William Morris Endeavor, all that, but you know what? They are legitimate agents. It's a start. It gets you in the door. That's what you need. You just want to get somebody who believes in you and who

is legitimate. They have relationships with networks and the studios and showrunners, and they can get your script read.

Let me just say this: trust me, somebody could pop up from Iowa and have a hit show on tomorrow, and that's the beauty of it. That's the great thing about Hollywood, anything is possible. So I tell people don't ever give up on your dream. Don't ever tell anybody what you can't do because you can come out here, and I'll be working for you tomorrow. You know you just never know. You can come out here and meet Steven Spielberg on the street, and Steven says, "I'll read your script," and then boom—you've got a movie.

Houston: Are the production companies required to accept at least one script per year from a freelance writer?

Finney-Johnson: Yes. The Writers Guild—that's some kind of rule they have. I think it depends on the number of orders that you get for your show, the number of episodes, but it's either one or two a year.

Houston: Okay.

Finney-Johnson: Usually agents have submitted scripts. You go through the scripts, see which one you really like or you feel is strong, and you invite that writer into the story. What we've done, and I know Mara did too; we had assistants—writer's assistants who were very interested in writing. They'd done very strong spec scripts. We gave them a chance to pitch. A couple of people got their first job from doing freelance on the show.

Houston: Well, can an unknown writer submit a pilot or a proposal for a new show these days?

Finney-Johnson: You could meet the best director or producer in the world, a Jerry Bruckheimer, and he might love your idea, and boom: you've got a pilot. But usually the networks want to go with experience when it comes to pilots, so I don't know. I think that's a tough one. I think that would be really tough but not impossible.

List: Do you have favorite episodes that, as a writer, you're most proud of? You've written so many, but are there any that are more important to you than others, and what about them makes them come to mind for you?

Finney-Johnson: Yeah, there's been so many. Immediately what came to mind, I remember the Moesha episode where she visits her mom's grave, it was a more dramatic moment for a comedy, and I wanted to include that type of moment on a sitcom.

I remember that one vividly. I loved that episode, and *The Parkers*—Mo'Nique. I have to say this—Mo'Nique was and is a joy. She was an extraordinary actress, but more extraordinary human being, so my working experience with her just renewed my faith in actors. It made me want to do better, made me a better writer. I just couldn't ask for anything more, and then to have Mara have me on her show and contribute to *The Game*—that was an extraordinary cast. Wendy Raquel Robinson, I adore, and all the episodes that really featured her. Of course, I wanted to write all of those I could, and I love those episodes. I would say the one probably where I think she broke up with Coach T, because that was also about insecurity and what we all go through in dealing with life and men. She was such an interesting character, so I love that.

I just enjoyed writing. It's always a privilege for me to have a chance to write, so I can't say there are one or two favorites. I love them all.

List: Any parting advice you would like to add?

Finney-Johnson: I guess I would say, if you're a writer then write, you know. It really gets me when people say, "I have a great idea!" I say, "Write it," the same thing Judi Ann Mason told me. So I would say write. Write as often, as much as you can, and have great passion for it. You must have passion for this. You must love it. I mean, that's the way I feel. There's nothing else I want to do. I'm not saying I won't do something else, but what I want to do is write, and I think if you don't have that passion, you will fall by the wayside. It's just too rough. You've really got to love it.

Interview with Judi Ann Mason

Judi Ann Mason was one of the first African American women to be admitted to the Writers Guild of America for writing a television script. During her long and successful career, Judi worked as a development executive, producer and writer in both film and television. Sadly, Judi passed away shortly after she granted us this interview. She was a beloved mentor to many African American playwrights and screenwriters. She will be greatly missed.

Among her many writing credits, Mason was the Associate Head Writer for *Generations*, NBC's first daytime soap opera to feature a core African American family. She also served as its Development Executive and is credited on over 150 episodes from1988-1990. Prior to this, Mason worked on *The Guiding Light* for CBS through Proctor & Gamble's Soap Opera Head Writer Development Program.

Over her long career, Mason was on staff for several hour-long dramatic television programs including *American Gothic* for CBS as Producer/Writer and *I'll Fly Away* for NBC as Executive Story Editor. Mason won an Emmy Award for her script, *All God's Children* for that series. She also authored the first episode to feature an African American family on *Beverly Hills 90210*, entitled "Ashes 2 Ashes."

Among her credits on situation comedies: *A Different World*, Executive Story Editor; *Good Times*, Production Liaison, Staff Writer and credited for four episodes; *Sanford and Son*, Freelance Writer, one episode; *America 2-Nite*, writer/recurring character—featuring Robin Williams, Carol Burnett and Martin Mull. Mason was also an Executive Producer on *The Alan Thicke Show*.

The next step in Mason's career involved movies. Mason was the Development Executive and Co-writer for *Sophie & The Moonhanger* for the LIFETIME Channel, which was nominated for a Cable

Ace Award for best writing. She was the Associate Producer and development executive on *Clover* for Hallmark Entertainment. She wrote the film *Donny's House,* for CBS, nominated for an Emmy for Best Children's Special. Later, Mason won a Kids Choice Award as the co-writer on *Sister Act 2: Back In The Habit* for Disney.

From 1988 to 2009 Mason also worked behind the scenes as a development executive and production liaison for several successful film companies and network television series under the supervision of top producers in the entertainment industry including Norman Lear, Bill Cosby, David Chase, Darren Star, Norman Jewison, Jeffrey Katzenberg, Frank Yablans and Sam Raimi. She was employed as script doctor on several theatrical films and award-winning cable TV movies and was an accomplished playwright whose works are published by Samuel French.

★ ★ ★

Houston: We'd like to start by asking you a little information on you, Judi Ann Mason. What made you become a writer?

Mason: I think it was Mrs. Best in my 6th grade English class. And it was just after the schools had integrated in the South, and she was my first white teacher. She made this comment in class, and she said, "You know, I really love your sentences." And that stuck with me forever, stuck with me forever. So I always liked to make beautiful sentences.

And then I went to college at Grambling State University. By that time, I was parentless. Both of my parents were gone, and I was pretty much on my own. I didn't know how I was going to pay for college, not in the least, but they'd allowed me to come into the school for that first semester with the work-study program. I knew that anything after that semester was up to me. I was in the Theater Department and saw a sign on a bulletin board about the Norman Lear Award for Achievement in Comedy Playwriting. At the time, he was just starting out as a young producer with shows like *All In The Family* and *Good Times, One Day At A Time.*

I really felt that, if I was going to stay in college, I had to come up with the money. The prize money for the Norman Lear Award

was $2,500, and he was going to fly the winner out to work on one of his shows. Low and behold, we entered that play into a contest, and I won the first ever Norman Lear Award. And as a matter of fact, I was on the campus newspaper staff as well, so I wrote a lot of articles for the campus newspaper and won a fellowship from the Gannett Foundation and went to work in California at the *Press Telegram* as a reporter the same year that I won the Norman Lear Award.

List: That's interesting.

Mason: It seemed it was the thing that I was meant to do so that's how it all began. But I discovered I liked creative writing more than I like journalistic writing—it's my ability to create things, to make the world the way that I think it should be, a world filled with love and not the cold realities of journalistic reporting. So that was the beginning, and that's what I've been doing the rest of my life, living as a writer.

Houston: How long have you been in that field would you say? How many years have passed?

Mason: Add 30 to two. And that makes it 32. I was a child prodigy. I don't even know how I got on national television writing at two years old.

Houston: Me either.

Mason: Well, you know, professionally, also that same year the Negro Ensemble Company got a copy of my play and produced it. So I've been writing professionally since age nineteen.

Houston: What was the name of that play?

Judi Mason: "Living Fat," it was the play that won the Norman Lear Award. It was also done by the Negro Ensemble Company and published by Samuel French. So before I was twenty I was making a living as a writer.

Houston: And since you do have that experience of both playwriting and screenwriting, we're going to utilize your talent and your information. We would like for you to expound on breaking into TV and how you would instruct a new writer who wants to do the same thing that you did.

Mason: When the Lear Award brought me to Los Angeles, the show I was assigned to was *Good Times*. Everybody loved that show because *Good Times* was number one, and I knew what the criticism was. I wasn't in a cocoon in Hollywood producing a show for a mass audience and not knowing what that mass audience wanted to see. And because *Good Times* was the first primetime television for blacks ever since *Amos and Andy*, I understood the historical significance of my being there. That never escaped me, because I was at a historically black college, and so I knew my place in history at that point in time.

List: Mhm-hm.

Mason: And I knew the direction that I felt that that show had to go. And fortunately, I had a good relationship with Norman Lear who was a mentor then and is still one now. I would discuss these things with him. And I said, "I would like to do something different." And I said, "It's a little heavier, because it's something that I experienced in my life," which was child abuse. And, thus, came my idea for my episode, which was part of the award. You come up with an episode, and they used it. My episode was "Penny For Your Thoughts" about a little girl whose mother was abusing her. The character Penny was introduced, and it's Janet Jackson. Now I turned my episode in and, of course, I didn't know anything about the formatting of writing. Then they thought I was going to go away. But low and behold, the audience fell in love with the episode. Although I wasn't credited with it, I had that $2,500 and the Norman Lear Award.

Houston: Mhm-hm.

Mason: And when I didn't see my name go across that screen, I called Norman Lear, "They didn't put my name on it. They didn't put my name on! Aaaah." I mean, really, I was just nineteen. Of

course, what was going to be my reaction? So and Norman said, "Well, listen, there's nothing I can do about that now, but when you graduate, you have a job working for me." And I said, "Okay, but they didn't put my name on it."

It was very heartbreaking. But the thing is that episode became very impactful, because the character was a recurring character for, the next three years on the show. And even today, people talk about that episode with Janet Jackson and how it just took *Good Times* to a different level in terms of dealing with issues that not only effect the black community alone, but issues that all people have to deal with. Children, no matter what color they are, are abused and somebody had to speak out. I was a child who was speaking out about what had happened to me as a child. If young people now would realize, if they have something important they have to say about what's happening in their generation, I believe that's the key that opens the door to them becoming effective and successful as writers in whatever genre they choose.

Houston: Judi, who created *Good Times?*

Mason: Actually, it was a show that was developed by, gosh, Eric Monte, a young writer in Hollywood, a young black writer who brought the idea to Norman. And Norman gave him credit as the creator of the show because at the time—and I can't really blame Norman because, see, Christine, you know as well as I do, that at the time there were no opportunities. Blacks were not working in executive positions. They brought cameras out, because part of the award for winning the Lear Award, you had to join the union because you wrote your first script. They brought cameras out when I went to get my union card. And they're taking my picture. I'm thinking, "Oh, is it because I won the Norman Lear Award?" They said, "No, because you're the first member, black woman to join the Writers' Guild for writing a television script." This is in 1975.

List: A long time coming!

Houston: They had no black women writers, African American –

Mason: Ever. And this was an amazing thing to me because I think – when I got to Hollywood, I was the first black a lot of things. And it was astounding to me, and that's when I started studying the history of blacks in television. Understood, first of all, that *Amos and Andy* was a radio show created by Amos and Andy. They wrote every episode, but they were not credited.

They starred in it, and they made a few dollars. Then there was the Mahalia Jackson series in the '60s, which once she did the March on Washington and started supporting Dr. King, her show was snatched off the air. We had never been on primetime in an episodic television series until *Good Times*.

Houston: Okay, I didn't deal with the variety shows because the majority of those did not have to be scripted.

Mason: Right, they didn't because she was just sitting there. You know, you can see clips of it now. She sang and talked about love and all of that kind of stuff. I think, the show lasted like maybe four, five, six weeks, something like that, and then she was snatched off. And then there was your *Julia*, but there were no black writers there. When I came, there was one black writer that was freelance on *Good Times* and I shall protect that name.

Houston: Okay.

Mason: But he said to me when I first got there to Hollywood, he said, "Look, this is what you need to do. You just take your check, go to the bank, and shut up." And I said, "What do you mean by that?" He said, "Don't be trying to get up here and do what these white people do. They've given you some money. Just put your money in the bank and shut up." But I was the wrong generation. [Laughs]

Houston: That's what they told me on *227*.

Mason: Yeah. It was just wrong.

Houston: Mhm-hm.

Mason: Anybody to think that. And so it took me a long time. It took me, I think, let's see, 25 years to get my first producer credit. And my lawyer would tell me all the time, "I'm trying." Because, you know, each season, each show you're moving up the ranks. But, you know, I went from freelance writer – no, I was production liaison with Norman first in which he gave me carte blanche to follow him to every show. And that's what I did. I went and watched him do it from A to Z on *the Jeffersons, All In The Family*.

Houston: He tried to do that with me also.

Mason: Well, yeah, I guess that was the good thing about Norman, he was opening doors for people. I mean, Virginia Carter was the first woman executive –

Houston: Mhm-hm.

Mason: So he just had that sort of thing because it was post-'60s and a lot of doors were being opened. And Norman was one of those producers that tried to get blacks and women, and people of other persuasions involved in television production.

All of that being the energy around us at T.A.T. was very good. However, it was very difficult to convince people that black writers could actually write. I mean, I think the reason why I was called a child prodigy for the longest time was because here I was a black kid from the South who could put sentences together.

And spell. And, you know, I didn't particularly write in dialect because that's not necessary, I think, because if you write something in standard English and give it to a black actor, if they're black they're going to sound black; so I don't have to try to learn how to write it.

List: What are the most important things that you think new writers should be looking at in their own writing?

Mason: I think they need to be computer literate and also understand that they are business people. The business of writing means, first of all, you are in control of where that writing goes and how it works for

you. And I think a lot of young people—they work for the writing instead of letting the writing work for them.

I don't believe that writers are made. You can't turn yourself into a writer. Writers are born. And I've had discussions with professors at the college where I am. I don't nurture writers. Because if the writer has a talent, all you have to say is, "There's talent. You have that talent." And that writer should stir that gift up inside them and keep going and going and going until what they have to say is heard by an audience somewhere.

List: Yes.

Mason: And back to my point of computer venues. The Internet, you can blog for Pete's sake. I met a writer who just said to me, "I've always wanted to write a book." "Well go ahead and write it." "Well, how do I get to a publisher?" I said, "Well, don't worry about the publisher. Just write the book first." And so what she would do—and I think she has like four books now that she's written—she started writing it online and sending it in chapters to people who were on her e-mail list.

List: That's a great approach.

Mason: And from that point on, she and I put out those chapters together. I walked with her to a printer so that she could get that printer to print this book out. She developed her own cover and started selling this book online. Random House picked that book up.

So it's a whole different ball game now. It's an entirely different ball game. Even here in Hollywood, I took a sabbatical for seven years and went to Louisiana to write. And when I came back, there was a Hollywood where there were no black writers. But I left at the time when *Booty Call* and *How To Be A Player* were the black movies that had black producers, finally, finding money to do them. And because I was there alone for so many years, I couldn't be a hater. I was just glad to see that this was happening.

The young people were really trying to do the things that were necessary to make changes and to bring progress to the industry. But when I got back, I realized that it was different, that there weren't

the big agencies that packaged all my material and made it possible for me to have cable movies sold. I was a script doctor for a number of years. Most of the studios, when they were doing projects and they needed some flavor added to something, some black flavor, I was the writer that got paid un-credited. But by that time, I was used to it. And then it's a matter of understanding that I had to rethink the way I wanted to do business here myself.

List: And so what changes did you make?

Mason: The changes were specific to the ones I just told you, that young people have to do. They really have to understand that the writing has to work for them. I did not try to become a member of the what's-currently-selling club.

Because rather than to come back here and get into an urban vibe that I didn't understand, couldn't possibly understand it, couldn't even tell the truth about it, because that's not my reality. I didn't know. I couldn't write about my own experiences, because I had none. I didn't grow up in a neighborhood where bullets were flying at night and where everybody cussed and, you know, the hoochies and the coochies and all of that. That wasn't a reality for me. And I didn't feel that I was in a climate that wanted it addressed the way that an older person would, because I was in my 40s then. So it was not something that I knew would be welcomed. And it took me a minute to find out that the studios had all developed what they call their Urban Development Department. They were looking for urban material.

List: Is there such a strong push right now for urban material?

Mason: Oh, it's dying. And my position on that is based on the fact that when I first got to Hollywood, there were three P's on the air: pimps, pushers and prostitutes.

It became my personal goal to cause that demise. And the shows that I worked on from *Generations* to *I'll Fly Away*, *American Gothic*, whatever show I was executive story editor on, I said, no P's; no pimps, no pushers, no prostitutes. And I saw this happen because at the time there was something that was going on in Hollywood.

It was a very small black community and we all said, starting at *Good Times* because I was there with John Amos when he left the show because he didn't like the direction that it was going and Esther Rolle, the same thing. And so we fought long, hard, battles at that table to bring *Good Times* up to a level of pride in terms of what we felt the black community was really about, and not have that show simply continue to be based on someone's stereotypical view of what we were about.

Television teaches black people who they are. We have to be socially conscious as writers and not just black writers; I'm talking about any writer –

List: Yes.

Mason: --Whoever that writer is. If you don't believe there is power in your pen or power in the words that you say, you should not do this.

Houston: Can I ask you the list of different positions starting with your first position as a writer and how you can progress?

Mason: Well, like I said, I started off as a production liaison for Norman Lear on all of his shows. And then I became a roving term writer, which was pretty much the same thing but I was guaranteed by contract that I would have at least one episode a season.

And from roving term writer, I became a staff writer on – *Good Times.* And then after *Good Times* was off the air, I went to New York to work on my theater career. I got an opportunity to enter another contest, which was sponsored by Proctor and Gamble. They were looking for black head writers for daytime soap operas. So I won that first fellowship, the P&G Soap Opera Head Writers Program, and I was assigned as associate head writer on *Guiding Light.* And that meant that I just spent a lot of time developing what's called a bible, the storylines for them.

They made it very specific, "We're not interested in any black characters so you have to write it all about white people." That didn't bother me. You know, I have studied white people all my life, and so I wrote stories just about people. And sure enough, I did that for two

years. My basic storylines were there. Then I was a freelance writer for *Essence* magazine, and I wrote about the experience because then the staff had come out saying that black people were the only ones, basically, watching soap operas, but there were no black storylines to follow. Then Brandon Tartikoff, president of NBC, was developing a soap opera featuring the first black core family. I got the job as associate head writer, the first and still now, the only black head writer to ever write for daytime soaps.

Houston: Was that for *Generations?*

Mason: It was set in Chicago, so I based the whole thing on Christine's family. You're laughing, but it's true.

List: She's got a great family.

Mason: This was great. I know some rich black people in Chicago.

Houston: Oh, right.

Mason: All I had to do was just put them in an ice cream shop. But unfortunately, I didn't feel comfortable in daytime television. It was just a grind. I had to write three scripts a week. Plus, I had to do stories for six months ahead. I was making a whole lot of money, but I couldn't spend any of it.

Houston: Well, once you left staff writer, what were the next successive positions?

Mason: Well, I skipped story editor and became executive story editor on *A Different World.*

Houston: Okay.

Mason: And my next position was supposed to be producer, but they wouldn't give it me. And my attorney said, "Well, you know, you're supposed to get it, but they said they can't do it." After story editor came executive story editor, then producer, then supervising

producer. Then from supervising producer there is co-executive producer.

Houston: And then executive.

Mason: Executive producer--who is actually the showrunner.

Houston: Uh-huh.

Mason: --The person who makes, you know –

Houston: The decisions.

Mason: No, not just the artistic decisions, but financial decisions. And so actually – that's not a bad idea to have two people doing that. When I left television, I left as a producer on *American Gothic.* Wait, let me back up. Let's see. It was *Good Times, Guiding Light, Generations, A Different World, I'll Fly Away, Beverly Hills 90210* –

List: What did you do on those shows?

Mason: I was a freelance writer, staff writer in story development.

List: Tell us about your experience as a script doctor.

Mason: Well, that was fun, because I sure made a whole lot of money. And what happens with the script doctor is they may purchase a script, basically, it's usually a movie script because a script doctor on a television series is actually the executive producer. Because, you know, your staff writers are assigned episodes, a certain number of episodes over a season. But when push comes to shove, and it's all said and done, the executive producer rewrites everybody because the thing is, the show has to sound the same every week.

I was executive story editor on *I'll Fly Away* and that's when I got this bit of information. And the executive producer was David Chase who created the *Sopranos.* And David taught me so much on that show. I learned so much from him. And one day he said to me, "You know what Judi Ann, you really are an original." I said, "Well,

thank you David. Thank you very much." He says, "I don't mean it as a compliment." I said, "What do you mean?" "You know, I really hired you because I thought you could write like me." "To write like me, you don't have to do so much work to make the show sound the same every week."

"I mean, all this time nobody told me this. I thought you wanted me to do my own thing." He said, "No, no, no. You're supposed to write like I write." I said, "Oh, okay." I think that's when I left television. I didn't want to do it anymore.

Because I just didn't want to try to imitate anybody, and I just felt that it wasn't for me. And I wished they had told me that earlier because I would have known that I was supposed to be imitating the way the executive producer writes on a show. And that's what it's about, you know. You understand that Jerry Bruckheimer has the last stroke of the pen on everything that he writes, and that gives a television show its consistency because that's why an audience tunes in. They tune in every week to see their old friends. They know exactly what they're going to say, exactly what they're going to do. And that's what makes a hit show.

List: Getting back to the script doctoring, can you explain what you did as a script doctor for the features you worked on?

Mason: Well, I was hired to come in just to create a shooting draft. A script doctor will know every aspect of production, meaning the costumes are created in that draft, locations pinpointed and brought down to matters in terms of a dollar amount. You are working directly with the director to refine the script not from the writer's point of view, but from the director's point of view. And it's actually a polish.

And you are not offered any credit. That's always arbitrated by the union. They're obligated that no matter who the participating writers are, your name must be listed. They will submit to the union the original draft from the writer and the script doctor's draft. And then the committee at the union will read both drafts, and then they'll go back to the production company and say, "You must offer the writer the option of credit or not." And most of the time at first, I said, "No, that's all right." You know, I didn't want any credit. But

when it got time for my first feature film that I had developed for two years, I said, "No, way. No, I'm going to fight for this." So what you do with the union, you actually draft a letter, stating that your desire is to receive credit, then why you think that you should get this credit, because you didn't actually create the material. The union makes the decision, and it goes to the production company, and then they have to put your name as credited writer. And that was the first time I ever fought ever. But, you know, I don't have any regrets for the times I did not, because it helped me to build relationships with some of the top directors in town like Diane Keaton and Alan Arkin and a good number of directors and producers who knew my work. And I kept getting work because I knew how to deliver that shooting draft.

List: Great. What are you currently working on right now?

Mason: Let's see, now what can I tell you? I am producing only now feature films, family, faith-based films. And we're in the very early stages of some very exciting things now. I've been very, very blessed to be able to work with the best people in the business, starting with Norman Lear and Bill Cosby and David Chase. And I'm working with Frankie Yablans, who used to be the president of Paramount Pictures in its glory days. He did the *Godfather*, *Serpico*, *Lady Sings the Blues*.

List: Fantastic.

Mason: He has his own production company now. And I am thrilled more than I could even say to have the opportunity to work with him now and his new company, and to once again be able to change the face of television and film production, to get out of the ghetto, out of the urban vibe. I want to change that vibe. I need to change the urban vibe so that there's a more diversified look at women, at families and of people of color, because that is the America that is now. We're not living in an America that's just black and white anymore. And we're not living in a time when women are sure of where they are and the place they're supposed to be.

I'm working feverishly to change those perceptions that people

have about women and about people of color. And that's where I am right now, and it's a very exciting time.

Interview With Shahari Moore

Born in Los Angeles and raised on the South side of Chicago, Shahari Moore brings a unique perspective to storytelling. Shahari is an alumna of Chicago State University, where she earned a Masters of Fine Arts in Creative Writing and was a recipient of the Kanye' West scholarship for emerging artists in 2007. As a postgraduate, she later completed writing workshops with Second City, the Hurston Wright Foundation, Nickelodeon Writers Lab, On The Page Studio and the Writers Guild of America West. In 2011, she Co-Directed *Swimmin' Lesson* with Christine List and won the Audience Choice Award at the Black Harvest International Film Festival in Chicago. She later won Best Film Depicting the Experiences of Marginalized Peoples at the Black International Cinema in Berlin and the Artistic Director's Choice Award at the Lady Filmmakers Festival in Hollywood. In 2012, *Swimmin' Lesson* was chosen as an Official Selection of the Short Film Corner at the Cannes International Film Festival in France and secured distribution with Shorts International, UK. As a finalist for Tribeca All Access and the Page International Screenwriting Award for her script, *Miracles: The Smokey Robinson Story*, she was recruited to write, *The Law of Love* and Cluck You! She received the Echoes of Excellence Award for Women in the Arts in 2010 for ESSENCE BESTSELLER, *Violets*. Shahari is the Historian Emeritus for the Cosby Screenwriting Fellowship at the University of Southern California's School of Cinematic Arts, and received commendations from Eric Garcetti, Mayor of Los Angeles for her contributions to education and the arts. She was a fellow of the inaugural class for the Diverse Voices in DOCS program. Articles about Shahari are published with Indywire's *Shadow and Act*, *The Chicago Citizen*, and *The Vyne Weekly*. Currently she is the Director

of Diversity for the Lady Filmmakers Film Festival of Beverly Hills and the Chair of the Africana Studies Department at Olive-Harvey College, one of the City Colleges of Chicago. Shahari Moore has graciously provided us with an inspiring inside look at what it's like to be on the screenwriter's journey.

List: Please tell us about your background and your journey to becoming a screenwriter.

Moore: I completed my second Master's in Fine Arts in Creative Writing in 2007 at Chicago State University. Prior to completing my MFA, I earned tenure in the Department of African American Studies at Olive-Harvey College. My first Master's is in psychology, but I've always written creatively for as long as I could write. However, for most of my life I looked at writing as a hobby. I wrote and illustrated my first short story at the age of six. Of course the writing wasn't great, but it told a story, and it was a reflection of the way that I thought about concepts and projects at an early age. It was written in simple sentences on notebook paper with an ink pen and opposite each sentence or scene there was an illustration. When I was done I stapled the left edge of the paper and made a spine. I titled my project *Cakeland*. It's the story of a family whose private jet crashes on a "deserted" island, that they later find is inhabited by walking, talking cakes who are at war with one another. I gave it to my mother, she kept it in her mommy archives, and later she showed it to me as an adult.

Houston: Cute.

Moore: My decision to go back to school to get formal training as a writer came shortly after the passing of my father in Los Angeles. His death taught me that life is too short not to pursue my passions. The time that I spent in LA handling his services reminded me that there was a whole other side of myself genetically, spiritually, culturally, and artistically that I had not spent time exploring. Not only was I a Chicago girl, whose Grandmother migrated from

Mississippi in 1914 and Grandfather in 1923, I was an LA native whose family migrated from Louisiana in the 1950s. Both migrations are historically significant and inform who I am culturally. When I returned from burying him in 2005, I applied to the Master of Fine Arts [MFA] program at Chicago State University and got accepted.

While working on my MFA, I studied various genres and started writing my first script. It was a story about a woman who loses her father and has to return home to bury him. Sound familiar?

I was obsessed with many elements, both good and bad from my own life, and the page was my basin to purge and explore them. After completing the MFA program I got accepted into a writing workshop with the Hurston Wright Foundation in Washington, DC. There I met Angela Nissell, and she encouraged me to write my first spec script and invited me out to LA to visit the set of *Scrubs*. I quickly read a bunch of books, studied *My Name is Earl*. I completed my first spec of a current television show and stepped on set two months later looking to be hired. I thought, "This is it!" In all of the books that I'd read over the last two months they said that it could take years to break in, but there were some exceptions. Well, I was the exception! Everyone that I encountered on the set was super friendly and kind towards me. However, I quickly learned that getting staffed as a television writer was not that simple.

While on the set of *Scrubs* I talked to Angela and other writers about writing fellowships and found out that all of the major networks had them. Someone mentioned the Cosby Screenwriting Fellowship, and I got excited. You mean Bill, Bill Cosby, the Bill Cosby, Mr. "Hey, hey, hey" Bill Cosby had a program for Black writers like me? Upon closer inspection I found that the program trained television and film writers and that there was an African American History course that was a component of the program as well. Again I thought, "This is it!" I'm gonna take my *My Name is Earl* spec script, and when they see that I am an Assistant Professor of African American Studies, then they will let me in for sure! I applied, waited, and instead of an acceptance letter, I got a pass letter, because I never say the "r" word and a long page of single- spaced notes telling me what was wrong with my script. I stuck my chin out and kept it moving. In the meantime I met with Angela one more time and she told me flat out, "If you want to write for TV, then you're going to have to

move to LA." I wasn't surprised. I'd read that in the books that I'd been studying over the last two whole months and while some of the information varied, that one point was hammered home again and again. She also mentioned a potential writers' strike.

I returned to Chicago, wondering how I was going to make it happen. I'd been sprinkled by the stardust of the dream of writing professionally in Hollywood, and I wasn't trying to shake it off. I applied for a sabbatical at work and started saving money obsessively—whole pay checks, change in my purse, and pennies on the street. When it came to money I did not discriminate. It all went straight into my account. My banker, Ethel at Harris Bank, began to comment on how often she would see me making deposits.

While in LA, I'd identified where I wanted to live and Oakwood Toluca Lake wasn't cheap, but I looked at this moment as a gift to myself, and I was worth it! Plus, the artistic energy of Oakwood was unmatched. I'd been through so much and I needed to nourish my core as a creative person. In the spring of 2007, I was granted a year-long sabbatical, which translated into fifteen months once I tacked on the following summer. I took a few months to feverishly tackle my research requirements for my sabbatical and get all of my work-related writing done. After that, I moved to LA without a car. Yes, you can manage in LA without a car despite what people say. It's rough, but doable. I left my recently rehabbed six-bedroom home in Bronzeville and settled into a studio apartment that boasted modern amenities and style. Hmm...the "modern" apartment, not so much. It reeked of the eighties, had a mirrored Murphy bed, carpet vs. hardwood, and was waaaaaaaaaaay overpriced. However, the grounds and amenities were worth it: two pools, two clubhouses, two gyms with spas, tennis courts, a hair salon, a grocery store, continental breakfast on Sunday, B-list celebrity neighbors, close to the WB and the NBC lots, legendary stories of "breaking in" (i.e. WILL.I.AM lived there before Black Eyed Peas blew up), and Linda Smith. Linda is an amazing jazz vocalist who I met through Robert Walker, one of my mother's buddies from her doo-wop days in Chicago. Linda taught me the ins and outs of LA and served as my primary support system before, during, and after my transition.

Every time I met people they'd say, "You live in Oakwood? You must have money." Of course I knew that was not the case.

I really didn't. However, I'd been planning for this time in my life for a whole year. I budgeted for a three-month stay, thinking that I could treat myself, then figure the rest out later. When I settled into Oakwood I found something that I'd been searching for—peace. The City Colleges of Chicago (CCC) had employed me since the age of twenty-two, and I was grateful for the stability. I'd spent my time as a young woman being political, constantly hustling for a full-time job, and then feverishly working to earn tenure after my full-time appointment. Everyone who walks through the doors of CCC was on a mission to obtain job stability, and I'd seen firsthand how far some people would go and what they would subject themselves to in order to get it. My creative muscles were flabby and my body was too. In my time at CCC, I gained about fifty pounds of who knows what? Worry, stress, disappointment, and anxiety hung out in the most unflattering places.

I had not had time to just sit still and be one with myself in months. Oakwood offered serenity and allowed me to try LA on for size, and it was a great fit! I met creatives who wrote, acted, danced, sang, swallowed swords, dressed up like characters and hustled for change on Hollywood Boulevard. Dreamers surrounded me and that alone encouraged me to dream. Every day that I woke up I felt invigorated, because every day in LA is an adventure. I cleansed, exercised, lost about twenty pounds, and wrote like a beast. I came up with a new moniker to describe my LA, "Never Never Land for Grown Folks." I wasn't working, but I was optimistic that work was right around the corner. I'd registered myself with Apple One temps, and they were great for assisting with jobs on studio lots, not to mention networking with my hand full of contacts. I'd finally found my utopia, and I was filled with hope about the future. Then the writers' strike hit.

I called Angela several times, but couldn't get her by phone. What did the writers' strike really mean? I read the trades and daily papers and educated myself about the issues on the table. The majority of the conversations centered around new media. Even my temp job was on hold. It was crazy! My lovely LA seemed like an eerie ghost town. With the writers on strike nothing moved. I, along with the whole town, quickly understood how valuable writers are. Everything starts with the script. Without a script there is no

foundation, and the rest of the body cannot stand. After pouting and being a pool bum for about a week, I had an epiphany. If all of the writers were picketing and out on strike, then perhaps I should go and be in solidarity with them. The next Monday, I scoped out all of the lots in walking distance to check things out. I turned the corner on Riverside and there they were! They were waving signs, shouting, cursing, soliciting honks from passing cars, spitting and stomping around for their rights. I was slightly afraid of the rowdy group on Riverside, but I jumped into the fray. It reminded me of a mosh pit at a rock concert. They were one of the largest crowds, and it was exciting once I got into the mix. However, I found it difficult to hold a conversation and network. Yes, network! I was invested in their struggle, but I still had to be mindful of the goal of eventually getting staffed and building relationships that would last beyond this moment. In order for that to happen, I needed to be able to at least introduce myself in a setting where my voice could be heard. I made a friend or two, including Arturo Toledo. Finally, I decided that I wanted to check out a different spot.

One morning while waking, I stumbled onto the back lot at NBC, where a group of quiet protesters carried signs and walked around peacefully in a circle like monks. The group was the polar opposite of the rambunctious writers on Riverside, but I gathered my courage, walked up with my picket sign, said, "Good morning," and filed into their rhythm. There were strange looks. I heard one of them whisper, "Who is she?" I pretended not to hear them and allowed their curiosity to build. There were more murmurs, then finally one of the "monks" introduced himself as I figured someone would. I was the only woman and the only African American in a contained group of white men. So, naturally I stood out. I returned the introduction, and, when they learned that I was an unstaffed writer who'd come out to support their cause. They began to talk to me one by one. Writers from popular NBC shows were represented: *Law & Order, Law and Order: SVU, Scrubs, Friday Night Lights, Heroes, The Office, 30 Rock* and new shows like *How I Met Your Mother, Lipstick Jungle,* and yes *My Name is Earl.* Jackpot! Within an hour I found myself on camera giving an interview. I felt honored to be a part of history. I showed up every day like it was a religion. I'd never been a PA or worked my way up the ladder on a show like the books suggest. However,

this was my unique way of paying my dues. I never talked about my writing. I just enjoyed the quiet camaraderie of the circle. Then one day one of the writers asked me about my work and offered to read me. After reading my script, he gave me notes and a deadline to incorporate the notes, which I dutifully met. Before the strike ended he gave me a WGA pendant and told me that one day I would be a member of the Guild. That writer was David Slack, and we are still friends today. His notes, guidance, and advice have been invaluable.

List: There are a lot of generous people who are willing to help if you approach them in the right way.

Moore: Yes. Definitely. After the strike ended, LA began to move again. The writers were back at work and studios were hustling to make up lost time. It was pandemonium! I kept my contacts and continued to write. In August, I got accepted into the Nickelodeon Writers Lab at the American Black Film Festival with the *My Name Is Earl* script that David had given me notes on, and I finished a feature script based upon the life of Smokey Robinson. I sent the script to Tribeca All Access, and I applied to the Cosby Program on the feature side this time. I also joined the Organization of Black Screenwriters (OBS) and became a volunteer at the Writers Guild Foundation. Both organizations have a lot to offer. I was drawn to them because they were both education driven. OBS held monthly meetings and invited notable industry professionals in to talk about their journey. They also offered writing groups, workshops, and contests geared towards helping emerging writers to move their careers forward. I got adopted by Writing Group Two that included, Tracy Grant, Terrell Lawrence, Corey Moore, Kevin Killebrew, Renee Rawls, Kaypri and later Miles Presha. Working with them sharpened my skills and made me more sophisticated when it came to the industry. The WGA Foundation offered genre-driven series on the craft of writing and brought in heavy hitters who were current in the industry. Honestly, I met more writers at the WGA than I can possibly name. After sitting in on enough workshops to be awarded another degree, I met Robert Eisele. In short, during the Q & A, I asked him an intelligent question (of which I don't remember). That question led to a longer conversation, and he ultimately became my mentor.

My Smokey Robinson script got me an interview with Tribeca All Access. The interviewer raved about the script and asked me several questions about my background. Her final question was about Smokey Robinson's life rights. After telling her that I had not officially acquired such rights there was a long pause. She encouraged me to attempt to get something in writing from Smokey and call her back as soon as possible.

Houston: How did that go?

Moore: Having acquired access to Mr. Robinson through his wife, who I'd met with through her pedicurist (gotta love LA), who I met through my new friend Sharon Day, a costume designer who I met when she offered me a ride when she saw me walking in the rain on yes, Riverside. Unfortunately, I could not get a response quickly enough from Mr. Robinson, and I was not able to participate in Tribeca All Access. In addition I received an unusual pass letter from the Cosby Program with no notes (odd considering that they took the time to do so before). The letter began, "Good writing is not enough..." What?! They acknowledged that my writing was solid, and I still didn't get accepted! I threw up my hands and decided that perhaps the industry was not for me. My sabbatical was ending, and I had not broken in fast enough. So like Cinderella, my carriage had turned into a pumpkin and it was time to go home barefoot.

I returned to the classroom in Chicago depressed and deflated. I'd experienced true freedom. I'd set out to carve out a creative life for myself and was not able to make all of the pieces of the puzzle fit together fast enough. As I exited the 90/94 e-way each day and saw the marquee for my campus, I felt nauseous. No offense to the institution, but I had simply moved on mentally, emotionally, and spiritually. Returning seemed like taking several steps back, and I felt that my writing career was being quickly enveloped by quicksand. I tried to make myself be cool with it, but it wasn't working. I walked around like a zombie for about a year and a half. So many of the issues at my job either seemed irrelevant, frivolous and petty. Some concerns were valid. However, my worldview and my focus had broadened. I felt suffocated and as if I was going to die, so I took a personal leave without pay in the spring of 2010. Then I got a call from Doreene

Hamilton-Hudson of the Cosby Program, who invited me in for an interview and later invited me to join the program as an Instructor of Black History, Media, and Popular Culture. The same program that did not accept me as a fellow recruited me as an instructor! That whole experience is a blessing and a story in and of itself. Of course, I accepted the position!

Houston: Of course.

Moore: That same year, Chris [Christine List] and I began to collaborate on *Swimmin' Lesson,* which was a flash fiction narrative that I'd written while taking a fiction writing class with celebrated author Sandra Jackson Opoku. It later appeared in *Warpland,* a journal published by the Gwendolyn Brooks Center at Chicago State University. We adapted the narrative as a screenplay and shot it in October of 2010 and finished editing in March of 2011.

Initially we didn't get much festival play, then finally we got our first acceptance from the Black Harvest International Film Festival in 2011 at the Gene Siskel Film Center where we won the Audience Choice Award for Best Short Film. After that we went on to screen at the International Black Film Festival of Nashville, the Reel Sisters of the Diaspora Film Festival and the Women of African Descent Film Festival in the Spike Lee Screening Room at Long Island University in New York, the Manly Short Film Showcase at Raleigh Studios in Los Angeles, the San Diego Black Film Festival, the Portland Oregon Women's Film Festival, Indie Night at the historic Mann Chinese Theatre in Hollywood, the Black Berlin International Film Festival, where we won an award for Best Film Depicting the Experiences of Marginalized Peoples, the Lady Filmmakers Festival in Hollywood, where we won the Artistic Director's Choice Award, and finally the Cannes International Film Festival Short Film Corner in France, where *Swimmin' Lesson* was selected for distribution by Shorts International. Post-Cannes, many doors that were closed are a lot easier to step through. I am still growing and getting established, but I feel that I am in a great place. I'm excited to see what the next year will bring.

List: How would you recommend an emerging screenwriter go about networking?

Moore: Emerging screenwriters really cannot afford to leave any stone in the dirt. You must flip every stone over that you encounter because you never know which one will prove itself to be a gem. Find a writing group. Writing groups are great for networking as well as honing your craft. Get on all industry lists, particularly the ones that are writer-friendly lists for mixers and educational opportunities.

Look at the WGA website and be on the lookout for events that are hosted by organizations with a diversity focus. Also, build relationships at the Directors Guild, the Producers Guild, and the Actors Guild, because those settings are not over saturated with writers and those individuals may be in a great position to get your work made.

List: How did you get your manager, and how is that relationship going?

Moore: I met my manager at a party thrown by Jason Nieves of Latino 101 at Frank Lloyd Wright Jr's, Sowden House in Hollywood. I remember that night. I was cranky, and I couldn't find a convenient parking space on the street. I had to park and walk six blocks up a hill in heels, and I don't like heels! But I was driven to make it to the party. I love beautiful structures, and I am in awe of the work of Frank Lloyd Wright! I didn't know when I would have access to Sowden House again. This party was a rare opportunity, and I had had a feeling that it would attract some interesting people.

While catching up with Jason, he asked me what I'd been up to. I told him that *Swimmin' Lesson* got into the Short Film Corner at Cannes. Jason was blown away by the fact that I had a film that was going to Cannes in just a few weeks, and that I was not represented. Word quickly spread through Sowden House that the Black woman with the dreads got into Cannes. People began to congratulate me. Jason introduced me to a well-respected manager, who complimented my heels, followed me around the party most of the night, and offered to read my work. We entered into a relationship that felt like dating. I sent him some writing samples. We talked about my work and my

future. Then he attended one of my screenings of *Swimmin' Lesson* and brought along a junior manager.

In time he told me in a roundabout way that he was handing me off to the junior manager. Honestly, it was odd because I did not feel that the junior manager was as enthusiastic about me. I am giving my manager the time and space to invest in me. I believe that when people are invested in you then they are more likely to perform on your behalf. I hope that the relationship with my management company is fruitful. However, the entertainment industry can be like dating in that oftentimes one relationship leads to the next, and the ultimate goal is finding a partner that you can grow and prosper with. I'm open to this process as it unfolds.

List: What are your plans for the future?

Moore: I'm writing *Cakeland,* the project that I conceived when I was six years old, so my future is bright! The story has evolved of course, but the basic premise is the same. Yes, that is an overused cliché, but I really believe it, and I've learned that passion projects work for me. I resist being pigeonholed as a writer, and my experience has revealed that playing both sides of the coin, i.e. television and film, works for me. I've also begun to work on a documentary project on the life and legacy of Gwendolyn Brooks, the first Black woman to win a Pulitzer Prize. I believe that my Smokey Robinson script will be made. Another feature that I've written, *The Law of Love,* is moving along as an indie film. I've got a couple of shorts in my back pocket as well. I'm still passionate about episodic television, and I trust that I will see some action in the writers' room in the near future.

I've taken the time to study the art of writing, and I'd like to continue to craft my scripts with skill and purpose. I continue to flex my creative muscles on a daily basis, and I'm constantly sculpting new stories. I still teach with the City Colleges of Chicago. However, I've learned to balance myself as a scholar and a creative writer. Post- Cannes, I have a little more support than I had previously from my institution, but it gives me comfort to know that they have a better sense of who I am and my needs. Many of my students with the Cosby Program at USC and Olive-Harvey have been supportive as well. Networking is a way of life for me. I have also connected

with screenwriting and filmmaking organizations like Reel Black Filmmakers in Chicago. Soon, I hope to be in a position to write on a fulltime basis. My elevator pitches are ready in my head and passion pumps in my heart. I keep my business cards locked and loaded in my purse. I have identified key players on my roster, and I continue to recruit new all-stars to be a part of my dream team. So when the right opportunities present themselves, I am poised to move forward!

Interview with
Kathleen McGhee-Anderson

Kathleen McGhee-Anderson has had an impressive career. She is best known as the Executive Producer of the primetime television drama *Lincoln Heights*, which ran for four years on the ABC Family Network. Before that, McGhee-Anderson was an executive producer on the dramatic series *Soul Food* and a producer on the series *South Central*. A versatile writer whose work spans several genres, McGhee-Anderson's numerous writing credits include *Touched by an Angel, Little House on the Prairie, Sunset Park, Amen, 227, The Cosby Show, Webster, Gimme a Break,* and *Benson.*

McGhee-Anderson received her BA in English from Spellman College and an MFA in Filmmaking from Colombia University. A truly prolific writer, McGhee-Anderson has been nominated three times for an NAACP Image Award for her work on *Lincoln Heights.*

List: Kathleen, how did you get started in the business?

McGhee-Anderson: I started out at another profession that was, in some ways, related to writing. I was a teacher. I had completed an English BA at Spellman, and then from there, I decided that I wanted to become a filmmaker. I went to Columbia University and got a Master's in directing, and realized that I couldn't just jump out of graduate school and be a director. So I began my career doing two other things. I was a film editor with an ABC affiliate in Washington D.C., and I was an Assistant Professor of Film at Howard University when I first finished graduate school.

List: Oh. Did you work with Haile Gerima?

McGhee-Anderson: I did.

List: Interesting.

McGhee-Anderson: I did a Masters that focused on directing, but I also was interested in the area that they called scholarship and criticism. So I really focused upon not just the production aspect, but also the art of filmmaking in terms of the critical aspect and the historical aspect and some other areas. I also focused on making documentaries.

So with a film program beginning at Howard, they had a need for an instructor, and I started out with them. I worked with Haile, who, as you know, is quite political, and we all were then. That was the thrust of our program—activism, especially as it related to filmmaking and art.

We had an organization called Street Cinema where we put up a screen in front of—it was my house, actually. I was married to Carl Anderson, who was an artist that was local. And we would screen a film in front of our house every week for the neighborhood.

List: Oh, fun.

McGhee-Anderson: And then we would have a dialogue with the people. Street Cinema is what we called it. And we would really try to bring in politically conscience films, films that would really inform the neighborhood about various issues or subject matter thematically having to do with the culture and the people and things like that. It was a really great time. We did a lot of activist stuff with Haile back in those days. And then my husband and I moved westward, and I didn't teach anymore after that.

Houston: So, Kathleen, who were some of your major influences as a writer?

McGhee-Anderson: Oh, I had one that influenced me beyond my greatest expectations of how I could be influenced, and that was Zora Neale Hurston.

Houston: Okay.

McGhee-Anderson: So important for me as a young writer, because I was trying to find a paradigm or a model of someone who lived as a writer, who could translate her passion for writing into a career, an African American woman. I know that there are some other races that have great female writers, but I didn't know of anyone prior to Zora who was able to make a living writing. I discovered her in college. I had a wonderful professor named Gloria Gayles, who's influenced many writers, many writers of our generation.

She brought Zora Neale Hurston to my attention in college. I could not read enough about her life because much of it is autobiographical, and she was an anthropologist. But many of her writings had to do with culture and our roots. And she was so illuminating to me, and she celebrated who we are as a people. That was just like getting a treasure, reading a treasure, and then to further see her brilliance at storytelling—I mean, she's a page-turner.

I was completely influenced by the way she told stories, the way she looked at life and, you know, beginning in the Harlem Renaissance, she was a glamorous figure. She was a romanticized figured. She wrote that great love story about Tea Cake. You know, she, herself, had a romance of sorts with Langston Hughes. And it was all so inspirational to me as a young writer. And she gave me a lot of courage in terms of going on the path of trying to become this person. When I started out, there weren't any African American women, or maybe one or two, who had come before me in Hollywood that had really made any kind of strides or were really able to etch out a career. In fact, Zora had spent some time in Hollywood.

Houston: Mmm.

McGhee-Anderson: She opened the door and led the way and gave me the role model that I needed to keep forging ahead. And she was a playwright as well.

Houston: I was really surprised when you said theater was your first love. You wrote plays?

McGhee-Anderson: Mm-hmmm.

Houston: Okay. Then I want you to just tell me a little something about how you started as a comedy writer and then made the transition into dramatic television. I assume that, as a comedy writer, you were writing your comedy in the form of a play?

McGhee-Anderson: You know what's funny about that question, Christine, is that I didn't start as a comedy writer. I started as a drama writer.

Houston: Okay.

McGhee-Anderson: Let me back up a bit. Because I really was a writer of all genres when I started out.

List: Mm-hmm.

McGhee-Anderson: I considered myself a poet first, then a playwright. Then I studied screenwriting and thought of myself as a screenwriter, although I had not sold any work. I thought that was the direction that I would move in. But when I finally did move to Los Angeles, it was a short story that I had written that captured the attention of a screenwriter who said, "You are really funny. You need to channel your expression, your humor into writing for television," which was a venue, a form of writing I had never considered. And quite frankly, I considered it a lower form of writing than writing for film or even prose writing, poetry and playwriting. But this screenwriter insisted that I apply to a screenwriting program, which was the very first screenwriting program that Warner Brothers gave. It was called the Minority Writers Workshop at that time.

The very first class was Winifred Hervey and myself, and that's how we met. There were twenty of us, and it was a workshop for African American writers to learn how to write both comedy and drama. I wrote an episode of *Amen* and an episode of *Little House on the Prairie*. And it was my episode of *Little House on the Prairie* that got the attention of Michael Landon. Michael Landon read it and hired me to write an episode of *Little House on the Prairie*. And that

was the first television sale, and first sale in the industry that I ever made.

At the time, I considered myself a drama writer. I did not consider myself a comedy writer. I did not think I had comedic chops, at least not the kind that I had witnessed being around people who I thought were more talented as comedy writers. But with the industry just beginning for African American writers, there were very few opportunities to write anything dramatic. And even though I had an agent who said, "This woman was taken in by Michael Landon and who really believed in her and gave her a script to write," I could never get another sale. And it was very demoralizing and depressing to me because I thought, wow, Michael Landon reads everybody and that would at least have given me—he tried to give me a little bit of a hand.

Houston: That's like winning the Academy Award, and then not getting any work.

McGhee-Anderson: Right. I mean, this man was so good to me. He taught me what I should and shouldn't do. He said, "You've got talent. I want to help you move forward." He was amazing to me. And at the time, he didn't have a staff. If he'd had a staff, he would have put me on it. He wrote with this other guy. They wrote them all. And so it was wonderful that he let me write one. So what my agents were able to do was to get me seen and heard in comedy, because, at that time, they were more open to African Americans being a part of the comedy writing aspect. And because I didn't consider myself a comedy writer, I did freelance episodes for many years. I did *Benson* and *Webster* and *Charles In Charge* and—

Houston: And *227*. (Laughs)

McGhee-Anderson: *227*. I did so many.

Houston: Can you describe your role and how you got to become Executive Producer of *Lincoln Heights*?

McGhee-Anderson: How did that happen? That happened because

I worked with *Soul Food* previously. And *Soul Food* was run by Felicia Henderson. I worked on her show for two seasons as a consulting producer. She left, and after she left, the executive at Showtime said, "We want you to run the show." So I took the show over and did the final season. So I was Executive Producer of *Soul Food* for the last season. I had been offered the job to be executive producer of shows previously. Felicia did it, and did much better than I ever could. I didn't do that job, but I did work for her when the show was in production for two seasons. I shied away from being executive producer. I always thought it was too much responsibility, and especially when I had a teenager, and I knew that it would take me away from my kid. I was a single mom, raising a teenager. So part of my shying away from executive producer work was the all-encompassing nature of it.

So after having run *Soul Food* for the last season, I met some people who were over at the ABC Family Network. When *Lincoln Heights* came along, they reached out and said, "Well, can you be the Executive Producer of *Lincoln Heights?*" It was an easy yes for me because I love the material, and I knew how to do the job. I knew the job wasn't too much for me. I knew it was just exactly what I should do. It was a combination of all the skills that I had been acquiring my whole life, and I didn't even know it.

Houston: Mm-hmm.

McGhee-Anderson: I was cutting film, and when I was studying filmmaking and learning how to be a director or at least how to talk to directors, I was acquiring all this stuff. And then music is a passion, always has been. So I was accumulating all the know – how and the ability and knowing how to interface with executives. That's a big part of being an executive producer. It's a multifaceted job, and part of it is truly a business job, a business executive job.

Houston: But as executive producer, you also wrote scripts for the show?

McGhee-Anderson: Well, I was really three things. In that role, you're not always three things. There are many executive producers in the business that are not the showrunner. In this instance, for me, at

Lincoln Heights, I was the executive producer. I was the showrunner. And I was also the head writer.

Houston: Did you have a writing partner?

McGhee-Anderson: No. No. But the good thing about that...

Houston: I don't feel bad, Kathleen, because I never had one. But everybody I ran into in Hollywood had a writing partner.

McGhee-Anderson: Yeah, most people do. I enjoy writing with people. I'm very collaborative. And the good news about being executive producer for many people, and not the way I run it, but one of the things you can do as executive producer is that you can take any stuff at any point and make it your own. And a lot of executive producers do that. There's a staff of writers, and the writers work on the material. And at some point, the executive producer could take it over. Because, bottom line, the executive producer is responsible for all the creative content. In my instance, I would always write the first episode and the last episode. Not the first season, because the first season of *Lincoln Heights* was completely and utterly mayhem. We got through it; and we did really well. I was on time and under budget, but it was a very difficult process. So I didn't do any writing.

I did something interesting the last episode of the season. I decided that I would try to get a variance of some of the Guild guidelines and have everyone write it that was on staff. I had a small staff, and we all wrote it. The Guild enabled us to do that so that episode was a five-member, five-team write.

Houston: That should be interesting and fun.

McGhee-Anderson: It was fun, Christine. I really liked the process. Yeah. We had a little bit of time. Everybody I knew was going to throw down and do their best work. And I felt that as Executive Producer, I should not come in and then take the credit for it all. I had seen it done with the Guild with *Amen* actually. *Amen* had gone to the Guild and said, "I need to get you to give us this consideration." So you have to pay a little bit more. But everybody got credited, and

it was fun. We were trying to bring scripts in at about fifty-seven pages, but with everybody going off with the five writers with their own little storylines, and I kept telling everybody you've got to keep it really tight, I think when we got our first draft back, it might have been eighty, ninety pages. That was the problem with five people. It could've been two episodes.

Houston: Kathleen, I was just wondering, with the dramatic series like *Lincoln Heights*, did you guys have what they call the bible, so that you knew in advance which direction you were taking these characters?

McGhee-Anderson: No. And I know what you're talking about with the bible, because earlier on, I got a job on a soap, too. It was called *Capital.*

Houston: Mm-hmm.

McGhee-Anderson: So, no, we don't have that kind of bible. But what we had, and on *Lincoln Heights* we only had, what is called a cycle now in this town. The whole process of TV is changing so much, and no longer do they have the traditional seasons. The first season, I got 13 out of the network. And then the next three seasons, I only got ten each.

Houston: Mm-hmm.

McGhee-Anderson: When we're sitting down for that particular season, what we do in the writing room is decide what direction we're going to be going in. We say we're going to start off here because that's where we left off with these characters, but then we're going to take them to this point. So there's a general arc in mind. But in terms of having a bible, what every single episode is going to be, we don't prepare that in advance. It flows. So we had general areas that we talk about in the beginning.

The whole process for the first month is to sit in the writing room with the writers and to figure out what stories we want to tell for these characters. And then on the board, as we're talking, we're putting up the general areas that we want to write stories in. But

you said this question, which was interesting to me: how can you describe your role as executive producer? For me, to do the job, I could describe my role to myself as the vision holder.

List: Mm-hmm.

McGhee-Anderson: Because there has to be one vision. There has to be one voice. It has to seem like the same show every single episode. It can't seem like a different person's point of view in telling the story, even down to the dialogue and the star. So there really does have to be one person's voice that's accountable, and that needs to be reflected in the show. Ultimately, it's the executive producer who comes up with what we're going to say.

What are the characters going to do this season that is meaningful to what the story is about? "What is *Lincoln Heights* about this season?" is the big question. Is there a theme? Is it a forgiveness season? Is it a season about redemption? Is it a season about rebuilding? We always had to have a thematic way of looking at the seasons so that it would all work together. [It was] easy doing it from my point of view because *Lincoln Heights* is about a community.

For me, that's an important thematic story to tell because I'm from Detroit. And so there's so much to say about African Americans in the community, about surviving and about, of course, rebuilding and about hope and how to get working together and commitment, and the past, the present, the future. It's all so rich.

Houston: Did the network generally have the final say on a show, on a particular episode?

McGhee-Anderson: Yes. Yes. And that's the thing that always brings you back to reality, even though you consider yourself an artist. I do consider myself an artist working in a commercial world, which is really exciting, because I could make a living and at the same time do...

Houston: What you like.

McGhee-Anderson: ...to some extent. That's the big thing you have to always keep in mind because it's all being done for a business.

It's being done because there's a bottom line, a financial bottom line, and you're making money for a company. And so basically, you're writing for hire, and you're writing to please the company that's hiring you to put this together so they can put it on the air to sell advertising.

So, yeah, it's an interface. It's a conversation that goes on constantly with the network. In my situation, I was extremely fortunate. *Lincoln Heights* was really great in that I had only one higher voice to answer to other than my own personal higher power—the higher power of the network.

List: Kathleen, could you describe a typical production schedule for your show from the writer's point of view?

McGhee-Anderson: From the writer's point of view, they are working in a story room where an idea becomes the genesis, the beginning of an episode. And in that room, then, with other writers, they do what's called "beat out the story." Then they sit down for several weeks and write it in terms of scenes and what happens in every scene and in terms of acts. And in terms of acts like the climax, the conclusion, and what happens, it's all written out ahead of time. So it's outlined. That's a several week process that goes back and forth, and there are a lot of conversations with the writers and the Executive Producer. And then, for me, taking that material and having conversations with the network of what we come up. Not in detail, but getting their input at that level. Then the writer goes off and maybe has—in Lincoln Heights, two weeks, two to three weeks to write it. Our first draft is then given in. And then, the way I ran the show, I gave the writers notes on their first draft. They could then go around, and in maybe four or five days, they were able to do another draft. So they got to do a rewrite.

List: Okay.

McGhee-Anderson: At that point, the draft is given to me. And at that point, depending on the timing, there's a very brief window to get a production draft out. And that production draft is exactly what is going to be given to the director.

It is my job, as the executive producer, to make sure that when we know what day an episode is going to start shooting, we know seven days prior to that the director is going to come in to start the pre-production work. For locations there has to be scouting. There have to be sets built. There have to be people cast. There has to be music obtained. So that's a seven-day period that the director comes and starts, so that script has got to be ready. So on that second pass for production, I take the script. And then at that point, as executive producer, I get a production draft ready, which is exactly what we're going to shoot.

I generally do a rewrite. And then the first day of pre-production, the director gets it and spends seven days with it. And the writer might ride around with the director and give ideas about what a location might look like and might have conversations with the director during those seven days. And then after those seven days are up, it's time for that director to go shoot, and it's time for that episode to be shot.

The director has the writer on the set with him at all times. The writer sits for that seven and a half days with the director on set. They're there to answer questions that the actors may have, modify a line. If the actor is having some difficulty with it, then the writer is there. The writer is there to interface with the executive producer, come back and say things, give me some information about how things are going or what might look good and what might not look good, or what problems are going on. They're the eyes and ears for the executive producer, and they're also there to assist, facilitate and help the director see the vision in a very non-invasive way, because the director has so much to do creatively. After the episode is shot, the writer's job is over. And not every writer is engaged in the production aspect of a dramatic series. Not every executive producer sends the writer on the set.

List: Did you work with the same group of writers for the duration of the show? Or did you bring in new writers?

McGhee-Anderson: I used the same writers. Almost all of them that started in the beginning were there at the end.

List: Oh, nice. So you really trusted your staff then.

McGhee-Anderson: And I nurtured them. And I was able to really bring out what I thought was the best in each of them, and then I was able to hire some more writers as the series went on. And not every writer has every strength, not at all. But, you know your writer that can give you your jokes. You know your writer that can make you cry. You know your writer that can write the procedural stuff. You know your writer that can do family and teen stuff. Do it all. Some of them can do two aspects, some can do not much, but they're really wonderful in breaking story. It's such an amazing skill when you can sit down and break a story well. Some are amazing for their ideas. You probably have a writer that could come up with all ten episodes if you had them sit down and break stories. There are some that are that fast when it comes to having ideas. But everybody is different. And an executive producer knows how to pick the right combination and put them all together. It's a fun thing to do. And it's even more fun when it works.

List: Kathleen, what would you recommend to new writers who are trying to break in?

McGhee-Anderson: Well, I think the first and most important thing that a writer has to do is really come prepared.

Houston: Mm-hmm.

McGhee-Anderson: I'm a firm believer in education. Of course, I think that a writer has to study and then write and rewrite the material over and over before it's in any shape to be competitive. Competition is so fierce out here. There are so many good writers, who know their craft. I'm not talking about just being able to write a character with some dialogue. There's a lot of craft to scripting. What does that mean? Understanding structure. Understanding story development. You do that by doing it and by studying. A new writer can usually only get that by studying. And studying with someone who can identify what shape a script really is in.

List: Mm-hmm.

McGhee-Anderson: Don't come to L.A. without a script that's been rewritten several times.

List: Great advice.

McGhee-Anderson: I just met with a writer last week who had done a play. This writer had had a couple of meetings on the play and had some response in the reading here and there, you know, affirmative, that kind of thing. But the play wasn't crafted, at all, wasn't ready to be produced. But in the conversation with this writer, there was the assumption that it was ready.

In terms of practical things, how you get an agent or how you get to the door—there are so many ways to do that, and none of them is the right way. Of course, networking. Who do you know that knows someone that could put material in the hands of an executive producer?

An advocate is what you want to find, someone who is participatory and has a real sense of the business. On a television show, who has the executive producer's ear? Who can get me in the room as a writer's assistant? How can I get to meet someone who can help me get a hearing? It's networking. It's about trying to make a connection that gets you closer, like one degree of separation from the show. The other things are programs. There are quite a few programs lately, I've been noticing, giving writers development access.

List: Yes, there are.

McGhee-Anderson: Disney's got one. NBC's got one. Warner Brothers has one. And there are others. So investigate online what those might be and try to get involved in those programs. If your material is good, it comes to the surface. If it's among the best, it should. But you just have to have the best materials.

Houston: Mm-hmm.

McGhee-Anderson: And if your material is really great and you submit it to these programs, you'll get recognized. That means you've got to go back to square one and write some new material. I read for some of those programs. And I can tell you that what I read for is the spark of something different, because writing for television is formula.

So you figure out how to do the formula of a procedural, for instance, and hit all the right marks in a formula. You can do that. But are you saying something? Are you presenting something unique? Or is there a character that's interesting and fresh? Or is there a way that they speak? Or is there something? Is it some thematic thing? What makes it unique? If there's a spark of uniqueness, I am interested, because there's so much of the same.

The other thing I would suggest is original material. A lot of people are reading more original material now than before. So before, if you had to write a spec, they'd say, "Write a spec, but don't write a spec." The advice was to write a spec, but don't write a spec of the show that you're interested in. If you want to write *House*, if you're passion is to be on the staff of *House*, don't send *House* to the show. It's never going to measure up to the *House* that the executive producer would write. So write something similar if you want to do *House*. If you want to do a show, don't write that show. Write something in the same vein, in the same genre.

List: Mm-hmm.

McGhee-Anderson: By the same token, it's even wonderful if you write something that's original. Original pilots are being read now, and also original material, such as film and plays.

List: Is there anything else you'd like to add in terms of advice to writers who are just starting out? I especially would love to hear how you managed to write raising a child and with all the things that come up in your day-to-day life when you were trying to break in. How did you discipline yourself to keep writing?

McGhee-Anderson: Well, I can say that, if you don't have a passion for this, then don't do it.

Houston: Mm-hmm.

McGhee-Anderson: Because I had a baby, a husband and a full- time, demanding job. And I didn't have any money. So I lived in a house without an office, without any space that I had as a place to put my, back then, typewriter.

List: I've been there too.

McGhee-Anderson: I took a cutting board, a chopping board, and I put it on a laundry sink. And I put my typewriter on it. It was a portable. And when my child went to sleep, I sat down and wrote. And I did that for a while. Even today, there're so many things that I want to produce and to write. I have lots of creative dreams, and they start with writing something. The only way that I can get it out is to do it the same time every day because if I don't, the day is gone. So I suggest that to be a successful writer, you must have discipline. And to have discipline, I suggest that writing the same time every day works.

Make it a discipline. You know, like, you get up and brush your teeth…Make your writing your habit.

List: That's great advice.

McGhee-Anderson: It's a thing you can't do without. And usually the best time to write for people is early in the morning or late at night.

Houston: Late at night.

McGhee-Anderson: So if you have some time, even if you write one hour before you go to bed. If you write one hour before you go to bed 30 straight days, and you get out one page in that hour--that month you will have 30 pages. And even if you write half a page of nothing, you're going to have something at the end of thirty days. And it's so hard, and you get so much rejection. And at the level that I am, I get rejection every day on stuff. But if you don't believe in yourself, and if you don't believe in what you're doing and love it—you're wasting your time.

Houston: I do tell young writers don't ever be discouraged by rejection.

McGhee-Anderson: No.

Houston: Just keep writing.

McGhee-Anderson: Yeah, I have this motto—that if I stop writing, they win.

Endnotes

INTRODUCTION

[1] See wga.org and afi.org. Each organization posts a list of their top 101 or 100 films respectively. The only film written by an African American to be included on either list is *Do the Right Thing* by Spike Lee, ranked 93rd by the WGA and 96th by AFI. The films on the list are chosen by the membership.

[2] In 1999 the NAACP joined together with Latino, Asian, and Native American media watch groups to pressure the four major networks to increase participation of minorities in the production and management of prime time television programming.

[3] "African American TV Usage and Buying Power Highlighted" on marketingcharts.com, August 2012.

[4] Nielsen Media Research, "TV Audience Special Study: African American Audience," by Jana Steadman, Summer, 2000, nielsenmedia.com.

[5] "The Power of the African American Consumer" on nielsonwire.com, September 22, 2011.

[6] African American women are turning out in large numbers to see the films of Tyler Perry. Their buying power is responsible for his tremendous success. "Keepin' it Reel: 6 Filmmakers on Image and the Future," Moderated by Sergio Mims, *Ebony Magazine*, March 2010, p. 123.

[7] "Recession and Regression: The 2011 Hollywood Writers Report," page 5, www.wga.org. Also, the data collected in 2004 indicated that less than ten percent of television writers and only 6 percent of film writers were non-white. For women the data showed that females comprised

only 27 percent of television writers and a mere 25 percent of employed screenwriters. "The 2007 Hollywood Writers Report: Whose Stories Are We Telling?" prepared by Darnell M. Hunt, Ph.D. pp. 5-6. www.wga.org. See also "2016 Hollywood Diversity Report: Busine$$ as Usual?" Ralph J. Bunche Center for African American Studies at UCLA.

[8] One exception to this will be the screenplay for *The Great Debaters*, directed by Denzel Washington and written by Robert Eisele, who is a writer of European descent and who beautifully crafts strong African American stories and characters.

CHAPTER ONE

[1] "Interview with Dwayne Johnson-Cochran" in *African American Screenwriters Now: Conversations with Hollywood's Black Pack*, Silvan 1997, p. 11.

[2] Facets Multimedia is a video rental company that rents films that are not available elsewhere, including many hard-to-find independent and international films. See www.facets.com.

[3] Producer's Guild of America, producersguild.org.

[4] Western movies romanticizied the notion of Western expansionism. They represented the American West as an unclaimed wilderness that needed to be settled by Americans of European descent. The point of view was based upon the concept of "manifest destiny." The concept ignored centuries of Native American and Mexican ownership of North America land and was a philosophy used to justify conquest of the Western territories.

[5] Kaleem Aftab, *Spike Lee: That's My Story and I'm Sticking To It*, page 392.

[6] A study by BET Networks commissioned in 2011 revealed that among African America audiences 69 percent of viewers ages 16 to 49 prefer comedy.

[7] "The Numbers" www.the-numbers.com

[8] "Blacks and the Movies," *Hollywood Reporter,* May 27, 2011

[9] For an in depth discussion of Akerman's work see *Nothing Happens: Chantal Akerman's Hyperrealist Everyday* by Ivone Margulies, Duke University Press, 1996. Also, a clip of the famous potato scene from Jeanne Dielman is posted on YouTube.

[10] Some directors intentionally create distance to make the audience stop and think. The technique referred to as "distanciation effect" was used in the theatre by German playright Bertol Brecht and was used by Spike Lee in *Do the Right Thing* where the characters face the camera and about racial slurs at the audience.

[11] *Eyes on the Prize,* Blacklight Producations.

[12] Aftab, pp. 23. – 24.

CHAPTER TWO
[1] There is evidence that Greek philosophy, arts and culture have origins in African culture. See *The African Origin of Civilization: Myth or Reality* by Chiekh Anta Diop, New York: Lawrence Hill Books, 1989 and *Black Athena: The Afroasiatic Roots of Classical Civilzation 2: The Archaeological and Documentary Evidence* by Martin Bernal, New Brunswick: Rutgers University Press, 1991.

CHAPTER THREE
[1] *Why We Make Movies.* p. 97

[2] *Script Magazine,* September/October 2008, p.51.

[3] Ibid., p. 50.

[4] Ibid., p. 51.

CHAPTER FOUR

[1] Gina Prince Bythewood uses these adjectives to describe Monica's mother in her screenplay *Love and Basketball.*

[2] Kenneth Atchity and Chi-Li Wong, *Writing Treatments that Sell,* New York: Henry Holt and Company, 1997, p. 10.

[3] *Love and Action in Chicago,* screenplay by Dwayne Johnson-Cochran. Logline and synopsis written by Christine List and Christine Houston for the purposes of this book.

CHAPTER SIX

[1] Excerpted from *Antwone Fisher,* original screenplay by Antwone Fisher

[2] Excerpted from *Devil in A Blue Dress,* screenplay by Carl Franklin adapted from a novel by Walter Mosely.

[3] Excerpted from *Malcolm X,* original screenplay by Arnold Perl and Spike Lee based on a novel by Alex Haley.

[4] Excerpted from *Eve's Bayou,* original screenplay by Kasi Lemmons.

[5] Excerpted from *A Soldier's Story,* original screenplay by Charles Fuller.

[6] For further reading see, Wolfram, Walt and Erik R. Thomas, 2002, *The Development of African American English.* Malden, MA and Oxford, UK: Blackwell. See also Smitherman, Geneva. 2000. *Black Talk: Words and Phrases from the Hood to Amen Corner.* New York: Houghton Mifflin.

CHAPTER EIGHT

[1] For more on this topic see *Syd Field, Screenplay: The Foundations of Screenwriting.* Delta: 2005.

[2] *Daughters of the Dust: The Making of an African American Woman's Film,* by Julie Dash with Toni Cade Bambara and Bell Hooks, New York: The New Press, 1992, p. 76.

[3] Ibid., p. 97.

[4] Armond White, Liner notes for DVD release. *Killer of Sheep: The Charles Burnett Collection.* Distributor: Milestone Film and Video, 2007.

[5] Ibid.

[6] Ibid.

[7] For further discussion of this idea see Nathan Grant, "Innocence and Ambiguity in the Films of Charles Burnett," *Representing Blackness: Issues in Film and Video,* Valerie Smith, ed. New Brunswick: Rutgers University Press, 1997, pp 135 – 156.

[8] Bogle, Donald. *Toms, Coons, Mammies and Bucks.* New York: *Continuum.* 1973; rpt. 1989.

CHAPTER NINE

[1] *Primetime Blues: African Americans on Network Television,* Donald Bogle, p. 33.

[2] Less than 19 percent of movies seen by African Americans in 2010 featured a predominantly black cast, storyline or lead star. *The Hollywood Reporter,* May 27, 2011, p. 12.

CHAPTER ELEVEN

[1] From a transcription of "The Big Chill" from *The Game,* Season One, Episode 19.

CHRISTINE HOUSTON

Christine Houston wrote *Two Twenty Seven*, a play about her childhood growing up at 227 E. 48th Street, located in what is now known as Bronzeville. She went on to win the ANTA West, the Lorraine Hansberry and the Norman Lear Playwriting contests. The latter took her to Los Angeles where she wrote a teleplay for the TV series *The Jeffersons*. Marla Gibbs, one of the stars of *The Jeffersons*, performed the play at her theater and received the NAACP Image award for best actress, while Mrs. Houston received the NAACP Image award for playwriting. Mrs. Houston went on to become a staff writer on the *Punky Brewster* TV series, and in 1985, *Two Twenty-Seven* was adapted to television and became NBC'S hit television series *227*. Professor Houston continues to write for stage and screen. Most recently, she finished her first novel called *Laughing Through the Tears*. Christine Houston is a Lecturer in Screenwriting at Chicago State University.

CHRISTINE LIST

Christine List is an award-winning screenwriter and filmaker whose work has been exhibited in the US and internationally. List has served as an evaluator and jurist for numerous national media organizations and competitions including the National Endowment for the Arts, the Film Studies Committee of the Fulbright Commission, Chicago International Film Festival, Women in the Director's Chair and The ABC New Talent Competition. List has been an editor for the media journal *The Democratic Communiqué* and has published widely on film and television, including her book *Chicano Images: Refiguring Ethnicity in Mainstream Film*. She currently heads the Program in Communications, Media Arts & Theatre at Chicago State University where she teaches screenwriting, media theory and digital cinema production.

CPSIA information can be obtained
at www.ICGtesting.com
Printed in the USA
BVOW06s1441080117

472928BV00018B/521/P

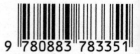